D1550226

Embodying Black Experience

WITHDRAWN

LIVERPOOL JMU LIBRARY

3 1111 01399 8453

THEATER: THEORY/TEXT/PERFORMANCE
Series Editors: David Krasner and Rebecca Schneider
Founding Editor: Enoch Brater

Recent Titles:

Embodying Black Experience

STILLNESS, CRITICAL MEMORY, AND THE BLACK BODY

Harvey Young

THE UNIVERSITY OF MICHIGAN PRESS

ANN ARBOR

Copyright © by the University of Michigan 2010
All rights reserved
Published in the United States of America by
The University of Michigan Press
Manufactured in the United States of America
⊛ Printed on acid-free paper

2013 2012 2011 2010 4 3 2 1

No part of this publication may be reproduced, stored in a retrieval system,
or transmitted in any form or by any means, electronic, mechanical, or
otherwise, without the written permission of the publisher.

A CIP catalog record for this book is available from the British Library.

Library of Congress Cataloging-in-Publication Data

Young, Harvey, 1975–
 Embodying Black experience : stillness, critical memory, and the
Black body / Harvey Young.
 p. cm. — (Theater: theory/text/performance)
 Includes bibliographical references and index.
 ISBN 978-0-472-07111-1 (cloth : alk. paper) —
 ISBN 978-0-472-05111-3 (pbk. : alk. paper)
 1. African Americans—Race identity. 2. African Americans in
popular culture. 3. African Americans in art. 4. Human body—
Social aspects. 5. Body image—Social aspects. 6. Anthropometry—
Social aspects. I. Title.
 E185.625.Y68 2010
 305.896'073—dc22 2009052181
 SBN13 978-0-472-02709-5 (electronic)

Take no one's word for anything, including mine—but trust your experience. Know whence you came. If you know whence you came, there is really no limit to where you can go.

—James Baldwin, "My Dungeon Shook" (1963)

Acknowledgments

This book has been my constant companion for nearly a decade. It outlived two computers, accompanied me on every vacation, and benefited from the advice of mentors, close friends, scores of conference attendees, and anonymous readers. Along the way, I have expressed my gratitude to many of those people. Here I offer a sampling of the many people whose support and suggestions enabled me to write the pages that follow.

LeAnn Fields, Senior Executive Editor at the University of Michigan Press, has been a tireless supporter of this project. In 2001, when I was a graduate student, LeAnn and I first broached the topic of working together on a book project. In the nine years that have passed since that early conversation, LeAnn has impressed me not only with her patience but also her dedication to mentoring junior scholars. David Krasner, the coeditor of the Theater: Theory/Text/Performance series, has been a friend, advisor, and mentor to me since we first met in summer 1998 at an Association for Theatre in Higher Education conference. His influence has touched every page of this book. Rebecca Schneider, the other coeditor of this series, served as my graduate advisor at Cornell. Our weekly conversations, between 1998 and 2002, laid the foundation for this project.

A large part of this book was conceived, if not written, during the four years in which I lived in Ithaca, New York. I am indebted to Timothy Murray, who cochaired my dissertation committee, provided endless encouragement, and helped me to refine my critical voice. Amy Villarejo read early drafts of this book and gave important feedback that substantially improved its overall tone. Kobena Mercer and Hortense Spillers helped me to develop the analytical frame through which I read black cultural performances. Manthia Diawara encouraged me to think about habitus as a way of theorizing

black experience. Roger Bechtel bailed me out of jail. Without his interven-
tion, this book might not have been written. Rebecca Devaney kept me smil-
ing and laughing even as I struggled to outline this project. My friendships
with Grace An, Derek Matson, Peter Civetta, Paige McGinley, Emily Col-
born-Roxworthy, Cathy Carlson, and Richard Klein enriched each day. I miss
living around the corner from them.

I finished writing this book in Chicago, where I have lived since 2002.
Barbara O'Keefe, Dean of the School of Communication at Northwestern
University, never hesitated to provide the research support that enabled its
completion. Virgil Johnson helped me to read the clothing styles of the 1920s
in the photographs of Richard Roberts. Ana Puga inspired me with her work
ethic and enveloped me with kindness. Sandra Richards, E. Patrick Johnson,
Tracy Davis, Susan Manning, Rives Collins, and Ramon Rivera-Servera are
friends, colleagues, and mentors whose example I strive to emulate.

I learned (and am still learning) the ropes of being an academic through
the informal mentorship of senior scholars who volunteered their time to as-
sist me in a variety of ways. I am particularly grateful to the guidance of Jen-
nifer Brody, Sue-Ellen Case, Catherine Cole, Jill Dolan, Harry Elam, Ellen
Gainor, Paul Jackson, Joseph Roach, and Sandra Shannon. In addition, a net-
work of junior and "emerging" scholars—many of whom have since attained
"senior" standing—provided invaluable support: Daniel Banks, Annemarie
Bean, Brandi Catanese, Faedra Chatard Carpenter, Tommy Defrantz, John
Jackson, Mechele Leon, Tavia Nyong'o, Jon Rossini, Andrew Sofer, Shannon
Steen, Melinda Wilson, Patricia Ybarra, Hershini Bhana Young, and Jean
Young, among others.

This book was supported by research fellowships from Harvard's Du Bois
Institute and Stanford's Center for Comparative Studies on Race and Eth-
nicity. It benefited from an American Society for Theatre Research Disserta-
tion Research Grant and numerous grants from Northwestern, including a
University Research Grant Committee award. Portions of chapters 4 and 5,
now revised, first appeared in the following publications: *Text and Perfor-
mance Quarterly* 23, no. 2 (2003): 133–52; *Theatre Journal* 57, no. 4 (2005):
639–57; *Assaph* (2007); and *Suzan Lori-Parks: A Casebook*, ed. Alycia
Smith-Howard and Kevin Wetmore, Jr. (New York: Routledge, 2007), 29–47.

Finally, the roots of this project anchor themselves in my youthful expe-
riences growing up in Buffalo, New York. I first encountered images of
lynchings in the books that belonged to my parents, Harvey Sr. and Regina.

The college textbooks of my sister, Cheryl, introduced me to black political history, a subject entirely absent from my elementary and high school education. Heather Schoenfeld, my wife, lived with this project for the past six years. She joined me in retracing the journeys of Tom Molineaux, Saartjie Baartman, and James Cameron. A diligent researcher, intelligent interlocutor, and my favorite travel companion, Heather has improved both this book and its author.

This book is dedicated to the memory of Charlie Young, Jr., my paternal grandfather. He lived in South Carolina during the days of legal lynching, moved to Buffalo as part of the last wave of the Great Migration, and embodied the world to his eldest grandson.

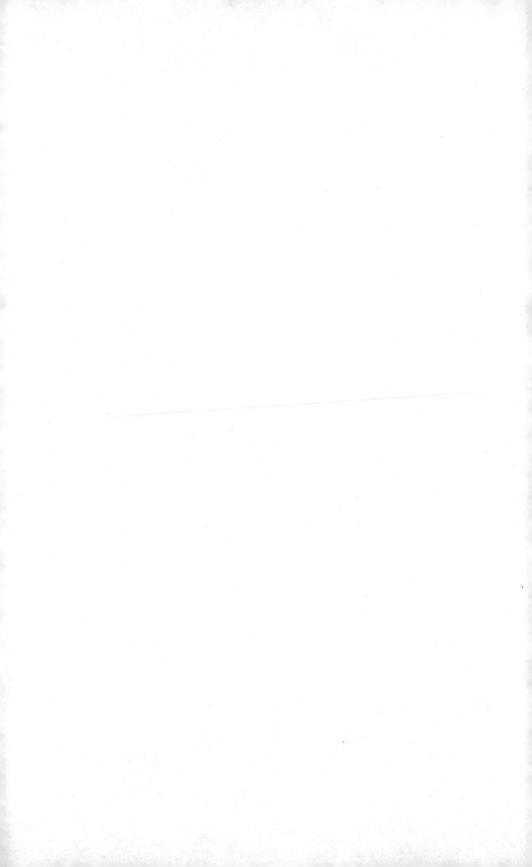

Contents

CHAPTER ONE

The Black Body

"Look, a Negro!" The circle was drawing a bit tighter.
I made no secret of my amusement.

—Frantz Fanon, *Black Skin / White Masks*

Writing in the 1950s, Frantz Fanon offers a compelling postcolonial critique of the negative effects of white European imperialism on the societal and self-perception of the black body. To him, the epidermalization of blackness, the inscription of meaning onto skin color, is something from which black men seek to escape. As he notes in *Black Skin / White Masks:* "However painful it may be for me to accept this conclusion, I am obliged to state it. For the black man there is only one destiny. And it is white."[1] In support of this "conclusion," Fanon outlines, as case studies, the bodily experiences of several black men and women whom he interviewed or treated during the exercise of his profession as a psychologist in Martinique. Despite the presence of these multiple recounted experiences, the voice that resonates best within his text belongs to Fanon himself, who intermixes his own story even as he maintains that he is relaying the experiences of others. The extent of the author's autobiographical investment appears most clearly and memorably in his recollection of a street encounter with a young white boy and his mother. In the remembered scenario, Fanon recalls walking along a city street and overhearing the loud and frightened voice of a child who exclaims, "Look, a Negro!" to his mother as she carries him.[2] The boy's statement is repeated twice more and then is altered slightly during its fourth iteration: "Look, a Negro! Look, a Negro! Mama, see the Negro!"[3] Whether these phrases were repeated in actuality at Fanon or were only stated once and then echoed in Fanon's imaginary like the tolling of a bell, it is clear that the look, announced, repeats. Referring to his encounter with the boy's address,

an address that was not intended for him but did target him, Fanon writes, "On that day completely dislocated, unable to be abroad with the other, the white man, who unmercifully imprisoned me, I took myself far off from my own presence, far indeed, and made myself an object."[4] The racializing look, announced, not only repeats but also transforms (the boy into a man!), dislocates, imprisons, and objectifies.

On a fall day in 2000, I went for a walk along a street, State Street, to be precise, in the northeastern town in which I lived. I was snapped out of my thoughts the moment that a carload of college-aged white boys roared by in a red sedan and screamed "Nigger!" as they passed me. The announced look had repeated. The event seemed not only a reenactment of Fanon's experience in Lyon, France, in the 1950s performed across my body in 2000 in Ithaca, New York, but also a replaying of my own previous experience in that very same town.[5] A year earlier, the same thing happened. The only difference: State Street was now Oak. The year before that I was arrested ostensibly for DWB: Driving While Black. My memory of the arrest remains vividly clear. I was driving my pick-up truck late one evening along a two-lane street. Stuck behind a slow-moving vehicle, I shifted lanes, accelerated, passed the car, and returned to my original lane. Seconds later, I heard a siren and noticed flashing lights in my rearview mirror. I pulled over and watched as two white officers, one male and one female, exited their vehicle and cautiously approached my truck with their hands hovering over their guns. I was informed that I had illegally crossed over into another lane. Officially, I had failed to stay right of the double line. I handed my license and registration to the male officer and waited with his partner while he returned to his cruiser and, presumably, radioed in that he had pulled over a six-foot something, twenty-something black male. As we waited, the female officer told me not to worry because such traffic violations were not only minor but also common and that they always resulted in a ticket and a small fine. When her partner returned, he ordered me to step out of the vehicle, displayed his handcuffs, and declared, "I'm going to take you in." I was shocked. I explained that I had just been told that I was going to receive a ticket and requested what charge prompted the arrest. He brusquely replied, "You're resisting arrest. That's the charge." Having visions of Rodney King, the black motorist who was severely assaulted by the Los Angeles police for resisting arrest in 1991, I extended my arms and allowed the officers to cuff me. With an officer's hand on my back, I was directed toward the police car and seated in

the rear of the vehicle. I was whisked away to a processing center where I spent two hours being shuttled from room to room. In one, I was required to stand still so that my photograph, my mug shot, could be taken from multiple angles. In another, an officer grabbed each one of my fingers, jammed it into a black ink pad, and applied it to an index card and then repeated the act until every digit was stained. I was taken to an interrogation room but never interrogated. Instead, I had a conversation with the female arresting officer, the one who told me that I would receive a ticket. When I stated, "I don't understand why I am here," she replied that I had performed an action that qualified as "passive resisting arrest—but still resisting arrest" by questioning why I was being handcuffed. She informed me that resisting arrest is considered a felony in New York State and is punishable by up to one year's imprisonment and a significant fine.[6] She further explained that I was eligible for bail, once the paperwork had been completed, and that I, if bailed out, would have to appear before a judge on the next business day.

I never saw the inside of a holding cell. A friend, Roger, a former lawyer who had abandoned legal practice to study theater history, bailed me out before I could be transferred to a cell where, I imagine, other unsuspecting people like myself were being detained as criminal suspects. The next day, I reported to the courthouse with my friend, and together we sat and watched as the judge ruled against every defendant and gave the maximum sentence or fine. Roger whispered in my ear, "This doesn't look good," and suggested that we locate the county prosecutor and request that the charge be dropped. The prosecutor refused but offered to reduce it to disorderly conduct, a misdemeanor carrying a several-hundred-dollar fine. I initially protested the reduction—I had not done anything wrong other than commit a minor traffic violation and ask a simple question under my right of free speech. I was warned that refusal to take the "deal" would leave the felony charge intact and result in me needing to hire a defense attorney for the trial. If I refused to plead guilty and pay the fine, I might spend considerably more money in lawyer fees yet still face the possibility of going to jail and being branded a convicted felon. I reluctantly agreed to the reduced charge and the drama ended.

Each of these incidents—the multiple hailings of/as "Nigger" and the unjustified arrest, separated by a couple of blocks and temporally by a few years—affected and effected me in the manner described by Fanon. I was and still am transformed, dislocated, incarcerated, and objectified by the

continued reverberations of these repeated encounters. Influenced, in part, by the similarity of the experiences of Fanon and myself and aware that they are not particular to our respective bodies, but are shared among the majority of recognizably "black" bodies, both male and female, who live(d) an objectified existence within the Western world, I have set both the black body and the experience of the black body as the objects of inquiry for the following project. Black bodies, in the twenty-first century, continue to share in the experiences of their ancestors who were viewed as "other," unjustly incarcerated, and subjected to limitless violence. The lynching of James Byrd in 1998, the public suffering of mostly black residents of New Orleans in 2005, and the circulation of racist stereotypes and caricatures during the presidential campaign of Barack Obama in 2008 serve as reminders of the continuing existence of twentieth-century prejudices. Although the legacy of past racism(s) can create the experience of racial déjà vu in the present, this book does not contend that black bodies today face the same societal limits as their forebears. The fact that Byrd's assailants were convicted and sentenced to death and that Obama won his election demonstrates the advances in society since Senator Ben Tillman, standing on the floor of the U.S. Senate in 1900, urged the nation to lynch blacks.

Embodying Black Experience spotlights the ways in which an *idea* of the black body has been and continues to be projected across actual physical bodies; it chronicles how the misrecognition of individuated bodies as "the black body" creates similar experiences. Despite the passage of years (nearly two hundred) and the shifting geography (across a variety of cities within a handful of Western countries), the embodied experience of the individuals profiled within this study resemble one another. Saartjie Baartman, the "Hottentot Venus" and the protagonist of Suzan-Lori Parks's play *Venus,* was paraded throughout London and displayed in carnival-like settings as a freak or oddity in the early 1800s. Upon her death, she was dismembered by natural scientist George Cuvier, bottled, preserved, and put "on show" at a Paris museum. Renty, an African captive in the United States, was photographed as a scientific specimen for a future study by Cuvier's former student, Louis Agassiz, in 1850. George Ward, a lynching victim, was attacked by a white mob, murdered, set afire, chopped into pieces, and sold to interested collectors as a souvenir of the black body in 1901. Jack Johnson, the first black heavyweight champion boxer, whose success prompted a national search for a "great white hope" in 1908, was harassed by federal and state authorities

within the United States, incarcerated, and staged within a variety of prison-based exhibition matches.

The projections continue to structure embodied black experience with each subsequent generation: James Cameron (1930s), who was literally dragged through the streets of Marion, Indiana, by a lynch mob; boxing champion Muhammad Ali (1960s), who struggled against societal efforts to transform him into a "black white hope"; and performance artist Robbie Mc-Cauley (1990s), whose dreams of her great-great-grandmother's sexual assault on a Southern plantation tormented her and inspired her to write her play *Sally's Rape*. Beyond drawing attention to the continuing existence or legacy of racial assumptions, I contend that their projections across individuated bodies exist as acts of violence that assume a variety of forms: an epithet, racial profiling, incarceration or captivity, and physical/sexual assault. Each engenders an experience of the body that informs black critical memory, shapes social behavior or everyday social performances (black habitus), and determines the ways in which black folk view the society in which they live and the people, including themselves, who populate it.

The premise of this book is not that all black people have the same experience; it is, rather, that a remarkable similarity, a repetition with a difference, exists among embodied black experiences. Unlike other studies that interrogate the lived realities and social performances of black folk, the emphasis here is not on the scalar differences that separate one person from another but on those moments of experiential overlap that frequently create common and, perhaps, shared understandings among black folk of the *similar* ways in which they are viewed and treated within society despite their differences from one another. The experience of Renty, who stood still before a daguerreotype camera, echoes the experience of other black captives who stood still on auction blocks and prefigures those of hundreds of thousands of black bodies who reenact moments of arrest and re-arrest in police precincts every year. Firsthand encounters with a racializing projection are not a requirement of embodied black experience. It can also develop through second- and thirdhand accounts that are shared among community members: the story of a neighbor being profiled by the police or the tale of a white cross being burned on someone else's lawn, among other possible narratives. Certainly, the terrorizing effect of a lynching affected more people than the individual(s) who suffered and died.

What separates this study from other books that either revel in the mis-

fortune of black people or set aside their suffering in an effort to privilege the joys of blackness is a pragmatic understanding not only of the ways in which the past shadows the present but also of how the joys and, perhaps, the *jouissance* of blackness, are tempered with pain. Employing performance studies methodology in addition to phenomenological and biographical methods, this book critically reads and theorizes this two-ness. The people profiled here, through perseverance and determination, stood up to, stood tall against, and looked back at a community determined to cripple them for the meaning that it ascribed to their complexion. They employed performance, frequently a performance of stillness across a variety of media—photography, theater, and museum display—to challenge racializing projections. Renty employs stillness to subvert the gaze of Agassiz. Ali uses it to refuse induction into the U.S. Army. McCauley stages it with the aim of reactivating the memories of her great-great-grandparents. James Cameron uses the still photographs of previous lynching campaigns and a souvenir from his own near-lynching to establish an archive of the horrors of U.S. racial violence.

This book is not about photography, theater, athletics, or museums. It is about how similar experiences of the body repeat within the lives of black folk and how select individuals have employed expressive forms to relay their stories and life lessons to largely unimagined future audiences. While the artistic framing affects the manner with which we encounter the black body depicted within it, its particularities are introduced primarily to reveal a new way of engaging with or encountering the embodied experience of its creator and/or featured protagonist(s). The fact that black captives sat before a daguerreotype machine, an early camera, is of greater concern than the history of photographic portraiture. Similarly, the stories of black captive women as portrayed by Suzan-Lori Parks and Robbie McCauley get more attention than theater architecture. Although book-length accounts of nineteenth-century daguerreotypes, Great Depression photography, African American boxers, the dramaturgy of black playwrights, and the philosophies of museum curators can be—and, often, are—compelling, this book strives to be none of them. *Embodying Black Experience* stands at the point where these various projects intersect. In retelling the stories of black folk, it begins with two-dimensional artistic projects and slowly moves toward three-dimensional interactive displays. In the journey from the photographic still to the museum, the existence of the black body proves not only unmistakable but also unavoidable.

Phenomenal Blackness

When popular connotations of blackness are mapped across or internalized within black people, the result is the creation of *the black body*. This second body, an abstracted and imagined figure, shadows or doubles the real one. It is the black body and not a particular, flesh-and-blood body that is the target of a racializing projection. When a driver speeds past a pedestrian and yells "Nigger," she launches her epithet at an idea of the body, an instantiation of her understanding of blackness. The pedestrian, who has been hailed and experiences the violence of the address, which seems to erase her presence and transform her into something else (an idea held by another), becomes a casualty of misrecognition. The shadow overwhelms the actual figure. The epithet, asserting an adjectival influence that locates within the seen (body) an aspect that is largely imagined, brings together the physical black body and the conceptual black body. It blurs them. Fanon was aware of this. He understood that the slippage of abstraction into materiality frequently resulted in the creation of an embodied experience of blackness that was tantamount to imprisonment.

As an instantiation of a concept (blackness), the black body does not describe the actual appearance of any real person or group of people. On this distinction depends a scene in Gordon Parks's film *Shaft*, in which a police lieutenant holds a black pen to the title character's face and declares, "You ain't so black"—to which Shaft, after comparing a white coffee cup to the lieutenant's corporeal mug, responds, "And you ain't so white, baby . . ." *Black* is always an imprecise projection or designation. It is an "enigma . . . wrapped in the darkest and deepest subliminal fantasies of Europe and America's cultural id," as Henry Louis Gates, Jr., has observed.[7] The mystery of blackness, which manages to become a *fact* through repeated deployment across a range of bodies, encourages the (mis)identification of individuated bodies (*a body*) as the black body. The latter replaces the former. The individual becomes anonymously or, more accurately, metonymically black—in much the same way that Renty became "slave," Fanon became "Negro," and lynching victim George Ward became (a) "souvenir." The epithetic nature of the black body does not erase or discount the unique experiences of individuals. It recognizes that each figure lives in a distinct temporal, geographic, and sociopolitical moment. However, it privileges those instances of similarity among these various bodies and collapses them into a singular body within the imag-

ination. The black body becomes a souvenir, a captive, a Negro, the Hotten-tot Venus, Renty, George, and Frantz. Equally importantly, each becomes the black body.

Capable of representing not only the racial fantasies but also the lived re-alities of people, the black body, even when not named as such, has stood at the center of a variety of academic studies on *diasporic* blackness. Consis-tently, these accounts champion one of two perspectives. On the one hand, the black body appears as a discursive practice employed within a particular setting or situation. Despite being an abstraction, it is conceptualized as pos-sessing a sociogeographic materiality. Radika Monhanram best represents this tradition of thought in *The Black Body* with her investigation into the in-terdependence of ideas of landscape, nation, and body. On the other hand, the black body has been critiqued as too narrow a category for broad appli-cation. Paul Gilroy, for example, has persuasively diagnosed the problem in-herent in understandings of a singular, unchanging idea of blackness by not-ing that black folk may share phenotypical similarities but different lived realities. In addition, a variety of feminist and womanist authors have cau-tioned the academic community about the dangers inherent in theoretical conceptualizations of the body. *Embodying Black Experience* positions itself between these two groups.

In *The Black Body*, Monhanram offers a phenomenological account of the manner in which the black body comes into existence. Following in a rich tradition of cultural thinkers, Monhanram defines blackness as "the confluence of history, culture, economics, geography and language which conditions the enunciative function."[8] Prefiguring E. Patrick Johnson's identification of the "endemic relationship between performance and black-ness," Monhanram outlines an active model in which the maintenance and existence of blackness, as a concept, depends upon continual and repeated deployment.[9] Like a stereotype, which must occur and continuously recur, blackness and the black body, its instantiation, requires enactment. Her analysis privileges geography, as affected by language and history, and traces its influence on the body. Championing a materialist analysis, developed through a phenomenological framework, she outlines the ways in which the landscape physically structures the relationships among bodies and promotes an ideological consideration of *nation* that, in turn, demands an appreciation of the ways in which history and culture inform both place and the body. Ac-cording to Monhanram, "'black' can only resonate with the meaning that it

does when it is considered to be geographically and socially in or out of place."[10] Although her investment in place discourages considerations of the ways in which blackness circulates in a similar manner across a variety of disparate geographical and temporal settings, her emphasis on the impact of historical and cultural influences on the situation of the black body is invaluable. The phenomenon of the black body, or, for short, phenomenal blackness, invites a consideration of history, habit, memory, and the process of racial mythmaking.

In centering the black body, I am sensitive to the ways in which the privileging of blackness, black experiences, and an idealized revolutionary body in U.S. scholarship of the 1960s and 1970s marginalized the experiences of differently complexioned and gendered bodies. The backlash to accounts of bodily singularity motivated the writings of a wave of black British, feminist, womanist, and queer scholars whose (re)conceptualization of African diasporic culture has shaped black cultural studies over the past four decades. Within this context, the writings of June Jordan, Stuart Hall, Paul Gilroy, Hortense Spillers, Barbara Smith, and Kobena Mercer, among others, not only emerged but also assumed the lead in defining the field. The black body, as developed within this study, bears the influence of these scholars and remains compatible with their theories. In the introduction to her collection of literary criticism, *Black, White, and in Color,* Spillers cautions that "the body" in critical discourse often reflects the subjectivity of the author:

> I would contend that the body is neither *given* as an uncomplicated empirical rupture on the landscape of the human, nor do we ever actually "see" it. In a very real sense, the "body," insofar as it is an analytical construct, does not exist in person at all. When we invoke it, then, we are often confusing and conflating our own momentousness as address to the world, in its layered build-up of mortal complexities, with an idea on paper, only made vivid because we invest it with living dimensionality, mimicked, in turn, across the play of significations.[11]

Conscious of the danger of making the Self, as an embodied abstraction speak for all, Spillers suggests that "the 'body' should be specified as a discursive and particular instance that belongs, always to a *context,* and we must look for its import there."[12] Building on Spillers, I contend that the black body exists as a theoretical construct that both represents and creates the ex-

periences of multiple, individuated bodies within specific contexts. Although Spillers would maintain that we never "see" the body and would emphasize that the seen (and, perhaps, the scene) is in actuality skin color, her position is not inconsistent with this understanding of the black body. From a phenomenological perspective, we never see our own body in a "true" or "objective" sense. Its completeness is rationalized, mediated by thought and imagination, and rarely witnessed by ourselves. We understand our place and position within the world by interacting with others, imagining ourselves from their perspective. As a result, we always see ourselves from a distance and from the (imagined) vantage point of another. The black body is who we see from that outside perspective. It is the imagined and, yet, highly (mis)recognizable figure who shadows the actual, unseen body. The important point, which Fanon understood, is that the (in)visibility and (mis)recognizability of black bodies structure experience.

There has been a backlash against efforts to understand racial (mis)recognizability as a determining factor in the lived experience of black folk. The argument, put forth by a range of scholars who champion a prismatic approach to understanding cultural identity, can be summarized with the following statement: *I may be black but I also am so much more than merely black*. They note that embodied experiences are influenced not only by racial visibility but also by sexuality, class status, physical condition (health), religion/spirituality, and education, among a variety of other factors.[13] It is these other factors that determine individual outlook and experience. For example, a seventy-year-old, black, Baptist, working-class, heterosexual male who lives in rural Mississippi has a different lived reality and daily experience of the body than a twenty-year-old, black, Jewish, upper-class, lesbian female who lives in New York City. While recognizable black skin is a trait held in common by the two individuals, it may be the only one that they share. To assert that the man and the woman have the same experiences would require one to overlook their many differences. It would reject the variability that exists within black communities in favor of an imagined, enforced, and limited notion of racial particularity. Indeed, the woman and the man, within this example, likely would have differing and, perhaps, contrasting experiences of racial paranoia and racial possibility. Each of their uniquely individual experiences of their own body is constituted by a mélange of their complected or epidermalized experiences, class experiences, and gendered experiences among others. Nevertheless, I submit that an acknowledgment of the multi-

ple determinants that inform an individual's perspective on the world (and on herself) neither limits group identification nor prevents the theorization of the black body.

Although it is difficult to parse the differences within the imbricated realities of race, culture, gender, and class, there are certain spectacular events, charged racialized and racializing scenarios, in which complected experiences assume a more active and, indeed, determining role in a person's lived experience. Despite being an early proponent of theories of intersectionality, an account of the intertwined nature of identity categories (i.e., being black *and* female *and* queer), sociologist Patricia Hill Collins acknowledges that there are moments in which phenomenal blackness assumes a more active role in individuated experience than any of these other identity markers. She writes, "In some situations, gender, age, social class, and education do not matter."[14] Racial profiling is an example of such a situation or event. Imagine looking at a motorist from a distance. What do you see? If the car drives past you, then you will probably observe, within the few seconds in which it passes you, the skin color of the driver, possibly the driver's biological sex (depending upon hairstyle, facial features, and available lighting), and the type of vehicle being driven. You may not be able to detect the age of the driver except within the broad categorization of young or old. Religion, class, health, wealth, level of education, and sexuality may not be discernable unless indicated by car decals or bumper stickers. While a luxury car could suggest that the driver is affluent and educated, a black body driving a luxury car may render the driver suspect to law enforcement. A successful black lawyer could be (mis)read as being a successful black drug dealer. In short, visible phenotypical characteristics become the primary determinant in racial profiling. Whether the driver is a religious gay man or an atheistic heterosexual female matters less in the moments preceding the stop than the similarity of their racial characteristics. Spectacular events demonstrate the ways in which conceptions of blackness are projected across individual bodies. They reveal that embodied experiences develop, in part, from racial (mis)recognition and spotlight how an idea of the black body materially affects actual bodies.

The pervasiveness of racial profiling and its ability to entrap a wide array of black bodies underscores the necessity of the current enterprise: to demonstrate the similar embodied experiences of differently placed, temporally and geographically, black bodies and to urge a reconsideration of postrace and/or pluralist accounts that maintain that recognizable blackness is no

longer a determining condition in the experience of the body. Unfortunately, the U.S. federal government does not require local and state law enforcement to maintain a record of their traffic stops. As a result, it is difficult to demonstrate that racial profiling exists. In an ongoing effort to gather evidence of this practice, the American Civil Liberties Union conducted a study of a stretch of Interstate 95 in Maryland in 1995 and 1996 and found that 75 percent of all traffic stops and searches were of black motorists but only 17.5 percent of the ticketed traffic violations were given to black drivers.[15] Officers were more inclined to pull over a black person than a white person without probable cause. In May 2005, the Arizona Supreme Court acknowledged the existence of racial profiling within its state when it dismissed charges, stemming from the results of searches conducted during illegal stops, against seventeen black and Hispanic individuals. The court, in a unanimous decision, observed that "a state can no more make 'driving while Black' a crime by means of enforcement than it could by express law."[16] According to a statewide review of police stops, "African Americans were 67 percent more likely to be stopped in 2008" in Missouri.[17]

Racial profiling also occurs in other Western nations in which the black body lives a minoritized existence. In March 2005, the *Toronto Star* interviewed several black police officers who openly discussed the prevalence of racial profiling in the Canadian city. Several officers even noted how they themselves had been victims of illegal stops.[18] Two months later, the Canadian Broadcasting Corporation reported that black drivers in the southern Ontario city of Kingston were 3.4 times more likely to be stopped than a white motorist.[19] When a "spectacular event" takes place, the individual differences between the Jewish black lesbian and the straight Baptist black man are for all practical purposes elided or erased.

The experience of racial (mis)recognition plays a determining role within the formation of phenomenal blackness. The black body, whether on the auction block, the American plantation, hanged from a lightpole as part of a lynching ritual, attacked by police dogs within the Civil Rights era, or staged as a "criminal body" by contemporary law enforcement and judicial systems, is a body that has been forced into the public spotlight and given a compulsory visibility. It has been *made to be given to be seen.* Its condition, as Du Bois famously observed, is a "sense of always looking at one's self through the eyes of others."[20] This awareness of one's status as the seen/scene structures behavior. Examples abound: the black shopper who dresses up to go shop-

ping in an effort to lessen the odds of being (mis)read as a potential shoplifter, or the black pedestrian who crosses the street when s/he sees a white pedestrian in order to reduce the chances of being (mis)taken for a pickpocket, robber, prostitute, or murderer. Even those pedestrians who refuse to switch sides of the street with the deliberate aim of "scattering the pigeons," as Brent Staples memorably writes, remain aware of their compulsory visibility.[21] In each case, the person bases her actions on how she is being perceived from without (outside) her own body.

In a 1993 speech in Chicago, Jesse Jackson, Sr., offered a firsthand example of the effect that external, dominating images of the black body have on the way that black folk are perceived by other black bodies. He noted, "There is nothing more painful to me at this stage in my life than to walk down the street and hear footsteps and start thinking about robbery—then look around and see somebody white and feel relieved."[22] His double vision creates a problem. Walking down the street, at first, he thinks of himself in the first person and only from his own perspective. Then, hearing footsteps, he worries about being attacked or mugged. More problematically, he imagines that the *heard* footfalls belong to a black assailant who waits for the right moment—such as getting close enough—to attack him.[23] Turning around, he realizes his mistake. The pedestrian is white and he has unfairly rendered the black body (as a) suspect. His pain emerges from his (mis)reading of the absent black body from the same outside perspective that conceivably could be used to (mis)read his own body. Arguably, this double vision is accompanied by an internalized double voice.[24] Perhaps this second voice within Jackson's imagination hails both his imagined assailant and Jackson himself as *nigger*. Is Jackson's pain anchored in the fact that his own imagination created a Fanonian moment in which he realized the fact of his own blackness? Did Jackson metaphorically look at himself and say, "Look a Negro! I'm frightened?" Did the presence of the white pedestrian that vanquished Jackson's anxieties of a black assailant prompt the civil rights leader to realize that he now might be the black assailant in that other person's imagination? Did the footfalls slow down as they neared the black body walking ahead of it?

Jackson's self-revelation suggests that the black body is both an externally applied projection blanketed across black bodies and an internalization of the projected image by black folk. Black folk also suspect the black body. In 1996, comedian Chris Rock gained international celebrity status when he placed a spotlight on the distinction between "blacks" and "niggas." At one

point within his routine, Rock declared, "I love black people, but I hate niggas, brother. Oh, I hate niggas!"[25] Highlighting the class differences within black communities, Rock offered a stereotype-laden description of "niggas" as poor, indolent, and criminal and "black people" as middle-class, hardworking, and moral. With his routine, Rock may have sought to revise the negative depictions of blackness by offering a more positive vision and, indeed, a different perspective on the black body. And he triggers laughter born of mutual acknowledgment of that sense of embarrassment that "respectable" middle-class or wealthy people have when they realize that they too have incorporated a stark vision of the black body as nigger. Unfortunately, the mainstream news and entertainment media condensed Rock's routine into the following sound bite: black people hate black people too.[26] Jackson's fear, Rock's portrayal of "blacks" and "niggas," and select media's fusion of Rock's two types into the black body of Jackson's imagination offer insight into the ways in which the idea of the black body and the actual, physical black body interrelate and, frequently, blur together. More recently, I was reminded of this double vision when I spoke with a family friend, Rick, a retired, eighty-two-year-old widower, former factory worker, and father of two. He proceeded to tell me how he hated seeing young, healthy "niggers" on the street asking people for money. He declared that "welfare," that is, state financial support for the poor, should not be given to able-bodied men, that they should either be forced to get a job or remain homeless. He ended his statement with the following: "I can say this because I've been a nigger for eighty-two years." What interested me during my conversation with Rick and continues to interest me is how he associated himself with the unidentified homeless black men even as he distanced himself from them. Although his own experiences of being a retired, blue-collar worker who worked to support a family and to create a retirement savings differ from the activities of the homeless man who, in his eyes, elects not to work, he refers to his own self, his own body, in the same way as "nigger." Despite the differences of perspective, he knows that he is seen from without in the same manner. One gets the feeling that Rick had to work hard to avoid (or refute) the label *nigger*, a label that, despite his best efforts, would continually be applied to him. It is this self-discovery that challenges arguments against the unanimity of select black experiences. Although black bodies vary, thus preventing them from having exactly the same experience, the similarities in how they are seen and see themselves constitute a relatable experience of the body.

Ledger of Slights

Barack Obama may be the most public example of a person who possesses the type of constructivist perspective on race being championed within this book. The son of a white American (Kansan) mother and a black African (Kenyan) father, Obama does not possess the "blood memory" of U.S. black captivity. Mixed race, he embodies the hybridized present, gestures toward a "postrace" future, and reminds everyone that racial intermixture occurred frequently within the past. Yet he identifies as black. His self-recognition steeps itself in the experience of being seen and, therefore, treated as a black body. In *Dreams from My Father,* the autobiography that he penned when he was thirty-three years old in 1995, the future U.S. president recounts a "ledger of slights" that informed his embodied black experience:

> The first boy, in seventh grade, who called me coon. . . . The tennis pro who told me during a tournament that I shouldn't touch the schedule of matches pinned up to the bulletin board because my color might rub off. . . . The older woman in my grandparents' apartment building who became agitated when I got on the elevator behind her and ran out to tell the manager that I was following her; her refusal to apologize when she was told that I lived in the building. Our assistant basketball coach . . . who, after a pick-up game with some talkative black men, had muttered within earshot of me and three of my teammates that we shouldn't have lost to a bunch of niggers; and who, when I told him—with a fury that surprised even me—to shut up, had calmly explained the apparently obvious fact that "there are black people, and there are niggers. Those guys were niggers."[27]

These direct experiences coupled with the stories that he heard—such as a college friend's account of being racially profiled by the Los Angeles Police Department ("They had no reason to stop me . . . 'cept I was walking in a white neighborhood")—informed Obama's understanding of the ways in which projections of the black body across recognizable African American bodies create similar embodied experiences. They shaped his outlook, an outlook that he summarized in a 2008 television interview: "If you look African American in this society, you're treated as an African American."[28] This perspective, also shared by his wife, Michelle, was expressed in an even more direct manner in her response to a question about the possibility of an

assassination attempt on her husband's life. She replied, "I don't lose sleep over it . . . the realities are that, as a black man, Barack can get shot going to the gas station." The horrific murder of Amadou Diallo, a twenty-something African immigrant who was misrecognized as another black body and subsequently gunned down by New York City police officers in 1999, is a testament to the ease with which a spectacular act of violence can intrude upon the everyday lives of black folk.

While common bonds of history can unite black people, cultural theorist Stuart Hall contends that the lived realities of their multiple and variable bodies in the present has the potential to create differing and divergent life experiences. According to him, "cultural identity" rests on a continuum between *being*, a "oneness" that enables a sense of unity and promotes community and *becoming*, an ongoing process of difference and discontinuity. Although he asserts that cultural identity shares attributes of both, he expresses a preference for becoming after observing that being, with its attention on the past, overlooks the present-day and future differences among black bodies. While it is possible to imagine a past moment or experience of commonality, this fictive retreat into an artificial nostalgia only can last for so long before differences and divergences in experience are encountered. Hall writes, "We cannot speak for very long, with any exactness, about 'one experience, one identity,' without acknowledging its other side—the ruptures and discontinuities which constitute, precisely, [individual bodies'] 'uniqueness.'"[29] Conversely, becoming looks at the body in the present day with an eye toward the future and allows for its future possibilities. Unlike being, which is an unchanging "one true self," becoming is a "production," continually developing beyond its historical base.[30] He writes:

> Identity is not as transparent or unproblematic as we think. Perhaps instead of thinking of identity as an already accomplished fact, which the new cultural practices then represent, we should think, instead, of identity as a "production" which is never complete, always in process, and always constituted within, not outside, representation.[31]

Hall encourages his reader to appreciate the uniqueness and self-fashioning abilities of individuals and, by extension, cultural groups. In *The Last Darky*, Louis Chude-Sokei provides a productive example that supports Hall's reading when he offers a glimpse at the tension(s) among black Caribbean immi-

grants in the United States and African Americans in the early twentieth century. Although both groups were subjected to the "color line," they repeatedly drew attention to their cultural differences. Chude-Sokei reads this tension in the multilayered performances of blackface minstrel Bert Williams, a Bahamian who moved to the United States and suppressed his accent on stage to play stereotypical African American characters. Williams's presence on stage and his depiction of the black body complicate, for Chude-Sokei, "the rhetoric of binary chromatism and American exceptionalism" in black cultural studies.[32] These tensions continue today.

E. Patrick Johnson, in *Appropriating Blackness*, revises Hall, situating the experience of the black body between the positions of "being" and "becoming." Not wanting to jettison the legacy of black experience in the construction of contemporary racial identities, Johnson maintains that the body simultaneously can exist as a "being" and a "becoming." He presents an account of the body of Marlon Riggs, the black documentary filmmaker who died an untimely death due to an HIV-complicated illness. The performance scholar asserts: "The beauty of 'being,' however, is that where it crumbles under the weight of deconstruction it reemerges in all its bodily facticity."[33] With these words, he suggests that the black body can be analyzed, scrutinized, examined, and critically dismembered but, at the same time, remain whole and always existing as a black body. Even as we look to see how blackness is constructed, we also face its embodied presence. Although this concept of an eternal, undying, and permanently indivisible blackness suggests immutability, it does not prevent the black body from being read in terms of "becoming." Johnson matter of factly states, "Riggs's body is also a site of 'becoming.'" He explains:

> He dies before the film is completed and his body thus physically "fades away," but its phantom is reconstituted in our current discourse on AIDS, race, gender, class, and sexuality. His body discursively rematerializes and intervenes in hegemonic formulations of blackness, homosexuality, and the HIV-infected person.[34]

For Johnson, the body enters the realm of "becoming" when it gets transformed (by death) into discourse. Being becomes becoming. In the death of Riggs, his body disappears and gets reborn as an immaterial, ideological entity with the power to effect change. The phantom of Riggs guides the cre-

ation of new theories and disciplinary studies. Indeed, Riggs remains one of the most visible and cited bodies within contemporary African American, documentary film, and gender studies. It is difficult to read a text in any of these disciplines and not encounter him. Nevertheless, a black body does not need to die to become discursive. It is always discursive, even while fleshed (or projected across flesh). It exists within the public imaginary, appears within public policy, dwells (or is confined) within public institutions. It is the body constructed by social paperwork (birth certificates, medical records, passports, court documents) and social enactments (juridical pronouncements and racial profiling, among others). The obsession over Saartjie Baartman within legal and medical discourse confirms this.

Critical memory assists the process of identifying similarities—shared experiences and attributes of being and becoming—among black folk not by presuming that black bodies have the same memories but by acknowledging that related histories create experiential overlap. For example, the experience of arrest and re-arrest was felt by a wide array of black bodies beginning in the earliest days of the slave trade and lasting through the present moment. In his 2001 article, "Black Modernity," Houston Baker emphasizes the potential political agency that rests within "black memory." Referencing Thomas Jefferson's concerns, published in *Notes on the State of Virginia,* that recollections of the mistreatment and abuses of the black body by white "masters" would prompt former captives, once emancipated, "into millennial warfare against their enslavers" and underscoring the former president's conclusion that freed blacks should not remain within the country, the cultural critic writes, "In sometimes sad, complicitous, self-destructive ways, we have assumed that if we blacks simply step back and erase our memory we will be allowed to remain healthily on American soil—and even be liked."[35] According to Baker, there is revolutionary power within black memory. It can spotlight the past assaults on the black body within both public and private settings and can name the culprits responsible for those abuses. Imagine if Jefferson's captive mistress, Sally Hemings, had publicly revealed her ledger of slights, including her experience of rape, and identified Jefferson himself as her assailant. Beyond indicting figures in the public record, the announcement of such memories of racial violence would have illuminated the widespread and systemic abuses experienced by black bodies.

Baker astutely points out the importance of holding onto one's individual memories of the past as well as the past experiences of others. He asserts that

both define who you are in the present: To ignore the past abuses of black bodies and, perhaps, the subjective positioning that those abuses create, would constitute a "betrayal" of your ancestors. In contrast to others who critique the idea of "imaginative rediscovery," the literary critic persuasively argues that to ignore—or deliberately forget—the past could be as "self-destructive" as living a life anonymously under the veil of another's racist idea of blackness—to live a lie, to revel in always being a shadow. In Baker's own nostalgic retreat, black memory, the individuated recollections of black folk, summons thoughts of the black Baptist church, southern-influenced literature, gospel music, historically black colleges, the blues, and the voice of Martin Luther King, Jr., among others. The site and person-specific grounding of Baker's black public sphere raises the following question: Why is black memory based in or derivative from the U.S. South? Baker contends that the black body, historically, bears an indexical relationship to the region.

> One might say that *being framed* for the black American is being indexed by—and sometimes *in*—the South. This is so primarily because at the moment of joy marked by the Emancipation Proclamation, more than four million of the United States's five-million-plus black Americans were enslaved residents of the American South. And as the nineteenth century came to a close, over 90 percent of black Americans still resided in the South.[36]

The significant number of black bodies that lived and labored in the southern United States combined with Baker's rearing in that region account for the South's centrality within his memories. It is conceivable that the memories of younger black bodies would have less specific (if any) recollections of the region but would possess memories tinged with southern resonances— the dialect of a grandparent or parent, a relative's sweet potato pie, a thirst for sweet tea—alongside those from their immediate surroundings. Critical memory is the act of reflecting upon and sharing recollections of embodied black experience. It does not presume that black bodies have exactly the same memories, yet assists the process of identifying connections across black bodies and acknowledges that related histories of discrimination, violence, and migration result in similar experiences. Critical memory invites consideration of past practices that have affected the lives and shaped the experiences of black folk. It looks back in time, from a present-day perspective, and not only accounts for the evolution in culture but also enables an imag-

ining of what life would be like had things been different. The appeal of critical memory is that it grants access to past experiences of select individuals. At the same time, it does not blind us to their (or our) present reality.

Although black bodies carry within themselves a history, a memory, and, indeed, a legacy of inequality associated with the "color line," the choices that those bodies make can determine the degree of influence that the past will play in the present or the future. Sociologist Pierre Bourdieu's theory of *habitus* offers the most useful way of understanding how *performance* allows the black body to be singular (black) and variable at the same time. We can think of habitus, the generative principle of regulated improvisation, rather reductively in the following manner: social expectations are incorporated into the individual, and the individual projects those expectations back upon society (and other individuals). For example, a person from a certain social category is taught how to perform successfully her role as a member of that category. Eventually, she inhabits this performance, and her performance of her class becomes the model upon which other members of that same category—and those who fall outside of it—are judged. What makes habitus so interesting is that we forget that we are performing. Like driving a car or riding a bicycle, each action becomes an "intentionless invention of regulated improvisation."[37] The theory of habitus—thought in terms of a *black habitus*—allows us to read the black body as socially constructed and continually constructing its own self. If we identify blackness as an idea projected across a body, the projection not only gets incorporated within the body but also influences the ways that it views other bodies. This is the painful experience of doubleness of which Du Bois wrote and upon which Jesse Jackson, Sr., reflected in his Chicago speech.

Critical memory informs the process with which we are socialized and, in turn, influences our habitus. We are taught within the family unit, the school classroom, the community in which we live, and the larger society that surrounds that community who we—as individuals and as parts of a larger group—are and how to act like ourselves. When Houston Baker locates himself in the American South (within the space of the black church, the black family, and an all-black elementary school), he gestures toward a few of the many influences that shaped his habitus. These encounters taught him how to continually be himself *as* a black person. In addition, they conveyed a sense of belonging to a larger community, comprised of individuals with sim-

ilar claims of blackness, by connecting his personal or individual experiences to other similar (black) experiences. Habitus does not end there. It continues to develop over time as it is affected by societal events. Beyond immediate communal and familial matters, black habitus has been shaped by the legacy of black captivity and other manifestations of discrimination within society: racial profiling and employment discrimination, among others. These experiences and memories structure our behavior. The past, memories and previously learned lessons, "survives in the present and tends to perpetuate itself in the future."[38] The experience of the black body becomes *futured*, the present and future understood from a past perspective. If habitus re-creates a prior experience in the present moment, then the question arises whether the black body in the present is merely a clone of the black body in the past with the *same* experiences and the *same* outlook. If so, can we ever escape from this closed loop of blackness?

We are never entirely trapped by our habitus for three reasons: (1) within habitus, there is room for difference through interpretation; (2) we have multiple habitus; (3) we can change our habitus. Despite the fact that habitus is learned and regulated, our actions are not predetermined. Habitus is like having the "feel" for a (sporting) game. We know the rules, yet we can act in a manner of our choosing within the parameters of the rules. Bourdieu develops this contention: "A sport, at any given moment, is rather like a musical work: it is both the musical score (the rules of the game, etc.), and also the various competing interpretations (and a whole set of sedimented interpretations from the past); and each new interpreter is confronted by this, more unconsciously than consciously, when he proposes 'his' interpretation."[39] Although the rules may be codified and unchanging, the way we read those rules varies widely from moment to moment and from person to person. If we were to watch a single athlete over a series of games or an actor throughout the run of a play, then we would observe the subtle variances of interpretation. The game or script remains the same, but the actions vary without breaking the rules. Habitus can help account for the differences among black folk who have undergone similar experiences.

We have more than one habitus. In order to avoid confusion, I will refer to multiple moments of habitus as *habiti* and use *habitus* to connote it in its singular form. We are the sum total of a series of overlapping habiti. Each works together to determine who we are and how we act. Baker, for example,

possesses both the habitus of a black person and the habitus of an academic, among other habiti. It is important for us to acknowledge both because they *effect* the manner in which he behaves and affect the manner in which we read his body. The habiti of Baker differ from the habiti of a black actor, a black homeless person, or a black laborer. While all of them have a connection to a black habitus, the critical memory of the black body, their actions and experiences will differ because of the influences of their other habiti.

We can change our habitus. This third contention undoubtedly will raise an eyebrow or two among readers, who are probably wondering how you can change a habitus when it often is thought to be unconscious. Although we internalize our habiti and quickly forget that we are repeatedly projecting them, we can control their particular expression. Admittedly, conscious control is rare. We change a habitus through the acquisition of new tastes. Taste, a manifestation of habitus that "raises the differences inscribed in the physical order of bodies to the symbolic order of significant distinction," is learned.[40] A member of a certain group learns to appreciate the tastes of that group. Conversely, a person can gain access to a new group (a new habitus) by learning to appreciate the tastes of another. This happens all of the time. The first member of a family to go to college develops a new habitus, one unrelated to her parents. She learns new tastes. This is not to say that she loses her former habitus. Instead her new academic habitus exists alongside her other ones. To understand how multiple habiti work together, let us imagine scenarios in which college students from underprivileged minority backgrounds return home during academic breaks. They must switch registers and access a different habitus. They often find themselves *acting* differently in each setting. They may speak with an affected accent. They may use different types of words (code switch) and may incorporate more (or less) gestures into their conversations, among many other possibilities. Without invoking the word *habitus* Richard Rodriguez has written about this pattern in his semiautobiographical *Hunger for Memory*, a book that used to be sent to every minority, first-year Yale undergraduate in advance of their arrival on campus.[41] Habitus allows us to think about the black body as a construct built by the sedimentation of similar experiences, critical memories, and enactments. It enables us to see that black bodies can be different—variably situated within society and equipped with opposing habiti—but can at the same time be read from a common perspective.

Repository of Experience

Black bodies have projected upon themselves a series of contradictory images premised upon the disjunction between their daily lived realities and societal assumptions, the myths, of the black body. In focusing upon the black body, I draw attention to how select individuals worked under and, at times, against the shadow of these projections. Whether we refer to it as a surrogate, an epithet, or a metonym, the black body continually doubles real bodies. Although *Embodying Black Experience* spans approximately two centuries, from 1810 to the present day, it has not been arranged chronologically. We will not encounter Saartjie Baartman and Tom Molineaux, who appeared as attractions in London in the same year, in the same chapter. The composition of each chapter has been organized by genre: photography, sport (boxing), theater, and museum display (historical artifacts). This approach not only renders the structural similarities across the selected case studies more visible but also creates the space (and opportunity) to adopt a different tone in each chapter. I shift the balance among biography, history, critical reading, and phenomenology in order to offer multiple perspectives on the experience of the black body. Considering that the majority of individuals introduced within this book lived in the same regions and, often, during overlapping time periods, the chapters—and the experiences encountered within them—inform one another.

Chapter 2 looks at the daguerreotypes of black captives taken by Joseph T. Zealy and reads them alongside Richard Roberts's studio portraits and Walker Evans's Resettlement Administration (later known as the Farm Security Administration) photographs. The Zealy daguerreotypes were created at the request of natural scientist Louis Agassiz, who was looking for evidence to support his beliefs that blacks were not of the "same blood" as whites. The chapter adds to the scholarship on these images by focusing upon the stillness of the captives who were required to sit before Zealy's camera. Noting that a nonblurry daguerreotype image taken in 1850 necessitated that the photographed subject remain still for upwards of a minute, it draws attention to the captives' performance of motionlessness and contends that their performances invite comparison with their other enactments of stillness (even while in motion) throughout the Middle Passage. The chapter, then, engages with the images of Roberts, a janitor and semiprofessional "in-

sider photographer" of black Columbia, South Carolina, in the 1920s. His pictures allow us to see the concerted efforts of his subjects to appear as their best selves and, perhaps, to refute popular stereotypes and caricatures of the black body. The final section goes "on the road" with Walker Evans as he documents government-sponsored relief efforts during the Great Depression. Evans's images affirm the black body's place within the popular iconography of the period.

Chapter 3 examines how Muhammad Ali transformed stillness into a performance of strength at the United States Army Induction Center in Houston in 1963. In addition, it spotlights the similar experiences of earlier generations of boxers: Tom Molineaux, Jack Johnson, and Joe Louis. Each heavyweight had a direct connection to the experience of black captivity, faced societal caricatures and stereotypes of blackness, and attempted to create a persona that differed from the prizefighters who preceded him. Jack Johnson did the things—sleeping with white women and taunting white men—that captive boxers and black bodies, more generally, could not. Joe Louis orchestrated a performance of an anti–Jack Johnson persona to help him claim the heavyweight championship. Muhammad Ali, familiar with the stories of both Johnson and Louis, critiqued the image of Louis as a "black white hope" and saw parallels between himself and Johnson. The embodied experience of Johnson affected Ali to such a degree that he once performed the role of the Johnson-like protagonist, Jack Jefferson, in Howard Sackler's play *The Great White Hope* with James Earl Jones, the actor who originated the role, seated in the audience.

Chapter 4 chronicles instances in which the replay of the experience of the black body reappears on the stage in the present. It examines the lived realities of Saartjie Baartman, the first "Hottentot Venus," as re-presented in Suzan-Lori Parks's play *Venus;* Sally, Robbie McCauley's great-great-grandmother, who lived on a plantation and reappears in the performance artist's play *Sally's Rape;* and playwright-performer Dael Orlandersmith, whose play *Yellowman* reenacts past critical readings of Orlandersmith's own body. In my analysis of the experiences of these three women, I discuss how history touches their bodies and, conversely, how we can understand history through an examination of the black body. In Parks's play, the title character stands in for the actual Saartjie Baartman and the other women who were paraded throughout Europe in the eighteenth century under the banner of the "Hottentot Venus." McCauley projects across her own body the experiences, as

she imagines them, of Sally, Sally Hemings, and the thousands of black women and men who were sexually assaulted throughout the era of black captivity. The critical fascination with bigness and blackness as embodied in Orlandersmith's performance in *Yellowman* reveal the ingrained and ongoing nature of social and racial prejudices that enabled the exhibition of Baartman two hundred years earlier. In each play, the playwright establishes the black body as the screen on which the drama of racism and abuse get (re)played.

Chapter 5 looks at the public abuse of the black body within the lynching spectacle in the United States between 1880 and 1930. It explores how the black body as the centerpiece of the lynching spectacle was dismembered into (and dis-remembered as) souvenirs, fetish objects, and performance remains. It introduces a series of individuals who were unwillingly cast in the lynching tragedy and asks, for example, what meaning the toes of George Ward had to the white mob members who paid one dollar per toe and kept them as keepsakes of his witnessed murder. Against this history, I present James Cameron, a lynching survivor, and chronicle both his creation of America's Black Holocaust Museum, a museum remembering the horrors of American lynching, and his establishment of himself within the museum as its "star exhibit." Cameron repeatedly told his story of near-death to his museum visitors with the aim of continually reviving the historical moment in the present and, in so doing, giving his guests access to his experience and the experiences of less fortunate lynching victims. Cameron's centrality within his own museum underscores the function of the body as the repository of black memory and historical experience.

Still Standing: Daguerreotypes, Photography, and the Black Body

It is singular what a peculiar influence is possessed by the eye of a well-painted miniature or portrait. —It has a sort of magnetism. We have miniatures in our possession, which we have often held, and gazed upon the eyes in them for the half-hour! An electric chain seems to vibrate, as it were, between our brain and him or her preserved there so well by the limner's cunning. Time, space, both are annihilated, and we identify the semblance with the reality.

—Walt Whitman, on the daguerreotype, *Brooklyn Daily Eagle*, 2 July 1846

In March 1850, seven black individuals, who dwelled in Columbia, South Carolina, were brought to the portrait studio of daguerreotypist Joseph T. Zealy. Like so many of Zealy's other clients, Alfred, Delia, Drana, Fassena, Jack, Jem, and Renty were there to have their pictures taken—and, as a result, to be captured for time immemorial by the new photography process that many people, including poet Walt Whitman, had identified as a form of painting at its most advanced state. Although the lack of historical records prevents us from knowing whether all seven arrived at once or over several days, Zealy's photographs evidence their presence and offer a limited glimpse at their movements within his studio. The captives, one at a time, sat on a wooden chair provided by the photographer, faced his camera, and remained still for upwards of a minute until their likenesses were recorded on the daguerreotypes' polished, silver-surfaced plates. Subsequently, they stood before the camera and then turned to the (left) side in order to present the daguerreotype machine with their profiles.[1] After turning yet again, they moved out of the camera's sight and disappeared from history.

In the early images, the seated captives' posture resembles that of other subjects who appear in mid-nineteenth-century daguerreotypes. With

shoulders square and head raised and level, they sit on a high-backed chair (equipped with an iron headrest). Their physical comportment bears a striking similarity to that of abolitionist Frederick Douglass and Liberian president Joseph Jenkins Roberts, who had their portraits taken by this relatively new photographic method in the late 1840s and early 1850s. The differences between the two sets of photographs emerge in terms of clothing. Whereas Douglass and Roberts appear well dressed—if not, dressed up—for the portrait session, Alfred, Delia, Drana, Fassena, Jack, Jem, and Renty appear in the opposite manner. They are dressed down and, literally, undressed. In their initial pictures, they sit with their shirts either pulled down to their waist or entirely removed. Regardless of gender, they appear bare-chested before the camera. In the latter images, they stand, completely naked. Their clothing, either bunched up or folded neatly on the ground (or chair) occupies the space off-frame along with the photographer and, perhaps, the other captives, who may have watched the photography session take place and awaited their turn before the camera. It is the nudity of the five men and two women in Zealy's daguerreotypes combined with the manner of their pose and the knowledge that the daguerreotype process was most popular in the early to middle nineteenth century that helps the viewer of the photographs to realize that Alfred, Delia, Drana, Fassena, Jack, Jem, and Renty are black captives who were compelled to appear before Zealy and his camera.[2] Their presence in the picture reveals their condition of servitude and bondage.

In this chapter, I study the photographs of Joseph Zealy, Richard Roberts, and Walker Evans. Each photographer captured a moment in the lives of their subjects and, in so doing, invite us, the viewers of their images, to witness the phenomenal experiences of the men and women who stood (or sat) before them. Zealy introduces us to black captives who labored on plantations in Columbia, South Carolina. Roberts presents black residents of the same city in the 1920s. Evans renders black bodies visible within the iconography and critical memory of the Great Depression. Although all photographic technology can freeze time, the pictures addressed here differ from most others in that their subjects actively perform stillness, an enactment of arrest that resonates with their daily, lived embodied experiences. I contend that a consideration of the stillness of black bodies within photography offers insight into the experience of the Middle Passage, the transatlantic crossing of black captives, and an opportunity to revisit conceptualizations of the

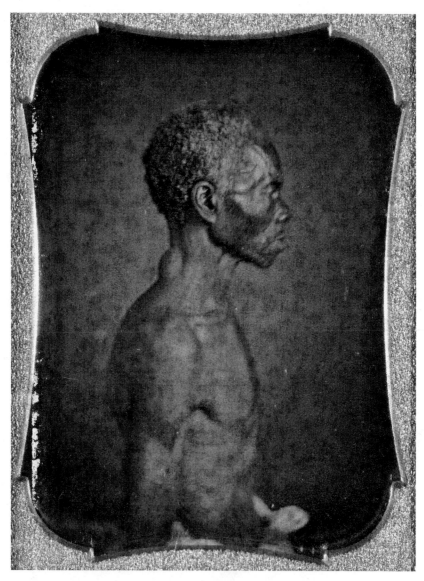

Renty, Congo (profile portrait). Courtesy of the Peabody Museum of Archaeology and Ethnology, 2004.24.27432A.

Black Diaspora as pure movement. The performance of the photographic subjects, especially those who sat before Roberts, demonstrates the efforts of black folk to rehabilitate and, indeed, refashion societal images of the black body. Furthermore, the still stand of black bodies, either in the studio or on the street, enabled the creation of the photograph and, in turn, established a place for the captives within the historical archive. In light of the concerted efforts throughout the era of legalized black captivity (and beyond) to prevent the recording of black history and memory, the preservation of past experiences within their bodies and the writing of history with(in) their performances are especially powerful acts. Thanks to their past stillness, we now have access to their experiences.

The Transmission of Truth

The portrait session involving Zealy and his subjects was arranged by Robert Gibbes, a local physician, upon the request of famed Harvard natural scientist and comparative anatomist Louis Agassiz. Swiss-born, Agassiz emigrated to the United States in 1846 and quickly became a leading natural scientist and, arguably, the most famous one in the United States. He was the first person to theorize the existence of an "Ice Age."[3] A strict creationist who believed that life originated as part of a divine scheme, Agassiz classified plant and animal species by geographical origin within a series of tiered categories, with humankind occupying the highest tier in the highest category of each locale. Despite being a lifelong critic of evolutionism because it did not acknowledge the role of the Creator, Agassiz unwittingly built the foundation for such rival theories through the development of a system that, according to its proponents, implied the occurrence of evolution. A given species could evolve from one level to the next (e.g., apes to humans). As Darwin observed in the *The Origin of Species:* "This doctrine of Agassiz accords well with the theory of natural selection."[4]

Despite the lack of surviving documents by Louis Agassiz that detail the conclusions he reached after studying the Zealy daguerreotypes, historical fragments can be pieced together to offer a glimpse at his aims. In his 1851 *Essay on Classification,* the comparative anatomist theorized that life began as a "thought of God" and occurred in separate geographical areas simultaneously.[5] He contended that these "thoughts" resulted in the development of regionally specific life-forms—plants, animals, and human types. The dis-

similarities of geographically distinct bodies anchored themselves not only in their differing creation histories but also in their exposure to the transformative effects of environment (climatological and geographical influences) over time. As a result, Agassiz concluded that the African body bore no relation to the European body. In selecting seven captives and commissioning the Zealy daguerreotypes, Agassiz likely sought to study the impact of environmental change, specifically geographical relocation, on a singular body type (i.e., the "African" body) across generations. In support of this experiment, he visited at least four plantations belonging to B. F. Taylor, Wade Hampton II, I. Lomas, and F. N. Green in Columbia, South Carolina, a city where he frequently vacationed and guest-lectured; inspected the bodies of at least seven captives; and identified at least seven captives whom he wanted photographed for further study.[6] Of these seven, five were born in Africa (Alfred, Fassena, Jack, Jem, and Renty) and two (Delia and Drana) were American born. Delia and Drana were the daughters of Renty and Jack, respectively. Although there is not any evidence to suggest that Agassiz was present in Zealy's studio during the portrait session or that he had ever met Zealy, the repeated poses and postures of the captives suggest that the photographer either received explicit orders related to the positioning of the seven captives or imagined which positions would best satisfy the desires of his patron's scientific eye.

Agassiz, a student and self-described "intellectual heir" of George Cuvier, the doctor who studied the actual, living body of Saartjie Baartman (aka "The Hottentot Venus") and placed her remains and a plaster cast of her body on display for the world to see, believed that scientific discoveries were found in firsthand observations and not in textbooks.[7] Noting that there was infrequent agreement among the practitioners of the natural sciences, he felt that the only conclusions a scientist could trust were his own. This was a lesson that he shared with his students. Lane Cooper, author of *Louis Agassiz as Teacher*, reveals that the Harvard professor repeatedly instructed them to "Learn to read the book of nature for yourself."[8] Similarly, Laura Dassow Walls, in her 1997 article on Agassiz, writes that he "liked to claim as his greatest achievement neither a theory nor an institution, but a method: 'I have taught men to observe.'"[9] She further contends, "What [Agassiz] teaches is nothing but vision, a seeing of such crystalline purity, so emptied of self, that it registers naught but the thing itself, in its purity; the scientific seer will be a pure vessel for the transmission of truth from nature to hu-

manity."[10] Walls's analysis of Agassiz proves of interest because she seems to say that the natural scientist was able to extract himself from his own analyses (and experiments), thus leaving only the object(s), and, in this case, the body of inquiry.

Agassiz's vision, contrary to Walls's assessment, was not a model of "crystalline purity." An established scholar, the natural scientist, especially toward the end of his life, felt threatened by the theories of Darwin, which not only challenged some of his widely accepted findings but also, and even worse, appropriated his work under the godless umbrella of evolutionism.[11] According to David B. Williams, Agassiz's disagreements with Darwin's theories began before the 1859 publication of *Origin of Species*. Williams reveals that Darwin sent Agassiz, along with Asa Gray, another respected scientist and one of Agassiz's Harvard colleagues, early copies of the unpublished *Origin* manuscript with the aim of soliciting a favorable review from them. Anticipating an Agassiz rebuff, Darwin humbly asked, within his cover letter, "As the conclusions at which I have arrived on several points differ so widely from yours, . . . I hope that you will at least give me credit, however erroneous you may think my conclusion, for having earnestly endeavored to arrive at the truth."[12] Agassiz never replied to Darwin's letter. However, his copy of the manuscript, which along with Darwin's letters to both Gray and Agassiz comprise a part of the Gray Herbarium archive at Harvard University, suggests that he not only read *Origin* but also disagreed with many of Darwin's conclusions. His marginalia dismisses Darwin's theories as "monstrous," a "mistake," and "likely to mislead!"[13] Several months later, following the publication of Darwin's book, Agassiz continued to disagree with its fundamental concepts. Williams quotes a letter from Asa Gray to Joseph Hooker, an English botanist, in which Gray summarizes Agassiz's reaction to Darwin's work in the following manner: "When I saw him last, [he] had read but part of it. He says it is poor—very poor!! (entre nous). The fact [is] he growls over it much like a well cudgeled dog [and] is very much annoyed by it."[14]

While Agassiz's disagreement with Darwin is not indicative of an unwavering, fixed bias that might have compromised his ability to render impartial scientific judgments, his comments, expressed in an earlier letter to his brother-in-law, demonstrate this bias. Shortly after arriving in the United States from his native Europe in 1846, the Harvard scientist checked into a hotel in Boston and encountered two black porters who were employed there. Although it is unclear whether Agassiz had ever seen or, at the least,

interacted with black folk before this point in time, it is clear that he found this particular encounter to be memorable and noteworthy. In the letter, he wrote:

> It is impossible for me to repress the feeling that they are not of the same blood as us. In seeing their black faces with their thick lips and grimacing teeth, the wool on their head, their bent knees, their elongated hands, their curled nails, and especially the livid color of their palms, I could not take my eyes off their face in order to tell them to stay far away.[15]

Within his letter, Agassiz reveals not only his observational skills but also his partiality. He draws attention to the distinctiveness of the lips, teeth, hair, hands, fingernails, and complexion of the porters. It is the differences between these features and the unspoken but presumed Caucasoid body that confirms his belief that blacks comprise a different species, a different "blood" than do whites. Agassiz's bias emerges not necessarily within his description of the black body, which repeats earlier and engenders future caricatures, but in the palpable anxiety and, perhaps, fear that accompanies his description. According to his own account, Agassiz's encounter with the porters prompted a visceral reaction to the black body that erupted with such force that he found it "impossible to repress the feeling." The "grimacing" black body with its "elongated hands" and "curled nails" proved monstrous to him. Similar to the young white boy in Frantz Fanon's oft-cited encounter, Agassiz confronted the black body and realized that he feared it.[16] He wanted the body to stay away, "to stay far away." *Look, a Negro! I'm frightened!* Unlike the boy, Agassiz, mesmerized by the black body, could not speak.

Four years after his encounter with the hotel porters, Agassiz visited several South Carolinian plantations and selected at least seven captives—Alfred, Fassena, Jack, Jem, Renty, Drana, and Delia—whose bodies he wanted photographed. In the years between his arrival in the United States and his plantation visits, it is conceivable that his attitudes toward the black body changed. Now residing in Massachusetts, the first state to abolish slavery, and a seasonal visitor to South Carolina, the state with the largest African American population in the United States, Agassiz likely encountered black bodies with great frequency. Was he startled and silenced each time that he saw a black body? Was he continually in a state of shock? Certainly, his visits to the

plantations of Taylor, Hampton, Lomas, and Green suggest that he managed to replace his desire for distance from black folk with a scientific interest that necessitated proximity. After all, he had to encounter numerous bodies, who likely stood still before him, so that he could select the ones to be photographed. Then again, his commission of Zealy, through Gibbes, could be read as a desire to limit the time that he had to spend in the presence of the black body. He might have preferred spending time with the photograph over the person. In light of the available evidence, it is not likely that Agassiz was able to change his mind or to look at black bodies without having his prejudices color his perspectives and, therefore, cloud his vision. The strength of his reaction to the porters and his impassioned rejection of Darwin's theories, which Agassiz could have interpreted as promoting a reading that blacks and whites have the same "blood," seem to deny this possibility.

The well-accepted, nineteenth-century theories of racial difference, including those championed by Louis Agassiz, were predicated upon findings that were corrupted by the personal biases of avowedly objective scientists.[17] In encouraging his students not to trust the conclusions of others but to read the "book of nature" for themselves, the Harvard professor not only championed the power of individual interpretation but also discouraged a more balanced approach in which scientists might test and, eventually, synthesize the findings of others within their own research. Whereas Darwin embraced portions of Agassiz's studies in his evolutionary theories, Agassiz not only dismissed the findings of Darwin but also may not have finished reading the *Origin* manuscript. As Gray noted in his letter, four months after having received Darwin's draft, Agassiz had "read but part of it."

In addition to Agassiz's preconceived notions that may have tainted the "purity" of his scientific vision, the natural scientist's findings could have been compromised by his decision to study the daguerreotypes rather than the physical bodies of the captives. He might have privileged the photograph because he, like many others, could have believed that the new photographic technology was capable of capturing the "truth" of nature. In an 1840 article for *Alexander's Weekly Messenger,* published in Philadelphia, novelist, poet, and amateur cryptographer Edgar Allen Poe introduced his readers to the daguerreotype and praised its virtues from a near-scientific perspective:

> If we examine a work of ordinary art, by means of a powerful microscope, all traces of resemblance to nature will disappear—but the closest scrutiny of a

photogenic drawing discloses only a more absolute truth, a more perfect identity of aspect with the thing represented.[18]

Poe writes that daguerreotypy, which does not require brushstrokes, more than any other visual medium re-presents objects and people as they actually appear. Like a mirror, the daguerreotype showcases the photographed subjects as they are. It is easy to imagine mid-nineteenth-century officers of large corporations and universities bemoaning the creation of this new technology that would deprive them of the "touch-ups" of portraiture and the liberal interventions of painters who could use their mastery to present idealized versions of their subjects. Whereas Poe praised the new medium for its ability to capture a truthful likeness, Walter Benjamin, a century later, famously opined that it could reproduce the image but could not capture the essence contained within the painted figure. The daguerreotype both was and was not or, to use a concept popular within the discipline of performance studies, was "not not" the photographic subject.[19]

It is the tension between readings of the image alternately as truthful and soulless that troubles any attempt to study the Zealy daguerreotypes. On the one hand, the daguerreotype's supposed ability to capture nature lessened Agassiz's reliance on the physical body. Rather than having Jem stand before him for hours on end, Agassiz could examine Jem's image at leisure. Within the daguerreotype, Jem remains standing. Even today, he continues to stand still. When the image gets read as "truth" and when scientific vision applied to it is labeled as "pure," the potential for misreading increases in proportion to the decrease in both scientific skepticism and self-regulation. On the other hand, the photographic portrait does not capture the spirit of the subject. We can think of elementary school portraits that, although offering a likeness of their subjects, often fail to seem "real." They look posed. Perhaps the rambunctious child appears overly sincere; as cultural anthropologist John Jackson, Jr., has observed, this performance of sincerity complicates and undermines traditional notions of authenticity.[20] Ultimately, the portrait session, directed by the photographer, subject, or both, creates a product that bears a resemblance to the subject but fails to be the subject. When we look at the daguerreotype of Delia, are we really seeing Delia?

This is the question that has troubled the various readings of Zealy's daguerreotypes since they were discovered by Harvard archivist Elinor Reich-

lin in 1976. Beginning with Reichlin's 1977 article in *American Heritage Magazine,* scholars, curators, and art historians repeatedly have attempted to provide authoritative close analyses of the images and/or have included them in art exhibitions with the aim of compelling the viewer to encounter and interpret them for themselves. What emerges from the various attempts at studying the images is the fact that they neither engender nor privilege a single narrative. Although scholars have created corrective readings with the aim of counterbalancing the presumed findings of Agassiz, the interpretations vary. Reichlin, who elects not to read the images but rather to recount the historical circumstances of the portrait session, makes a brief reference to the "humiliation" that the seven captives must have felt before identifying them as "real survivors of a painful epoch."[21] Alan Trachtenberg, in his 1990 book *Reading American Photographs,* seeks to empower the subjects by asserting that they are "performing the role of specimen."[22] His invocation of the word *performing* rescues the figures from being objectified by the camera and the various looks that ghost it—Zealy's, Gibbes's, Agassiz's, Reichlin's, and ours among numerous others. Despite their captive status, they still have power and control over their representation. In contrast, art historian Cherise Smith elects to read the figures as being powerless. Nevertheless, Smith, referring to the daguerreotypes of Delia, observes, "She gazes into the camera, appearing calm, yet painfully aware of her inability to change the situation."[23] Despite the fact that the author does not afford Delia agency, it is possible that her selection and use of the word *appearing,* similar to Trachtenberg's *performing,* could be read as an attempt to grant the figure corporeal agency. Although Delia cannot extract herself from the studio session, she can control her physical comportment and facial expressions. She can perform calm. While it is possible to create empowering counterreadings of these images, there is little in the photographs themselves that support these conclusions, as Michael Kimmelman noted in his review of "Police Pictures: The Photograph as Evidence," an exhibition that included several Zealy daguerreotypes. Kimmelman announces that interpretations of the images are based more upon the viewer's imagination than anything contained within the frame but cannot resist the temptation to offer his own reading: "They prove only that we see in photographs what we want to see. I stare at Zealy's picture of Renty Congo, a slave from South Carolina, and find only a man of doleful beauty."[24] In each case, from Agassiz to Trachtenberg to

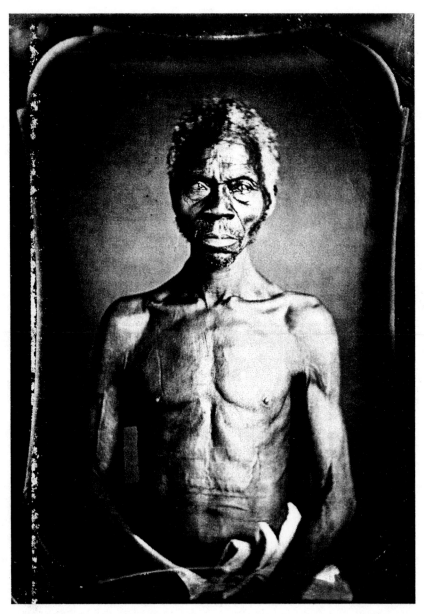

Renty, Congo (front portrait). Courtesy of the Peabody Museum of Archaeology and Ethnology, 35-5-10/53038.

Kimmelman, the figure of the interpreter shapes the interpretation more than the image. The "truth," that a black body sat before a camera, of the daguerreotype portrait is of secondary importance.

Crossed Bodies

In his review essay, Kimmelman, possibly overlooking the comma that separates Renty's name from his geographical origin, identifies him as "Renty Congo." While this unintended error offers the photographed figure a last name that replaces that of the plantation master with something that sounds more identifiably "African"—an activity that would consciously be employed by many African American civil rights activists more than a century after Renty entered Joseph Zealy's studio—the reality is that the images, when discovered, failed to include a last name for any of the seven figures featured in the daguerreotypes. In her 1977 article, Reichlin writes that the fifteen surviving images, when she found them a year earlier, were individually encased in a frame marked with the imprimatur of Zealy's studio and were accompanied by a note identifying the captives by a single name, the plantations on which they labored, and the geographical regions of their birth. According to the note, Renty was identified as being from the Congo; Alfred, Foulah; Fassena, Mandingo; Jack, Guinea; and Jem, Gullah. Both Delia and Drana were listed as being "country born." It is not known who recorded the notes—Zealy, Agassiz, Gibbes, or someone else entirely.[25] The uncertainty that shrouds the notes' authorship also calls into question the accuracy of the identification of each captive's geographical origin.

I am inclined to trust those notes. Renty's presence in the daguerreotype signals his status as a black captive in South Carolina. This reading renders less significant whether his name really was Renty and whether he dwelled on B. F. Taylor's plantation (or on another plantation). Furthermore, Agassiz's desire to chronicle physical changes effected by differing geographical locations/climates suggests that he needed to know from where each figure derived. While the dispersion of black bodies across the Middle Passage and throughout the hemisphere calls into question definitive knowledge of origins, Joseph E. Holloway asserts that South Carolinian plantation owners preferred captives from select regions of Africa to perform specific functions on their plantations. Angolans were often purchased to labor in the fields, Guineans and Mandes in the house or in another skilled position. In re-

sponse to this consumer-driven demand, Holloway notes, "Slave merchants took great care, throughout the entire history of the South Carolinian trade, to inform potential buyers of the African region and geographic point of origination of the slaves being sold."[26] Considering that plantation masters often knew the origins of their African-born captives and that Agassiz required this information in support of his study, there is a high probability that the seven captives who appear in Zealy's daguerreotypes derive from the places recorded on the accompanying notes.

While the bulk of academic criticism focuses upon Delia, likely the youngest captive to be photographed, it is the five men—Alfred, Fassena, Jack, Jem, and Renty—who most intrigue me. Although these writings on Delia by Mandy Reid, Deborah Willis, and Carla Williams, among others, provide cogent, corrective readings by spotlighting how the presentation of clothing (the pulled-down shirt) reveals that she, as a captive, was compelled to appear before Zealy's camera, those same texts, through the reproduction and re-presentation of her image, continue to objectify her for the multiple gazes of their readers.[27] She becomes a sexual object, the embodiment of "specimen," and an idealized xenotype of the "other." In much the same way that the circulation of lynching photographs, as Eric Lott, has noted, "participate[s] in the act of lynching," the hypervisibility of Delia's image promotes her ongoing objectification. I wonder if Agassiz, similar to Baron Docteur, the character based upon George Cuvier, in Suzan-Lori Parks's play *Venus,* had more than "a scientific interest" in the display of the black female body. Is this why the daguerreotypes were hidden—shelved in a cabinet? This is not to say that Alfred, Fassena, Jack, Jem, and Renty are free from the exoticizing, objectifying, and, indeed, erotically charged look. They too have been undressed before Zealy's camera. In one daguerreotype, the fully nude backside of Jem has been photographed. The camera's gaze, never challenged by Jem's direct address, lingers upon his body and invites comparisons to the more contemporary photographs of Robert Mapplethorpe, Thierry Le Goues, and Lyle Ashton Harris. In turn, it creates ambivalence in the spectator that resembles that experienced by art critic Kobena Mercer upon encountering Mapplethorpe's photographs of black male nudes.[28] My interest in these five figures has less to do with their physical appearance—their state of undress—and more with the materiality and the facticity of their bodies. Each captive—Alfred, Fassena, Jack, Jem, and Renty—survived the Middle Passage. Their bodies are not the products of the Middle Passage. They em-

body the Middle Passage. It is possible to locate the experience of the "black Atlantic" within their bodies and to identify their *stillness* as an integral part of their Atlantic crossings and, more generally, the Black Diaspora.

Despite the innocuous beginning of "diaspora" as a signifier for the act of scattering seeds, it, over time, has gained traction within critical discourse through its application as a descriptor of the dispossession and enforced exile of Jewish communities in the eighth and sixth centuries BCE and later as a shorthand for *bodies in motion*—describing the exilic movements of African captives across the Atlantic and Indian Oceans, the forced relocation of indigenous peoples within the Americas, and the dispersal of Asian laborers throughout the Caribbean and Central America, among other places. With the passing of time and the heightened interest in the effects of globalization, the diaspora label, according to Nicholas Mirzoeff, evolved from a pejorative—suggesting "disruption" or "excess"—to a positive attribute, implying "interconnectedness." Diasporic groups, within academic discourse, transformed from unwanted refugees of the past into idealized banner carriers and, perhaps, the "first citizens" of a new, largely imagined, global future. It is the (in)voluntary exiles, with experience crossing cultural differences and national boundaries, who not only embody the spirit of global flow and exchange but also the possibility of refashioning nationalist societies into global communities. The redefinition and revaluation of the diasporic experience has prompted the search for and the labeling of an increasing number of groups as "diasporic." Today, there are so many "diasporas" that it seems like every minoritized group—organized by common racial, religious, or sexually oriented affiliations—has one to call its own to remember and, on occasion, to commemorate within academic conferences and publications.

The multiplicity and, indeed, the ongoing multiplication of diasporas has prompted several scholars to call for caution and precision in the application of the *diaspora* label with the aim of preventing the term from losing its efficacy. Jana Evans Braziel and Anita Mannur in the introduction to *Theorizing Diaspora* observe:

> Analogous to the problematic use of the term *border* within branches of area and ethnic studies in general, the term "diaspora" risks losing its specificity and critical merit if it is deemed to speak for all movements and migrations between nations, within nations, between cities, within cities, *ad infinitum*.[29]

Although the concept of the "border," like "diaspora," maintains its critical merit but could benefit from a theoretical rearticulation, especially within the discipline of performance studies, the authors correctly contend that the overuse of any critical term will result in a loss of specificity and, perhaps, meaning. Kim D. Butler offers a similarly cautionary note: "Human beings have been in perpetual motion since the dawn of time, but not all of their movements have resulted in diasporas."[30] In an effort to protect the descriptor from the blurring nature and dulling impact of misapplication, Butler reviewed published scholarship on the label and identified the following three characteristics: first, "There must be a minimum of two destinations"; second, "There must be some relationship to a real or imagined homeland"; and third, "There must be a self-awareness of the group's identity."[31] To these features, Butler added a fourth characteristic "involving the temporal-historical dimension: its existence over at least two dimensions."[32] Although the author is careful not to explicitly downgrade another's diaspora, her fourth condition, which requires that the dispersal of bodies be an ongoing activity that spans a significant period of time, eliminates the possibility of refugees or "temporary exiles," who flee their homes to escape a momentary crisis (hurricanes or the manipulations of a single political regime), from being understood as a diasporic people. By delimiting the possible applications of the concept, Butler confirms the legitimacy of those long-recognized and widely accepted events, such as the Black Diaspora, which consisted of the dispersal of human bodies across the Atlantic and Indian Oceans, throughout the Americas, the Caribbean, and Europe, and resulted in the creation of a self-aware group identity centered upon a reality-based, *and* an imagined, concept of Africanness alongside the recognition that an ancestor was displaced in the past.

The Black Diaspora itself is an expansive concept that has been broadened over the years to consider not only the movement of Africans as captives across the oceans but also the postcolonial return of their children. As Tiffany R. Patterson and Robin D. G. Kelley have observed, it is no longer dependent upon the naming (or imagining) of Africa as the origin or the identification of "African" cultural practices that appear to have survived not only the transoceanic crossings but also the centuries since the first ships set sail. Its definition anchors itself in the act of being scattered—which implies origin, movement, and destination in the same moment. Awam Amkpa, in an ongoing project that expands upon the writings of K. Anthony Appia, offers

an insightful challenge to assumptions of Africa as merely the staging ground for the later movement, across oceans, of black captives by investigating the "pre-modern" movements of heterogeneous, native African communities that took place before and during the Black Diaspora. Amkpa contends that multilingual African societies, divided into distinct ethnic and cultural groups, have been in circulation on the continent for centuries (thus accounting for their linguistic and cultural differences). Their frequently nomadic existences belie theories of "African" culture as singular and static. In short, he argues that black bodies were *on the move* long before captives were exported across the oceans. Amkpa's research in this area is worthy of extended consideration for its ability not only to counter assumptions of originary presences and locations but also to expand the temporal-historical dimensions of black bodies in motion.[33]

As the limits of "diaspora" have been pushed by readings of postcolonial return or premodern communal activities, the scholarly emphasis on diaspora *as* movement has similarly increased. While movement or, at least, displacement stands at the heart of the diaspora concept, I, like Butler, am reluctant to endorse any efforts that seek to read it solely as pure movement. Theories that focus primarily on the process of dispersal, with an attendant interest in routes, pathways, and passageways, threaten to overshadow and, potentially, absent the bodies that are actually moving. Despite the fact that Paul Gilroy, in *The Black Atlantic,* critiqued the theorization of "abstract embodiments of the triangular trade" by underscoring the materiality of the ship and recounting the travels of select figures, including Martin Delany, Frederick Douglass, and the Fisk Jubilee Singers, contemporary critical engagements with his seminal book tend to treat the ship as a metaphor and its "routes" as abstractions without sustained and meaningful consideration of the bodies that traversed those routes on those ships. Such overlooking of black bodies threatens to absent from history the African captives who survived or perished during the voyage while, ironically, protecting and maintaining a more contemporary identitarian category that presumes their past travels. I deliberately employ the word *overlooking* here because black bodies are not being neglected consciously. Instead, like a student who sits in the front row of her class and, because of her proximity to the professor, gets overlooked (or looked beyond), they are such an obvious and proximate part of the diaspora that they often fail to be considered. As a result, it is possible for a person to think of the diaspora in terms of the circulation of ships, mu-

sic, or food without ever considering physical bodies. Although the ship may serve as a useful and productive metaphor, the cargo holds on those ships were filled with human bodies. The Zealy daguerreotypes, particularly those featuring Alfred, Fassena, Jack, Jem, and Renty, restore the historical presence of individuals who have been overshadowed, if not absented, by diasporic theories that center the movement of other commodities. They remind us that the bodies, occasionally densely packed as cargo and often shackled, were rendered immobile even as they moved across an ocean. They reveal that *stillness,* like movement and the body, is an integral and defining part of the Black Diaspora.

To echo Reichlin's description, Alfred, Fassena, Jack, Jem, and Renty are "survivors." They endured the multiple legs and enforced immobility of the Middle Passage journey. Their stillness before Zealy's camera recalls this experience. Contrary to popular belief, movement was not the primary feature of the Middle Passage. Captives were not always *running* from captors, *marching* (as captives) to loading docks, *sailing* on boats to the Americas, and *marching* (yet again) to auctions to be auctioned. Within and betwixt these movements, there was a lot of stillness. The captives, confined within holding cells, spent more time waiting to travel the Atlantic than it took them to sail across the ocean. Once loaded on the boats, the shackled captives continued to have limited spatial options. They remained immobile even as they moved. Historian Herbert Klein gestures toward the stillness of bodies within the transport of African captives when he quantifies the length of their various movements and, more important to this study, their waits:

> To put the so-called Middle Passage in context, it should be recalled that the water crossing on average took a month from Africa to Brazil and two months from the West African coast to the Caribbean and North America. But most slaves spent at minimum six months to a year from capture until they boarded the European ships, with time waiting on the coast to board the ship alone being on average three months.[34]

Klein dispels the romance of black diasporic movement by drawing attention to the prolonged periods in which African captives did not move. Simple arithmetic, using Klein's figures, tells us that the black captives' crossing, from capture to American arrival, lasted between seven and fourteen months. They had to endure the wait at the various camps constructed as rest

areas on their way toward the coast; the wait within the holding cells along the shipyards before they were loaded onto ships; and, of course, the wait on the auction block (and the various holding cells that both preceded and followed the auction itself). These sites where captive bodies were kept immobile not only remain today but also, as Edward Bruner's, Sandra Richards's, and Saidiya Hartman's separate writings on slave castle-dungeons in Ghana reveal, have become tourist destinations for "diasporic Africans" who seek an encounter with the material remains of the diaspora and/or to imaginatively experience a part, the wait, of the Middle Passage.[35] Even while being transported across the Atlantic or Indian oceans, the confined and shackled bodies experienced the stillness of the wait for upwards of sixty days. The irony appears: the movement of the captives was predicated upon a delimitation of their spatial options and a concerted effort to render them motionless.

The stillness of the body that was subjected to and survived the diaspora appears in Zealy's daguerreotypes of Alfred, Fassena, Jack, Jem, and Renty. Unlike contemporary photography and digital imaging in which a moment can be recorded within a fraction of a second, the daguerreotype process demanded that the photographic subject remain motionless for upwards of three minutes in order to generate a clear, nonblurry image. While this did not pose a problem in the creation of funerary portraits or landscape photographs, it was the source of great difficulty in the taking of pictures of living subjects. Louis Jacques Mande Daguerre, the inventor of the technology that bears his name, praised the success of his new creation but also identified its shortcomings when he publicly introduced the daguerreotype in September 1839.

> Everyone, with the aid of the DAGUERREOTYPE, will make a view of his castle or country-house: people will form collections of all kinds, which will be the more precious because art cannot imitate their accuracy and perfection of detail. . . . Even portraits will be made, though the unsteadiness of the model presents, it is true, some difficulties.[36]

Although technological advances had lowered the exposure time to a minute by 1850, the process still required subjects to remain motionless and to endure the wait. The quality of the Zealy photographs suggests that all seven captives were subjected to the wait of the photography session. They did not merely sit or stand for Zealy. Instead, they remained sitting and remained

standing and were caught in the process—the act of doing so. In addition, the multiple images of the same captives in different poses reveal that their enactment of stillness occurred more than once. It repeated at least twice. Despite the fact that Reichlin only found fifteen daguerreotypes of the seven captives in a cabinet drawer, it is likely that Zealy took more than fifteen pictures and those pictures either await discovery, perhaps in another drawer, or were destroyed (or discarded) in the Civil War era. How many other captives were exposed to the look of Agassiz and Zealy?

While Manthia Diawara, Joseph Holloway, and Henry Louis Gates, Jr., have written persuasively about the global reach of the diaspora and its impact upon contemporary culture through an analysis of music, food, and literary tropes, I find myself most invited into the critical memory of the diaspora and aware of its affect and effect upon present-day "diasporic Africans" whenever I encounter the images of Alfred, Fassena, Jack, Jem, and Renty.[37] These men were born on the African continent, held in holding cells along the Atlantic coast, loaded upon ships destined for the Americas, confined for upwards of two months on those ships, transported to South Carolina, subjected to the auction block or the slave market, and sent to work on the plantations of B. F. Taylor and Wade Hampton II, among others. Decades later, they were summoned to be inspected by Agassiz, transported to Zealy's studio, and ordered to remain motionless multiple times before his camera. I am fascinated by these men because their bodies represent the Middle Passage in a way that inanimate commodities cannot. They dispel the romance of travel narratives and challenge the academic thrall to movement through a seemingly effortless but, undoubtedly, physically taxing performance of stillness. It is these men who sat and stood still in cells, holds, blocks, and plantations who repeat those prior performances within the studio session. Furthermore, their performance of stillness opens up new possibilities for critical reading strategies and, indeed, positionings for cultural historians and scholars. Their daguerreotypes, unlike other photographs—most famously the motion studies of Edweard Muybridge—which offer the impression that image-capturing technology could not capture the movement of life, succeeds in capturing motion.[38] That motion is stillness. To look at Alfred is to see a person who stood still not for a brief moment but upwards of a minute. It is to see a person who consciously is enacting motionlessness. His performance becomes atemporal. It collapses the past with the present with the promise of extending into the future. Alfred stands still and still stands.

All Eyes on Me

Although it is unknown how much influence the directives of Agassiz and/or Gibbes had on the (re)presentation of Alfred, Delia, Drana, Fassena, Jack, Jem, and Renty, the daguerreotypes bear the markings of a professional photographer. Zealy's presence and, indeed, gaze in the studio session appear most clearly in the manner in which he used lighting to reveal the bodies of his subjects. With a light source located behind or next to his daguerreotype machine, J. T. Zealy projected a focused beam of light on the captives' faces. This intervention rescues the black body from the encroaching darkness of the studio and gives it what Melissa Banta deems a sculptural quality.[39] Through lighting, the daguerrian not only transformed a scientific study into an object of art for future audiences but also succeeded in creating an image, similar to art historian Rosalind E. Krauss's definition of sculpture, that "is peculiarly located at the junction between stillness and motion."[40] Although his specially lit daguerreotypes give the impression of liveness with the promise of movement and breath, they are recorded, motionless, and silent. With qualities that extend beyond a still life but fall short of a tableaux vivant, a popular nineteenth-century performance practice in which actors re-created easily recognizable paintings through a variety of still stands, they function as a limen, simultaneously separating and being the living/dead, moving/still, and breathing/breathless.[41] The aesthetic stillness of the daguerreotypes echoes the captives' multiple performances of stillness throughout the Middle Passage and within Zealy's studio.

Despite Zealy's role as daguerrian, Brian Wallis notes that the "authorship" of these images "pertains more to Agassiz than to the photographer."[42] Although the comparative anatomist was not present at the portrait session, he constructed the scene by commissioning Zealy, through Gibbes, to imagine his future, scientific look at the captives and then to re-create that look in the present moment. The captives' nudity underscores their objectification for a general spectatorial gaze and a specific scientific eye. Standing still within the studio, the seven slaves are captured, by the daguerreotype process, performing "the role of specimen." The resulting images further commodified an already commodified body, reducing it to a miniaturized, two-dimensional object with a scientific value tantamount to the life-size, three-dimensional figures of the slaves themselves. The daguerreotypes may have proven more valuable to the scientist because they could be transported

to his Harvard laboratory. Their compact size could travel more easily than the bodies of the seven captives. More importantly, the fact that Massachusetts was a free state likely prevented Agassiz from even considering bringing them to Harvard. It is easy to imagine the uproar that would have been generated by the docking of a boat with seven slaves who were destined to become objects of study at Harvard and possibly future residents in the university's Museum of Comparative Zoology.[43] The daguerreotypes, created for the Harvard scientist, enabled him to study the bodies of individuals who were *still* slaves despite their move to a free state and their accession into the scientist's collection.

In addition to imagining Agassiz's future look in the present moment, Zealy also re-created Agassiz's past inspections of the captives in the present moment as a *futured* look. His daguerreotypes reprised a past performance for the future. In March 1850, Agassiz, escorted by Gibbes, visited several South Carolinian plantations with the aim of encountering captives who were born in various regions of the African continent. Gibbes, writing to Dr. Samuel Morton, a friend and a leading proponent of phrenology, recalled, "Agassiz was delighted with his examination of Ebo, Foulah, Gullah, Guinea, Coromantee, Mandrigo (sic), and Congo Negroes."[44] Considering that the importation of captives into the United States was banned in 1808, the natural scientist likely limited his study to individuals who were in their midforties or older.[45] Although it is difficult to determine the age of the seven individuals within the daguerreotypes, the presence of wrinkles and gray, receding hair on the men suggests that they were born prior to 1808. Within his letter, Gibbes elects not to describe the nature of the interaction between the captives and Agassiz. Instead, he simply notes, "[Agassiz] found enough to satisfy him."[46] In light of the fact that the surviving daguerreotypes feature men who are identified as Congo, Foulah, Gullah, Guinea, and Mandingo, five of the seven regional designations identified by Gibbes, it follows that Agassiz inspected the bodies of more than seven captives and selected only seven to be photographed and/or that more than seven captives were photographed, although only the daguerreotypes of seven of them were found by Reichlin. Regardless of the exact number, the daguerreotypes exist as a replay of the captives performing "the role of specimen" before Agassiz and as a re-creation of Agassiz's previous look at their bodies. Their still presence in the studio and, by extension, in the picture, can be attributed to their prior stand on the plantation grounds before the comparative

anatomist. Indeed, a consideration of the look of Agassiz at the black body within Zealy's daguerreotype reveals the existence of a temporal vortex that threatens to collapse the past (Agassiz on the plantation), the present (Zealy's studio session), and the future (Agassiz's look at the daguerreotype). Within this vortex, Alfred, Delia, Drana, Fassena, Jack, Jem, and Renty are caught within a cycle of repetition within which they are repeatedly and ceaselessly enacting stillness.

Although the captives find themselves continually standing or sitting still before differing temporal audiences, Alan Trachtenberg, in his study of the daguerreotypes featuring Delia, Drana, Jack, and Renty, contends that their gaze challenges efforts to objectify them:

> The absoluteness of their confinement to [the role of specimen] has the un-intended effect of freeing their eyes from any other necessity but to look back at the glass eye staring at them. Their gaze defies the scrutinizing gaze aimed at their nakedness, and challenges the viewer of these daguerreotypes to reckon with his or her own responses to such images.[47]

The "confinement" of the captives proves "freeing." With these words, the cultural historian suggests not only that there is potential for movement within stillness but also that stillness itself can be a source of agency. Each of the four captives, within the context of a tight medium shot, returns the look of the observer (the camera, Zealy, Agassiz, and us). The daguerreotype gives the impression that the captives are looking at us. This returned look proves powerful when we consider that blacks, throughout the era of captivity and into the post-emancipation years, could be punished or killed for looking a white person in the eyes. "Reckless eyeballing" combined with a whistle killed Emmett Till in 1955, more than a century after the studio session. Thanks to the pause of the daguerreotype process, which magnifies the captives' stillness, the captives never look away.

In addition to the captives' direct address, it is worth considering the "space off" looks of those enslaved who were outside of any single daguerreotype's frame but were present during the portrait session. Although the absence of material (documented) evidence prevents us from having a full picture of the scene of Zealy's studio on that March day in 1850, it is difficult to resist the temptation to imagine the scene of the session and the movement (or lack thereof) of the captives. Film theorist Christian Metz

noted the allure of the off-frame space in photography: "The spectator has no empirical knowledge of the contents of the off-frame, but at the same time cannot help imagining some off-frame, hallucinating it, dreaming the shape of this emptiness."[48] Melissa Banta, the curator of the Harvard Peabody Museum photography collection that includes the Zealy daguerreotypes, has maintained that the captives arrived together (or near the same time) and were ordered as a group to remove their clothes.[49] While it is possible and probable that the captives from the same plantation arrived together, the fact that the daguerreotypes show them in various states of undress—nude, shirtless, or with shirt pulled down—suggests that the captives were not told to disrobe at the same time. While it is conceivable that shortly after the captives arrived at his studio, Zealy could have ordered Delia, Drana, and Renty to pull their shirts down, Jack to remove his entirely, and Alfred, Fassena, and Jem to completely undress and then to wait for their turn before his daguerreotype machine, it is more plausible that the directives were issued in the moments immediately preceding their performance of stillness and not all at once.

If the captives arrived at the same time and remained together within the studio session, then it is likely that they recognized the body that performed stillness before themselves and the camera as their *futured* bodies. They too would have to disrobe and then sit (or stand) before Zealy. Conversely, the captives who had appeared before the daguerreotype machine had to have understood that the off-frame captives were waiting to replay their own prior experience of the body (i.e., to do what they had just done—sit or stand still). If, like Merleau-Ponty, we contend that a person's awareness of self emerges through the look at another (or, even, the look of another), then it follows that Renty and Jack might have first recognized their own experience of stillness and, indeed, captivity through their observations of fellow captives who were confined in rest areas, holding cells, ship holds, and on auction blocks and realized that this experience, again, was repeating in the present moment. Although they certainly did not have to imagine life as a slave—they lived the experience of captivity every day of their lives—the witnessing of their fathers' stillness may have given Delia and Drana an insight into how the embodied histories of captivity have been transferred upon them. In addition, the shared environment of the studio session, which featured at least seven black captives in various states of undress, likely underscored the commonality of the black captives' experiences in that moment and, perhaps, the

fact that their individual bodies were being viewed as a singular type of body, the black body as imagined by Agassiz and imaged by Zealy.

Within the daguerreotypes, we can also see ourselves. By this suggestion, I am not offering an essentialist argument that finds a universal kinship in every black body—although I am not entirely hostile to this position—in order to suggest that there is an instantaneous bridge between the body posing and the one looking. What I am saying is that we can see our reflections in the daguerreotypes, literally. Daguerreotypes, silver-surfaced plates polished to a mirrorlike finish onto which images are positively burned and later developed over mercury and fixed with salt solutions, are highly reflective. When a person looks at a daguerreotype, she, more often than not, will see her reflection alongside or superimposed over the framed image. In fact, this distracting element was an occasionally cited critique of the photographic method. The reflective surface brings us, the viewer, into the picture. If we were to look at the original daguerreotypes, then we would see in their aged and weathered silver surfaces both the figure of the photographed subjects and also our own reflections.[50] This is a crucial attribute of the daguerreotypes that does not appear in the widely circulated paper-based photographic or digital reproductions of the images. Despite the fact that the paper-based copy prevents us from having this experience, we must try to picture ourselves in the daguerreotype even as we look at its surrogate. We must imagine ourselves as the seer who sees the captives as photographed and as the seen who is photographed (or, more accurately, reflected) alongside the captives. In this way, not only does the distance between the captives as being there in the frame and the viewer, outside the frame, disappear but so does the temporal separation between the 1850 studio session and our third millennial spectatorship. The result is that we enter their present and they join us in our present. The past/passed becomes present.

The capacity of the daguerreotype to serve as a spatial and temporal bridge allows the contemporary viewer to realize that neither race nor the history of "race," as a social concept, is something from which black bodies can easily escape. It does not instantly lose its meaning the moment that a century ends or a new millennium begins. It simply cannot be discarded because ethnologists in the past have employed the term to read black bodies as being different from and inferior to differently colored bodies. The daguerreotype shows us that past events continue to echo in the present. We can see ourselves in the past. They also reveal that the *futured*—our ever

evolving present viewed from a past perspective—is implicated in the past. This is why *futured* is always passed (tense). To read the daguerreotypes is not to revisit a race-themed endgame in which the black body exists as a series of limited historical possibilities. Instead, the daguerreotypes reveal the convergence of the past, present, and future.

Déjà vu, All Over Again

The reverberations of the Zealy daguerreotypes can be felt in the 1920s portraits of Richard Samuel Roberts, a semiprofessional photographer who lived and worked in Arsenal Hill, the predominantly African American section of Columbia, South Carolina. His surviving images, more than three thousand glass negative plates depicting assembled families, church groups, and social organizations, offer the contemporary viewer a privileged glimpse into the communities within which black men, women, and children lived. Although the majority of Roberts's surviving images are studio-based portraits, there are scores of pictures that were taken outdoors within black Columbia. While such "on the road" images record a variety of lived experiences of the photographic subjects—a child's birthday party and the scene of a baseball game, among other events, I focus here upon the portraitist's studio-based photographs depicting "dressed up" subjects with the aim of drawing a comparison with those of Joseph T. Zealy. They not only bear a compositional similarity to the earlier daguerreotypes but also challenge the objectification of black bodies as the black body that occurs within the work of Zealy.

Studio portraits tend to resemble one another. The expectations of the form (and the photographed subject) demand this. Subjects appear centered within the frame and, more often than not, look directly at the viewer of their image. Some sit. Others stand. Although painted and photographed portraits belong to collections of art museums across the globe, they often are not considered "art" or, at the least, representative of a particular artist's oeuvre. For example, the National Portrait Gallery, the London-based museum dedicated entirely to portraiture, acquires paintings and other images based not upon the artistic merit of the work (including the status of the artist) but on the historical significance of the subject. According to the museum's self-description, it "was established with the criteria that the Gallery was to be about history, not about art, and about the status of the sitter, rather than the quality or character of a particular image considered as a work of art."[51] The Na-

tional Portrait Gallery's philosophy is straightforward. Visitors and viewers of the portraits accidentally may encounter "art" when looking at the portraits that hang on the museum's walls, but they always will be surrounded by history. Tom Molineaux, the African American boxer who appears in the next chapter, is a part of this history and maintains a presence at the Gallery.

Many scholars and artists, including Paul Ardenne, Frances Borzello, and Shearer West, have written in support of the artistry of portraiture. While I do not disagree with them, I elect, within this chapter, to read the subjects of the various photographs primarily as subjects of history, whose imaged presence offers the contemporary reader (of the photograph) the opportunity to encounter a past historical moment and to better understand the embodied experiences of those figured within it. Roberts's photographs are particularly powerful because they reveal the conscious efforts of both the photographer and the photographed to create a differing and more honest depiction of the black body to contest the popular, caricatured representations that circulated at the time of the portrait sessions. This attribute was underscored in the promotional advertisement for a 2004 exhibition of Roberts's images at the Columbia Art Museum: "At a time when American society often presented stereotyped images of African Americans in films and advertisements, Roberts amassed a sophisticated body of portraits that reveal the sensitivity, individuality, and intelligence of his subject."[52] Although the advertisement overreads the pictured bodies by identifying abstract, unquantifiable elements (i.e., "sensitivity" and "intelligence") within the pictures, the conscious efforts of the subjects can be read not by focusing upon the immaterial but rather by paying close attention to the material elements that fill the frame—physical bodies and clothing.

The subjects in Roberts's portraits are related to the subjects in Zealy's daguerreotypes. Despite the fact that there is not any evidence to support the contention that the numerous, unidentified faces who appear in Roberts's surviving negatives are direct relations to any of the black captives who stood still before Agassiz (and later Zealy), the fact that the individuals lived in the same city, shared a recent history of black captivity, and were separated by, on average, two generations opens up the possibility. Could the unidentified person in this or that portrait be related to Alfred, Delia, Drana, Fassena, or Jem? Could she be one of their children? Grandchildren? Great-grandchildren? While we can delight in imagining the possibilities, new evidence is unlikely to surface that conclusively will genetically link them. Nev-

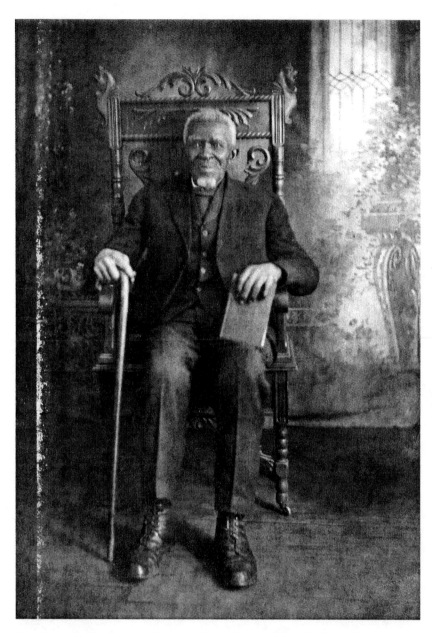

Reverend Charles Jaggers. From *A True Likeness: The Black South of Richard Samuel Roberts, 1920–1936,* edited by Thomas Johnson and Phillip Dunn, by permission from the Estate of Richard Samuel Roberts and Bruccoli Clark Layman, Inc.

ertheless, we can contend with some certainty that the bodies share similar histories with the ones in the daguerreotypes. Despite not being related to these captives, Roberts's numerous subjects are the daughters, sons, grandchildren, and great-grandchildren of captives who lived and worked on southern plantations, especially on plantations in South Carolina. Their bodies, like the bodies of Delia and Drana, are the children of the Middle Passage. They are the offspring of those individuals who survived the journey. Furthermore, their daily reality, living in Columbia in the 1920s, was affected by the history and legacy of black captivity.

In select instances, the bodies in Roberts's portraits could have been the same body seen/scened in the daguerreotypes. Roberts's photograph of Reverend Charles Jaggers, a preacher who served as an advocate for the homeless and who sat before the photographer's camera sometime between 1921 and 1924, assists this reading. Within the portrait, the reverend, an elderly black man who appears short in stature, sits in a studio chair. He wears a white-collared, button-down shirt under a dark-colored sweater, vest, and sport coat. Dark creased pants, possibly slacks, black socks, and shoes complete his outfit. With his arms positioned on the armrests of a seemingly oversized chair, Jaggers holds a Bible in his left hand and a walking cane in his right. Both are raised as if he is showing these objects to the viewer. He looks directly at us—the viewer of his image. Although his mouth is closed, Jaggers appears to be smiling or, perhaps, smirking. In the background of the image, a decorated canvas hangs on which we can see that a window, ornate wall decorations, and flowers have been painted.

Despite the presence of all of these details, the most important feature to this analyst is the body of Reverend Charles Jaggers. Born in 1831, Jaggers, white-haired in the photograph, was at least ninety years old at the time of the portrait session. His aged body functions as an index of generational constancy and change. It reveals that the subjects of Zealy's daguerreotypes and Roberts's photographs were not necessarily unique. Jaggers, a former captive who labored on a South Carolinian plantation, was nearly twenty years old when Agassiz inspected the bodies of black captives on various plantations and Zealy photographed them.[53] Despite the fact that the circumstances of Jaggers's birth would have prevented him from being selected alongside the other men in the surviving daguerreotypes, Jaggers conceivably could have joined both Delia and Drana as scientific examples of the "country born" black body, the *after* to the *before* embodied by Alfred, Fassena, Jack, Jem,

LIVERPOOL JOHN MOORES UNIVERSITY
LEARNING SERVICES

and Renty. What separates the daguerreotype from the portrait session is a mere life-span. The bodies featured within each become less distinct. They could be the same body.

Obviously, every body could not have been the same body imaged for Agassiz's study. Although Jaggers may be an exception, his presence within Roberts's collection helps us to realize that the comparatively younger subjects in the same set of photographs share a historical experience similar to that of those who were compelled to sit before Zealy's camera. This similarity, which accounts for divergences in individual lifestyles, also appears in Roberts's re-creation of the studio moment in Columbia, South Carolina. He, along with his subjects, who agreed to sit or stand still, created images that challenged and, ultimately, rehabilitated mainstream representations of the black body. Unlike the black captives who are exposed for Zealy's camera—photographed naked and nearly naked—the black customers in Roberts's portraits wear layers upon layers of clothing and accessories. For example, unlike Renty, whom he remarkably favors, Reverend Charles Jaggers wears a lot of clothes: shirt, vest, and suit jacket. Each layer barricades his body from the objectifying look of the viewer. Furthermore, his accessories, the Bible and the cane, deflect attention away from his body and enable a variety of possible readings of both his body and his multiple habiti. The Bible suggests a religious figure and, perhaps, a priest. The cane conforms to our suspicions that the subject is advanced in age. His clothing—meticulous in appearance—suggests a person of higher social standing. In the other photographs within Roberts's collection, viewers similarly encounter layers of clothing and accessories worn across the bodies of his subjects. The presence of clothing within the studio portrait proves neither shocking nor alarming. The lack of exposed flesh is not surprising. However, it does spotlight the controlled nature of the earlier daguerreotypes. Alfred, Delia, Drana, Fassena, Jack, Jem, and Renty were made to undress and forced to stand or sit still before the camera. The nudity of the figures in the daguerreotypes testifies to their captive status in the same way that the accessories on the bodies of Roberts's subjects represent their independence.

The legibility of Roberts's portraits derive, in large part, from the presence of clothing and accessories. It is not necessarily these items in themselves but how they are worn that suggests that many of the photographer's subjects "dressed up" for the portrait session. In his portrait of "Mr. and Mrs. Boyd," Roberts presents a married, middle-aged couple. The husband,

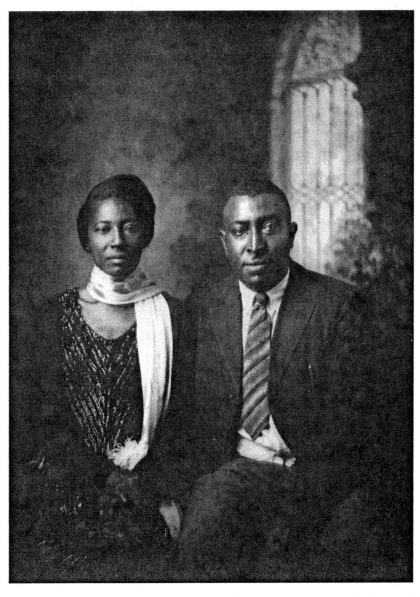

Mr. and Mrs. Boyd. From *A True Likeness: The Black South of Richard Samuel Roberts, 1920–1936,* edited by Thomas Johnson and Phillip Dunn, by permission from the Estate of Richard Samuel Roberts and Bruccoli Clark Layman, Inc.

dressed in a dark suit, white shirt, and tie, sits to the right of his wife, who wears a black-and-silver evening dress. A white scarf, wrapped around her neck and draped over her left shoulder, completes the outfit. Interestingly, it is the scarf, as a fashion accent, that spotlights the Boyds' desire to "dress up." While Mrs. Boyd's costuming, either as a version of her best self or imaginatively as a member of a higher social class, proves successful on its own merits, the fact of her performance reveals itself once we consider the self-presentation of her husband. Unlike his wife, Mr. Boyd's costuming is immediately apparent. He wears a wrinkled shirt and an equally wrinkled suit jacket. Furthermore, his tie hangs off-center and appears to be too short. In many of the other portraits, wrinkled and/or misfitting clothing signals the subjects' efforts to control their representation. While Mr. Boyd's ill-fitting clothing suggests that he does not regularly wear a suit, it also spotlights a desire to be photographed and, by extension, to be, preserved within history looking his best. Although these aspects suggest the class status of the subjects and their inability to perform the "look" of a higher class, they also, through their visible failure, spotlight the intentions of the subjects and of the photographer to project a certain image of the black body. The crooked tie and wrinkled shirts reveal a group of working-class men and women who sought to perform and render static in a photographic image their idealized selves. They wanted to capture not their everyday selves but themselves either as they saw themselves or as they imagined themselves to be.

Unlike the Zealy daguerreotypes, Roberts's portraits were commissioned by their subjects. They were not going to be shipped to an Ivy League school to be closely examined by a scientist who was looking for evidence that blacks and whites were inherently different. They were not meant for museum exhibition. Instead, they were constructed for the interior, private space of the familial home. The photographs served multiple purposes. They were keepsakes, depicting beloved family members. They were memorials, featuring the recently deceased. In short, they were history. To a people who had been forcibly separated from their families, auctioned away to new "masters," and denied the opportunity to record their memories, photography allowed the past to be accessed in the present and the present to be captured for the future. As cultural critic bell hooks has written, the value of photographic technology anchors itself in its ability not only to preserve history but also, and more importantly, to document it in a manner than can be easily transported and, if the need arises, hidden for future rediscovery:

The camera was the central instrument by which blacks could disprove representations of us created by white folks. . . . For black folks, the camera provided a means to document a reality that could if necessary, be packed, stored, moved from place to place. It was documentation that could be shared, passed around. And, ultimately, these images, the worlds they recorded, could be hidden, to be discovered at another time.[54]

There is power in the photograph; it affords the agency to refute "representations of us created by white folks" through its ability to document "reality." This image of lived reality carries within it the potential to challenge and, possibly, erase stereotypes and caricatures of blackness. More constant than orature and smaller than a memory quilt, the photograph, as a historical document, reveals to the viewer, in the present, a past presence that is now absent.

The photograph pauses the flow of time and grants the viewer a privileged glimpse into a moment that no longer exists. It enables an encounter with the past even as it compels us to acknowledge that our present and, indeed, our future soon will have passed. Susan Sontag, the influential art critic, echoing the writings of Phillipe Dubois and Christian Metz, refers to this attribute in the following manner: "To take a photograph is to participate in another person's (or thing's) mortality, vulnerability, mutability. Precisely by slicing out this moment and freezing it, all photographs testify to time's relentless melt."[55] The picture-taking process creates evidence of the subject's presence in the present while foreshadowing his or her impending disappearance. An example of this appears in late nineteenth-century mortuary or funerary daguerreotypes of deceased children that were taken as evidence of that child's existence. A death image is created to recall a passed life. Another, more contemporary, example is the placing of the photograph of the once living body, such as Emmett Till, near a casket containing the actual, physical remains of the same body that now no longer lives. The juxtaposition of the image of the body with the body itself suggests that the image will replace the body. In fact, this transference likely already has occurred for those well-wishers and respect-payers who find that the photograph proves a better likeness of the dead than that person's actual corpse. Eventually, the physical body will be interred or cremated. It will disappear but its photograph will remain. The value of the memento mori function of the photograph anchors itself less in abstract notions of haunting or ghosting and more in the suggestion that the image can offer access to a past bodily presence.

This is not to say that Mr. and Mrs. Boyd visited Roberts's studio, posed for his camera, and gained a newfound awareness of their own mortality. Despite the fact that the photograph preserves them in the present for the future, it probably was taken to commemorate any one of dozens of possible celebrations and events. Was this their wedding anniversary? Was this one of their birthdays? Was this picture destined to be a gift for someone? Or was Roberts merely offering a discount on studio portraits? Regardless of the reason, the picture became a historical document possessing a particular meaning to the subjects within the image that may or may not differ from the meaning that it has to the viewer of the image. In reading the image without regard to the unknowable event that prompted the studio session, I focus only upon the fact that the Boyds' presence within the photograph makes them subjects of history who were capable, in tandem with Richard Roberts, of controlling their own representation. Despite the passage of years and the passing of the Boyds, the photograph, a memento mori, renders present the still bodies of the married couple.

In addition to revealing the photograph's ability to record the present for the future, Roberts's images visualize the touch of the past on the present. Several of his pictures feature elderly subjects, like Reverend Jaggers, who survived the era of black captivity within the United States. Whereas Jaggers sits alone, the majority of the other older figures appears alongside younger family members. These depictions of multiple generations within a single frame not only preserve a present moment for future reflection and remembrance but also and, more abstractly, suggest that the past has made an impression on the present. This is the reason that cross-generational photographs—pictures of children with their parents; grandchildren with grandparents; or, the gold standard, children, parents, grandparents, and great-grandparents—are deemed valuable. In Roberts's photograph of a pair of unidentified women, this generational touch appears. The image features an older woman, perhaps in her eighties, sitting in a high-backed wooden chair to the left of a younger, standing woman perhaps twenty or thirty years old. Both appear before the same painted backdrop that hung in the portrait of Jaggers. The older woman, with white hair, parted in the middle and combed down to each side, sits, upright, wearing black-rimmed glasses; a thin, knee-length coat over a patterned black dress, which fastens near the neck with a jeweled, butterfly clasp; and flat-bottomed black shoes. The younger woman, standing to her right, wears a long, flowing, white day dress

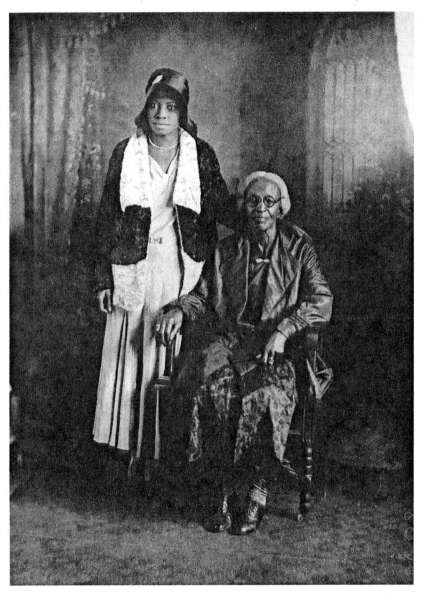

Untitled. From *A True Likeness: The Black South of Richard Samuel Roberts, 1920–1936*, edited by Thomas Johnson and Phillip Dunn, by permission from the Estate of Richard Samuel Roberts and Bruccoli Clark Layman, Inc.

with a butterfly-style pin (or clasp) at waist level, under a black-and-white jacket. She also wears a black cloche hat and a gleaming necklace. She stands slightly behind the older woman with her right hand at her side and her left hand on the left shoulder of the seated woman.

The presence of the two women within the frame of the studio portrait suggests that they share a connection. Unfortunately, the "unidentified" status of the sitters prevents us from knowing the nature of their relationship. Were they grandmother and granddaughter? mother and daughter? friends? lovers? neighbors? Regardless of the nature of their relationship, the arrangement of the figures, with the younger woman's hand touching the shoulder of the older woman, proffers the sense of shared intimacy between the subjects. While this "intimacy" easily could have been engineered by Roberts, who likely arranged his subjects and determined their pose, the presence of the two women within the portrait studio and their appearance within a single frame reveal their willingness and, perhaps, even desire to be photographed together. This complicit desire required corporeal enactment—the hand on the shoulder in addition to their physical presence/appearance within the photograph—in order to be made legible to the viewer of the image. Beyond gesturing toward their relationship, this touch literally connects the two figures—bridging the physical space separating them. Arguably, it can be said to give the younger woman access to the older woman's experience of the body. The encounter establishes each subject as a witness to the other's staging of her own future. The younger (or older) woman possesses the ability to offer an informed, albeit subjective account of her perception of the actions and experiences of the other. Considering the age differential, we can predict that the younger woman is likely to live longer than the woman who sits before her and, as a result, become an authority on that woman's experience. This is not to say that she can testify to the experiences of the older woman as perceived through her (the older woman's) eyes or as felt through her body. Instead, it is to say that she can speak, from her own vantage point, as a person who shared a space, a moment, and the same presence with the now absented figure and, as a result, can testify that the woman, indeed, was there and can describe what that woman might have felt and seen because she (the younger woman) too was there. This authority predicates itself upon the imagination, remembrances, and subjective positioning of the survivor. However, there is no guarantee that the younger woman will outlive her photographic partner. The high mortality rate of

black women—which could account for the conspicuous absence of Drana's and Delia's mothers in Agassiz's study—suggests that the older woman, having endured the history of slavery, decades of prejudice, and, perhaps, the dangers of childbirth, may be the survivor, and that the younger woman will have plenty of challenges awaiting her.[56]

In *The Visible and the Invisible*, incomplete and posthumously published, phenomenologist Maurice Merleau-Ponty observes that a person can comprehend the perspective of another by situating the imagined vantage point of that other person within her own body. He writes, "This other who invades me is made only of my own substance: how could I conceive precisely as *his, his* colors, *his* pain, *his* world, except as in accordance with the colors I see, the pains I have had, the world wherein I live?"[57] Merleau-Ponty underscores the seeming uniqueness of experience by grounding it within the individual. Although we can approximate the experience of another, ours will never be the same. This does not mean that a similar experience cannot be shared among or understood by multiple bodies. While the body stands at the center of individuated experience, it also filters shared, including perceived, experiences. This filtering, a form of translation, transforms another's experience into something recognizable, bearing a resemblance, to one's own self. Our ability to talk to one another about whether a particular food dish is too salty, a movie scary, or the weather hot hinges upon our capacity to translate or filter perceived and/or announced experiences of other bodies within our own. Although Merleau-Ponty's writings on the internalized processes that render recognizable another's experience of the body offer a way of thinking about similar, embodied black experiences, they do not account for the external factors that structure similar experiences, especially among minoritized bodies. Unlike a person who has to decide whether her conception of "salty" resembles a friend's before (dis)agreeing with that friend's assessment of a particular entrée, the target of racial profiling or race-based lynching does not have the opportunity for such equivocation. The event happens and an experience gets created regardless of whether the person "sees" herself as being recognizable from without or, for that matter, from within as a black body. Certainly, this experience creates an affect that prompts self-evaluation, but the self-evaluation itself does not solely engender the experience. In addition to emerging from within the subject, these experiences externally envelop her.

When Roberts's subjects, Reverend Jaggers and the Boyds among hun-

dreds of others, entered his portrait studio, they challenged the contemporary representation of the African American body within society. While we will never know how aware they were of these environmental/external representations, the popularity of racist commodities and the public speeches of local politicians suggest that they were inescapable. Henry Louis Gates, Jr., discusses the role that such themed commodities played in the reification of black stereotypes at the dawn of the twentieth century:

> To roll back the social, economic, and political clock to 1860, American racists flooded the market with tens of thousands of the most heinous representations of black people, on children's games, portable savings banks, trade cards, postcards, calendars, tea cosies, napkins, ashtrays, cooking and eating utensils—in short, just about anywhere and everywhere a middle—or working-class person might peer in the course of a day.[58]

The projection of racist imagery on everyday possessions—salt shakers and ashtrays—served the purpose of ingraining stereotypes through repeated, daily reinforcement. While the figures in Roberts's portraits may not have possessed such objects, it is difficult to imagine them not being aware of their existence. In addition, the subjects lived during the championship reign (1908–15) of black heavyweight boxer Jack Johnson, who not only beat a series of "white hopes" in the boxing ring but also, and more controversially, was married to, and eventually imprisoned for his relationships with, white women. Racist caricatures of Johnson circulated throughout major (white) newspapers, and race riots occasionally erupted following Johnson's victories during this period. For many of Roberts's subjects, the rise of Jack Johnson may have encouraged them to prepare for a spate of racial violence, including lynchings. Some had to have remembered that two decades earlier, Ben Tillman, their U.S. senator, stood on the floor of the Senate and forcefully advocated the murder of all black bodies who behaved like Johnson.

> We of the South have never recognized the right of the negro to govern the white man, and we never will. We have never believed him to be equal to the white man, and we will not submit to gratifying his lust on our wives and daughters without lynching him. I would to God the last one of them was in Africa and none of them had ever been brought to our shores.[59]

Tillman died in office in 1918, a few years before Reverend Jaggers sat to have his portrait taken by Roberts. The temporal proximity of the senator's statement and his Senate tenure to the lives of the subjects allows the possibility that they could have been aware of the senator's, among others', statements against the black body. For those not acquainted with his words, they likely were aware of the physical threats that he championed. Considering that the last "legal lynching," in which a trial was not conducted, in South Carolina occurred in 1947, nearly forty years after Tillman's speech and twenty-five years after Reverend Jaggers sat before Roberts's camera, it is likely that the subjects in Roberts's photographs shared the common experience of knowing both how they were being depicted and what dangers potentially awaited them outside of black Columbia.[60]

In the face of negative stereotypes and physical threats, the subjects within Roberts's portraits present an air of calm and civility. They do not resemble in the present—within their photographs—the image constructed by fearful South Carolinians, like Tillman, or fearful South Carolinian tourists, like Agassiz. What we see are refined individuals, who appear either individually or with family members or friends. Whether they dressed up because they were paying for the portrait session or because they wanted to challenge contemporary caricatures of blackness, their presence within the photographs rehabilitates previously circulated images of blackness.

The Pause, Revisited

In the preceding sections, I discussed the role that the still image plays within the studio portraits of J. T. Zealy and Richard Roberts. I noted that it renders the past (and passed bodies) present, thus bridging differently placed (temporally) and spaced bodies and enabling the transmission or sharing of embodied experiences. In this section, I continue my analysis of the black body, specifically the black body scened in the southeastern United States, by reading it from a slightly different angle. Rather than focusing on portraits, I look at documentary photographs, specifically the 1930s Resettlement Administration images of Walker Evans, and discuss their ability to record the presence of the "pause" that existed not only within the studio moment but also within the daily lives of the photographed.

The Resettlement Administration (RA), later renamed the Farm Secu-

rity Administration (FSA), was created in 1935 for the expressed purpose of remedying the negative effects of the Great Depression on the rural areas of the United States. A federal agency, the RA directly funded new construction projects, such as the building of dams, irrigation canals, highways, and houses that, in turn, created employment opportunities in economically depressed regions. In order to document the Depression-era plight of Americans and, later, to record the success of its initiatives, the RA opened an Information Division under the leadership of Roy Stryker, an economics professor with little experience in arts management. Stryker hired nearly a dozen photographers, supplied them with film, and ordered them to travel through portions of the United States and document governmental relief efforts. Although he assigned his staff to specific regions of the country, he did not order them to take any certain type of pictures. They were free to capture whatever caught their eye. Dorothea Lange, one of Stryker's more famous photographers, recalled her first impression of the Information Division's headquarters in the following manner: "I found a little office, tucked away, in a hot muggy summer, where nobody especially knew exactly what he was going to do. And this was no criticism, because you walked into an atmosphere of a very special kind of freedom."[61] Walker Evans exploited this freedom.

Walker Evans had little in common with the poor, uneducated, landlocked subjects in his RA photographs. A wealthy midwesterner by birth, Evans was educated at the most prestigious boarding schools in the Northeast and later at Williams College. After two semesters at Williams, Evans withdrew and with his father's (financial) support spent three years learning French and reading French literature in preparation for a move to Paris. He set sail on 6 April 1926 and stayed there for one year. Evans's single year in Paris, according to several of his biographers, informed his artistic eye and influenced his future photographs. Maria Morris Hambourg, writing for the Metropolitan Museum of Art's 2000 catalog on the photographer, joins the company of those scholars who romanticize the effect of his year abroad when she writes, "Evans was good at absorbing Frenchness through a kind of literary and experiential osmosis."[62] Despite his shyness, which presented itself in the young photographer's tendency to shadow the American expatriate community, including Ernest Hemingway and F. Scott Fitzgerald, and to peer into their windows but never enter establishments to associate with them, Morris Hambourg asserts that "Evans was a natural in the Baude-

lairean role" of the "perfect *flaneur*."[63] It is this role that she says character-
izes Evans's approach in his later photographs, including his RA work.

Evans, contrary to his legendary depictions within academic texts, was
not a ghost of European modernism who managed to float into the domiciles
of rural farmers and record their lives undetected. In fact, he was the com-
plete opposite. Evans knew that he was a white man of privilege who lacked
any substantive experiential connection with the people whom he pho-
tographed. How did Evans, as stranger and outsider, succeed in capturing
what art historian Michael Brix calls the "undisguised expressions" of his sub-
jects faces?"[64] Evans, in a *Boston* interview answers, "For one thing, we com-
pensated these people. We bought them, in a way. That sounds more corrupt
than it was meant to be. We went into their houses as paying guests, and we
told them what we were doing, and we sort of paid them for that. Good
money."[65] The seeming honesty of Evan's RA photographs roots itself in his
status as intruder and outsider. A self-described "aristocrat" who worked for
the federal government, Evans traveled throughout the most economically
depressed regions of the southeastern United States, and compensated
people for appearing within his photographs. Despite his expressed apoliti-
cism, Evans stood as the personification of FDR big government. Similar to
the relief organizations that necessitated that needy rural farmers wait in line
to obtain assistance, the photographer insisted that his subjects perform cer-
tain tasks for money. They had to stand still for his camera.

Evans's success at recording the faces (and bodies) affected by the Great
Depression in the American Southeast can be seen in the fact that Michael
Brix and Brigit Mayer observe that "our present conception of America in
the thirties is strongly influenced by Evans's FSA photographs."[66] This seems
to have been Evans's goal: to record the present for future consideration. In
his "Author's Note" for the original 1938 collection of his photographs, Evans
writes:

> The journalism of the present is so corrupt that its products in the field of
> photography are only sparsely and accidentally of any value whatever; and
> only in time, when removed from their immediate contexts, will they serve
> the purpose under discussion. In example, photos of prominent people will
> be printed to advertise something, or just for themselves, or as in the case of
> "society" illustrations, merely to advocate the fitness of such-and-such a per-
> son's activities; but the accidental use to which these images may be put by

future students and examiners of the period is far from the minds of the news photographers or of their employers. And then one thinks of the general run of the social mill: these anonymous people who come and go in the cities and who move on the land; it is on what they look like now; what is in their faces and in the windows and the streets beside and around them; what they are wearing and what they are riding in, and how they are gesturing that we need to concentrate, consciously, with the camera.[67]

Evans realized that the photograph represents absented presence; past subjects appear present despite their present-day absence. The ability of the image to survive the subject enables previously unimagined uses of the photographs. For example, the studio portraits of Zealy and Roberts, along with Evans's RA photographs, have been exhibited in art museums. While the "accidental use" of images cannot be controlled, Evans urged photographers to focus upon the often overlooked with the aim of restoring and, perhaps, affirming their societal and historical presence. In recording the present for the future, the photographer succeeded in rendering the Great Depression visible. The lasting value of this action appears when we consider historian Lewis Allen's description of the Great Depression: "One of the strangest things about the Depression was that it was so nearly invisible to the casual eye (and to the camera for that matter). To be sure, the streets were less crowded with trucks than they had been, many shops stood vacant. . . . There just didn't seem to be many people about."[68] Within his photographs, Evans gave the Depression a face. He revealed that there were many people who were "about" but previously ignored. These individuals, although rarely seen in shopping plazas, stood in government relief lines and were, in many cases, black.

Walker Evans's 1941 photograph *Love or Leave America,* despite having been taken four years after the photographer ended his association with the Resettlement Administration, offers a useful starting point in a discussion of how his photographs capture the pause that manifested itself within the lives of black bodies in the southeastern United States during the Depression era. The photograph depicts four white women being chauffeured in a parade celebrating Italian-American heritage. One sits in the front passenger seat. The other three occupy the rear of an open-topped black convertible. All wear white uniforms accented with a large, presumably red, white, and green, pageant-like ribbon. A similarly colored bow adorns their white hats.

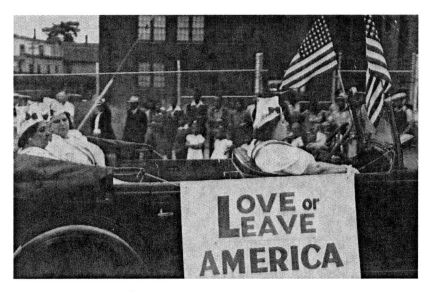

Walker Evans, *Bridgeport Parade/Bridgeport's Italian Women Insist Upon Their Patriotism*, 1941, gelatin silver, 13.2 × 21 cm. The J. Paul Getty Museum, Los Angeles.

On the automobile, two American flags are frozen in midwave and a white sign (with red lettering) proclaims: "Love or Leave America." What interests me in the photograph is not the images in focus, but rather those left blurry—those grainy, background figures captured on film, namely the spectators who are caught in the process of being passed by the car.

The spectators, with the single exception of a white man who stands toward the edge of the left frame of the photograph, are all black. Black men stand next to black women and behind black children, thus giving the impression of a series of assembled black families gathered together to witness the spectacle of the parade occurring before them. Contrary to our expectations of how spectators of a parade are supposed to act, the men, women, and children do not wave, cheer, point at, or even applaud the carload before them. Instead, they stand with their arms folded and look away from the women. Their attention and gaze are directed elsewhere. They look (to their) right. The women are at center. Heightening this feeling of spectatorial detachment within the photograph is the seeming indifference of the women within the car who—also contrary to our expectations—choose to ignore the

crowd by not waving. The inactivity and the tension between the two groups appear even more pronounced given the *pause* established by Evans's camera. It is only the sign, "Love or Leave America," that bridges the gap. It speaks. The sign, read within the context of the photograph, suggests that the imagined America that the white women claim to represent excludes diversity. America is white. It is industry. It is indifferent to the presence of others. It threatens, "Love it or Leave It." Despite the ultimatum, there appears to be no real opportunity within the photograph to "leave." Looking at Evans's picture, we can see that the black spectators are hemmed in not only by the street and the car before them but also by the barbed-wire fence behind them. There is no escape. They cannot leave. The only alternative for these fixed bodies is to look away . . . and they do.

Many of Evans's RA photographs, similar to *Love or Leave America,* are defined by their ability to record the fixed status of the black body within the American landscape. In his pictures, black men, women, and children are depicted in exterior, rural settings. They sit outside of barbershops and wait in federal relief lines. In each setting, a feeling of slowness, stillness, and stasis exists within the photographs that exceeds the pause granted them by Evans's camera. We can see this in the series of photographs taken by Evans in 1936 of men waiting outside of a barbershop in Vicksburg, Mississippi. In one of the photographs, four men, sandwiched between the wooden, clapboard structure of the barbershop and the city street, wait their turns on the sidewalk of E. C. Clay, the barbershop proprietor. Three men sit. One stands. Of the seated men, the two on the edges, who appear to bracket the others, look strikingly similar in both posture and dress. They sit, slightly hunched over, on their respective stools with hands rested on their laps and wear almost identical clothing: scuffed shoes, worn work pants, a slightly wrinkled white work shirt covered by a light jacket. In contrast to the weathered and worn look of these men, the other men project an aura of confidence. The seated man, wearing a white shirt, tie, and slacks and leaning back in his chair with his legs crossed, and the standing figure to his left, who is dressed entirely in black—slacks, turtleneck, sweater—present an image significantly brighter than the drab working-class look of the men who bracket them. In the next photograph within the series, the number of idle, prospective patrons is reduced by one and the seeming indifference of the three remaining men transforms itself into a focused interest in the look of Evans and his camera. They return his look. In the photograph, the working-

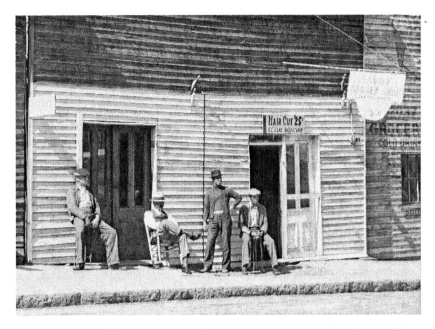

Walker Evans, *Vicksburg Negroes and Shop Front, Mississippi,* 1936, Library of Congress, LC-D16-fsa-8c52213.

class man positioned to the left in the earlier photograph has disappeared, and only his stool remains. The other three men, in shirt and tie, black turtleneck, and worn work shirt, appear in essentially the same positions as in the earlier photograph, except that their look is now directed at Evans. They watch him take their portraits. Whether their returned gaze is defiant toward or compliant with the act of having their picture taken, it is clear that they acknowledge the presence of the photographer, an outsider, within their space. Speaking of Evans's series of barbershop photographs, Jeff Rosenheim writes:

> It is, however, Evans' series of photographs depicting African-American men before a row of barbershops that makes his work in Vicksburg a high point in his career. After discovering a row of ramshackle wooden shops that descend one of the city's hills, he made a few views looking down the street toward the six stores and recorded the general scene, a stage set for the human traffic

meandering along the sidewalk. Then he set up his camera opposite three ad-
jacent barbershops in the middle of the row. . . . To capture momentary ges-
tures, he used his second-fastest shutter speed, one-twenty-fifth of a second,
the paradoxical result is that the men appear to have been posed.[69]

What is of particular interest in Rosenheim's reading of Evans's photographs
is his suggestion that the space of the barbershop is marked by the move-
ment—the "human traffic"—of potential customers. Evans is fortunate to
capture this activity on film. References to the "meandering" pedestrians and
their "momentary gestures" suggest a feeling of restlessness. They also es-
tablish the need for the heightened shutter speed of Evans's camera to
record the images appearing before them before they are forever lost. Such
aspects do not appear within the photographic sequence. The men remain in
essentially the same position as in the earlier photographs. With the excep-
tion of the disappearance of one man and the returned look of the subjects,
little else has changed in the picture.

This feeling of stillness continues into Evans's 1937 photographs of black
flood refugees in Forrest City, Arkansas. Each photograph in the series de-
picts a fragment of the relief line in which black men, women, and children
stand awaiting their food rations. The theme of fragmentation, which pre-
sumably began with the flood's severing the refugees from their homes, con-
tinues with Evans's selective editing of the line and appears most visibly in
the way that his camera frame cuts and splinters the bodies of his subjects. In
one memorable photograph, Evans centers two hands belonging to two dif-
ferent refugees. The hardened, weathered, and well-worked hands grasp
onto one of the few remaining objects remaining to them. On the left, a hand
holds a tin plate, most likely a plate initially given by a government relief or-
ganization or private charity. To the right, the hand holds a chipped ceramic
bowl. Each waits its turn to fill those empty dishes with food. The faceless-
ness (not necessarily anonymity) of the photograph contrasts with the detail
and contours of the lines on the hands, the chips on the bowls, and the wear
on the background clothing that speak in specific detail of the hardships en-
countered because of the flood. Faces are not needed. Bodies are. The frag-
mentation of bodies urges the viewer to focus on the body part and to imag-
ine the part as whole and, through this imaginative recovery, to see the body
as a core text rife with meaning.

When Evans does depict faces, he presents them in the same style as

Walker Evans, *Negroes in Line-up,* 1937, Library of Congress, LC-USF3301-009230-M4.

those hands. They become specific points of focus that testify in detail to the larger and comparably more general suffering of the flood victims. It is no accident that the bodies remain split and severed by his frame even as faces come into focus. Most of Evans's photographs of flood refugees are framed by the partially present people who either were not successfully captured in their entirety or failed to escape completely from Evans's frame. In this partial presentation, the photographer succeeds in relaying to his viewer the fact that the experience that they are attempting to read from the faces of those caught on film is incomplete and significantly larger than his viewfinder allows to be recorded. It is indeed only a fragment. This technique continues into arguably the most powerful of the refugee photographs, namely Evans's pictures of the children who wait in the relief line. Either tilting his camera down or squatting to capture the faces of children, Evans cuts off the heads of the backgrounded adults from the image and succeeds in relaying the impression of children unknowingly caught within a dire situation. Framed

against the headless bodies of black men and women, the children appear even smaller and more vulnerable. Heightening our spectatorial connection with the young refugees is the fact that they willfully return the look of Evans. They look at his camera. They look at us. They watch us watch them. What does a child think as she watches a person watch her in a time of need but refuse to help? What does a child think as she watches her parents and other black bodies, who are similar to her, stand in a relief line?

Evans, his camera, and our prolonged look at the refugees are facilitated by the relief line itself. Like the space of the barbershop that demands a wait long enough that the promise of a haircut seems almost an impossibility, the relief line with its infinite, as depicted by Evans, length demands a temporal investment that seems like it will never pay off. In this waiting, time slows down and the opportunity for the extended moment to be captured on film occurs. Positioned before the refugees and with his camera not only in hand but also poised to record, Evans seems to have made the most out of his encounter with a moment in which time has stood still.

Evans's RA photographs are reminiscent of Zealy's daguerreotypes in that they showcase the stillness of black bodies. Like the captives who are standing and sitting before the daguerreotypist, the subjects in Evans's pictures are in the process of performing an activity. They too are sitting and standing. They sit outside of shops and stand along streets and in relief lines. The only difference is that Evans's subjects did not have to remain standing or sitting in order to allow the picture-making process to complete itself. Whereas the captives had to perform motionlessness, the RA subjects could move and yet still appear still. Evans's heightened shutter speed allowed this. Despite the fact that they could move, the bodies in the RA photographs did not. They probably assumed a similar posture before the click, (obviously) during the click, and even after the click of Evans's camera. Indeed, Evans's photographs give the impression that the bodies in the frame are still standing. We watch them perform their everyday selves. Thanks to the pause granted by the camera, we are granted an opportunity to enter the past and witness the experiences of these selected black bodies.

Looking Back

In *The Four Fundamental Elements of Psycho-Analysis*, the published collection of a series of lectures delivered at the École pratique des hautes études,

Jacques Lacan recounts an experience he had on a fishing vacation taken in his early twenties. Allying himself with a family of fishermen, all of whom would "die very young from tuberculosis," he set out to sea. He recalls:

> One day, then, as we were waiting for the moment to pull in the nets, an in-
> dividual known as Petit-Jean, that's what we called him . . . , pointed out to me
> something floating on the surface of the waves. It was a small can, a sardine
> can. It floated there in the sun, a witness to the canning industry, which we,
> in fact, were supposed to supply. It glittered in the sun. And Petit-Jean said
> to me—*You see that can? Do you see it? Well, it doesn't see you!*[70]

Lacan continues on to say, "He found this incident highly amusing—I less so." Trying to understand why he did not share Petit-Jean's amusement, he offers the following: "The fact that he found it so funny and I less so, derives from the fact that . . . I, at that moment—as I appeared to those fellows who were earning their livings with great difficulty, in the struggle with what for them was a pitiless nature—looked like nothing on earth. In short, I was rather out of place in the picture."[71] This encounter maintains a lasting significance to Lacan because it demonstrates to him the fact that he does not control every perspective and vantage point. The world is not laid out for his eye alone. There are multiple looks and perspectives. In some of those perspectives, he may be centered. In others, he may be nothing more than a "spot."

The experience of Lacan proves of interest to this analysis on the photographic representations of the black body by Zealy, Roberts, and Evans in that it reminds us that there is more than one perspective at work when we look at the images. As we examine the faces captured by Zealy, they look back at us. In Roberts's portraits, the same occurs. It is difficult to study the photographs and, specifically, the subjects within them without having the sensation that they are staring at you. In Evans's photographs, the returned look is often multiple. We, the viewers, feel like we are being overpowered by their collective gaze. Even within his fragmented images of splintered (by the frame) bodies, there is the feeling that those off-frame heads are watching Evans (and, by extension, the viewer) take pictures of their children—in the same manner that the off-frame or "space off" captives may have watched Zealy take pictures of the other captives.

In addition to the presence of multiple gazes, the power of the images

derives from the photographs' ability to facilitate and stage an encounter be-
tween the contemporary spectator and the past (and passed bodies). This
may explain why Agassiz, an outspoken advocate of close analysis and obser-
vation, elected to study the daguerreotypes of the captives rather than to
work solely with the captives themselves. The daguerreotypes gave the im-
pression of physical presence within a photographic copy. Writing for the
Brooklyn Daily Eagle in summer 1846, Walt Whitman described this new
form of image technology as being so lifelike that "time, space, both are an-
nihilated, and we identify the semblance with the reality."[72] More recently,
Alan Trachtenberg, summarizing dominating, historical perceptions on the
daguerreotype, wrote, "The daguerreotype lent special authority to the no-
tion that a photograph *repeats* its original—not so much a copy as a simu-
lacrum, another instance of the same thing."[73] The photographic copy re-
creates the body. The viewer can engage with the imaged body in as much as
she can engage with a living, breathing person. Herbert Blau, discussing the
virtual image, supports this contention: "The fractitious reality of the figures
on a screen could have considerably more vitality, as if they were truly alive,
than the flesh and blood actors on stage."[74] While each theorist agrees that
the imaged body and the physical body are not the same, all acknowledge
that there are similarities between the two. The absented body in the da-
guerreotype, photograph, or screen can give the impression of presence. In
granting these bodies a presence, the photographs allow their viewer to en-
gage with the bodies of the imaged subjects. The temporal and spatial col-
lapse that results from the past being given a presence in the present (and fu-
ture) fosters the idea that the bodies within the frame are within reach. We
can almost touch them. They can almost touch us. This is the magic of the
photographs of Zealy, Roberts, and Evans.

The images share a number of similarities. Chief among them is their
ability to foreground the stillness of the black body in the moment of the
photography session and in the everyday lives of their subjects. The captives
had to sit before Zealy's camera and not move for a minute or more. The
clients in Roberts's studio also had to remain motionless as they sat or stood
before the photographer and posed for his camera. In Evans's nonstudio im-
ages, the subjects, who, of the three groups, had the most freedom to move,
remained still. The heightened shutter-speed of the photographer was not
needed. There is the sensation that the image might have looked the same
(or similar) had he used a daguerreotype machine. In addition to capturing

the likenesses of its subjects on a metal plate, glass plate, or celluloid nega-tive, the camera records the stillness within its subjects' lived experience. The seven captives lacked freedom and were forced to labor on South Car-olinian plantations. Prior to appearing on the plantation, five of them experi-enced the *wait*—in cells, on holds, and on blocks—of the Middle Passage. Those who appear within Roberts's photographs lived their lives not only bat-tling the stereotypes of the black body as a criminal body but also avoiding lynch mobs who threatened to render the black body permanently still. The black men and women in Evans's photographs appear trapped. Sandwiched between parade routes and wire fences, forced to stand, out of necessity, in government relief lines, and compelled to suffer the seemingly interminable wait of the barbershop, his subjects lead lives marked by stillness.

Although the black body scened within the southeastern United States has been the focus of this chapter, this analysis of stillness is applicable to bodies who reside(d) outside this region. The FSA photographs of Gordon Parks, who was hired by Stryker several years after Evans ended his associa-tion with the governmental agency, demonstrate this continued trend within his documentary photographs of residents of Maryland and Washington, D.C. Certainly, lynching pictures, which appear within James Allen's *With-out Sanctuary* collection, literally present the stillness of the black body in both the American Southeast and beyond. The Depression-era portraits of James VanDerZee, a Harlem-based photographer, stage scenes of affluence, wealth, and plentitude that appear consciously designed to combat stereo-typical, caricatured images, or, in the case of the lynching pictures, terroriz-ing images of the black body. In the next chapter, I continue to discuss the role of stillness in the experience of the black body by introducing the em-bodied experiences of four professional boxers and chronicling how one of them, Muhammad Ali, succeeded in controlling the presentation and re-pre-sentation of the black body by literally standing still.

Between the Ropes:
Staging the Black Body in American Boxing

There are languages of the body. And boxing is one of them.

—Norman Mailer, *King of the Hill*

My case revives his story.

—Muhammad Ali, comparing his legal troubles with those
of boxer Jack Johnson

On April Fool's Day, 1967, undisputed heavyweight boxing champion
Muhammad Ali received a letter from President Lyndon Baines Johnson.[1]
Opening the envelope, Ali was greeted with the following words printed in
capital letters across the top of the correspondence: ORDER FOR
TRANSFERRED MAN TO REPORT FOR INDUCTION. Ali had been
drafted. Four weeks later on 28 April 1967 at 8:30 a.m., the heavyweight
champion arrived at Local Board No. 61 in Houston to be inducted into the
United States Army. After filling out the necessary paperwork and taking a
written test, Ali was subjected to a series of invasive physical examinations.
He remembers:

"Gimme your papers," the next doctor snaps as I move into his stall. He's
fidgeting and he speaks with a strong Southern drawl. "Take off your shorts
. . . all the way down." He adjusts his glasses and appraises me like I'm a bull
that came into the herd. "Up closer!" he snorts, leaning down to examine my
penis. Of all the doctors I face, he is the most hateful. . . . The doctor jabs his
hand into my testicles. He feels around with his thumb until he finds the spot
he's looking for, and tells me to cough. "Again," he says. "So you don't want to
go and fight for your country?" His hand is tight on my testicles and I say

nothing. A chill creeps over my whole body, and I think of the days when castration and lynchings were common in the South.[2]

Following the examination, the doctor ordered Ali to get dressed, to go to the "reception room" for lunch, and to stay there until his name was called for induction.

The induction ceremony is a rather simple one. A group of drafted men are instructed to stand in a horizontal line. When the name of a drafted man and his "service," the branch of the military in which he will serve, are called, he is to take a single step forward. The step inducts him. In the step, the drafted man crosses an invisible threshold and in the passage announces his willingness to fight (and therefore die) for his country, thus essentially negating his "drafted" status. When Ali heard his birth name, "Cassius Clay," called within the induction room and as part of the ceremony, he stood still. When his name was called a second time, Ali, again, did not move. The lieutenant in charge of the ceremony, now looking even more intently at Ali, then called, "Mr. Ali." Still no movement. After having called out the champion's name three times—twice by his birth name and once by his assumed Muslim-identified name—the lieutenant ushered Ali to a small room and warned him that failure to take the step would result in criminal prosecution and carried a penalty of up to five years in a federal prison and a ten-thousand-dollar fine. The induction agent informed Ali, "I am authorized to give you an opportunity to reconsider your position. Secret Service regulations require us to give you a second chance."[3] Presented with this "second chance," Ali thanked the lieutenant and respectfully declined stating, "Thank you, sir, but I don't need it." To which the lieutenant responded, "It is required that you go back into the induction room, stand before the podium and receive the call again."[4] Realizing the futility of the situation, Ali returned to the induction room, stood in line once again, heard his name called, remained standing, heard his name called again—now for a fifth time—and still did not move. Finally, the lieutenant, realizing that the champion was not willing to be drafted, ended the ceremony and escorted Ali back through the building, downstairs, and ultimately outside, but not before notifying him that he would soon be contacted by the United States Attorney's Office.

Exiting the induction center, Ali faced a crowd of fans, a swarm of reporters who wanted to know whether the champion had taken the step, and

a single, elderly, white woman who managed to capture the eye of the heavy-weight champion as he was ushered to an awaiting taxicab. Ali recalls:

> "You headin' for jail. You headin' straight for jail." I turn and an old white woman is standing behind me, waving a miniature American flag. "You goin' straight to jail. You ain't no champ no more. You ain't never gonna be no champ no more. You get down on your knees and beg forgiveness from God!" she shouts in a raspy tone.[5]

The image of the elderly white woman waving her small flag and taunting Ali is reminiscent of the four women in Walker Evans's *Love or Leave America* photograph, who sit in a black automobile adorned with flapping American flags and a sign that reads "Love or Leave America," and pass a grouping of black families assembled to witness a parade in which the women themselves are participants. While there are certainly differences between the two—it is Ali who enters the car while the woman is left on the sidewalk; it is only one white woman and not four, and she directly hails Ali while the women in Evans's carload allow their sign to speak for them—the thematic similarity of the images lessens the impact of their differences. In the previous chapter, I contended that Evans's photograph showcases the captive status—the enforced stillness—of the backgrounded black bodies. Hemmed in not only by the street (and the processional) before them but also by a barbed wire fence behind them, the black spectators of the parade do not have the option to "leave." They are trapped. Similarly, the "old white woman" at the induction center reminds us of the fixed positioning of the black body. Revisiting the scene of the induction ceremony, it is clear that the drafted body—in this instance, the drafted black body—has no real opportunity to "leave." The body that takes a step forward becomes institutionalized within a branch of the armed services, renounces its civilian status, and moves closer to becoming a war casualty. The body that stands still finds itself caught within an endless cycle of hailings and through the cycle is repeatedly reminded of how difficult it is to occupy the space between the federal military and the federal prison. A slight movement—indeed, a single step—is a decisive act. The body that takes a step back faces another form of institutionalization. To paraphrase the woman, the body that steps back is headin' for jail, headin' straight for jail. It's goin' to jail. The repetition implies a certainty of the space/place in which the body will find itself. It will be in jail.

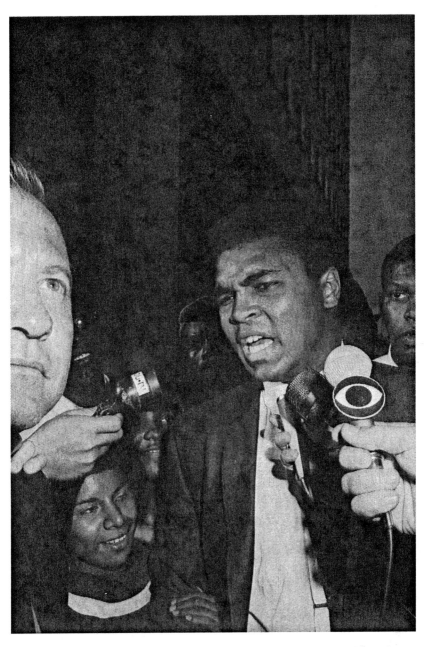

Cassius Clay leaving Federal Court, 27 June 1967, Bettmann/Corbis.

Both the induction ceremony and the woman's words, as remembered by Ali, prompt a further investigation into the stillness of the black body. They seem to suggest that Ali's body could operate only within—and, therefore, was trapped within—three spaces: the military, the boxing ring, and the prison cell. When Ali refused to enter the military by not taking the step at the induction ceremony, he not only turned his back away from one of the three spaces specially designated for the exhibition of the black body but also initiated a chain of events that would ultimately further reduce his spatial options. A few hours after Ali's enactment of stillness, the World Boxing Authority (WBA) stripped the prizefighter of his title, and the New York Boxing Commission took his boxing license. The World Boxing Commission (WBC) and the International Boxing Federation (IBF) would shortly follow their lead. Ali was no longer champion. In fact, he could no longer enter the ring in a sanctioned professional bout. Two months later, the former champion was convicted of refusing induction and given the maximum sentence: five years imprisonment and a ten-thousand-dollar fine. True to the woman's words, Ali found that he was "no champ no more" and was "goin' straight to jail."

In this chapter, I present the similar and repeating experiences of four black professional boxers: Tom Molineaux, Jack Johnson, Joe Louis, and Muhammad Ali. I share their biographies and, along the way, reveal how their lived realities were affected by both societal projections of the black body and their critical memories. Molineaux, a black captive, fought on the plantations of his "master," eventually won his freedom, and traveled to London, where he competed for the championship title. Johnson, the first black heavyweight boxing champion, endured and, at times, embraced the projection of racist stereotypes and caricatures throughout his championship tenure. Louis, determined to create an image that contrasted with Johnson's, crafted a public persona as a "Black White Hope." Ali, the most contemporary of the boxers profiled within this chapter, was acquainted with the stories of black captive boxers, Jack Johnson, and Joe Louis. Familiar with the tragic falls of the boxers who preceded him, he refused to behave like his predecessors. Whereas the others either agreed to allow their bodies (and celebrity) to be used by the U.S. government or fled governmental authorities, Ali held his ground. His performance of stillness refashioned the ways that he was seen within the space of a military induction center and within society at large.

Sporting the Black Body

It is not known when or, for that matter, how boxing as a spectator sport began. The most accepted theory is that boxing, which features combatants fighting before an assembly of spectators, evolved from the public staging of human sacrifices in honor of a god or in memory of a deceased relative. Whether the sport developed from the early stagings of gladiatorial combat in Roman-ruled Britannia in the third or fourth centuries or, as is popularly rumored, began with a bored aristocrat ordering his butler to fight a butcher in 1681 for his amusement, boxing became a popular and widespread pastime by the early 1700s.[6] It was formally taught within a variety of British academies beginning in 1719 and spawned a championship series less than a decade later. The lessons learned within British academies were brought back to the United States by the sons of wealthy colonizers and, later, Americans, who studied in England and then sought to re-create the sport within the United States, especially on southern plantations.

The exhibition of the black body, as a captive body, in the boxing ring within the United States began with boxing lessons on southern plantations.[7] As with all forms of instruction, boxing lessons require that the sport be demonstrated and then *repeatedly* demonstrated before the boxing pupil. The student, then, gets brought into the demonstration, is carefully monitored, and is coached to ensure that the lessons are learned. Considering that lessons on southern plantations during the era of captivity likely followed this basic formula, it is important to ask who demonstrated the sport, repeated it for the benefit of black captives, and coached them. While the logical answer is that the older captives taught the younger ones how to box, it fails to address the question of who taught the *first* captive on each plantation? Lacking options, the "instructors" likely would have been the sons of plantation owners who studied in England and brought the sport back with them.[8] With the "owners" as the "instructors" in the sport of boxing, the lessons themselves reflected the institutional system of race-based oppression that was captivity. Despite the momentary inversion when the white body as demonstrator performed (boxing) before black bodies as spectators and became the object of their look, the moment that the captive was brought into the demonstration to spar with his or her "owner" marked the return of the black body as an objectified body.

Although the sparring exercises may have presented the captives with

the opportunity to vent their aggressions against the white bodies who claimed to be their "master," the captives must have been aware of the reprisals that would come their way if they did hit the plantation owner even within the frame of sport. Not unwilling, but knowing better than to strike the "master," the captives became analogous to punching bags that were placed within the ring for the amusement (or exercise) of the white body. Continually beating their captives under the guise of instruction, the plantation owners repeatedly reaffirmed their racial dominance.[9] Like Thomas Sutpen in William Faulkner's *Absalom, Absalom,* owners staged the black body in order to demonstrate white superiority.[10] Through sparring, they "instructed" not only the captive body in the ring but also those outside of it, the witnesses to the ring event, to accept the black body's position as inferior and subordinate.

Once the lessons were learned, the boxing ring on southern plantations became the place in which plantation owners would pit their best fighters against one another. More lucrative than cockfights, these events attracted white spectators who often would wager on the outcome.[11] To the captives, the incentives for performing well within these fights were obvious. Beyond the threat of punishment or even death for a loss, there was the promise of better treatment (better food, better lodging) and even the possibility of winning one's own freedom. Despite the fact that the sport was staged within an enclosed area (the ring) that was surrounded by spectators, boxing often offered an escape from the conditions of captivity. It contained within itself the promise of freedom. "Masters" would promise their enslaved boxers a prize—sometimes manumission—if they were successful within the ring. For those who were never offered such rewards or never received them, the ring presented them with the chance to fully control their own body and exert mastery over another—activities that were not possible for a black captive outside of the sport of boxing. An example of the sport's liberating potential appears in the case of Tom Molineaux, a former black captive who became a professional fighter and a legitimate contender for the (British) heavyweight championship.

There are many rumors and few recorded facts about the life of Tom Molineaux. It is assumed that Molineaux was born in captivity on a southern plantation in South Carolina, Virginia, or Maryland in 1784. It is rumored that his father was a successful captive "boxer" and his mother a field cap-

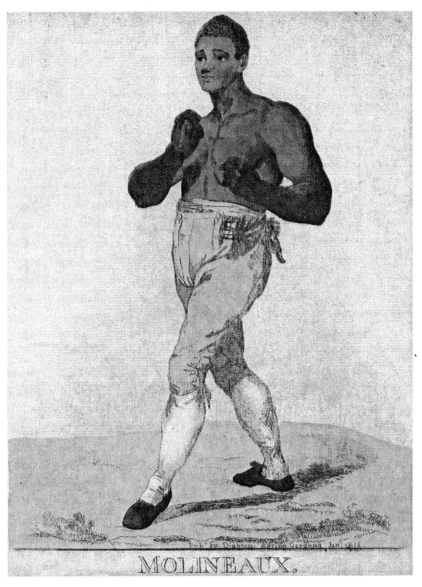

Molineaux (Tom Molineaux), by and published by Robert Dighton, hand-coloured etching, published January 1812. Courtesy of the National Portrait Gallery (London), NPG D13314.

tive.[12] Despite the questions that circulate around his parentage, it is widely accepted that Molineaux fought in boxing contests staged by his "owner" and eventually was awarded his freedom following a victory in the ring over a black captive from a nearby plantation.[13] In its brief biographical sketch of the boxer, the International Boxing Hall of Fame (IBHOF) notes:

> [Molineaux] began boxing other slaves while plantation owners wagered on the bouts. Finally after defeating a slave from a rival plantation, he was given his freedom and $500. He traveled to New York and then, in 1809, he left for England and began boxing.[14]

The IBHOF account gestures toward a commonly told story that Molineaux won so much money for his "master" that he was gifted his freedom as a reward. Although it remains unclear why the "master" would dispense with such a valuable, profit-generating captive, consistent references to the sum of money given to Molineaux, some $10,000 in contemporary dollars, suggests that the "master" had accumulated enough wealth to no longer require the services of Molineaux.

After two decisive wins in England, Molineaux was scheduled to fight Tom Cribb, the British heavyweight champion. The match, set for 10 December 1810, drew a large crowd because it was both a title fight and featured a black American against a white Englishman.[15] Although the fight was undoubtedly one of the more talked-about events of the year in England—as evidenced by its memorialization in lithographs, mass-marketed commodities (toy figures), and pub songs, there remains little in American cultural memory of the fight itself.[16] What is readily known is that Cribb successfully defended his title, Molineaux lost, and a rematch was scheduled for ten months later on 18 September 1811. Beyond that, things begin to get a little hazy. The IBHOF notes in the boxer's biography that in their first fight "Molineaux collapsed after 39 rounds," but Alex Brummer in a 1989 *Guardian* article claimed that Molineaux knocked out Cribb in an early round:

> Tom Molineaux, a former slave, became the first known victim of referee racism when he knocked out the British Champion Tom Cribb, in the 26th round on 10 December 1810, at Copthall Common in Susses (sic). In the interests preserving Caucasian superiority, the 30-second count was extended to two minutes to ensure Cribb's victory 16 rounds later.[17]

Although *Independent* columnist John Sutherland contends that "the chronicles I have looked at record that the Bristol batterer won it fair and square, both times," Cribb's actions after the fight suggest otherwise.[18] His agreement to a rematch shortly after his first bout with Molineaux implies that his initial fight with the former captive was at the very least competitive and offers the possible reading that doubts might have existed over the legitimacy of "The Champion of Champions" win. A rematch was required to repair and restore his image. For Molineaux, a rematch offered him another chance at victory, a purse significantly larger than a bout with a lesser-known boxer, and the opportunity to bolster his celebrity status. Following Cribb's decisive win in the second fight, the champion, without retiring or relinquishing his title, subsequently refused to fight another opponent for the next eleven years. He officially retired from boxing as heavyweight champion in 1822. While Cribb abandoned the ring, the former captive, setting a precedent that would be followed by a series of future black boxers including Jack Johnson and Joe Louis, stayed in the ring past his prime, continued to make an exhibit of his body for less and less money, and eventually faded into obscurity. By 1812, a single year after his rematch, Pierce Egan, a sportswriter, described Molineaux as "unknown, unnoticed, unprotected, and uninformed."[19] Six years later in Galway, Ireland, Molineaux was knocked out in a boxing match against a local blacksmith. Carried to a nearby military barracks by two black British soldiers to recover from his injuries, Molineaux died a few days later.

Exactly one century after the first Molineaux-Cribb match, a black body was again in the public spotlight as he entered a boxing ring and fought for the title in a heavyweight championship bout. It was the same play with one important difference: the black body was now the reigning heavyweight champion. The players were Jack Johnson, the current champion, and Jim Jeffries, the former (white) heavyweight champion who had retired undefeated in 1905 and through retiring initiated the chain of events that would lead to Johnson winning the championship from Canadian Tommy Burns in 1908. The Johnson-Jeffries match would become the biggest event in boxing and one of the most significant sporting events of all time. It was scheduled for 4 July 1910.

Performing the Exhibited Body

John (Jack) Arthur Johnson, like Tom Molineaux, was the son of a former captive who, it is rumored, was a bare-knuckle boxer on a Maryland planta-

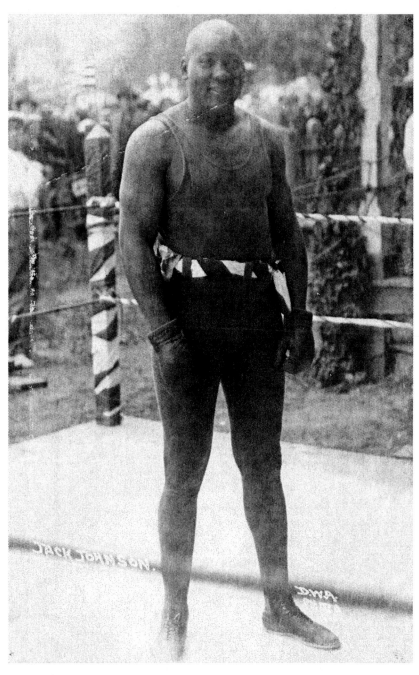

Jack Johnson, between 1910 and 1915. DWA photo, Library of Congress, LC-USZ6-1823.

tion.[20] Unlike Molineaux or even Johnson's father, Johnson, born in the years following the emancipation of black captives, was not reared within the space of a plantation in which his body would have been staged for the amusement and potential gain of a "master." Instead, he was raised "free" in Galveston, Texas. Despite these differences—in time, location, and "status," Johnson found himself continually replaying the experience of the black body in captivity. His body was repeatedly displayed as an object for amusement and even potential financial gain for others. What separates the champion from the contender is that Johnson, over the years, not only became increasingly aware of his own exhibited status but also actively sported his own body for financial gain. Through performance, a performance of himself as a body on display, the prizefighter asserted control over the presentation of his body.

Jack Johnson, according to biographer Geoffrey C. Ward, began boxing in the form of street fighting at the age of twelve at the behest of either his maternal grandmother, Grandma Gilmore, or his mother, Tiny Johnson. Quoting from an unpublished memoir written by the future heavyweight champion during his stay in Leavenworth State Prison (1920–21), Ward recounts a version of Johnson's often changing tale about how he was drawn into his first fight. In this account, the biographer asserts that Grandma Gilmore witnessed another child "strike" her grandson and promptly yelled the following to him: "Arthur, if you do not whip [that boy], I shall whip you."[21] Johnson, spurred to action, "sailed into [the boy] and whipped him." In other versions, Tiny Johnson, or Lucy, one of Johnson's sisters, is credited as being the motivational (and threatening) source.[22] Interestingly, his father rarely is identified as an influence on his career. Despite the varying accounts concerning the manner in which Johnson was introduced to fighting, there is a consensus on the fact that the champion's first extended encounter with the sport of boxing occurred in the form of street fighting at an early age in Galveston, Texas. While his brawls on the streets served, as Johnson biographer Randy Roberts notes, to "define him as a man," it also caught the attention of white men who were looking for cheap amusement and possibly a nearby attraction on which to gamble.[23] Eyeing Johnson and the other black youths with whom he fought, these white spectators staged "battles royal" in which Johnson and others were herded into a "ring" and encouraged to fight. The last child standing, able to fight, or willing to continue fighting was declared the winner. The "winner" usually received the pocket change from the spectators. The losers returned home bruised and empty-handed. Some-

times the spectators, in an effort to heighten the entertainment value of the boxing spectacle, would create new rules. Ralph Ellison, in *Invisible Man*, offers his reader an accurate portrayal of the scene of the battle royal and the nature of its shifting rules—blindfolding, in this instance—when he allows his fictional narrator to recall the experience of being caught within one of these fights:

> A glove smacked against my head. I pivoted, striking out as stiffly as someone went past, and felt the jar ripple along the length of my arm to my shoulder. Then it seemed as though all nine of the boys had turned upon me at once. Blows pounded me from all sides while I struck out as best as I could. So many blows landed upon me that I wondered whether if I were not the only blindfolded fighter in the ring. . . .
>
> Blindfolded, I could no longer control my motions. I had no dignity. I stumbled about like a baby or a drunken man. The smoke had become thicker and with each new blow it seemed to sear and further restrict my lungs. My saliva became like hot bitter glue. A glove connected with my head, filling my mouth with warm blood. It was everywhere. I could not tell if the moisture I felt upon my body was sweat or blood. A blow landed hard on the nape of my neck. I felt myself going over and my head hitting the floor. Streaks of blue light filled the black world behind the blindfold. I lay prone, pretending that I was knocked out, but felt myself seized by the hands and yanked to my feet. "Get going, black boy! Mix it up."[24]

The purpose of the battle royal was less to stage the athleticism of particular black youth and more to create a forum in which to first exhibit the black body and then to proceed to demean and debase it. It served to remind the bodies both inside and outside the ring that the black body was an object for amusement. The types of battles royal in which Johnson was staged as participant or encouraged to witness were not substantially different from the fictional encounter imagined by Ellison. According to Ward, who relies heavily upon Johnson's unsubstantiated hyperbolic statements to create a larger-than-life account of the prizefighter, the future champion also appeared blindfolded within the ring and, like Ellison's protagonist, faced the charge of the other black boys. Unlike the novelist's narrator, Johnson, according to Ward, "retreated to the corner and, with his back to the ropes, knocked out the first two with right hands to the jaw, then connected to the midsection of

the third, dropping him to his knees," eventually knocking out the fourth and final person in the ring.[25] Gerald Early, author of *The Culture of Bruising*, takes a more measured approach. He simply states, "The Black fighter Ellison particularly wants to suggest [in *Invisible Man*] is Jack Johnson."[26] When actual battles royal differed from Ellison's imagined scenario, they were often worse. Roberts, speaking of the battles royal staged in Galveston, offers:

> When the dignity of one-on-one battle was permitted, it usually involved some other twist to subtract from the fighter's self-respect. For example, as a preliminary to the Johnson-Joe Choynski [*sic*] fight in 1901 in Galveston, two one-legged "colored boys" fought each other. To the cheers of the all-white audience, they hopped around the ring as if fighting on pogo sticks. Other one-on-one contests saw fighters tied together by the arms or ankles, or forced to take turns fighting each other, or even to fight nude.[27]

Although Johnson, in his early twenties, was spared the humiliation of actually participating in the spectacle that occurred before his exhibition with Choyinski, his previous experiences performing in battles royal and staged fights combined with his possible witnessing of the preliminary "match" did, in fact, make him a participant within the spectacle. At the very least, Johnson, once in the ring, must have known that his body was being perceived in a similar manner as those "one-legged 'colored boys.'" His body was their futured body.[28]

While Choyinski's biographers remember the 25 February 1901 Johnson-Choyinski exhibition for the latter's victory by knockout—one of the few early career knockouts Johnson would suffer—Johnson scholars refer to it as the beginning of his career as a professional fighter. This is not because he received a large paycheck following the "exhibition" or he caught the eye of boxing managers who wanted to schedule additional fights for the up-and-coming fighter. In fact, neither happened. What did is that both Johnson and Choyinski, with Johnson still lying on the canvas, were arrested for violating Galveston's ordinance against prizefighting and were carried to the local jail.

Within the confines of Galveston's jail, the two boxers were well treated by both the officials at the jail and the inmates within it who were fans of their sport. As evidence of the popularity of boxing inside the jailhouse, the warden encouraged both fighters to spar for his officers', his prisoners', and his own amusement. Although Johnson biographers disagree on the fre-

quency with which these jail-based exhibitions were staged, there is consensus on the fact that they did take place throughout the twenty-four days during which the boxers were incarcerated before the charges against them were dismissed.[29] In the month that they were together, Choyinski essentially trained Johnson in the trade of professional boxing. Johnson's boxing career therefore "began" in late February 1901.[30] A year after his "exhibition" with Choyinski, Johnson was established as an up-and-coming professional boxer in California, one of the few states where prizefighting was legal, and had landed a high-profile match with Jack Jeffries, the brother of the reigning heavyweight champion and soon-to-be "Great White Hope" Jim Jeffries.[31] The fight was scheduled for 16 May 1902. At the time, Johnson was still an unknown fighter and Jeffries was well recognized as a boxer with limited abilities. Despite the expected noncompetitiveness of the bout, the match sold well among audiences who attended less for the boxers in the ring than for the boxer who would be outside of it watching the event, namely heavyweight champion Jim Jeffries. While Jim Jeffries was the intended object of the spectatorial eye, Johnson upstaged the champion upon entering the ring. The *Los Angeles Daily Times'* postfight coverage underscores the role that Johnson as spectacle played in the match and its surprising outcome:

> Mistah Johnsing made his appearance last night in a most amazing pair of pink pajamas.
>
> The crowd, which filled every nook and cranny of the Pavilion gasped with admiration and astonishment when the pinkies came up through the ropes. It wasn't an ordinary, inoffensive kind of pink. It was one of those screaming, caterwauling, belligerent pinks.
>
> Mistah Johnsing was the only person in the hall whose nerves were not affected. Any fellow who could gaze-one rapt, fascinated glance at those pinkies and not go down to defeat, paralyzed must be a better fighter than Brother Jack. These were undoubtedly the chief cause of his defeat.
>
> Mistah Johnsing himself was seemingly unconscious of the riot that encased his legs.[32]

The degree to which Johnson proved an object of fascination for those in attendance can be seen in the preceding commentary. Ample attention is di-

rected toward the boxer's appearance and scant mention is made of his decisive victory. Johnson knocked out Jeffries in the fifth round.

Beyond the fact that Johnson defeated the younger brother of the heavyweight champion, what really matters is the *manner* in which he did it. Unlike earlier moments in his career in which Johnson found himself staged for others—in battles royal or in the various exhibitions with Choyinski—Johnson, in this moment, alerts his audience outside the ring and even his opponent within it that what they are witnessing is a performance. They are watching not the black body exhibited for others but a black body that has chosen to perform itself as an exhibit for itself. In this turn of phrase, the body gains agency by replaying the conventions of the boxing spectacle differently. Entering the ring, Johnson guaranteed that the ensuing fight would be witnessed on his terms.[33] If he were to lose, then his parody of the exhibited body would lessen the likelihood that spectators would contend that the fight reflected the superiority of the white body over the black body.[34] If he were to win (which he did), then the victory would add insult to injury. The success of the Johnson-Jeffries fight set a precedent that would be followed by the boxer in successive bouts. Although he no longer would don pink pajamas (but would wear colorful robes), he would often taunt his opponents in the ring, talk with the spectators in attendance at the event throughout the fight, and make inflammatory comments preceding and following his matches. Each activity served to remind all involved with the ring event— from the spectators, to the fighters, to the referees—that boxing was a performance and that Johnson was its star.

Contrary to what many may expect, the prizefighter's quick victory did not spur talk of a match with the Jeffries viewing from the audience, for two reasons. First of all, it was popularly known that Jack Jeffries lacked the talent in the ring that his brother possessed. A Johnson victory against Jack was not tantamount to a win over Jim. Second, it was well known that Jim Jeffries drew the "color line." Continuing the tradition begun by heavyweight champion John Sullivan in 1892, Jeffries agreed to fight any man, except a black man.[35] While some may have imagined the pairing, they had to have known that it was highly unlikely that the two would ever meet within a sanctioned, professional match.[36] When Jim Jeffries, unable to find worthy (white) opposition, retired from boxing, still undefeated, in 1905, the idea of a Johnson-Jeffries match seemed a near impossibility.

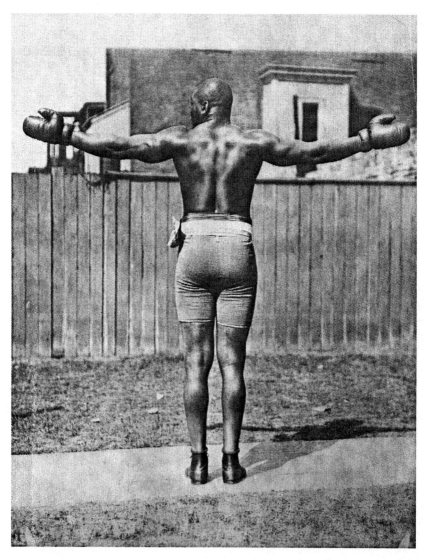

Heavyweight boxing champion Jack Johnson posing outdoors, ca. 1915. Underwood & Underwood / Corbis.

In the years between the Jack Jeffries match and Jim Jeffries' retirement, Johnson continued to both fight and win. He fought the relatively few white boxers of caliber who were willing to set aside the color line and all of the best black boxers of the period, including Joe Jeannette and Sam Langford. When Jeffries retired and Moses Hart was named the new heavyweight champion, Johnson sought a title match against him. Hart refused. As it turned out, Hart's refusal proved less of a setback than Johnson initially thought, for the newly crowned heavyweight champion lost in his first title defense against Canadian Tommy Burns. By 1906, Johnson had a singular goal: to fight Burns and win the heavyweight championship. In order to achieve this aim, the prizefighter had to stalk the Canadian for nearly two years. Wherever Burns went, Johnson followed. In those years, Johnson traveled throughout North America and spent extended periods of time in both England and Australia. To make money, the boxer would stage boxing exhibitions and would appear onstage within a variety of vaudeville acts and plays, including *Othello*. Finally, Burns, having fought the majority of the white contenders and in need of money, agreed to fight Johnson in Australia on 26 December 1908. Despite receiving little attention in the United States, the Johnson-Burns bout did produce at least one item that was worthy of the headlines: the heavyweight champion was now a black man.

Independence Day

The Johnson-Jeffries fight has been investigated in numerous academic and popular books and articles from a variety of angles. Collectively, these texts cover in detail the original plan to stage the fight in California, the refusal by Governor J. N. Gillett to allow the fight in his state, a refusal motivated by a vigorous letter-writing campaign by religious organizations that cited the (racial) consequences of a Johnson victory, the eleventh-hour decision by Nevada governor Denver S. Dickerson to present the bout in Reno, the prefight publicity, the blow-by-blow events of the actual fight, and, of course, the chaos that ensued following Johnson's decisive victory. Rather than trace the exhaustive history of a fight that remains intact in the American cultural memory and accessible within a variety of texts, plays, films, and digital sources, I propose to look at one largely unexplored aspect of the fight, namely the imagined meaning of the two bodies involved in the ring.

As can be expected, "Jack Johnson" was received differently by black and

white audiences. To black men and women, "Johnson" represented the race. Able to look through the boxer's flashy appearance and over his penchant for white women, the black bodies who watched and applauded each of the champion's victories saw themselves in his visage. Like the unnamed narrator in *Invisible Man* who does not have a name because "none seemed to fit, and yet it was as though [he] was a part of all of them, had become submerged within them and lost," "Jack Johnson" represented more than Jack Johnson.[37] He was the black community (at least when he stood in the ring).[38] Evidence of the black community's support for the prizefighter appears in various black newspapers—such as the *Chicago Defender*—which chronicled, with great frequency and detail, the near-daily events in the boxer's life throughout his championship reign. When Johnson signed a contract to appear in a new Broadway show, the black press noted it. When he traveled to a new city, the press published his itinerary. If his plans called for a stop in Chicago, or any other large city with a significant black population, then the press would tell its readers where and when to welcome the champion. Consistently, thousands of black spectators would attend these welcome and send-off events. On the eve of the Johnson-Jeffries fight on Independence Day of 1910, the *Boston Globe* reported that a congregation of a black church in Hutchinson, Kansas, had planned for the following morning (during the fight) to "pray and sing religious hymns until Johnson wins the battle 'if it takes all night.'"[39] The fact that a Massachusetts-based newspaper reported the activities of a congregation in Kansas who were focused on the outcome of a fight in Nevada gestures to the level of national attention directed toward the fight by the black community and their vicarious involvement in the fight itself. The Kansas church would not be the only black social organization holding a vigil for the champion. Such events were to occur all over the United States.

The extent of the public interest, both within and outside the black community, in the fight can be seen in another *Boston Globe* article that appeared on 2 July 1910. The article succeeds not only in spotlighting the intensity of the national focus on the fight but also in offering a glimpse into the manner in which the performance in Reno would be replayed before differently placed bodies across the United States:

> In San Francisco one paper has taken a huge arena where the public can gather on July 4 and hear the news of the fight as it comes sizzling over the

wires from the ringside. Nothing less than a calamity like that which struck the city four years ago can keep the people out. At other places actual contestants will reproduce the blows and counters that are occurring in the mountain fastness of Nevada.

In every city of any consequence bulletins will be flashed over the heads of yelling multitudes, the returns will come by special wire to every club of prominence in the United States and Canada, not to speak the countless resorts of different character.

Where matinees are held the news will be read between acts for the delectations of the theatre patrons, men and women alike. Streets from Bangor to Seattle, from Edmonton to Key West, will echo to the clank of presses and the cries of newsboys, and yet prizefighting is tabooed.[40]

The fight would be everywhere—not just in Reno. Replayed before differently placed audiences with varying investments in the fight (and its outcome) in near real-time, spectators, unable to travel to Nevada—at a time before the advent of live television—could say that they were there at the fight and had seen it "live." In light of the degree of national attention directed toward the match, it follows that the black communities who saw "Jack Johnson" as representative of their bodies would place an added emphasis on the bout. The match was an event. It had meaning.

Equal to the esteem given Jack Johnson by blacks was the loathing directed toward him by many whites. To them, "Jack Johnson" represented the most detestable traits of the black race. He was arrogant and flashy, and his desire for white women established him as a threat. The popular animosity toward the heavyweight champion can be seen in his descriptions by the press. Even the most liberal northern newspapers reminded their readers that Johnson was "the big black" or the son of "a slave mammy."[41] Clearly, the most threatening aspect of Jack Johnson to those who feared him was his liaisons with white women. The champion himself derived pleasure from this image and even worked to promote it. Randy Roberts writes:

Consciously, Johnson exploited the myths. . . . In public he wore tight-fitting silk shirts and liked his companion of the hour to run her hands over his chest and back. Perhaps the most blatant exploitation of the myth was a practice he sometimes employed while training of wrapping his penis in gauze bandages, enhancing its size for all to see.[42]

It is this public image—Johnson as the hypervisible and hypersexual black "buck"—that would lead to his downfall. In the year following the champion's victory, federal agents would begin to mount a case against Johnson using the rarely invoked and vaguely worded Mann Act, a law designed to prevent the importation of foreign prostitutes by organized crime factions. The law made it illegal for a man to transport a woman who was not his wife across state lines for the expressed purpose of sexual intercourse. With a jilted lover as its prime witness, the federal government mounted its case against Johnson. He was convicted in May 1913, sentenced to a year and a day in prison, and fled the country, only to return five years later penniless and willing to serve his sentence.

Compared to Johnson, "Jim Jeffries" was a veritable saint in the eyes of dominating culture. Since disappearing from the public spotlight with an undefeated record, the former champion had remained perfect to them. In fact, Jeffries was almost mythic. Like Paul Bunyan, he was viewed as a midwestern man chiseled by his environment and not softened by the city. James J. Corbett, the former heavyweight champion and trainer to Jeffries, noted on the eve of the Johnson-Jeffries fight, "Jeff is the embodiment of all that is powerful and brutish in the white man. He always lived to nature, and fortunately for him has but little experience with big cities, and the taming effects of big cities. He is like a wild horse that has never been bridled."[43] Eight years earlier, the *Los Angeles Daily Times* similarly used an animal metaphor to describe Jeffries. Contrasting the reigning champion with Jack Johnson, who, at the time, was fighting "Brother Jack," the *Times* reported, "There was a hush heard presently. Jim, 'de champ,' was coming. Mistah Johnsing, over in his corner, opened his eyes and looked at the great hulk of a man in a gray undershirt the way a little mangy dog with a lame leg stops in the road and looks at a St. Bernard."[44] Despite the passage of time, the myth had remained intact. Entering the ring on 4 July 1910, Jeffries was heavily favored to win.

Throughout the match, the spectators in attendance at the event in Reno and those who witnessed it via its various replayings around the country watched in near silence as their mythic hero was being cut down to size. W. W. Naughton, who chronicled the fight for the *Washington Post,* described the scene in the following way:

> The finish differed from all of the finishes of championship fights I have seen.
> There was one yelp when Jeffries was tumbled the first time, just as there is

when the end of any ring event is in sight. Then those who yelled seemed to suddenly remember that a negro was beating down a white man. In the other knockdowns Jeffries fell in silence, and when [referee Sam] Berger interfered and the decision went to Johnson there was no acclaim, such as is generally in evidence when a fighter has worked his way to a victory.[45]

John S. Sullivan, the former heavyweight champion and an outspoken Jeffries supporter before the fight, noted in his syndicated column:

> All of Jeffries's much-vaunted condition and prodigious preparations that he went through availed him nothing. He wasn't in it from the first bell tap to the last, and he fell bleeding, bruised, and weakened in the twenty-seventh second of the third minute of the fifteenth round, no sorrier sight has ever gone to make pugilistic history. He was practically knocked out twice this round.[46]

Adding to the "sorry sight" of the fallen champion was the fact that the fight had to be stopped to prevent further harm to both Jeffries the man and "Jeffries" the legend. The *New York Daily Tribune* reports that Jim Corbett, "who stood in Jeffries's corner during the fight telling Johnson what a fool he was and how he was in for the beating of his life," ran into the ring as Johnson stood over Jeffries. According to the newspaper, Corbett was "crying, Oh, don't, Jack; don't hit him."[47] In the other journalistic reviews, there is a general consensus that the spectators at the event pleaded for the referee to intervene and prevent Jeffries from being counted out. Indeed, Berger did stop the fight before the count of ten and Johnson was awarded the knockout.

Despite being saved the humiliation of being counted out, Jim Jeffries' status as an icon of American heroism was over. Two days after the match, the *New York Daily Tribune* described the former champion in the following way: "In his every stumbling movement, in his bowed head, in the depths of his sombre eyes, in the nervous rubbing of his swollen face and blackened eyes, in his almost timid shrinking back from the public, Jeffries showed that his defeat had dealt him a terrible blow."[48] The extent of Jeffries' fall in the eyes of his supporters can be seen in the new words used to characterize him following the loss. He was now timid, somber, nervous, and stumbling. Furthermore, the battered status of Jeffries' body served not only to destroy his image following the match but also motivated some to reevaluate the myth of Jeffries as it existed before the fight. For example, Rex Beach, in his post-

match assessment, noted, "I doubt that even in his best days, Jeffries could have won from the African."[49]

By far, the most damage to Jeffries' reputation came from the person who similarly bruised his body. While Jeffries was extraordinarily humble in his defeat, noting, "I shot at the mark, but missed it. There is nothing to do but to congratulate the winner," Johnson was a model of arrogance.[50] Immediately following the match, Johnson, within his changing room and surrounded by a swarm of reporters and trainers, was quoted as having said the following:

> I could have fought for two hours longer. It was easy. . . . I'm going to give one of my gloves to Jeffries and the other to Corbett. I guess Jeff won't be so grouchy now. Somebody wire my mother. I wish it was longer. I was having lots of fun. Not one blow hurt me. He can't hit. He won't forget two punches I landed on him. He was only half the trouble Burns was.[51]

In Johnson's other comments, the boxer speaks from a perspective that suggests an awareness of media characterizations of the champion as the "son of a slave mammy." In a published letter to the editor written (and printed) before his bout with Jeffries, Johnson wrote:

> When I go into the ring to fight Mr. Jeffries I will do so with full confidence that I am able to defeat him at the game of give and take. I honestly believe that in pugilism I am Jeffries' master, and it is my purpose to demonstrate this in the most decisive way possible.[52]

Indeed, Johnson both mastered and was the master of "Mr. Jeffries." In an inversion of the Faulkner scene, the black body stood over the "just fallen" white body and through this posturing told the world that the white body could no longer lay hold to claims of dominance and supremacy. The captive's son had become the "master's" master.

Johnson, following the fight, intensified his race-themed rhetoric by embracing his hypersexual reputation and portraying Jeffries as the object of his sexual desire. At a train-stop rally in Ogden, Utah, the champion declared, "Well, people, I turned the trick, and I'm going back to Chicago to my old mammy. I went out there determined to turn the trick and I had no trouble in doing it."[53] A "trick" is a sexual act performed by a prostitute, and John-

son's figuring of Jeffries as a john who gets "turned" by him further chips away at the former champion's iconic status.[54] He becomes the victim of a sexual assault. The assault is worsened, within the popular imagination, by the fact that it was Johnson, a black body, who was the aggressor. While not responding to this particular statement, Jeffries' postfight comments do express a heightened embarrassment over the fact that his assailant was a black man. He states, "I don't regret the fact of my defeat so much as I do that it was a Negro who beat me. . . . I would have rather been beaten three times over by a man of my own race than to have been the means of placing a Negro in this position."[55] Undoubtedly, "position" assumes a second meaning when read relative to Johnson's comments.

Return of the Rope

On the same day that Jack Johnson entered the ring to fight Jim Jeffries and exposed the myth of white superiority, a series of white-on-black race riots erupted across the United States. The *New York Times* offers an example of one such riot in Clarksburg, West Virginia: "Angered at the demonstration of Negroes celebrating the Reno victory, a posse of 1,000 white men organized here tonight soon after the announcement of the news and drove all the Negroes off the streets. One was being led with a rope around his neck, when the police interfered."[56] I am intrigued by this incident, for it represents a reversal of the events that occurred earlier that day. Despite an earlier victory, the black body, once outside the ring, was brought back into the "ring" and again staged for the amusement of a white audience. The act of lynching created a new spectacle that served to neutralize the exploits of the black body between ropes by featuring a body hanging from one. The return of the rope marked the beginning of a second performance, a replay of the first but with a different ending.

Jack Johnson, too, would eventually find himself caught within the "ring" replayed. Returning from his self-imposed exile and willing to serve his prison sentence for violating the Mann Act, the heavyweight fighter was taken to Leavenworth State Prison and to the office of its "ex-officio warden" and superintendent, Denver S. Dickerson. Dickerson, the former Nevada governor who had played an instrumental role in staging the Johnson-Jeffries bout in Reno, offered Johnson two options. On the one hand, the boxer could appear in publicly presented and filmed prison-based exhibitions

against fellow prisoners and professional fighters, the latter traveling into the prison in order to fight the former champion. If Johnson elected this option, then he would receive better treatment, including a larger cell, an easier work assignment, and larger food rations. On the other hand, the prizefighter could reject the first option.[57] Refusal meant a shared cell, longer and harsher working conditions, limited food rations, and continual harassment from the prison officials. Johnson agreed to return to the ring.

With each "exhibition," the prizefighter lessened the impact of his prior boxing performances, particularly his successful encounters with both Jeffries (Jack and Jim). Regardless of the manner in which the former champion performed or presented himself within the ring, it was clear to all who attended the fight or witnessed it via its various (primarily film) replayings that the body within the ring was a convicted body, a controlled body. The frame of Leavenworth had neutralized the power of Johnson's performance and had given his body a newly captured status: incarcerated, confined, displayed, and exhibited. Standing in the ring, the former champion replayed the experience of Tom Molineaux, Molineaux's father, and possibly Johnson's own father—all of whom fought on plantations. He also re-created his own prior performances of appearing in battles royal as a child, witnessing them as an up-and-coming fighter, and being staged in numerous jail-based "exhibitions" against Choyinski.

Following his prison stay, Johnson discovered that he could regain neither the heavyweight championship title nor control over the presentation of his own body. With note to the former, two things were against him. The first was that Johnson was past his prime in boxing. The few remaining championship-caliber years he had left were squandered in his five-year exile and one-year prison stay. The second, and more significant factor, was that the reigning (white) heavyweight champion, Jack Dempsey, ironically, respected the "color line" that Johnson himself redrew as champion.[58] With the pinnacle of the profession kept permanently out of his reach, the former champion fought in numerous fights and repeatedly rented his body out as an exhibit for decreasing amounts. To earn money, Johnson made appearances at the 1933 Chicago World's Fair. Randy Roberts writes:

> He boxed exhibitions with children. For a dollar your son could flail away at the once great and proud champion. . . . For a dollar Johnson had agreed to become a freak. For a dollar he was willing to push aside his challenging,

threatening past and become the black man whites wanted to see. The only refuge for the man who recants is the freak show.[59]

While Roberts's analysis is a bit harsh, especially considering the nationwide economic depression occurring at the time and the former champion's personal debts resulting from his exile, he is correct in his assessment that Johnson spent his final years as an exhibit for hire. Despite the infrequent moments when Johnson's nobility seemed restored—for example, he campaigned for Frederick Delano Roosevelt in 1935 and, two years later, offered to train heavyweight champion Jim Braddock, who was slated to fight, and would lose to, Joe Louis (Braddock declined the offer)—the down-and-out fighter worked a series of jobs that were united only by the fact that they similarly staged his body for the amusement of white audiences. Johnson continued to box until he was sixty-eight years old.[60] "In the closing years of his life," Finis Farr notes, "the steadiest employment Johnson had was lecturing in Hubert's Museum, the noted collection of educated fleas, fortune-telling machines, and sideshows . . . in New York."[61] Johnson's "lecturing" was a form of exhibiting himself as a freak or oddity for the entertainment of others. Similar to the 1933 World's Fair, Jack Johnson showcased "Jack Johnson" for a price.[62] The decline of Johnson, like Saartjie Baartman (the "Hottentot Venus") and the thousands of lesser-known figures who appeared within the freak show circuit, offers a glimpse into the similar experiences engendered by participation in the boxing ring and the freak show, two media linked by the spectacular display of the black body.

After Jack Johnson lost his championship title in 1915 to Jess Willard, a black boxer would not be given a chance to compete for the heavyweight belt until 1937, twenty-two years later. White boxers, neither wanting to lose to a black fighter nor to create another "Jack Johnson," simply redrew the color line by refusing to fight a black contender. Between 1915 and 1937, there were a dozen title fights and seven heavyweight champions: Jess Willard (1915–19), Gene Tunney (1926–28), Max Schmeling (1930–32), Jack Sharkey (1932–33), Primo Carnera (1933–34), Max Baer (1934–35), and James J. Braddock (1935–37). When the opportunity did arise for a black boxer to vie for the championship title, it was neither an accident nor an oversight. It occurred thanks to a combination of a marketing campaign to promote the image of the contender as the anti–Jack Johnson, elevated American nationalism and patriotism in the face of the growing threat that

was German fascism, and the unparalleled abilities of the contender himself.

Joe Louis, the son of an Alabama sharecropper, the great-great-grandson of a former captive, and the great-great-grandson of that captive's white "master," moved from Lexington, Alabama, to Detroit in 1916 at the age of twelve.[63] In Detroit, Louis frequented a local gymnasium where he learned how to box and eventually launched his amateur fighting career. A successful amateur, Louis attracted the attention of John Roxborough, an African American lawyer who agreed to manage the future heavyweight. Roxborough knew that Jack Johnson's legacy threatened to derail the careers of his most promising black fighters. In an effort to give those under his management a better chance at the title, Roxborough carefully crafted their public image. He would not allow his fighters to be photographed with white women, to be seen entering a nightclub without a black female companion, to gloat over the fallen body of an opponent (something that Johnson did in many of his fights), to "fix" a fight, or to prolong a fight for the sole purpose of humiliating the opponent (another Johnson tactic). Roxborough, intent on informing the general public of his code of ethics, encouraged reporters affiliated with regional newspapers to publish his "rules."[64] Several did. "Roxborough's rules" became an unofficial contract that prescribed the actions of his fighters, including his most successful boxer, Joe Louis.

Joe Louis's rise to the status of contender cannot be attributed solely to the maintenance of his public image. He was a tremendously talented fighter. Between July 1934 and June 1936, the first two years of his professional boxing career, the future champion won all twenty-seven of his fights, with twenty-two of them being by knockout. In contrast to most emerging fighters, who seek to build an impressive (win) record by fighting mediocre or declining opponents, Louis primarily fought contenders and former champions—and he fought them often. Among those he defeated were former champions Primo Carnera and Max Baer, whom he fought within three months of each other—on 25 June 1935 and 24 September 1935 respectively. By the eve of his subsequent fight with then number one contender and former heavyweight champion Max Schmeling, Louis had overwhelmed the boxing world with the speed of his ascent up the heavyweight rankings. Despite being black and not even the highest ranking contender, he had become the most prominent celebrity in the sport in the United States. An example of Louis's status within the boxing world can be seen in an article circulated by the Associated Press on 26 March 1935, *before* he had fought

either Carnera or Baer. It contends that "Louis has put boxing back on its feet."[65] Other contemporary articles on the boxer made frequent mention of his consecutive victories (often by knockout) and observed that he "has burned up the heavyweight division."[66] On the morning of his 19 June 1936 match with Schmeling, Louis was the ten-to-one favorite. He would lose (but would win the rematch). A year after his bout with the German, he would fight heavyweight champion Jim Braddock for the title. Louis, again, was favored to win, and he did.

When Louis bested Braddock on 22 June 1937 to become the heavyweight champion, there was not widespread protest or panic. Whereas Johnson's victory resulted in a series of riots and lynchings throughout the nation, such incidents did not occur following Louis's win. There are several reasons why a backlash did not occur. Above all, it was expected that Louis would win. Unlike the Johnson-Jeffries match, in which oddsmakers, blinded by the myth of Jeffries, favored the former champion to defeat the current one and were shocked by the outcome, the Braddock-Louis event was more transparent and predictable. It was commonly known that Braddock was a champion on the decline. A talented and aging fighter who suffered from arthritis in both hands and had not fought a title defense in nearly two years since winning the championship, he seemed an unlikely victor over the best of the younger heavyweights. When Braddock entered the ring to defend his championship title, there was not any expectation that he would leave it with his title intact. The fight was a coronation. It was, from start to finish, a ritual to mark the ascendancy of Louis.

In addition to the fact that everyone was prepared for the fall of Braddock, John Roxborough had cultivated the "Joe Louis" persona in order to prepare boxing audiences for the rise of another, the second, black heavyweight champion. In the years immediately following the Great Depression, Louis existed as a working-class hero—who, despite being a member of the underclass and relatively uneducated, persevered, climbed to the top of the rankings, and exemplified, to all, the benefits of a good work ethic. Two decades before the Supreme Court ruled in *Brown v. Board of Education* and, effectively, ended legalized segregation, Louis embodied the promise not only of Alain Locke's New Negro but also the integrationist future of the black body. Both envisioned a muted *blackness* in which the stereotypical excesses that were best exemplified by Johnson—gold teeth, white women, lawbreaking, and so on—were rewritten into a quieter and, perhaps, lighter

blackness. In the opening moments of his championship reign, Louis maintained his anti–Jack Johnson performance. On the night of his victory over Braddock, rather than breaking out of character in this moment of exultation, Louis kept to his manager's script. Unlike Johnson, who celebrated his victory by mocking Jeffries, Louis spoke briefly about his achievement and proceeded to praise Braddock. A *New York Times* reporter, summarizing the new champion's words and mannerisms following the victory, wrote, "Louis took his triumph with customary stoicism."[67]

Finally, the lack of widespread concern over the possibility and eventuality of Louis being the heavyweight champion may have rooted itself in the perception that it was the lesser of two evils. Braddock was originally slated to fight Max Schmeling, the number one contender for the title. Schmeling, a German fighter, climbed to the top of the rankings by decisively beating every boxer of promise, including Louis. He was next in line for the title—or, at least, for the opportunity to compete for the title. Scheduled to fight the German, Braddock broke his contract and opted for a match against Louis. Why did he do this? On the one hand, it seems like Louis would be a slightly easier opponent for Braddock than Schmeling (since Schmeling beat Louis). On the other hand, it could be asserted that Braddock sensed that he might lose his title defense and preferred that the heavyweight championship be held by an American—even if that American was black—over a German. In *The Greatest Fight of Our Generation*, Lewis Erenberg acknowledges both as factors but identifies a third, more compelling reason: money. Erenberg writes, "Despite his contract to fight Schmeling, Braddock and his managers had their eye on the biggest payday they could find."[68]

It is interesting and, quite frankly, surprising that, less than a generation after the Johnson-Jeffries match, race was not the defining issue of the Braddock-Louis fight.[69] In fact, it is (generally) not mentioned in the press coverage of the ring event. Although Louis's various monikers—the "Brown Bomber," "Tan Tornado," and "Sepia Slugger," among others—drew prominent attention to the racialized status of the contender and, therefore, promoted a greater level of racial awareness than any of the title fights in the past twenty years, there was not a consistently expressed concern or anxiety within newspapers over the prospect of a black heavyweight champion. While several editorials, especially in southern newspapers, used racist language and characterizations in their portrayal of Louis, the volume of their critiques was much lower than in previous years. It is not clear why this was

the case. There are a number of possible reasons. A plausible one is that box-
ing, as a sport, had lost its popularity in the United States through the steady
succession of champions who seemed less grand than the ones who preceded
them. For example, Braddock, despite being heavyweight champion, had
lost fifteen matches in the five years before winning the championship from
Max Baer in 1935. It is conceivable that the aftermath of the Great War and,
more immediately, the Great Depression had given the general population
other things to worry over than the race of the champion of an increasingly
irrelevant sport. It is possible that the northern migration of blacks into in-
dustrial cities had established vibrant and segregated cultural communities
that did not threaten the established social order and, therefore, lessened
concern over a black champion. It could even be argued that Louis, outside
of the black community, wasn't deemed "black" enough to promote wide-
spread anxiety. Although a lot can happen in a generation (and a lot did hap-
pen between 1910 and 1937), it is important to note that American society
did not resolve its racial issues within this span of years, as evidenced by the
continued popularity of lynching across the United States. Three months be-
fore Louis met Braddock for the championship, *Time* magazine chronicled
the manner in which Bootjack McDaniels, a twenty-six-year-old black man
who had been accused of murdering a (presumably white) grocer in Duck
Hill, Mississippi, was treated by a mob shortly after proclaiming his inno-
cence in a courthouse.

> Bootjack McDaniels, a lanky Negro with powerful shoulders, was asked to
> confess first. He gibbered that he was innocent. A mobster stepped forward
> with a plumber's blow torch, lighted it. Another ripped McDaniels's shirt off.
> Again he refused to confess. Then the blue-white flame of the torch stabbed
> into his black chest. He screamed with agony. The torch was withdrawn. He
> reiterated his innocence. Again the torch was turned on him and the smell of
> burned flesh floated through the woods. Again he screamed, and when it was
> withdrawn this time he was ready to confess. . . . When his confession was de-
> livered in sufficient detail, the lynchers fell back and a volley of bullets
> crashed into Bootjack McDaniels, 1937's lynching victim No. 2.[70]

While it is true, as Erenberg notes, that "little racial animosity in the part of
whites was expressed toward Louis and his breaking the color line," it is con-
ceivable that "racial animosity" could have been redirected toward other,

more proximate black bodies.[71] Did Bootjack McDaniels exist not only as a "murderer" but also as "Joe Louis" or "Jack Johnson" in the eyes of individuated mob members?

Interestingly, race emerged as the primary issue within coverage of Louis's first match with Schmeling. This is not to say that there was a mass movement of white Americans who objected to the occurrence of the fight, as happened in Johnson-Jeffries. This movement did not occur. In the previews of the fight, which did not get nearly as much media attention as Johnson-Jeffries, Braddock-Louis, or Louis-Schmeling II (rematch) because it was not a championship match, the issue of Louis's blackness does not appear to have been the most significant factor to American journalists. When race does get mentioned within the American press, it surfaces in the context of critiquing and, indeed, ridiculing the German government's objection to the fight over the fear that a black man might beat a white man in a public forum and before a world audience. Despite the fact that the rhetoric used by the Germans echoed that of American politicians and religious figures during Johnson's championship years, the U.S. press relished spotlighting these statements as overtly racist. In a 8 April 1936 article, the *New York Times* chronicles the German position in the following manner:

> The National Socialist sport authorities are boycotting plans for a German excursion to the Max Schmeling–Joe Louis fight in the United States in June. . . . There are two explanations for the decision by the same Nazi functionaries who are propagandizing so enthusiastically for international sport in the case of the Olympics, to take the rather drastic step of boycotting the Schmeling-Louis fight. The first is race prejudice. The Nazi authorities feel that Schmeling as an "Aryan" and a representative of the Third Reich should not be fighting a Negro. . . . The second explanation is the Nazi prejudice against professional sport resulting from the theory that sport is essentially a political matter—a theory that reappears in every leading article in the Reich Sport Journal, even when it is devoted to the coming Olympics.[72]

The German boycott can best be understood when we recall that the match was set to take place two months before the 1936 Olympics, which were to be held in Berlin. German chancellor Adolf Hitler viewed the Olympics as the perfect venue to showcase the (physical and intellectual) superiority of the German state, as represented by the Aryan body, over all other nations

and bodies, especially the black body. In this light, the match between the German hero and the black American carried a greater racial/political meaning to the parties involved because it not only preceded the summer games but also condensed the arguments of racial pride and nationalism into a singular body rather than diffusing them among multiple bodies. It was an all-or-nothing gamble. If Schmeling were to lose, then the (German) national agenda of Aryan superiority would also be lost or, at least, compromised. The myth of Aryan superiority would be revised in the same manner that the myth of Jim Jeffries had been rewritten following his match with Jack Johnson. Fortunately (for the German fascist agenda), Schmeling won. He was toasted throughout Germany and declared a national hero. Jesse Owens, winner of four gold medals at the 1936 Olympics, found inspiration in Louis's defeat and later noted that "inwardly many of us were trying to atone for Joe's loss."[73]

Throughout his twelve-year reign and twenty-seven title defenses as heavyweight champion, the longest tenure and the most title matches in the history of boxing, Louis maintained his dutiful and respectful public image. He not only lent his celebrity status to support the U.S. military in World War II but also joined the armed services as a physical education instructor. In 1949, Louis, still champion, retired from boxing. He was the second American fighter—Gene Tunney was the first—to retire undefeated. Louis's decision was both mourned and praised. Rather than wanting to see the champion lose the title to another boxer, there was a general sentiment expressed in newspaper columns that the fighter should retire because he was too noble to be humbled in the ring. Arthur Daley, in an editorial, applauded the fighter for his decision to retire as champion. He wrote:

> The Louis career comes to an end with the champion still on his feet. If he had continued in the ring, his finish inevitably had to be different. The end would have come with the Dark Destroyer groveling on the canvas and staring at the lights with unseeing eyes, a knockout victim of some fellow he could have flattened with a punch in his prime. This is the better way by far.[74]

Nevertheless, the champion attempted a comeback. Over the next two years, he would twice attempt to regain his title. He would lose both matches. In his final bout with Rocky Marciano, Daley's words came back to haunt the former champion. In the eighth round of the match, Marciano knocked

Louis *through* the ropes of the ring and onto its canvas apron. Semiconscious, lying on his back on the apron and with his legs in the ring, suspended on the third (from the top) rope, with the referee and Marciano, standing within the ring, looking at him, and with camera flashbulbs blazing, Louis ended his professional fighting career.

Black White Hope

Three months after Ali refused to take the step at the induction center, Howard Sackler's play *The Great White Hope* premiered at Arena Stage in Washington, D.C. The play, which chronicles the rise and fall of the boxer Jack Jefferson, a character based on Jack Johnson, was a critical and commercial success. Advertised as a "modern Othello," the production not only revived the dormant discussions concerning Johnson's life but also launched the career of its lead actor, James Earl Jones. In his autobiography, Muhammad Ali recalls a conversation that he had with Jones in which the actor explained Ali's influence on his performance of the Johnson-like Jefferson. He writes:

> Jones told me that he had built his Jack Johnson concept around me and my life, but I told him I had been offered $400,000 to play Jack Johnson in a movie even when I was in exile, when I had no income, and I had turned it down. A black hero chasing white women was a role I didn't want to glorify. I thought a black male hero needed to glorify, in real life or on the screen, some of the black women who brought them and their brothers into the world.[75]

Ali's association with Johnson proves of interest to this analysis because he both distances himself from and identifies with the controversial figure at strategic moments. On the one hand, Ali rejected many of Johnson's lifestyle choices and social tastes. The earlier fighter's penchant for alcohol and women, particularly white women, garnered criticism from Ali. As the preceding excerpt reveals, Ali was aware of the iconic status that comes with being the heavyweight champion. For Johnson to associate with white women was, in the mind of the more contemporary fighter, to effectively insult all black women. A black man—"a black hero"—should be with a black woman.

The first black (heavyweight) boxing champion should have known better. Ali, the seventh black champion, knew this.

On the other hand, Ali viewed his persecution following his decision not to be inducted as analogous to the experience of Johnson following his victories over Burns and Jim Jeffries. James Earl Jones, appearing on a late-night television talk show program in 2003, recalled that, during the 1968 Broadway run of *The Great White Hope,* Ali attended the production several times. After one show, long after the audience had departed the theater, the former champion, according to Jones, asked him to sit in the audience and then proceeded to perform a scene from the play with himself in the role of Jack Jefferson. According to Jones, Ali remarked that he knew the story of Johnson because it was his story. All a person had to do was to replace white women with Ali's contemporary issues around the draft to see the similarity.[76]

Overall, Ali thought himself to be a man of greater principle than both Jack Johnson and Joe Louis. Recently converted to Islam, the champion disliked the manner in which Johnson lived his life. He was a poor role model and a deeply flawed representative of black folk. On the contrary, Louis succeeded in projecting a positive image of the black body, but this projection was more artifice than truth. Whereas the public Louis was a man of wealth and privilege who remained faithful to his wife, his black wife, throughout his lifetime and appeared as the model of clean living, the private (real) Louis was weighed down by tremendous debt, had involved himself in numerous extramarital affairs with black and white women, and suffered, toward the end of his life, from drug addiction. Although an awareness of the *real* Louis reveals his "customary stoicism" to be a brilliant performance of stillness, one that enabled him to attain the championship, there is not any evidence to suggest that Ali drew inspiration from him for his still stand. Angered by the comments and actions of "conservative" black boxers like Louis and middleweight Sugar Ray Robinson, who repeatedly critiqued him for his political stances, Ali began to view boxers of their generation and demeanor as the modern-day equivalent of houseboys on southern plantations during the era of captivity. They were passive figures who had lost their "fight," accepted the bribes of dominating society, and willingly assumed the role of the nonconfrontational black body.[77] They were black people that white people would like. Aware of how Joe Louis's image was crafted to respond to Johnson, Ali was determined neither to be controlled nor to have his image created by

LIVERPOOL JOHN MOORES UNIVERSITY
LEARNING SERVICES

others. In his autobiography, he writes that he was not going to allow himself "to be groomed, deliberately, or not, to become a 'White Hope.' Of course, I understand that they would prefer that the White Hope be white. But, Hopes having come upon hard times in boxing, I could see that they would settle for a Black White Hope, as long as he believed what they believed, talked the way they talked, and hated the people they hated. Until a real white White Hope came around."[78]

Muhammad Ali's determination not to become a black white hope appears in his various stands, the most obvious being his literal stand taken at the induction center in Houston. In order to fully appreciate what Ali did on 28 April 1967, it is necessary that we revisit his experience of the body on that day. Ali traveled to Houston for the sole purpose of responding to the draft letter. Entering the induction center, Ali passed a crowd of people who were there to see the heavyweight champion and to learn whether or not he would take the step within the induction ceremony. Inside the center, Ali completed all of the necessary paperwork, disrobed, and subjected himself to the invasive inspections of various health officials, and then was escorted to the room where the final part of the draft ritual, the induction ceremony, was to occur. It was there that Ali elected to stand still. Why would Ali respond in this manner? If the heavyweight champion did not want to enter the military, he could have remained at home. A figure in the public spotlight, Ali could have announced his decision through the various print and broadcast media that were available to him rather than performing it, through his body, in the interior space of the induction center. Why did Ali travel to Houston?

The heavyweight champion's decision to travel to Houston and participate in the draft ritual reflects his mastery over the representation of his body. Ali, not wanting to be the black white hope, a Joe Louis character who hid his own desires in order to project those of dominating society, refused to be a body for others—or at least, a body for others who were not of his choosing. Entering the induction center, the prizefighter gave the impression that he would support the government and enter the armed forces. He would agree to be drafted. Otherwise, why would he appear? Like other famous Americans in the past, Joe Louis, Jimmy Stewart, and Clark Gable, among others, who appeared in propaganda campaigns and served in World War II, he not only would lend his celebrity to aid the war effort but also would become an active booster for the cause. He was there to announce his willingness to serve his country by taking the step. Adding to this expectation was

the heightened visibility of former white heavyweight champions Gene Tunney and Rocky Marciano, who, contemporary with Ali's experience in Houston, traveled across the country and encouraged Americans to join the war effort. White hopes supported the war. Black white hopes supported the war. Surely, Ali would too.

He did not. Ali's stand rested upon his valuation of his personal, religious beliefs over the national agenda. Ali was not only a Muslim but also a Muslim minister. Having converted to Islam in 1965, shortly after winning the heavyweight championship, the prizefighter instantly became one of the most recognizable Muslim ministers within the United States and abroad. He traveled extensively, preaching to the Islamic faithful and to those considering converting to Islam. Although many public figures and innumerable ring opponents doubted the sincerity of the champion's conversion, Ali frequently and openly spoke about the redemptive value of his new faith. A decade after adopting Islam, the champion explained how his developing habitus saved him from repeating the life choices of Jack Johnson and Joe Louis. In a 1975 *Playboy* interview, he reflected:

> If I was Cassius Clay today, I'd be just like Floyd Patterson. I would probably have a white wife and I wouldn't represent black people in no way. . . . If I was Cassius Clay *tonight,* I'd probably be staying in a big hotel in New York City, and I might say, "Well, I got time to have a little fun. I'm going out to a big *discotheque* full of white girls and I'll find the prettiest one there and spend the night with her."[79]

His conversion was neither a publicity stunt nor a ploy. The champion viewed it as inextricably linked to his particular vision of the black body, as informed by the teachings of the Nation of Islam.

Ali's efforts to avoid the draft exceeded his performance at the induction center in Houston. In the preceding weeks, he and his legal team petitioned the federal courts to nullify the prizefighter's draft notice. On the evening before the induction ceremony was to take place, Ali sent an eleventh-hour petition to a federal judge in which he asserted that he could not be both a Muslim minister and a soldier.[80] The two were incompatible. His petition was rejected. With the courts having dismissed his case, Ali faced two options: either maintain his principles and refuse to be inducted into the army or overlook his beliefs and behave in the manner that the government

wanted him to act. Although the champion knew that high-ranking officials within both the American government and the three boxing associations wanted him to publicly support the war by consenting to be drafted, Ali refused to be miscast in a role that did not adequately reflect his beliefs. He refused to be another person's idea of the black body. In his autobiography, the prizefighter reveals why he felt that dominating culture found so shocking his decision not to take the step:

> They don't look at fighters to have brains. They don't look at fighters to be businessmen or human, or intelligent. Fighters are just brutes that come to entertain the rich white people. Beat up on each other and break each other's noses, and bleed, and show off like two little monkeys for the crowd, killing each other for the crowd. And half the crowd is white. We're just like two slaves in that ring. The masters get two of us big black slaves and let us fight it out while they bet. "My slave can whip your slave."[81]

Unlike Tom Molineaux, a captive boxer who was staged by his "master," or Joe Louis, who allowed the national agenda to be projected across his own body, Ali actively refused to assume the position of the silent screen upon which the desires and thoughts of dominating culture would be projected. Ali controlled Ali. He determined what he thought, where he would go, what he would do, and how he would behave. Whether (or not) those actions coincided with the hopes of dominating society, Ali did not care. He was his own master.

Ali's *performance* in the induction center reveals his mastery over the presentation and re-presentation of his own body. Aware of how the black body, specifically the black body in boxing, had been staged by others, the heavyweight champion, through his actions in Houston, succeeded in scripting and directing a performance in which he stood at its center. Rather than remaining at home and refusing to respond to the draft notice, Ali elected to travel to the center and chose to participate in each of the various medical inspections before demonstrating his unwillingness to take the step. Why would Ali do all of these things? Why did he not remain at home? First of all, Ali's decision to travel in order to stand still revealed that he—and not anyone else—controlled his body. Despite the fact that he was *ordered* to report for induction and *ordered* to strip by the medical doctor in the center, Ali, by not taking the step, showed that he never relinquished control of his body. In

fact, he consented to the draft letter, consented to the doctor's demands, and, most importantly, did not consent to the lieutenant's call in order to demonstrate that the presentation and the staging of his body required his (and only his) permission.

Second it was common knowledge that Ali did not want to be drafted and that he would not allow himself to be drafted. As early as mid-March 1967, following a publicly made federal announcement that Ali would be drafted and weeks before the prizefighter would receive his draft notice, Ali began, in press interviews, to make statements not only against the war effort in Vietnam but also against his participation in it. On 17 March 1967, Dave Anderson, writing for the *New York Times,* observed that Ali probably would not consent to being drafted.[82] Less than a week later, Ali appeared at a rally at Howard University where, according to an unidentified *New York Times* reporter, he said "he will go to prison before he serves [in the army]."[83] On the eve of the induction ceremony, Robert Lipsyte, in another *New York Times* article, quoted the heavyweight champion as saying, "I don't want to go to jail but I've got to live the life my conscience and my God tell me to. What does it profit me to be the wellest-liked man in America who sold out to everybody?"[84] The following day, Lipsyte reported, in the first sentence of his front-page article on Ali's induction performance, "Cassius Clay refused today, as expected, to take the one step forward that would have constituted induction into the armed forces."[85] Ali's decision was not a surprise.

What is impressive about Ali's performance is the fact that everyone, including Ali, knew that he was going to refuse the draft and that he would be charged with having committed a felony crime (for the refusal), and yet he still arrived at the induction center on 28 April 1967. He went there not only to stand still but also to face the federal charges that would result from his stand. He arrived at the center prepared to be arrested and sent to jail. Robert Lipsyte, in his article written on the eve of Ali's visit to the induction center, observed that the prizefighter had placed a number of personal possessions in storage and had moved out of a hotel where he was staying with the expectation that he would be taken to jail for an undetermined period of time following his refusal to be inducted.[86] By appearing at the induction center, Ali did something that Jack Johnson did not do. Whereas Johnson ran away from the authorities, Ali traveled to them. He stood before the law and demanded that his individual rights, specifically his religious freedom, be respected. He expressed these sentiments in a second stand that he took at the

induction center. Escorted by the lieutenant in charge of the ceremony back through the building, Ali made a brief stop in a room where a collection of news media were stationed to cover the champion's refusal to take the step. Appearing before the cameras, Ali elected not to say anything in that moment and proceeded to distribute a prepared statement. Within the statement, he asserted:

> I strongly object to the fact that so many newspapers have given the American public and the world the impression that I have only two alternatives in taking this stand: either I go to jail or go to the Army. There is another alternative and that alternative is justice. If justice prevails, if my constitutional rights are upheld, I will be forced to go neither to the Army nor jail.[87]

With his words, Ali told the assembled media that he decided to not take the "step" in order to maintain his liberty, his freedom. Furthermore, he revealed that he employed the stillness of his own body to critique the notion that his body had to be confined in either the federal military or the federal prison. Whereas Jack Johnson's movements in the face of the Mann Act charges resulted in his eventual incarceration, Ali stood motionless in order to prevent his own body from being fixed.

The Final Round

In the preceding sections, we encountered the experiences of the body of Tom Molineaux, Jack Johnson, Joe Louis, and Muhammad Ali. Although the sociotemporal environment of each prizefighter's life differs from the others, there are a number of similarities that connect their bodies. Each had a similar relation to captivity, having lived in or under the threat of captivity. Each knew that his body represented more than the physical limits of his own body. Each, as time progressed, learned the experiences of those who preceded him and made life decisions aware of the fate of the others. All of the boxers within this study were ghosted by the institution of black captivity and/or the threat of incarceration. Tom Molineaux, born a captive to captive parents, learned to box on the plantation and appeared in plantation-based matches. His presence within the American boxing ring reminded everyone who participated in his fights, either as fighters or witnesses, of his enslaved status. Johnson, the son of black captives, replayed the experience of Moli-

neaux's body when he was forced to appear in battles royal as a child and when he agreed to appear in exhibitions at Leavenworth State Prison. Louis, the great-grandchild of black captives and the great-great-grandson of their white "master," managed to avoid the experience of Molineaux and Johnson for the first half, the championship years, of his life. Unfortunately, the prizefighter discovered not only that he was nearly bankrupt following his retirement but also that he owed the federal government several years back taxes. Lacking money and constantly under the threat of incarceration for tax evasion, Louis returned to the ring to fight exhibitions, referee bouts, and even wrestle. Ali, the descendant not only of black captives but also (according to a rumor begun by his family) prominent white legislator Henry Clay, spent four years, between the induction ceremony in 1967 and the Supreme Court's June 1971 ruling in favor of Ali, living under the threat of incarceration.[88] Barred from entering the ring and dispossessed of his championship title, the former champion struggled to make a living without compromising his ideals. When Ali was vindicated and allowed to reenter the ring, his best years had been lost to the draft controversy.

Each of the boxers knew that his body represented a meaning that exceeded his own physical body. "Molineaux" was more than Molineaux. "Johnson" more than Johnson. "Louis" more than Louis. "Ali" more than Ali. Molineaux, on the American plantation, represented his "master." When he entered the ring to fight the captive of another plantation, he embodied all of his master's interests. Like the bird in a cockfight or a horse on a racetrack that stands in for its owner, the black body on the plantation mirrored the "master." When Molineaux won his match, the "master" won. Once in England, Molineaux continued to represent more than himself. Within the ring, he not only symbolized "America" but also the bodies of black boxers who preceded him in the English ring, including his trainer Bill Richmond. Johnson comprehended the significance of his body and worked to create his own mystique. During a time when he was seen as representing the race, the heavyweight champion, although not explicitly a race man, relished every opportunity when he could humiliate a white opponent by prolonging a match or insulting him in interviews (or even at the match). Joe Louis, a Roxborough protégé, knew that image was everything. He understood that how a person appears and how he actually is do not have to be the same. Throughout his boxing career, he obeyed each of Roxborough's rules and became the anti–Jack Johnson in the process. Offering a glimpse into the untarnished

public image of Louis at the time of his first retirement in 1949, Arthur Daley eulogized the champion: "Boxing became a better place because of the presence of Joe Louis in it. . . . He was a King in every mannerism."[89] In contrast to Louis, Muhammad Ali crafted and controlled his own image creation. Not only did he eventually convince the world to accept his religious conversion and his new name (Ali versus Clay) but he also, through sheer repetition, created his own legacy. Repeatedly referring to himself as "The Greatest" in newspaper interviews, televised sports profiles, and his own autobiography, the champion persuaded the American public that he was, indeed, the greatest heavyweight champion ever to hold the title.

Most importantly, each successive fighter knew the experience of the boxer(s) who preceded him. In many ways, the boxers, aware of the past experiences of others, were able to identify the similarities between their temporally disparate bodies. Beyond merely acknowledging that certain conditions recur, they allowed their knowledge of the past to shape their behavior in the present. While it is speculative to say that Molineaux watched his father perform in boxing rings on plantations and, perhaps, realized how his body would be perceived years later, we can, with greater certainty, say that Johnson was aware not only of the roots of plantation-based boxing contests but also the residue or legacies of those matches decades later in battles royal. Knowing how the black body was seen and manipulated by others, Johnson actively refused to be a body for others (black or white). Both inside and outside the ring, the heavyweight champion did everything that a black captive boxer, like Molineaux, was prohibited from doing.[90] He openly taunted his white opponents, he declared himself the master of the white body, he consorted with white women and embraced the stereotype of the hypersexual black body. In short, he represented the postemancipation fears of the nation. If Johnson represented the black body at the extreme limit of self-indulgence, then Louis was the body constructed to be accountable to others. Louis knew Johnson. The two fighters resented one another and thanks to Roxborough never appeared in public together—or, at least, in a picture together. The second black heavyweight champion understood that Johnson's exploits would make it difficult for future black fighters and, more generally, future black athletes to reach the pinnacle of their respective sports. In an effort to give himself the best chance possible at the title, he became the antithesis of all that Johnson represented. He was soft spoken,

rarely smiled in postfight pictures, did not drink, married a black woman, and worked to end his bouts as quickly, and efficiently, as possible. As champion, Louis maintained the facade. When called upon by the government, he joined the armed services and allowed his likeness to appear on numerous military recruitment posters. Even as he was being hounded by the Internal Revenue Service for back taxes in the 1960s, Louis maintained his allegiance to his country and became an outspoken critic of Ali. Ali understood the experiences of Molineaux, Johnson, and Louis. He realized that captive boxers, like Molineaux, were commodities. He respected Johnson for his independence but felt that the controversial champion failed to meet his expectations of a "black hero," a champion of and for the black community. Overly concerned with his public image, Louis could not be both "Louis" and Louis. He could not be himself in public. Hiding his true nature, the public Louis, according to Ali, was a hypocrite.

By knowing the story of the experience of Molineaux's, Johnson's, and Louis's body, Ali could anticipate the expectations that dominating culture had for his own. He knew that dominating culture wanted to control the black body and that each of the fighters who temporally preceded him had agreed to be controlled by others. Molineaux fought in matches staged by his master. Johnson appeared in battles royal and in prison exhibitions. Louis loaned his likeness and celebrity to national propagandist campaigns. What did each boxer receive in exchange for their efforts? Molineaux died impoverished in a military barracks. Johnson, similarly, died without money after spending years working the carnival circuit and appearing in exhibitions. Louis, hounded by the IRS, took a job as a greeter at the front doors of a Las Vegas casino and died a destitute drug addict. Reviewing the experiences of the three fighters, it is not surprising that Ali elected to take a path different from those who preceded him. He refused to allow himself to be used. Whereas he could have taken the step at the induction center and probably would have been given a vanity military assignment (like Louis, who fulfilled his military obligation by working as an army boxing instructor) and, more importantly, would have retained his heavyweight title, the champion knew that such agreements played a role in the loss of a fighter's integrity. Had Johnson not agreed to fight in Dickerson's exhibitions at Leavenworth, then his historical legacy would have been decidedly more positive. Had Louis ignored Roxborough's rules and the demands of dominating culture, then he,

even if he never attained the heavyweight title, would have fulfilled Ali's criteria for the black "hero." Unlike Molineaux, Johnson, and Louis, Ali willingly sacrificed material comfort and his freedom to defend his principles.

Ali's performance of stillness proves of interest to this study because he succeeds in reclaiming and reappropriating a position that has, for centuries, disempowered the black body. In order to see how enforced stillness repeats across the black body, we can think of black bodies, throughout history, shackled together, either loosely or densely packed in cargo holds; forced to stand motionless on auction blocks as they were poked, prodded, groped, and inspected by doctors and potential "masters"; tied to whipping posts on plantations; placed in jails and prisons at disproportionate rates in the postemancipation period to the present day. Ali, in the moment of the induction ceremony, reclaims the stillness of the black body and transforms it into a position of power. Despite the loss of his title, his boxing licenses, and four years' worth of earnings in the ring, Ali, through his stand, left the induction center having won a major victory. He succeeded in getting the U.S. government, represented by the lieutenant, to acknowledge his religious conversion. After hailing Ali unsuccessfully several times by the name "Cassius Clay," the lieutenant submitted to the prizefighter and referred to him as "Mr. Ali." This easily overlooked victory was the first of several for the heavyweight champion. He did not have to go to jail. He did not have to pay the $10,000 fine. He remained a "hero" to the black community. He proved that the black body could be a body for itself and a body for select others. He demonstrated that the repeated, similar conditions and expectations of the black body do not automatically lead to the creation of the same experience of the body.

Touching History:
Staging Black Experience

The cover of the Theatre Communication Group's (TCG) edition of Suzan-Lori Parks's play *Venus* features a silhouette of Saartjie Baartman, a South African woman who gained European celebrity status as the "Hottentot Venus" in the early nineteenth century.[1] Her ample backside, a condition known as steatopygia that endowed her with a shape that the bustle attempted to approximate four decades later, made her famous. The cover emphasizes this feature—this main attraction—by centering the figure against a white backdrop against which the black bottom of Baartman appears even more pronounced. Superimposed and vertically running down her silhouette, the name of the play—*V-E-N-U-S*—appears. The letter *U*, located at her midsection, has been scripted in a font that is nearly three times larger than any other letter and, in turn, emphasizes her steatopygia. The *U* attracts the eye and subtly encourages a reading of "Us." TCG draws additional attention to Baartman's midsection by incorporating latitudinal and longitudinal lines around her lower torso. The confluence of these design elements suggests a play that not only centers a black body within (and, perhaps, as) the world but also locates "us," the viewers, within the experience of the black body.

The cover gestures toward the play's ability to reenact and flesh out the experience of the black body. A blue silhouette of the Hottentot Venus stands against the black one. The misalignment of the images—blue overlapping black—hints at the ways in which Saartjie Baartman has been approximated in both life and art. In *Venus,* an actor plays "Venus Hottentot" and/as Baartman. In real life, Baartman simultaneously was and was not this role. The slippage between her willing role-play, the enforced projection of the role across her body, and her relative silence within the historical record

appear within the opening moments of the play. *Venus* begins with Venus Hottentot standing upon a rotating platform. Similar to the TCG cover, she appears in profile. Her pronounced backside, enabled by the adornment of a prosthesis, is on display. She "revolves" until she "faces upstage," thus enabling spectators to continue to gaze upon her body without having their looks challenged by her. Her movements followed by her stillness are reminiscent of Alfred, Fassena, and Jem, among others, who, as Alan Trachtenberg has noted, performed "the role of specimen" before Joseph Zealy's camera. As Venus stands still and silent, the other company members in the production introduce themselves to the audience. Following the last introduction, they point to the black body on the platform and name her as the Venus Hottentot. The actor, playing the title role, repeats after them: "Venus Hottentot." She confirms the label and, in so doing, appears to consent to her new identity. On the heels of Venus's acceptance of their projection of the black body, a character declares: "The Venus Hottentot iz dead." Another adds: "There wont b inny show tonite." Despite these proclamations, the viewer suspects that there will be a show tonight but may wonder whether the silent figure on display, the black body, will speak again.

Reconstructed from the surviving historical documents that feature Baartman—the lectures of George Cuvier, the doctor who dissected Baartman and paraded her remains around the world; the recorded, eyewitness accounts of spectators who paid to see Baartman on display in various carnival circuits; and the court proceedings, prompted by many of those negative accounts that sought to determine whether Baartman was being exhibited against her will—Suzan-Lori Parks's play *Venus* re-creates not only the experience of the "Hottentot Venus," but also the environment within which she lived. In her historical revisitation, Parks encourages her audience to ask several questions. Can historical documents represent the experience of a black body? Can the experiences of the displayed black body get reclaimed by theater? Or does the representation of the body, as centered and central to the dramatic narrative, replay or reenact its previous experience of being the exhibited body, but before a different audience? How do the repeated similar experiences of passed/past (historical) black bodies touch the black body in the present and in the future? In the following pages, I explore each of these questions by looking at how three playwrights—Parks, Robbie McCauley, and Dael Orlandersmith—use theatrical reenactment to gain access to the experience of select historical figures. Parks stages Baartman. Robbie Mc-

Venus. Photograph by author.

Cauley mines her dreams to represent the sexual assault of her great-great-grandmother. Dael Orlandersmith, despite viewing her play as nonhistorical and not autobiographical, tells a story that reflects the treatment of her own body. In bringing the bodies of the characters Baartman, Sally, and Alma within their respective performance projects—*Venus, Sally's Rape,* and *Yellowman*—to the stage, each playwright activates black memory and gives voice to embodied black experiences.

"She'd Make a Splendid Freak"

Born in 1789 into the Griqua tribe, a part of the Khoi-Khoi (or Khoisan) people who lived on the Eastern Cape of South Africa, Saartjie Baartman worked as a field hand on a Dutch colonial farm.[2] By the age of nineteen or twenty, she had attracted the attention of William Dunlop, a visiting ship's

doctor. According to rumor recorded as history, Dunlop convinced Baartman that she could greatly profit by returning to England with him and exhibiting herself as an oddity in the English carnival circuit. "With stars in her eyes," Baartman scholar and South African anatomist Phillip Tobias notes, she "accepted his offer."[3] Arriving in Piccadilly in 1810, Baartman appeared on a "stage two feet high, along which she was led by her keeper and exhibited like a wild beast, being obliged to walk, stand or sit as he ordered."[4] Naked with the exception of face paint and a flimsy apron of feathers tied around her waist, Baartman was paraded throughout the greater London area over the next four years. In addition to these public displays, Baartman was also exhibited in private sessions. While these sessions certainly suggest the likelihood that the young woman was prostituted, recorded history resists such conclusions. Sold to an animal trainer in 1814, Baartman was taken to France, where she continued to appear as an oddity on display for both public and private consumption. As the entertainment at a social event for French politicians, Baartman attracted the attention of George Cuvier, Napoleon's surgeon and Louis Agassiz's future mentor, who claimed a "scientific interest" in her and initiated an association that lasted well beyond Baartman's death less than a year later. Despite the close scrutiny of Cuvier, who experimented with Baartman's body while she was alive and eventually dissected her following her death, the actual cause of her death remains unknown. It is generally felt that syphilis, tuberculosis, and the consequences of alcoholism were the primary culprits.

In death, Baartman remained on display. Cuvier created a plaster cast of her body, dissected her body—preserving her genitals and brain in a glass jar—and reassembled her skeleton. The results of his autopsy served as the basis of a series of lectures that he delivered around the world and were later published. The physical remains of Baartman's body were shipped to the Musée de L'Homme (Paris) and placed on display until the middle of the twentieth century. While the preserved brains and genitals and the reassembled skeleton were the first items to be shelved—literally taken off display and put on a shelf in a back storage room—by the museum curators, the plaster cast remained on exhibit until the mid-1970s. According to several museum guides, the cast was removed not because of public protest but because it was creating problems for the museum staff. Apparently, the image of Baartman awakened the sexual desires of tourists that occasionally erupted in the form of visitors groping the cast, masturbating in the (public) presence

of the cast, or attempting to sexually assault tour guides after having seen Baartman.[5] The cast was removed to maintain decorum. In February 2002, the cast, skeleton, and jarred remains were returned to Baartman's native South Africa. Six months later, they were buried. Between the homecoming and burial, Suzan-Lori Parks won the Pulitzer Prize for drama.[6]

Parks's *Venus* restages and to a certain extent remembers Saartjie Baart-man. Written nearly a decade before Baartman's remains were returned to South Africa, the play succeeds in gathering up the material remains of Baartman's life, as recorded in history and science and repeated in myth and legend, in order to reinvent Baartman. Before our eyes, the woman who had spent over 150 years as a series of parts on display becomes whole again. While the play does take liberties with what is known about Baartman—chief among them is the suggestion that Cuvier and Baartman developed a ro-mantic relationship—the portrait of Baartman accords with extant historical and legal accounts. Within the frame of the theater, as within the frames of history, myth, and science, she remains an object of curiosity, an exhibit of otherness—a woman with magnified proportions (emphasized in the play through the use of prosthetic accessories)—at whom we look.[7] The question of whether or not Parks's play repeats the objectification of Saartjie Baartman and, more generally, the black body is worth considering. Does the play em-power her or merely recast her in the role of exhibit of otherness? The most cited and critiqued opinion on this matter belongs to Jean Young, who rails against both Parks's play and Richard Foreman's 1996 production of it. Young's argument is relatively straightforward. As its title, "The Re-ob-jectification and Re-commodification of Saartjie Baartman in Suzan-Lori Parks's *Venus*," suggests, the article details the author's belief that the play restages Baartman again (and again) as a freak or oddity. She remains an ob-ject of otherness to be gawked at, pointed to, groped, and abused. Young most strenuously objects to the play's suggestion that Baartman was "an ac-complice in her own exploitation," assuaging white male guilt over her exhi-bition not only through Baartman's complicity but also through the casting of a black male actor as the Baron Docteur in the Foreman production.[8] With note to this latter theatrical-historical inversion, Young writes, "This attempt at multicultural casting by director Richard Foreman suggests that Black men are the primary exploiters of Black women, further distancing white males from a recognition of Baartman's (i.e., the Black woman's) exploitation and dehumanization."[9] In short, Young as spectator of the theatrical text,

played and replayed, witnessed and rewitnessed on recorded video, objects to the fact that at no point in the text does the playwright or the director point a finger of blame at the individuals who brought her from South Africa to England, who caged and exhibited her, who profited from her exhibition, who paid to see her, who dissected her, and who ultimately participated in her dissection by attending the museum exhibitions of her displayed remains. The play merely stages a woman who wants to be staged. This is Young's complaint.

Michele Wallace, in her review of the live performance for the *Village Voice*, takes a different tack. To her, the play, as well as Foreman's production, fuses multiple elements so as to distance the audience, bring them into history, and ultimately entertain them. Reading Wallace's review, I find that there is not the slightest hint of frustration. After offering a brief historical introduction of the real Saartjie Baartman, she writes:

> But don't waste your precious brain cells trying to correlate the tale I've told with the one Parks tells of Baartman as a lusty, lovely lady who falls in love with the mad scientist who will ultimately dissect her. Just sit back and enjoy Parks's outrageous script and Richard Foreman's deft staging and directing. Don't be afraid to laugh at the plentiful humorous sight gags. Parks's point is at once archeological and devilishly playful, a Brechtian process of refamiliarizing what is ordinarily considered a mundane body part in order to plunge us backward into a period of history we've chosen to forget.[10]

For Wallace, Parks deftly takes her audience backward in time to consider the political ramifications of the backside. More than a mere meditation on the mundane, the play encourages us to seriously consider the representation of the black body. Wallace's most profound insights on the play are introduced in the final sentence of her review. Wallace observes that *Venus* "actually draws upon a wide range of divergent, comparatively new and unexplored discourses: stereotypes of race and gender in Western culture, the plight of the black female body in representation, and the ethnographic subject of the social sciences as a by-product of colonial power, wherever there were inconveniently located indigenous populations who couldn't or wouldn't get with the program."[11] Despite the lack of elaboration, the author, contrary to Young, seems to suggest that a not so subtle critique of colonialism

and representational histories exists within the play. The play is more complex than Young's initial assessment.

W. B. Worthen continues Wallace's argument in both point and style. Having introduced Young's review, Worthen challenges it by referring to an unpublished article by Irma Mayorga and Shannon Steen: "[The authors] undertake a fully-developed challenge of Young's essay, citing both inconsistencies in Young's article and making a case for the play's strategic representation of Baartman; they argue that Venus challenges the fiction of identification with Baartman, or the sense that her subaltern subjectivity is recoverable, especially in the visual dynamics of theater."[12] Faced with the difficult task of imagining a "fully-developed challenge" from a single sentence summary, we can only pretend to know what the argument is. Does the Brechtian style mentioned by Wallace prevent any sort of identification with the title character? Are we deliberately kept at a distance in order to understand Baartman as an object of otherness? Rather than reobjectifying her, does our abeyance reveal the workings of the colonialist structure? Does the framework of theater and the spectatorial relationships that it engenders prevent the audience from doing anything but looking at Baartman? Is the goal of the piece to become aware of one's look? Is this why the play operates as a meditation on the mundane? As the mundane gains interest (becomes more interesting to us), do we enter history and encounter the race-based representational practices of nineteenth-century science (e.g., the workings of Cuvier and Louis Agassiz)?

Rather than repeating the methodological approaches of Wallace and Worthen, who seem to point at the play and say that "there is something important there," without actually detailing what or where "there" is, it is necessary that we sharpen our analysis by separating Foreman's production of the play from the play text. Despite the fact that I would usually cringe at such a suggestion, *Venus* operates as one of the exceptional cases in which the original production actually creates an obstacle to a clear interpretation of the play text. Evidence of this appears in the fact that Worthen elects to read a Stanford production as the representative performance rather than Foreman's original staging at the Yale Repertory Theatre. Moreover, Young's negative review often makes reference to the heavy-handed intervention of the director and how his presence may have disrupted authorial intent. A quick perusal of the other reviews of the production reveals that Worthen

and Young are not alone in their critique of Foreman. These reviews consistently remark upon the presence of Foreman's signature décor—the network of strings, crisscrossing overhead—and how this imprint marred the production. Alvin Klein, a *New York Times* reviewer, offers the most critical reading of the Yale Repertory Theatre production: "That Richard Foreman, the revered playboy of the avant-garde, is the director for Ms. Parks's intense cause defeats it perversely, creating further distancing and reducing it to drivel and ostentation." He later adds, "With style being all, 'Venus' comes off as snob theater, full of exclusivity, pretense and showy effects, signifying trendiness."[13] Several weeks later, a letter to the editor appeared in the *New York Times*. It echoed Klein. Having read another *New York Times* article on Foreman's style by Don Shewey, the letter writer, Murray Berdick, observes, "Some of the confusion I experienced a few weeks ago at the Yale Repertory Theater in New Haven has dissipated, now that Don Shewey has told me more about Richard Foreman . . . I understand now that the inexplicable features of the production are all mannerisms of Mr. Foreman's."[14] After outlining each of these features—the strings and a red light that remained blinking throughout the production, Berdick concludes his letter with the following: "The photo with the article suggests that the playwright and the director have a good relationship. But I think the director has put his personal and psychic needs ahead of his responsibility to communicate the playwright's message to the audience."Although Berdick's conception of Parks's message remains unknown, it is evident that he found Foreman's directorial inventions to be distracting. These inserted elements stole attention away from the playwright, play, and the black body.

The Limit of Language

The need to sever the presence of Foreman and the spectral presence of his production of *Venus* from our analysis of Parks's play appears in Berdick's letter. Foreman's imprint obscures the playwright's message. While the phrase "playwright's message" dangerously elides with other equally problematic theatrical clichés such as "director's vision," which ultimately mean nothing, we can, nonetheless, study the medium through which that "message" expresses itself: language.[15] How does Parks utilize language and linguistic style within Venus? How does language and linguistic style comment on phenomenal blackness and the experience of Saartjie Baartman?

Every text on Suzan-Lori Parks—whether academic criticism or theatri-cal reviews of her work—discusses the playwright's unique relationship to language. In one of the earliest major newspaper reviews of her writing, Mel Gussow, reviewing Parks's 1989 production of *Imperceptible Mutabilities in the Third Kingdom* for the *New York Times*, likens Parks to Adrienne Kennedy and Ntozake Shange and notes that her play "has a playful sense of language."[16] Three years later in a *Boston Globe* profile, Patti Hartigan ob-serves, "What she is about is language, the sheer sensuality and physicality of words. There are no stage directions in Parks's script, she says she writes the movements into the dialogue so that actors inherently know what to do while speaking."[17] Alvin Klein, in his review of the 1994 premiere production of *The America Play* at the Yale Rep, notes that "the verbal acrobatics, perpet-ual punning and provoking subtexts" make the play "a cerebral workout."[18] David Richards, reviewing the play three months later, after it moved to New York's Public Theatre, comments that it "relies heavily on wordplay, symbol-ism, and free association."[19] Two years later, Klein, writing about *Venus*, de-clared, "The playwright is on her customarily unstoppable word high."[20] Shawn-Marie Garrett, in an October 2000 *American Theatre* profile of Parks, summarizes the playwright's style in the following manner:

> Like Ntozake Shange before her (though in a different style), she crafts a the-atrical poetry that bears the same relation to black dialectical forms that, for example Joyce's language bears to the speech of the Dubliners he heard and remembered. Meanwhile, Parks's spelling, which can make her plays look impenetrable on the page, is part of a tradition in African-American letters of deliberately damaging and reshaping written English. Shange writes that African-American writers have to take English "apart to the bone / so that the malignancies / fall away / leaving us space to literally create our own image." Parks's approach is more playful, and the dangers (as well as the pleasure) of image-creation are major themes of *The America Play* and *Venus*.[21]

In the more academic treatments of Parks's work, the playwright's use of lan-guage remains central to commentary. Harry Elam and Alice Rayner con-tend that "it is precisely in words that Parks herself identifies the intersec-tions that comprise her theatre: the intersection of ritual, language, gesture, history, and ethnic identity."[22] W. B. Worthen centers "the patterns of verbal and gestural echo that run throughout" Parks's plays, particularly *Venus*.[23]

Joseph Roach, reading *The America Play*, investigates Parks's use of liturgi-cal silence to mine and restage history and historical figures. Comparing the play with Samuel Beckett's *Waiting for Godot* and Femi Osofisan's *The Oriki of a Grasshopper*, Roach observes that these plays "share a memory of the Atlantic world that eludes conventional narrative. They must seek other lan-guages for their retelling—languages of image, of gesture, of sound, and es-pecially of silence."[24] Elizabeth Lyman chronicles how "Parks relies upon vi-sual effects of typographical and page design to create a linguistic accompaniment to verbal dialogue and stage direction."[25] Contrary to what I will assert later in this section, Lyman maintains that Parks's language and linguistic style is visual and does not merely strive toward the visual. In sum, the volume of critical work that centers Parks's use of language points to an academic and "high-cultural" infatuation with the uniqueness of her prose. Parks, in a comment about the 2002 bidding war among publishers who sought the rights for her first novel, *Getting Mother's Body*, appears to com-ment on the frenzy her writing has generated within the theater community. She states, "They're excited about the writing. I love it. I love it, but it's weird, the reaction. What's going on? Did I sprinkle crack cocaine on the pages?"[26]

I, too, wish to meditate on the use and function of language within *Venus*. Rather than highlighting its musical influences, "rep and rev" form, or non-standard use of English—all tenable subject matter for an analysis of the play—I will focus on the limitations and failures of Parks's "language." This focus should not be considered a critique. In fact, it is my contention that the playwright should be lauded—as she has been—for attempting to take the written word where it ultimately can never go. In striving to give the word a multidimensional visual presence, Parks takes her readers and audiences to the very ends of textuality. We can see this in the playwright's scripting of ges-tures and her stage directions, emphasis on nonverbal moments, and even the narrative history of the Hottentot Venus that fails to adequately repre-sent the body of Saartjie Baartman.

Parks incorporates the gestural and physical into her words. Or, more to the point, her writing strives toward visual embodiment. In a 1992 *Boston Globe* article, the playwright is quoted as saying, "Language is about breath-ing. It's about teeth and mouth and spit in your mouth and how your jaw works and what your hands are doing. It's all there. It's in the lines and the ac-tors can pick it up and do something with it."[27] Two years later, in "Elements

of Style," Parks expanded her understanding of the physicality of words by noting:

> Words are very old things. Because words are so old they hold; they have a big connection with what was. Words are spells in our mouths. My interest in the history of words—where they came from, where they're going—has a direct impact on my playwrighting because, for me, Language is a physical act. It's something which involves your entire body—not just your head. Words are spells which an actor consumes and digests—and through digesting creates a performance on stage. Each word is configured to give the actor a clue to their physical life. Look at the difference between "the" and "thuh." The "uh" requires the actor to employ a different physical, emotional, vocal attack.[28]

Venus, as with all of Parks's plays, is filled with the "physicality" of language. An example appears in the following moment taken from the play's overture:

THE MAN, LATER THE BARON DOCTEUR.
 I say:
 Perhaps,
 She died of drink.
THE NEGRO RESURRECTIONIST.
 It was thuh cold I think.
THE VENUS.
 Uhhhh!
THE CHORUS OF 8 HUMAN WONDERS.
 Turn uhway. Don't look. Cover her face. Cover yer eyes.

In the preceding excerpt, the characters come alive and into being through the playwright's use of the "uh" sound. Whether the "uh" requires the actor to employ a differing physical, emotional, and vocal attack may depend upon the actor playing the role, but it is clear that the "uh" creates and distinguishes the characters. The Baron Docteur, a representative of conventional, standardized, and successful Western education, remains "uh"-free. His speech is proper and punctuated. In contrast, the Negro Resurrectionist, the Venus, and the Chorus of 8 Human Wonders are marked as being different from the Baron. They are minoritized individuals who express themselves in a minoritized, nonstandarized speech pattern. They are the embodiments of "uh." Each expresses his or her "uh" formation differently. It is an article, a

declaration, and an adverb. Despite these differences, the "uh" sound comes together and repeats itself in a strange accumulation of "uhs" within the excerpt. Within this concatenation, the "uh" strives to project an experience of the minoritized body.

While the presence of "uh" certainly informs the audience's expectations of the characters appearing within the play, the "uh" sound is not inherently physical, gestural, or visual. Certainly aural, the sound and the process by which that sound is generated may prompt the actor to become newly aware of her body, but it does not immediately conjure the image of the body. We may hear the sound of the actor but we cannot see her. This is the limit of language. The physicality of Parks's language is aural and visceral but not visual. You can hear it. You can feel it. You cannot see it.[29] We can attribute this feature of the playwright's writing style to her training as an actor who wanted to become a playwright. "I knew that the only way I could become a better writer," Parks once told an interviewer, "was to study acting. But I never wanted to be an actor, Never. Ever. Ever."[30] Her decision to study acting may root itself in the playwright's desire to better understand how the body speaks. Parks listens to the body and then strives to record its voice. This is the basis of the "physicality" of her language. It is not anchored in her writing "uh" and then creating a performance based upon that utterance by an actor. The performance begins before the writing. She imagines herself or some other body with whom she converses saying "uh." The focus here rests not on the utterance itself but the process by which that utterance manifests itself, the position of the body at the moment of enunciation, and the reverberations of the sound having been spoken. This is what she seeks to encapsulate in language. Language strives to become something that it can never be. It can gesture toward that prior physical enactment but it will never fully embody the moment that precedes the utterance.

Parks also reaches the limit of language in the form of "spells," which she defines as an "elongated and heightened (rest). Denoted by repetition of figures' names with no dialogue. Has sort of an architectural look."[31] An example of a "spell" in Venus appears below:

THE VENUS.
THE BARON DOCTEUR.
THE VENUS.

Continuing her definition, Parks writes:

> This is the place where the figures experience their pure true simple state.
> While "no action" or "stage business" is necessary, directors should fill this
> moment the best they see fit. The feeling: looking at a daguerreotype; or the
> planets aligning and as they move we hear the music of their spheres. A spell
> is a place of great (unspoken) emotion. It's also a place for an emotional tran-
> sition.[32]

A spell, occupying the space between a beat and a moment, is the point at
which something happens. It is a special, nonverbal happening that is filled
with meaning. It exists beyond words. It is an experience. As an actor-play-
wright, Parks runs into the spell at the very moment that language begins to
fail her. How do you represent that which refuses to be represented? How do
you express the nonverbal in words? You cannot. Rather than attempting to
write stage directions or dialogue that approximates the moment without
embodying it, Parks stops short. She introduces the participants and then re-
sorts to silence. We must imagine the moment. We must conjure our own
spells. The spell operates as a moment where language absents itself in an ef-
fort to evoke a physical, visual presence. It marks the place where the word
surrenders to the image. While the dialogue that precedes any given spell
certainly creates the environment in which the spell gets enacted, the fact re-
mains that the spell itself is both improvised and imagined. It is a scripted
improvisation. It is where the playwright stops writing, the actor stops read-
ing, and they momentarily move beyond the ends of language and into the
realm of visuality.

The limit of language repeats as a replay within *Venus* in Parks's repre-
sentation of historical documents that pertain to Saartjie Baartman.[33] The
presence of these various recorded and archived materials proves of interest
to our study because they give the impression that they are honest represen-
tations of Baartman when, in reality, they only obscure her image. The lec-
tures of Cuvier restage Baartman as an exhibit within a new space and, ar-
guably, before a differing audience. The stage becomes the examining table.
The carnival, the lecture hall. Baartman remains the object to be seen. The
court transcripts drawn from the 1810 case to determine whether the young
woman was being exhibited against her will similarly restage Baartman.

Within the actual transcripts, Baartman remains silent. The magistrate either speaks for her or summarizes what she supposedly said to him or others behind closed doors.[34] The eyewitness accounts of Baartman's mistreatment that prompted the court proceedings rehearse her position as a body on display for others in that we continually experience her exploitation through the vantage point of others who paid money for the privilege of seeing a black body on display. Their humanitarian concern emerges only after their curiosity has been satiated. In each case, we never encounter Baartman. We never see her. We do not hear her speak. She remains absent and silent within history.[35]

What the presence of these historical documents reveals is the absence of the black body within recorded history. Specifically, it points to the absence of Saartjie Baartman within the volumes of recorded history. How can there be so many sources concerning Saartjie Baartman while her body remains invisible and silent? How can we know so much about the woman called the Hottentot Venus and at the same time know nothing? What the entrance of written history does in this moment is to reveal a known truth. Those who record and preserve history have often overlooked the black body. Ironically, the end result of these historical figures' overlooking of Baartman's body is that they fail to adequately represent her.

Reclaiming the Black Body

In her review Jean Young identifies Parks's representation of the black body as the play's tragic flaw. It is not difficult to side with Young. Imagine witnessing the performance of *Venus* at the Yale Repertory Theatre. Not only does Yale, as does every collegiate institution of a similar age and prestige, have a fraught relationship with the history of black captivity and the equal treatment of women, but there is also the fact that sitting alongside you are predominately white patrons who paid significant sums of money to witness the event.[36] This is the bite in Young's critique. She sees the replay of history in the very presence of white audiences paying to see a black female body appear on stage as an exhibit of otherness. Interestingly, a similar argument can be used against Robbie McCauley and Jennie Hutchin's *Sally's Rape*, a performance piece examined later in this chapter. Young's response begs the question: can a play like *Venus* create an opportunity to reclaim and refashion a more positive image of the black body? Young would say no. To her,

Parks reobjectifies and recommodifies Baartman. Parks, like Cuvier, packages Baartman and displays her to the masses for a price. Young's conclusion anchors itself in her reading of the historical inaccuracies of the Foreman production and Parks's display of Baartman. Both offend her. It is not difficult to understand her offense. I am offended whenever I work with Zealy's daguerreotypes or the photographs of lynched and burned black bodies. These images always remind me of the day when I, as a child, discovered a book on my parents' bookshelf turned to the image of a black body, Willie Brown's body, burning before a crowd of white men dressed up for the evening/event and posing before the camera and the body, and realized with horror that that body—that body there—could be my own.[37] Young's reaction is justified. It is not, however, the only reaction. Whereas Young finds the play offensive, Michele Wallace thinks of it as "fun." The fact that Wallace views Venus differently simply gestures toward the imbrication of black habitus, black memory, and the personal nature of visceral response, which itself emerges through differing learned experiences of blackness. Where does such a reaction belong in academic discourse? As I tell my students, you must begin with your "gut reaction" and then work outward. You must return to the body.

Worthen, despite his general disagreements with Young, briefly sides with her when he notes that history—or at least, the history represented within *Venus*—cannot be reclaimed. Although Worthen makes repeated reference to history, it is worth noting that his "history" is textual: written and recorded. Within *Venus*, it is the textual traces of Baartman's very existence and exhibition. It is the lectures conducted by Cuvier, the court transcripts, and other similar records. These traces specter the body. They mark its prior presence and its "It's right here before my eyes" status. In many ways, history (the text) becomes the body of Baartman. She is the text made flesh. Can we take back this history? Not according to Worthen. He believes that the very condition of theater prevents this from occurring. The theater, a place for seeing, ultimately re-creates the body of Baartman as a spectacle. Rather than reclaiming the body, it recapitulates it. He writes, "Performance can surrogate history, metaphorize it, cite it, but not reclaim it, at least not this history: it is too closely bound to the rhetoric of performance itself—'don't look'—a rhetoric that determined how Saartjie Baartman would enter history."[38]

While the theater certainly makes the look apparent, the presence of the look does not rule out the possibility of reclaiming embodied experience.

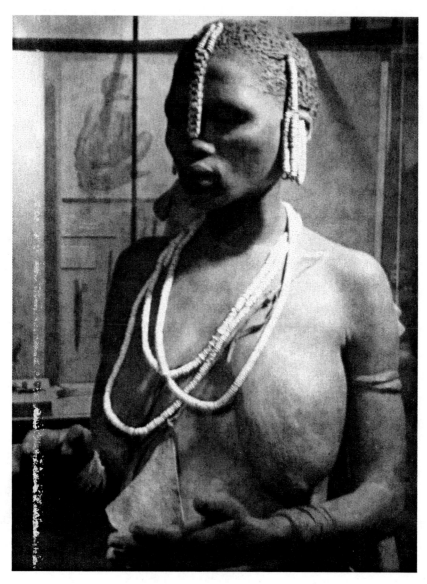

Khoisan woman. Photograph by author.

The drawback with the proposal outlined by Worthen and Young is that the theater can only reobjectify the black body. Part of the confusion may rest in the word *reclaim*. Worthen uses it to connote historic erasure followed by a rewriting. There is the feeling that a successful reclamation consists of audiences being able to see the character Baartman onstage without being ghosted by the lived reality of Baartman. However, there is an alternate way to consider theatricalized efforts to engage with and, ultimately, to reclaim aspects of the past. The black body, the accumulated and repeated similarities of the embodied experiences of black bodies, is a body that is made to be given to be seen. It is a projection that is always on display, always on stage, and always in the process of its own exhibition. In light of this past, present, and *futured* condition of the black body, it is not sufficient to say that the framing of theater can only repeat what occurs in everyday life. Support for this contention threatens to ignore all of the future possibilities of black bodies onstage and seems to suggests that the body can only be a historical body replayed.

Re-claiming does not require that we erase the past and script a new one. The prefix tells us this. To reclaim is to take something back. It is to possess something in the present while knowing that it has only recently been back in your possession. It is to remain aware of its previous "claims" even as you articulate your own. It is to know the past in the present as you work toward creating a future. Read from this perspective, Parks's play allows us to reclaim, to take back, and to know the passed/past in the present for the future. On a variety of levels, it enables us to claim the experience of Baartman and the other, lesser-known women who were subjected to the title "Hottentot Venus." First and foremost, Parks's play, to echo Wallace, encourages us to focus on an often-overlooked body part and to understand its historical significance. The centrality of exposed flesh, including but not limited to the buttocks, reveals that there is an originating point—the body—in the experience of the black body. It is the presence and recognizability of the black body within the medical theater, in the boxing ring, before the camera, and on city streets that spark an experience of phenomenal blackness.

Second, we need to consider the physical movement of the remains of Baartman from the Musée de L'Homme. After nearly a decade of negotiations, the skeleton and plaster cast of Baartman were finally returned to the Khoisan people of South Africa. Back "home" and given a long overdue burial, the remains are no longer on display, and the almost two-hundred-year

show has ended. As Parks, employing her characteristic spelling, declares, "There wont b inny show tuhnite." Despite the fact that the remains were returned several years after Parks's play was first produced, the process of reclaiming them had begun before the play had even gone into production. It seems logical to say that Parks—in light of the abundant research required to write the play—had to have been aware of the efforts of the Khoisan people and the South African government to reclaim Baartman's remains. Whether the final lines of the character Baartman were written merely to give an update on the location of Baartman's body or to spur those in attendance to support the Khoisan–South African cause, the fact remains that the playwright reminds us that even as the character Baartman's exhibition is ending before the theatrical audience, the real Baartman—even in death—continues to be on display. The character Baartman, referring to herself at the end of the play, declares, "Loves corpse stands on show in museum. Please visit."

An *American Theatre* article by Shawn-Marie Garrett hints at yet another way of understanding the process by which Parks reclaims embodied histories. Referring to Parks, she notes, "Her theatre of history, then, unlike August Wilson's, is a space of simultaneity. History for Parks is not necessarily a progressive experience, or even a set of finished events that can be divided and dramatized by decade. The pain of the past that has never passed is precisely what sharpens the bite of her wicked satire."[39] Reviewing the final words of the character Baartman, we can see that her exhibition continues. There is no absolution in death. "Loves corpse stands on show in museum." In these words, we can see that history has been paused but has not passed. The result is that Baartman, a historical figure of the past, has not passed but remains paused in the moment of her exhibition. What Parks succeeds in doing throughout the play is animating the still body of Baartman. This is why the play begins and ends with the character's still stand and the pronouncement that "Thuh Venus Hottentot iz dead."

Finally, the reclaimed status of the embodied experience of Saartjie Baartman anchors itself in her request that we "Please visit." Why does she want us to visit? After all, one might think that more spectators would only heighten the feeling of objectification and commodification. Even the play, according to Young, does this as a replay. It reobjectifies and recommodifies her. Is this her aim? The answer may rest somewhere between Parks's need to converse with the dead to tell their stories and our need to rewrite history by digging it up in order to encounter our paused passed/past. To converse

with history is to both see it—as imagined, remembered, and/or reenacted—
and to be touched by it. Literary critic Hershini Bhana Young offers an elo-
quent description of this process, in relation to Saartjie Baartman:

> The black body is thus always a collective as it remembers both its ghosts
> and that which has traumatically marked it as Other. The artificiality of the
> appendage that conjures up Baartman's ghost speak to the weight of vio-
> lence that has inorganically fragmented and reconstituted the black body,
> creating a racialized creature with phantom limbs. This body, overburdened
> by the discourse of race and representation that created its blackness in the
> first place, can only survive by acts of (aesthetic) identification that create
> community.[40]

In *Haunting Capital,* Young champions a similar conception of the black
body but develops it through a literary analysis structured upon trauma the-
ory and accounts of ghosting. Although the author privileges a reading of the
experience of the black body as being phantasmic, she similarly acknowl-
edges that an engagement with embodied black experience offers access to
the "weight of violence" that frequently accompanies the black body. The act
of conversing with history—of passing on stories—invites a consideration of
that violence. It enables that weight to be encountered, recognized, and,
eventually, shared. An example of this appears in Robbie McCauley and Jen-
nie Hutchins's *Sally's Rape,* in which McCauley shoulders the "weight of vi-
olence" that was directed toward her great-great-grandmother.

Touching History

Sally's Rape, Robbie McCauley's 1992 Obie Award–winning performance
project, roots itself in the presentation of two women, one black (McCauley)
and one white (Hutchins), who, initially over tea, civilly discuss various as-
pects of their lives and upbringing. Interspersed throughout these vocalized
nostalgic retreats are several moments where McCauley recounts, and to a
certain extent relives, the experience of her great-great-grandmother, Sally,
who was sexually assaulted on the ground(s) of a Georgia plantation. Al-
though the recounted and represented act appears in only two of the ten
scenes, it remains central to (and centered in) the play. The title of the per-
formance project draws itself from the assault, remembered; and the various

nostalgic conversations that revolve around childhood, etiquette, and distant memories exist as a counterpoint to the experience of Sally. In this section, I investigate how the body touches history and how history touches the body. How does, for example, the black body experience the embodied histories of prior bodies? I question: how does the passed become *futured* across present bodies?

On a certain level, the body is the futured history—the future made past—of a prior body. My body is the futured body of my great-great-grandmother, my great-grandmother, my grandmother, and my mother. It is the future manifestation of my ancestors' bodies viewed from a past perspective in which the future past, the futured, is the then-present that is now. To look at my skin, my own body, and my image reflected in a mirror is to see not only me—standing there looking at myself—but also to view the various parts of these other bodies that ghost my own. I am the embodiment of their experience of the body. I am the causal result of their bodily activities. Of course, my body will never be the same as their bodies. They are many and I am but one. Differences will exist. However, it is my body, as the site of similarity, where we come together.

Robbie McCauley's body is her ancestral body. It represents, and indeed re-presents, the bodies and the embodied experience of her ancestors whose previous actions invoked her current presence. McCauley, herself, confirms this connection early within *Sally's Rape* when she asserts, "I become others inside me."[41] Among the many "others" inside her stands Sally, McCauley's great-great-grandmother. Within the performance project, McCauley reveals to her audience that the experience of Sally haunts her in the present. In dreams, she not only remembers Sally and remembers Sally's experience of the body, but also believes that she has become Sally and shares Sally's experiences of the body in the moment of the sexual assault. She declares, "In the dream, I am Sally down on the ground being done it to."[42] McCauley can access and replay the experience of her great-great-grandmother, in part, because the embodied experiences of Sally were always already in the performance artist's body. Standing before an audience, four generations after the assault, McCauley exists as evidence (the stain) of the rape act. She is its futured remains. She carries it with her because it is her. It is an experience of the body that she may not have personally experienced, but it is an experience of the body (of Sally's body) that constructs her person. If the assault had never occurred, then McCauley would not be here to talk about it. Without

the rape act, there would not be a Robbie McCauley. Her experience of the body began the moment that the plantation "master" assaulted Sally. Her future was located in this past enactment. This is why she can "be" Sally.

When McCauley does re-present the "rape" of her great-great-grandmother within the context of a dreamt remembrance, it is important to note that Hutchins does not play a role. Interestingly, the sexual assault is recast and remembered as a solitary act. McCauley, alone, replays it. Rather than perform the moment of the assault, the performer presents the assault as an aftereffect, a happening that happened and now is being reviewed within the context of a remembrance. Within the performance of the remembered encounter in which McCauley is "bein'" Sally "being done it to," there is not an aggressor. There are not any movements or physical gestures to give the impression of the rape act occurring onstage. Neither is there an attempt at introducing a real (visible, onstage) or imagined "master." Instead, McCauley sits naked, wrapped in a blanket, and remembers the "rape." This remembrance combined with her posture establishes the action as an aftereffect. It happened but its reverberations can still be felt. The echo of the rape act appears in the language that the performance artist employs to describe her dream of the assault. She declares:

> In the dream I. I am being Sally. Bein' bein' I . . . I being bound down I didn't didn't wanna be in the dream, bound down in the dream I am I am Sally being done it to I am down on the ground being done it to bound down didn't wanna be bound down on the ground. In the dream I am Sally down on the ground being done it to. In the dream I am Sally being done it to bound down on the ground.[43]

The echo of the remembered assault can be heard not only through the repetition and fragmentation of the central phrase "I am Sally bound down on the ground being done it to" but also through the similar sounds of the often repeated words *bound, down,* and *ground.* Together these recurring elements create a loop in which the experience of the sexual assault continually returns to be experienced again and again. We can think of each sentence in the preceding excerpt as the point where the cycle repeats. In the dream I am Sally down on the ground being done it to. What does it mean for the experience of Sally to repeat? To repeat across generations? To repeat within the frame of theater as a representation of an actual, prior moment?

Although the experience of Sally that gets replayed in the preceding excerpt is certainly singular—it pertains strictly to Sally—the experience created by the replay, the performance of McCauley's dream, is multiple and variable. Several factors contribute toward the widening of this experience of a single body into an inclusive arena for multiple bodies. On one level, McCauley can imagine and approximate her great-great-grandmother's reactions in the moment of and following her sexual assault. Her ability to access this experience in a tangible manner begins with her realization that she must work backward, commencing with herself as the remains of the performance, the rape, until she can reach the original act itself. This movement toward reclaiming the past from a past perspective located within the future, a future that is passed, gets complicated when we realize that the remains from which she began were created not only by the experience of Sally's body but also of the unnamed, within the performance project, "master." When McCauley replays the moment of the assault, as an imagined reenactment, a dreamed remembrance *and* an aftereffect of having been done it to, what she accesses is not only the first-person thoughts of Sally but also the first-person thoughts of the "master," her great-great-grandfather. Although McCauley's approximation of Sally's experience of the body gets voiced within the project, the experience of the "master's" body remains unspoken despite the fact that it provides the actions to which McCauley's Sally reacts. We can imagine the voice and remembered experience of the "master," who also resides within McCauley, as providing the antiphony to McCauley's dream remembered:

> In the dream I. I am being Master. Bindin' Bindin' I . . . I binding down I didn't didn't wanna be in the dream, binding down in the dream I am I am Master doing it to I am down on the ground doing it to binding down didn't wanna be binding down on the ground. In the dream I am Master down on the ground doing it to. In the dream I am Master doing it to binding down on the ground.

This inversion clarifies an aspect of McCauley's performance. It suggests that McCauley, caught between the experiences of both of her ancestors, does not comfortably inhabit either one. Within *Sally's Rape,* she imagines the experience of her great-great-grandmother and expresses her desire to escape both the dream and the re-created moment of the rape act. She states, "I

didn't didn't wanna be in the dream," and later, "I didn't wanna be bound down." While the experience of rape, as remembered and imagined, provides a likely explanation for her discomfort, it could also be asserted that McCauley has difficulty imagining and re-creating an assault between two bodies who dwell within her own. In the inversion of the remembrance in which McCauley becomes "master," we can make a similar argument concerning the discomfort generated over assuming the role of, in the dual sense, ancestral rapist: a rapist as an ancestor and a rapist who assaults an ancestor. Although the ambivalence of the "master"—didn't wanna be binding down—in this imagined scenario does not accord with popular representations of such "masters," the fact remains that within McCauley's performance project the actions from which it draws its title occur between her great-great-grandmother and her great-great-grandfather. When remembered through her body as both the screen across which the dream gets played and the remains of the act that the screen seeks to capture, the rape of Sally invokes the presence and experience of both Sally and the unnamed "master."[44]

The absented presence of the "master" within the performance project encourages the widening of the experience of Sally to include more than just Sally, McCauley's great-great-grandmother. The performance artist herself initiates our move toward such a reading in both *Sally's Rape* and within its preface when she introduces another Sally, Sally Hemings, the captive and mistress of Thomas Jefferson. Sally Hemings, like Sally, was also "raped" by her "master." McCauley, in the preface to her play, writes: "I'm going against the myth of the romance of the slave master and the overseers with the slave women, even Thomas Jefferson. I'm going against the myth because it was a power thing, so we call it rape. Sometimes it was actual, brutal rape; sometimes it might have been romantic. It doesn't matter. It was a rape that happens in those power situations."[45] To McCauley, rape includes not only an act of forcible aggression against one's will but also seemingly consensual relationships in which the two participants widely vary in terms of symbolic capital. Despite the fact that the relationship between Jefferson and Hemings is considered to be loving and romantic within the popular imagination, McCauley reminds us that Hemings was Jefferson's captive and begs us to ask whether a loving, romantic relationship could exist under such conditions.[46] Although Hemings lived in the eighteenth century and may have consented to her relationship, and McCauley's ancestor lived a century later

and may not have consented—as evidenced by her imagined protestations—there are several obvious similarities between the two women. They were named Sally. They were sexually involved with their "masters." They bore children by their "master." Clearly, the experience of Robbie's Sally is not unique.

The similar, repeating experiences of both Sallys reveal how history operates as a replay across the black body. *In the dream, I am being Sally.* Sally's experience repeats that of Sally Hemings. Sally Hemings's that of her mother, Elizabeth Hemings, and her grandmother (whose name escapes recorded history). Sally Hemings's grandmother was an African captive who was sexually involved with the English captain, Captain Hemings, who oversaw her transport from Africa to the Americas. Once she was in the United States, John Wayles purchased the now pregnant African captive. Shortly thereafter, Elizabeth (Betty) Hemings was born and her parentage was discovered.[47] Many years later and after the death of Wayles's third wife, the plantation "master" took Betty Hemings as his lover and fathered six children, including Sally, by her. These children, always considered to be servants, were raised alongside his other (white) children from his previous marriages. When Wayles's (white) daughter Martha married Thomas Jefferson in 1772, Betty and her children, Martha's illegitimate stepmother and half-siblings, moved to Monticello, Jefferson's estate, to live with them. Following Martha's death a decade later, Jefferson took Sally as his lover and fathered at least one of her six children. Reviewing Hemings's genealogy, it is difficult to ignore the repeated similarity of the liaisons of plantation masters—Captain Hemings, John Wayles, and Thomas Jefferson—with black women. It happens again and again and again over at least three consecutive generations.

While there are few narratives by black women that document the earliest instances of such liaisons, the fact that they did occur can be seen in many of the surviving, recorded court proceedings and legislative acts of colonial America. In 1630, eleven years after the first black captives were brought to Jamestown, Hugh Davis, a white settler in the Jamestown colony, was charged and punished for being sexually involved with a black captive. It was ordered that Davis "be soundly whipped before an assemblage of Negroes and others for abusing himself to the dishonor of God and the shame of the Christians by defiling his body in lying with a Negro."[48] With public punishment not curbing racial intermixture and the increasing number of mixed-

race childbirths, the Virginia Assembly needed, in 1632, to officially determine the status of these offspring. The result was the following decree: "Whereas some doubts have arisen whether a child got by an Englishman upon a Negro should be free or slave, be it therefore enacted by this present grand assembly, that all children born in this country shall be bound or free according to the condition of the mother."[49] With the decree, sexual relationships no longer appeared to carry the immoral signature evident in the earlier ruling. It also deemed such relationships and the products of such liaisons to be potentially profitable. The black female body became the site for both pleasure and profit for the "master." Literally, he could profit from his pleasure.

Although the legislature, relying upon popular (conservative) notions of white femininity to prevent the liaisons of white women with black men, unknowingly opened the possibility that white female abolitionists could have a series of relationships with black men and populate the colony with free mulattos, it closed the door in 1691 when it created a new law declaring that a white woman who had a mixed-race child had to pay a fine to the church and that the child would be taken into slavery until the age of thirty. The goal of the legislature was clear. Racial intermixture was permissible, moral, and profitable when it involved a white male and a black female. In light of the fact that these encounters were protected both by law and by the privacy of the plantation setting, the question arises: How many women had an experience similar to Sally's? The fact that the Virginia State Legislature, in an effort not to disenfranchise its leading and oldest families, passed a law, in 1785, that a person with less than an eighth black blood was white reveals the widespread nature of racial intermixture within the period. This law contrasts with the ones enacted a century later in which "one drop" of black blood or the presence of one black ancestor was all it took to be considered legally "black." What the earlier law reveals—something that legislators later disavowed—is an awareness that racial intermixture occurred often and that very few people, if anyone, were racially pure.[50] Clearly, the experiences of Sally, Sally Hemings, Betty Hemings, and Betty Hemings's mother were not unique to them. How many Sallys were there? How many of us, both black and white, have a Sally in our past? It is difficult to conceive of the experience of the black body or phenomenal blackness without these histories of assault. It is an experience that was not limited solely to women. While black men had access to the abuses of their female ancestors, they too were the tar-

gets of sexual assault. In addition to the more frequent accounts of the sodomizing of the black male body as part of a lynching campaign, black males were the targets of sexual abuse within the era of black captivity. The protagonist (Simon) in Tanya Barfield's play *Blue Door* is a black slave who was repeatedly abused by his "master."

The touch of history on the black body appears not only in the realization that McCauley's body is her ancestral body, but also in the performance artist's figuring of her body in a historically significant manner. Specifically, she replays the moment of the auction block within *Sally's Rape*. Occurring as a prologue of sorts to her dreamed remembrance of Sally's experience, the auction block scene begins with McCauley quickly and unnoticeably standing on a block and dropping her sack dress. Her ascension, as does her nudity, catches the audience unaware and by surprise.[51] At the moment that the audience begins to understand what has happened, Hutchins goads them into chanting, "Bid 'em in." As the group, repeating the phrase, speaks, their collective voice gains strength. Bid 'em in. Bid 'em in. Bid 'em in. The words of McCauley in this moment prove less significant than her physical position. Her body speaks. In re-creating the moment of the auction block before a theatrical audience, the performance artist collapses the temporal distance between herself and those who were forced to stand on the auction block. Her body becomes representative of their bodies. Her body becomes an example of the black captive body on display. Beyond the external association of nudity, the similarity between the two temporally distinct performances appears through the foregrounding of the auction block itself. The auction block, from an African American cultural perspective, is an American icon. It represents the black body being stripped of its individuality and displayed, as a commodity, for the highest bidder. Captives on blocks do not have names; they have (lot) numbers. When McCauley ascends her block and drops her dress, she catalyzes our memories of the auction block as a site of black oppression. On the block, she is no longer Robbie McCauley, a performance artist whom an audience has paid to see. She absents herself to reveal an experience of the black body, which rejects the specificity of a name because of the commonality of its history.

In *Conjure Women*, a documentary film featuring McCauley reflecting upon *Sally's Rape*, the performance artist asserts, "I am interested in breaking silences about things that are hard to talk about." The experience of black captivity and the memories of the abuse of black bodies comprise the

difficult subject matter of her play. In making this statement, McCauley aligns herself with cultural theorist Houston Baker. She underscores the importance of critically mining black memory. She agrees that everyone needs to engage with and reflect upon the embodied black experiences that continue to structure social relationships. Risking not being "liked," the performance artist dares to shift the nature of her civil conversation with Hutchins. She activates the memory and experience of the decidedly uncivil treatment of her ancestors and shares them with Hutchins and her audience. McCauley demonstrates Hershini Bhana Young's assertion that to "pass on a story, to enter the portal of re-memory where the past, present, and future come together, often means the inheritance of injury."[52]

The power of *Sally's Rape* is rooted in the reenactment of the abuses of black bodies on stage. It emerges through McCauley, standing naked on a block, as audiences gape and stare and chant and gasp and respond in a host of other ways. It is within these moments that the reverberations of history—the echoes of phenomenal blackness—can be felt. Standing still before the audience, McCauley becomes not only her great-great-grandmother but also Saartjie Baartman and all of the other women who were called "Hottentot Venus." Despite the fact that her performance mirrors the exhibition of Baartman and the thousands of black bodies who were forced to stand as "lots" in auctions, McCauley controls the larger frame within which she appears and, in so doing, encourages those who witness her performance to read the black body from her perspective. In the course of the performance, she addresses her audience and declares, "I wanted to do this—stand naked in public on the auction block. I thought somehow it could help free us from this." The stage directions reveal the "this" to be "her naked body." McCauley volunteered to stand on the auction block and, in so doing, to open the floodgates of black memory associated with this bodily positioning. Her performance invites comparison with Muhammad Ali, who similarly subjected his body to inspection and, later, stood still in order to fashion a new understanding of the black body. However, McCauley's stand does not "free us" from the black body. To the contrary, her presence onstage reminds us of the ways in which the black body structures the everyday experience of black folk. It only takes her nude body on stage to jog memories of black captivity. Her presence and the meaning that it creates within *Sally's Rape* reveal the persistence of the idea of the black body as a projection frequently applied to individuated black bodies.

In her play *Yellowman,* Dael Orlandersmith similarly mines the influence of the past on the present. Although her protagonist, like McCauley, strives to break free from the experience of the black body, the play stages the passing of the "inheritance of injury" from one generation to the next.

Shouldering History

In *Yellowman,* playwright and actress Dael Orlandersmith, following in the footsteps of Suzan-Lori Parks and Robbie McCauley, remembers and stages the bodies "being done it to." The play's core characters, the "lithe bodied" and "extremely light-skinned" Eugene and "large-sized . . . medium brown" Alma, encounter, react against, and, ultimately, embody societal prejudice that manifests itself in the form of internalized race-based self-hatred and intrablack racism. The drama of the play anchors itself in how the characters, who were childhood friends who later became lovers, were indoctrinated by the racist rants and tirades of their relatives. It is harrowing to watch as the young, innocent, race-blind Eugene and Alma are subjected to their parents' stereotypical conceptions of blackness. Emphasizing the influence that adults have on their children, the same actor often plays parent and child.[53] Alma's mother, Odelia, spews gin-fueled critiques of her daughter's blackness that emerge from and target the same body. At regular intervals throughout the play, Odelia tells her daughter that she is an "ugly black thing." Apparently, the bodies *being done it to* are doing it to themselves.

Commissioned by the McCarter Theatre and developed over two consecutive summers at the Sundance Theatre Lab beginning in 2001 under the supervision of Emily Mann, *Yellowman* fuses Mann's theater-of-testimony style with Orlandersmith's tendency to meditate on societal racism within her performance projects. The result is an engaging play built upon long, descriptive, and, at times, repetitive monologues that give the piece not only a documentary feel but also a revealing insight into the psychological interiority of the play's characters. Similar to Orlandersmith's solo works *Beauty's Baby* and *My Red Hand, My Black Hand,* the play prompts its audience to ask: What does it mean to be *raced,* to be visibly marked as a racial other, within contemporary society? In contrast to her other works, Orlandersmith's *Yellowman* features a second performer who shares the stage with the play's protagonist, Alma. According to the playwright, the performance piece

was expanded to include two actors with the explicit aim of making the play more palatable to regional theaters that were reluctant to program one-person performance pieces and, perhaps, were less likely to include a one-woman show featuring a darker-skinned, full-figured black woman.[54] From the beginning, the play proved to be a critical success. Of the plays discussed in this chapter, *Yellowman* garnered the most positive reviews and had the greatest commercial appeal. It was named a finalist for the 2002 Pulitzer Prize in Drama (losing to Suzan-Lori Parks's *Topdog/Underdog*) and won Orlandersmith the 2002–3 Susan Smith Blackburn Prize, an "award given annually to a woman who deserves recognition for having written a work of outstanding quality for the English-speaking theatre." Why was the play so well liked, and apparently so widely? If the story of a white French doctor's thinly veiled lust for a black African woman whom he eventually would dismember and the portrayal of the experiences of a black captive being bid on and later sexually assaulted by a plantation "master" did not invite widespread critical acclaim, then what was so inviting about the problematic love affair between the light-skinned Eugene and darker-complexioned Alma that results in murder and a willful miscarriage? Is it that same-race liaisons are less threatening to theatrical audiences than miscegenation?

One explanation often cited for the play's critical success is its ability to honestly depict the damage created by self-hatred. Consistently, reviewers asserted that *Yellowman* audiences, regardless of their race, skin color, nationality, sex, gender, or bodily shape, could identify with the issues at the heart of the play. *Curtain Up* reviewer Karen Osenlund, having attended the 2002 premiere productions at the McCarter and the Wilma theaters, observed that the character Alma "fights the negative self image that most of us experience, whatever sex or color we are."[55] Referring to the reactions of fellow spectators at the performances, Osenlund wrote, "You can feel the recognition in the audience." Claire Hamilton, reviewing a 2004 production that did not feature either Orlandersmith or her costar, Howard Overshown, at the Everyman Playhouse in Liverpool, England, contended that "the story may not directly reflect your own experience, but I defy you to leave the theatre unmoved or unashamed at the prejudice that corrupts the human spirit in all walks of life."[56] That same year, in a different production that also did not feature Orlandersmith or Overshown at Arena Stage in Washington, D.C., theater critic Peter Marks observed:

The play harbors intimations of "Romeo and Juliet": Does anyone in Verona remember the root cause of that "ancient grudge" between the Capulets and Montagues? Indeed, you could substitute Alma and Eugene for any couple anywhere, from Belfast to Belgrade, that has had to run the gantlet of inter-family opposition.[57]

Although a few theater critics cautioned prospective audiences about the severity of the language, the plentiful racial epithets strewn throughout the play, and, in one instance, advised against bringing young children to the show, the majority praised both Orlandersmith and her play for offering a truthful, recognizable, and relatable drama about the anxieties related to self-image or familial tensions.

I am intrigued by these repeated suggestions that anyone who has had an anxious moment related to her own self-image or familial dysfunction can identify with Alma, because they consistently downplay the specific, racialized experience addressed within the play. Faedra Chatard Carpenter, in her investigation into "anxiety provoking" moments in performance projects involving color consciousness, offers an insightful study of the varied negative reactions that specific audience members had to *Yellowman*. Rather than privileging newspaper columnists, Carpenter interviewed theater historians who witnessed multiple productions of the play and were attuned to the reactions of fellow audience members. Among the recounted experiences privileged within her study, the author incorporates her own memories of watching the 2004 production of *Yellowman* at Arena Stage, the same production witnessed by Marks.

Upon arriving in the theatre I was immediately struck by the sight of several white patrons trying to sell their tickets in the theatre lobby. I had never witnessed this in a regional theatre before. . . . From that point on I became very aware of audience reaction. Not only did I notice the blank expressions, but there were many seats that emptied at intermission, never to be filled again . . . what I found most disturbing in terms of audience reaction was not the early departure of some white audience members, but rather the multiple moments of inappropriate laughter that erupted from black audience members.[58]

Carpenter's experience suggests that some critics (perhaps Marks?), in an effort to highlight *Yellowman*'s broad audience appeal, might have overlooked

the specific, visceral reactions that spectators were having to the play and were staging within the space of the theater. Select patrons traveled to the theater in order to create a public show of their unwillingness to witness the performance. Others, having weathered the first half of the play, opted to leave. In the two favorably reviewed productions of *Yellowman* that I attended in 2004 in Chicago and in 2007 in upstate New York, I did not observe anyone attempting to sell their tickets. However, a significant percentage, possibly as many as 25 percent, of audience members did not return for the second act of the Chicago production. Although the motivations for the Arena Stage's spectators' decision to sell their tickets or leave early are unknown, the limited number of explanations range from having extra tickets to the show (which still implies an unwillingness to see the production), to the late hour of the show, to a desire not to witness a production with racial/racist overtones. The patrons at Arena Stage who either deliberately or inadvertently created a public spectacle of their resistance could have assumed that the play, involving issues of embodied black experience, would cast them, as Robbie McCauley did in one memorable moment in *Sally's Rape*, as the race villain, the slave auctioneer or, worse, the plantation master. This does not happen within *Yellowman*. What greets the spectator, regardless of race, who enters the theater is the history of bodily abuse and the historical weight of racist stereotypes and caricatures condensed into language and then deployed, like weapons, by Orlandersmith's characters. The result is a theatrical experience that can overwhelm, offend, and prompt a desire for escape—whether physical departure or laughter. While Carpenter does suggest that the "inappropriate" laughter likely resulted from the women's own discomfort with the material presented within the play, the profound impact of their laughter on Carpenter and, perhaps, other audience members rests in the fact that bodies that share a similar history of oppression and are substitutable for the abused body on display *appear* to derive pleasure from the enactment of abuse. Imagine a black spectator laughing at—or, in the face—of Drana, Bootjack McDaniels, or Saartjie Baartman. The laughter heightens the feeling of vicarious victimization potentially felt by other spectators.

Orlandersmith scripts these heightened moments within *Yellowman*. Every time the actress playing Alma becomes Odelia and equates blackness with bigness and ugliness, she *appears* to derive pleasure from an insult. The characters seem to be laughing at themselves. This, according to Nicole Fleetwood in her *Theatre Journal* review of the 2002 production of *Yellow-*

man at the Manhattan Theatre Club, is the insurmountable problem of the play. Orlandersmith creates "a closed world of black on black discrimination" without addressing the larger, societal factors that led to the internalization of dominating stereotypes and prejudices.[59] Although the playwright does not explicitly center the structures of violence that undergird societal biases, she utilizes her "closed world" to reveal a palpable fear or anxiety of blackness that is symptomatic of a larger, social problem. The majority of her characters share a desire to protect their children (or grandchildren) from having to live the black experience within the United States. It is this goal that fuels a longing for "lightness" and prompts their actions. A pregnant Alma willfully aborts the child she carries because her child could share her skin tone. Eugene's light-skinned grandfather disinherits his darker-skinned son-in-law and names his grandson his heir—but only after he learns that Eugene and he are the same complexion. Odelia encourages Alma's relationship with Eugene but not with Alma's darker-complexioned friend Alton. Despite their varying skin tones, Orlandersmith's characters understand the complexities and complicatedness of embodied black experience. They have all been racially profiled by one another.

Orlandersmith introduces this theme and enables a reading of the commonality or, at least, the similarity of embodied black experience within Alma's opening monologue. Sitting "in a chair upper stage right on a raised platform talking directly to audience," Alma declares:

> My mother women like my mother and her mother before her toiled/ tugged the soil beside the men. They were dark and therefore not considered pretty/ . . . the men beat them/ leave them/ they ride them/ they don't make love to them/ they ride them/ the men/ always on top/ like my father/ they rode/ on top/ they rode/ they entered/ they shot their seed/ then left them. My mother/ women like my mother and her mother too/ ate it/ accepted it.[60]

With these words, Orlandersmith as Alma describes the experience not only of Odelia and Odelia's mother but also of "women like my mother and her mother before her." This reference to others who exist outside of the frame of the play and beyond the present moment serves as a reminder that those bodies being ridden and then abandoned—the ones *being done it to*—are not products of the playwright's imagination. Orlandersmith grounds these embodied experiences within real bodies who toiled, tugged, and tilled the

soil. While we might presume that the playwright locates these bodies within South Carolina, the setting of *Yellowman,* she does not definitively place them. Her silence invites us to be more inclusive and consider the hundreds of thousands of black bodies—captive, indentured, leased, and free—who worked the cotton, tobacco, and other agricultural fields across the United States.

Alma's monologue, linking black bodies, sexual assault, and the ground, invites a return to Robbie McCauley's frequently repeated phrase in *Sally's Rape:* "I am Sally down on the ground being done it to." The attention given to the ground, the soil, in the repeated victimization of the body in each, suggests that place structures the abuse and exploitation of the black body. Ongoing academic investigations of the treatment of black bodies within African slave "castles," onboard ships within cargo holds, and within the current prison industrial complex privilege this perspective. As background, backdrop, or setting, the plantation conditions the abuses of the black body, in part, because the productivity of the land was tied to the labor, in the dual sense, of those who cultivated it. Deborah Gray White in *Ar'n't I a Woman?* asserts that "some women of childbearing age plowed and ditched when they were pregnant," but the majority, owing to their "masters'" desire for "natural increase," were spared the arduous work assignments until they reached middle age.[61] Angela Davis offers a more colloquial account of the abuses of those who were forced to work: pregnant captives subjected to physical punishments were instructed to lie on the ground, with their enlarged bellies positioned in a previously dug hole, before being whipped.[62] The positioning of the "body down on the ground being done it" was meant to protect the captive's child and the master's investment. Does the transmission of embodied black experience, the socialization of blackness across generations, begin in this grounded, prenatal moment? Is the child also being whipped? Does the unborn child of a black captive sense her own captive status *before* she has been birthed?

In addition to prompting questions related to the socialization of blackness and revealing the entanglement of race, sexuality, and geography within a specific sociohistorical moment, Alma's opening monologue invites consideration of the play's situation of black women as unseemly, unloved sexual objects. Suggestive of the manner in which animals are mated for breeding purposes, her words establish black women in a past moment as depersonalized figures who are mounted, impregnated, and, subsequently, left. There

are historical precedents for Orlandersmith's depictions: the sexual assaults of black women on slave ships and on plantations by white sailors and plantation masters. In his 1789 autobiography, Olaudah Equiano, speaking of the treatment of "cargoes of new Negroes" by sailors and clerks in route to the Americas, recalls that

> it was almost a constant practice with our clerks, and other whites, to commit violent depredations on the chastity of the female slaves; . . . I have known our mates to commit these acts most shamefully, to the disgrace, not of Christians only, but of men. I have even known them to gratify their brutal passion with females not ten years old.[63]

A century and a half later, in 1937, W. L. Bost, a former captive who was interviewed as part of the Federal Writers Project, alluded to ongoing sexual assaults of black women committed by white plantation "masters" in South Carolina and North Carolina during the waning years of legalized black captivity. Bost observed, "Plenty of the colored women have children by the white men. She know better than to not do what he say. . . . If the missus ["master's" wife] find out she raise revolution. But she hardly find out. The white men not going to tell and the nigger women were always afraid to. So they just go on hoping that things won't be that way always."[64] The opening monologue in *Yellowman* gestures toward these experiences. It refers to the uncounted and uncountable numbers of assaults that occurred throughout three centuries of legalized captivity. The objectification and commodification of the black body lasted for so long and occurred within so many places that the black body's experience seems almost atemporal and ahistorical. It is against this backdrop that the decision to "accept"—but not to allow or to understand—the treatment can be viewed as a survival mechanism.

Unlike *Sally's Rape, Venus,* or the scenarios outlined in the preceding pages, *Yellowman* centers the relationships of black men and black women. There are not any white characters within this play. The sexual encounter described by Alma, in the opening monologue, occurs between black folk. What is the effect of casting black men, instead of white men, as the historical victimizers of black women? Influenced by Jean Young's disagreement with Richard Foreman's decision to cast a black actor to play the Baron Docteur in *Venus,* we can say that this decision scripts a new past, a new historical record, that absolves the white (male) body of its complicity in the abuse

of the black body. Indeed, when the play finds itself subject to negative crit-
icism, this is the point that is raised most often. Its presentation of a "closed
world," to invoke Nicole Fleetwood's phrase, cloaks the dominating structure
that positions the black body, both male and female, as object and victim.

Although Fleetwood makes a compelling point that the presence of black
bodies combined with the absence of white characters can be understood as
de-emphasizing the role that dominating society played in the structuring of
embodied black experience, there is a way of reading and thinking about the
play that does not lessen the complicity of the plantation masters, overseers,
and professional slave breeders among others in the abuse of the black body.
It is not accidental that the two characters are the results of differently com-
plexioned parents. Alma's mother Odelia is dark-skinned and her father
light-skinned. The opposite is true for Eugene. In addition, Eugene engages
in a sexual relationship with Alma, who, according to Odelia, is "ugly, black."
Although all of the pairings involve black bodies, they also gesture toward a
series of past sexual assaults, presumably (but not necessarily exclusively) by
white men upon black women. The lightness of Eugene, his mother, and his
grandfather, for example, exists as the by-product of the type of encounter
described by both Equiano and McCauley. Each character, like McCauley,
exists as a by-product (or stain) of that prior act and, as a result, carries both
the experiences of the light (and, at some historical point, white) and the
darker complexioned within themselves. While Eugene's grandfather's ge-
nealogical proximity to whiteness could explain his intense hatred of black-
ness, there may be another way of looking at this response. What led his
daughter and his grandson to covet that which he despised?

Providing counterpoint to Alma's spoken anxieties relating to her self-im-
age and Odelia's critiques of blackness, the desire for brown skin is an-
nounced by Eugene, as he recounts his first, teenage experience "making
out" with a girl, a "fair girl" who was introduced to him by his childhood
friend Wyce. He recalls thinking, "The girl is sweet and fine but Alma is
sweet and fine to me—I want this girl to be Alma."[65] Later, when he an-
nounces his desire for Alma and kisses her, he states, "Kissing Alma, I was
home—I knew I was finally home."[66] When they "make love," he takes care
"not to ride her" but to "make love to her."[67] He finds her "beautiful." Al-
though the play's centering on Alma and Eugene prevents any sustained un-
derstanding of the nature of the relationships involving the other characters,
there is a brief moment when Thelma, Eugene's mother, explains her attrac-

tion to Eugene's father. His father, according to Thelma, "is one of the gentlest human beings there is."[68] Black gentleness stands in contrast to the white (sexual) violence in each character's ancestral past. These statements in support of the beauty and desirability of blackness are significant because they reveal that Eugene and Thelma covet the type of blackness that Alma seeks to escape. What is the source of their longing? It could be steeped in an effort to recover some lost part of themselves (i.e., their blackness). It could be to create darker and darker progeny whose appearance at some point in the future effectively would disavow the appearance and, perhaps, the actions of the "master," overseer, or breeder. Or it could be the embodied lust of the "master," overseer, or breeder (re)asserting itself.

Black Like Me?

Dael Orlandersmith, in a series of interviews, has asserted that *Yellowman* is not autobiographical. "Everyone assumes that [it is autobiographical] because I'm in it," she noted in a 2002 interview.[69] According to Joyce Paran, the McCarter dramaturg who worked on the play, Orlandersmith "is pretty adamant about thinking of herself as an artist telling a story."[70] Although the playwright admits that the play is "very, very loosely based upon a family" whom she encountered in South Carolina, the rest is pure fiction. Any suggestion that the play reflects her own experiences or, more generally, engages the experiences of the black body, in Orlandersmith's eyes, is a complete misreading. In several interviews, the playwright makes a concerted effort to identify herself as apolitical within her plays and to promptly end any assertion that she speaks for or seeks to document the history of black people. In the same 2002 interview, she declares, "My background may not be similar to another black person's background. . . . Certainly, there is a given history, but we are also individuals. And when people expect us to write about the same thing, I have a major problem with that." Despite the playwright's desire to be seen as an artist capable of inventing a fully realized scenario, it is difficult to ignore the resonances and resemblances between elements of the play and her own life.

Even as Orlandersmith cites her experiential differences from other, unnamed black bodies, her similarity to her character Alma is unmistakable. The playwright has revealed that the first play that she saw, as a child, was *The Great White Hope,* premised on black heavyweight boxing champion

Jack Johnson, whose color renders him an outcast in society and whose romances with white women led to criminal prosecution and eventual imprisonment.[71] How impactful was this play's staging of black vice and white desirability on her young mind? More recently, the playwright has said that her entrance into the theater was prompted by her difficulty being cast in commercial television and film. The industry, according to Orlandersmith, desires lighter complexioned actresses: "A Halle Berry, a Jada Pinkett—lighter-skinned actresses are working more so than darker-skinned black actresses. . . . And darker-skinned people are made to feel ugly because they are dark."[72] It is difficult to imagine Orlandersmith not identifying with her own protagonist's racial anxieties.

Her anxieties (if any) could have been heightened by the critical reception of her performance as Alma. Despite the fact that the playwright has noted that she only added a second performer to *Yellowman* to increase the odds of it being produced in regional theaters, her lighter-complexioned costar (Overshown) consistently received higher praise by theater critics. While the majority of reviewers lavished praise on both actors, several intimated that Orlandermith, despite being an experienced solo performer, appeared tense, anxious, and never entirely at ease on stage. David P. Stearns, reviewing the 2002 opening night production at the Wilma Theatre, suggested that the playwright's seeming discomfort could be located in the autobiographical nature of the play.

> The playwright is also the star, and knowing that there have to be some autobiographical elements (both character and creator attended Hunter College, for example), you wonder how she can stand to relive this pain-steeped narrative on a nightly basis. During bows, as costar Overshown was smilingly receiving applause, Orlandersmith remained visibly shaken. The run of this play has only just begun. Pray for her.[73]

In the critical reviews of Orlandersmith's prior performances, including *The Gimmick* (1996) and *Monster* (1999), there is not any indication that the actress does not control the stage. It is conceivable that the subject matter of *Yellowman*, possibly a reflection of the playwright's experience, could have affected the manner in which she approached the role. Having to carry and endure the "weight of violence" and an "inheritance of injury" throughout an evening's performance, the performer could have been exhausted by the

emotional and physical toll of playing Alma. It is also possible that the presence of Overshown may have compelled the solo-performance artist to adapt her style to accommodate another presence onstage. This could explain her apparent discomfort.

What is fascinating about the critical reviews of Orlandersmith's early performance projects, especially those written by Peter Marks, is the attention that they direct toward her body. Marks, in his review of *Monster*, writes, of Orlandersmith, "It is impossible not to empathize with the character as she stands on a darkened stage, her ample figure filling every inch of her black leotard."[74] It is not clear what elicits Marks's empathy: Orlandersmith's autobiographical tale, in which she was called "white girl" because of her "aspirations that defied boundaries" of blackness, or Orlandersmith's physical size—a big, black body squeezed, within Marks's imagination, into a piece of clothing that reveals her body-shape. In his review of *The Gimmick*, Marks makes frequent reference to the actress' physical size. He describes her as "imposing in size," and notes that "Ms. Orlandersmith fills the New York Theater Workshop with the outsize proportions of her formidable fury . . . [S]he fills the space." He calls her "unapologetically large," and makes reference to her "intimidating body."[75] Although Marks does not refer to her skin color, I suspect that it is implied—as *bigness* and *blackness* are corollaries in many, popular descriptions of black bodies. Indeed, the critic in his 2004 review of *Yellowman* recollects that Orlandermith is "big and black" and seems to long for her "big" and "awkward" presence in the Arena Stage production. Alma's opening monologue echoes Marks's review:

> My mother women like my mother and her mother before her toiled/ tugged the soil right beside the men/ They were dark and therefore not considered pretty/ they were dark and large—therefore sexless. They were sometime bigger than the men/ their bodies filling space.

There is a similar attention to *bigness* amplified by *blackness*. Both are undesirable. Although they can elicit empathy, they, with their heightened presence, also threaten and intimidate. Despite the fact that Orlandersmith promptly dismisses any attempt to draw parallels between herself and Alma, the resonance of Marks's words opens up the possibility that *Yellowman* might have been influenced by or written in reaction to critical receptions of her earlier performance work. In channeling the spirit of the fictional Odelia

and presenting her voice before an audience, the playwright appears to cite and embellish the critical readings of her own body. She stands before members of the audience and, perhaps, tells them what they might be thinking about her or, perhaps, what they suspect that the person next to them might be thinking about her and themselves.

Orlandersmith, similar to McCauley in *Sally's Rape,* asserts that she wants to move beyond the black body or, at least, blackness. In the majority of interviews, the playwright rebuffs efforts to identify her aesthetic as bearing black traces, roots, or style. Unlike Suzan-Lori Parks, who, while citing the unique nature of her own life experiences as an "army brat," draws influence from jazz style and rhythms, Orlandersmith keeps identifiably black arts at a distance and downplays their influence on her dramaturgy. Her repeated dismissals, combined with her frequent citation of her partial Puerto Rican identity, being half black and half *puertoriqueña,* within nearly a dozen newspaper reviews proffer the impression that Orlandersmith does not want to be read as *black* and, as a playwright, does not want her work to be understood as being representative or, perhaps, emblematic of black style. The lady dost protest too much. And like Gertrude (in *Hamlet*), who watches the play within and comments upon the characterization of herself, the public Orlandersmith seems to make proclamations that do not jibe with the more accurate portrayals on stage. Although Orlandersmith emphasizes her Puerto Rican identity with the aim of suggesting that the black experience does not solely define her, it is important to remember that a similar experience of blackness, anchored in negative reactions and responses to darker skin complexion as manifested through theatrical and televisual performances of blackface, is a part of Puerto Rican cultural identity. Indeed, the privileges associated with lightness compared with darkness (Taino or Afro-Caribbean) in Puerto Rican history are analogous to the situation within *Yellowman.* Although Orlandersmith wants to move beyond the body, like McCauley, her appearance onstage and her replaying of select, racialized experiences only reify it. This return to the body proves particularly powerful and impactful. The problem is that Orlandersmith believes that she is breaking the cycle of repetition and return. She thinks that she is moving away from *the black body* by placing her black body onstage. Even as the story of *Yellowman* proves increasingly self-referential, the playwright-performer contends that the story is not about her and that she exists outside these embodied black experiences.

In spotlighting Orlandersmith, I seek not to flatten the differences that separate her from Suzan-Lori Parks and Robbie McCauley but to emphasize her staging of repeated, similar experiences that have affected, and, indeed, effected black bodies over the past two centuries. *Yellowman* is ghosted by the history and legacy of sexual assaults in slave castles, ships, and plantations. The voice of Odelia echoes the spoken barbs of countless individuals whose prejudices justified the institution of black captivity within the Americas and supported discriminatory policies in the century following emancipation. Eugene's final condition, alone and in prison, resembles Saartjie Baartman's status at the close of *Venus* and similarly reminds the audience that captivity continues to haunt the black community. The three plays discussed in this chapter—*Venus*, *Sally's Rape*, and *Yellowman*—are difficult plays to watch. Referring to Orlandersmith's play, Chuck Smith, resident director at the Goodman Theatre in Chicago and the director of a 2004 production of the play, told me that he would never direct the play again. He cited the "hatred" that gets spoken and pointed out that the sheer repetition of Odelia's and Eugene's grandfather's words within rehearsals and performances "wears you down." The same can be said about the other two plays. *Venus* centers a black body put on display both in life and in death. It stages the power dynamic between white seer/master/aggressor and black seen/slave/victim that Robbie McCauley identifies as "rape." Within the play, the black body exists as a freak, an oddity, and ultimately, a scientific specimen. In *Sally's Rape*, McCauley wants to interrogate the past histories of bodily abuse, specifically sexual assault, that ghost black bodies in the present. After all, she (McCauley) is the result of a past rape act. The "master's" aggression is part of her being. At the same time, she wants to move beyond this history and to move beyond the black body by, ironically, restaging past abuses across her own body. While she reenacts the auction block moment by recasting audience members, who paid to see her perform, as potential masters who now must bid on her naked body, she represents the rape act as a dream remembered. The assault does not occur onstage—only her imagined memories of it. Much like Parks, McCauley's replay can be read as an interventionist act. She uses reenactment to assert the black body's agency in scenarios within which it historically has been rendered powerless. Although the performance artist explicitly expresses a desire to move beyond bodily based experiences, her production only emphasizes its importance. Similar to *Venus* and *Sally's Rape, Yellowman* stages the weight of past sexual as-

saults and the ongoing socialization of skin color prejudice that must be shouldered in the present. The character Alma exists as a modern-day Baartman; Eugene as one of Sally's children. Despite the twenty-first-century setting, the characters have not reached the point in which their blackness no longer defines them nor structures their experience of the body. Taken together, the three plays, which present stories based upon or inspired by the lives of real people, suggest that the past bears an impression on the ongoing present.

In the preceding sections, we engaged with the black body on display or, to put it another way, the black body as spectacle. Saartjie Baartman's body transformed her into a sideshow attraction that, in turn, caught the attention of George Cuvier. Robbie McCauley's body echoed the abuse of other bodies whose sufferings and labor on the grounds of southern plantations engendered future generations of black bodies. Dael Orlandersmith's body, on the twenty-first-century stage, reminded us not only of the way in which stereotypes of blackness are maintained through the cross-generational socialization of children but also the race-conscious perceptions (and, indeed, projections) of members within dominating society. In *Venus, Sally's Rape,* and *Yellowman,* Parks, McCauley, and Orlandersmith use the theater to gain access to these historical experiences of the black body and present them before an assembled audience. Although they frequently contend that their pieces seek to move beyond and, in short, to transcend the black body, I have maintained that the power of their respective performance projects anchors itself in the authors' ability to replay in the present the past experiences of bodies that have passed.

In this final section, I look at the character/caricature of the "black welfare mother" in Suzan-Lori Parks's *In the Blood* and contend that the playwright's staging of a black body coupled with her presentation of it as silent or rarely verbal, encourages audiences to imagine the experience of the body and, eventually, to speak on her behalf (and in her support). Loosely based on Nathaniel Hawthorne's *The Scarlet Letter,* Parks's *In the Blood* centers Hester LaNegrita, a homeless, illiterate, black woman who independently raises her five children. Throughout the dramatic narrative, Hester encounters a series of individuals: Chilli and Reverend D., the fathers of two of her children (Jabber and Baby, respectively); The Welfare Lady, the federal program personified; Doctor, the embodiment of the federal Medicare system; and Amiga Gringa, her homeless "white" friend. Although each individual

can provide some form of assistance to Hester, they do not. Instead, they use her—often sexually—before discarding her. Simultaneously abused and neglected by these five characters, Hester struggles to survive each day and to provide for her children. Eventually, poor nutrition, poverty, and the weight of societal ridicule prompt her to kill her eldest child, Jabber. The play ends with Hester, standing at center, covered in blood as bars are lowered around her body.

In the Blood begins with a chorus, comprised of all five individuals, talking to one another about Hester. Their voices overlap and they speak together as one, not necessarily in unison, but from a single mind-set. It is clear that they view Hester as being socially beneath themselves. More to the point, they blame her for her various predicaments—single motherhood, poverty, and homelessness. At various intervals, they announce, "SHE'S A NO COUNT / SHIFTLESS / HOPELESS / BAD NEWS / BURDEN TO SOCIETY / SLUT!"[76] These words, which are declared before Hester appears onstage, frame the expectations of the audience. The play will be about a woman who is at fault for her social status and standing. With the entrance of Hester, who appears in tatters compared to the more refined clothing of the chorus, the chorus parts and the play begins. It takes several minutes for the audience to realize—with the entrance of Hester's five children—that the choral members will play dual roles. It takes several more, with the entrance of the Doctor, for spectators to understand that the chorus has been triple cast. The actor who plays Doctor also plays Trouble, Hester's son, and the role of chorus member. Reverend D. is Baby and also a part of the chorus. The Welfare Lady (hereafter Welfare) is Bully and chorus. Amiga Gringa is Beauty and chorus. Chilli is Jabber and chorus. Despite the multiple casting, it is immediately clear that the adult roles can be equated with the chorus and should be read as distinct from the children. In short, the chorus consists of Chilli, Reverend D., Amiga Gringa, Welfare, and Doctor.

Throughout the dramatic narrative, the individuated choral members interact with Hester. The nature of their respective encounters reflects an extended familiarity with the protagonist, despite her lower social standing, and reveals their responsibility for her homelessness, poverty, and single-parent status. Chilli and Reverend D. are absent fathers who refuse to pay child support. Welfare underemploys Hester by paying her to make dresses. Doctor loans her a dollar and threatens to perform a hysterectomy on Hester but does little to elevate her social position. Amiga Gringa steals money

from Hester. Each encounter ends with the choral member leaving Hester and, before exiting the stage, speaking in direct address to the audience. Parks labels these moments "confessions." They are the moments when the individuated choral characters, who have already demonstrated their role in Hester's "low" status, reveal to the audience that their involvement is more complex than initially presented. What makes these confessions dramatically interesting, beyond offering more examples of how Hester was used, is that they end without the characters accepting their roles in her mistreatment. Toward the end of his visit with Hester, Doctor announces that she will have to have a hysterectomy, referred to as a "removal of your womanly parts," because of the number of children she has had—each by a different father. His state-sponsored intervention suggests that Hester actively disregards safe-sex practices and that her actions and the consequences of her actions, her children, have created problems for the locality. As a result, she, like an animal, must be corrected—"fixed." Following his announcement, the Doctor confesses the following to the audience:

> When I see a woman begging on the streets I guess I could bring her in my house / sit her at my table / make her a member of my family, sure. / But there are hundreds and thousands of them / and my house cant hold them all. / Maybe we should all take in just one. / Except they wouldnt really fit. / They wouldnt really fit in with us. / Theres such a gulf between us. What can we do? / . . . / Shes been one of my neediest cases for several years now. / What can I do? Each time she comes to me / looking more and more forlorn / and more and more in need of affection. / At first I wouldn't touch her without gloves on, but then—/ (Rest) / we did it once in that alley there, / she was / phenomenal. / (Rest) / . . . / Sucked me off for what seemed like hours / But I was very insistent. And held back / and she understood that I wanted her in the traditional way. / And she was very giving very motherly very obliging very understanding / very phenomenal. Let me cumm inside her. Like I needed to. / What could I do? / I couldn't help it.[77]

Robbie McCauley would identify Doctor as a rapist. Indeed, all of the other adult characters within the play use their elevated social status to abuse Hester. Welfare, despite maintaining that she "walk[s] the line between us and them / between our kind and their kind," reveals that she participated in a ménage à trois involving herself, her husband, and Hester.[78] Ending her con-

fession, Welfare declares, "It was my first threesome and it wont happen again. And I should emphasize that she is a low-class person. What I mean is that we have absolutely nothing in common."[79] Reverend D., after having Hester perform oral sex on him and then compensating her with a "crumpled bill," states, within his confession, "Suffering is an enormous turn-on."[80] Despite his involvement with her, the Reverend, who has fathered her youngest child, refuses to allow her "to drag me down / and sit me at the table / at the head of the table of her fatherless house."[81] Chilli, Hester's first love, father of Hester's first child, and, possibly Hester's first sexual/romantic partner, revokes his marriage proposal to Hester after encountering her children. His rejection, simply stated within his confession, appears as follows: "She was my first. / We was young. / Times change."[82] Amiga Gringa convinces Hester to appear in sex shows for money.

Similar to Doctor, each character explains their actions to the theatrical audience. Collectively, their words chronicle a series of assaults against the black body and offer a glimpse at how historical reflections can simultaneously center the black body and overlook the experiences of the black body. It is easy to picture George Cuvier, especially as imagined by Parks, or Louis Agassiz or Sally's "master" using similar wording to describe and, indeed, justify their actions. It is not difficult to envision how racial privilege and social capital informed the manner with which Jim Corbett, Captain Hemings, and, perhaps, Walker Evans interacted with black folk. Hester's silence invites a closer examination of the black body. Although she exists at the center of each confession, Hester remains silent. Parks, as playwright, does not give her protagonist an opportunity to directly address the audience. She is prevented from being able to tell her story—to relay the facts from her perspective. This is not to say that the character is mute within the narrative. She interacts with the five chorus members but does not offer any insight into her perspective. Admittedly, the playwright does script a sixth and final "confession" that she awards to Hester. However, this "confession," in style and content, differs from the ones that precede it. Whereas the other monologues are relatively long and develop both logically and realistically, Hester's final words are comparatively shorter and more expressionistic. Her repetitive, wandering statements appear to be more a vocalization of her fragile mental condition—after having killed her son—than a persuasive, direct appeal to connect with the audience. Hester's silence is intriguing. Why is she the only

character who does not confess? Why does Parks deny her the opportunity to testify about her experiences?

I am making the following assumption: that *confession* and *testimony* are related terms. Despite the fact the former tends to carry an association of guilt over actions performed, whereas the latter centers itself on witnessed events and often allows the speaker to choose silence rather than to incriminate herself, they share the fact that they gain their legitimacy through an association with governmental or religious institutions and that they are spoken narratives performed by participant-observers before a disinterested third party. While Parks, a talented and dutiful linguist, may have elected to use the word *confession* to associate a sense of guilt or, at least, immorality with each of her characters, the content of their monologues appears equally to confess and to testify to their actions. This is a both/and scenario, not an either/or. Within their confessions, the characters testify. "To testify," writes Shoshana Felman, "is more than simply to report a fact or an event or to relate what has been lived, recorded and remembered. Memory is conjured here essentially in order to address another, to impress upon a listener, to appeal to a community."[83] Felman's definition reminds us that testimony, like confession, begins at the point of reception and not at the moment of enunciation. With its increasing specificity of the role of the audience in testimony—from merely "another" to "listener" to "community"—Felman's description suggests that the receptor of the delivered testimony represents the locality, the society in which the testifier lives. To testify is to speak to your neighbor in the form of a direct appeal. Within our present-day, mediatized society, testimony is everywhere. It is both unavoidable and inescapable. It is impossible to turn on the television and not be confronted with a spoken personal narrative in the form of court proceedings, therapy sessions, talk shows, and infomercials. While one might have contended in the past that testimony differed from confession in that the former was a public act and the latter private, our contemporary media environment erases this difference. At any time and, virtually, in any place, we can encounter the personal narratives (whether testimonies or confessions) of others.

Noting the overabundance of people willing to talk about themselves before an audience and recalling that each chorus member in *In the Blood* delivers a confession, we are even more surprised that Hester, the protagonist and the center of both Parks's narrative and the narratives of the chorus

(which are also Parks's narratives), does not confess. At no point in the play does she do what Doctor, Amiga Gringa, Welfare, Reverend D., and Chilli do. She does not stand at the center of the stage, look directly at us, the audience, and tell us about her past and past encounters. Instead, she remains silent. When she does elect to speak, she rambles incoherently. Unlike the others who confess, Hester jabbers. In light of Parks's careful use of language in her dramaturgy, it seems intentional that Hester, after killing Jabber, loses the capacity to speak on her own behalf and before an audience. While this certainly offers one possible explanation of why Hester remains silent or, more accurately, lacks the ability to confess, there are other, equally plausible options. First, the chorus members represent the spectators in the audience. With the exception of Amiga Gringa, each chorus member is a respected figure within the imagined community of the play. Even Gringa, thanks to her seeming whiteness, has access to societal privilege. These connections allow the chorus members to appeal to the various privileges that they share with the play's spectators. In their confessions, they are speaking with peers and, perhaps, colleagues, people who understand their point of view and likely share their biases and prejudices. Hester, a member of the underclass, cannot interact with her audience on the same level as these others. Her only recourse is to not talk, or to talk to herself.

Second, we can borrow Giorgio Agamben's reading of the limits to the authority of the witness and apply it to *In the Blood*. In *Remnants of Auschwitz*, Agamben suggests that there is a fundamental deception in the testimony of witnesses. According to him, the ideal witnesses are those who did not survive to testify. He writes, "The 'true' witnesses, the 'complete witnesses,' are those who did not bear witness and could not bear witness. They are those who 'touched bottom.'"[84] The inability of these idealized nonwitnesses to testify necessitates the emergence of others who must attempt to speak from the unknowable position of the absent witness. In the case of the Holocaust, the present witness must pretend to speak from the position of the dead. Although Hester lives and, therefore, seems capable of speaking on her own behalf, she too needs a surrogate because she has "touched bottom." Agamben's reading of the true or complete witness suggests that successful witnessing and testimony require distance from the actions, events, or persons that they detail. Hester is too close to the experience to be able to witness it, and therefore, to be able to speak about it. Indeed, she is the experience, or at least the sexualized body that creates the experiences for the

chorus members. She continues to live that embodied experience in the present, whereas the chorus members recount their interactions with her from a past perspective.

Third and, perhaps, most interestingly, Hester's silence compels us spectators to imaginatively situate ourselves in her place in order to understand her behavior as announced in the confessions of the chorus members or witnessed onstage. It encourages us to attempt to understand her perspective and experience of the body. Her silence elicits our empathy. This may have been Parks's intention. In a January 2004 interview with a student journalist at Eastern Michigan University, Suzan-Lori Parks was asked, "What is the one quality that you think that every person should work on improving?" The playwright replied, "Compassion." When pressed to explain why she chose that word, Parks responded:

> Because if you can see someone's side of it regardless of who they are, what they're going through, if you can see, you know, Saddam Hussein getting his mouth opened and feel something other than, like, the thing you're programmed to feel . . . that's a great, powerful thing, and it's a force for positive change. You know, if you can see the Unabomber and feel compassion for him, if you can see the sniper and feel compassion for him. You know? If you can see the serial killer and feel compassion for him, that's a great thing. That's what Jesus and Gandhi and Buddha and Martin Luther King did.[85]

What does it mean for Parks to equate silence with compassion? Saddam Hussein, the former president of Iraq who was deposed and imprisoned by the United States in April 2003 and executed in 2006, appeared silent in the publicly circulated images of his health inspection (by U.S. doctors) following his arrest, and yet Parks suggests that his silence should encourage compassion for him. Silence elicits empathy. Why? In a world in which people rush to tell others about themselves, the disempowered often lack a voice. Silenced and marginalized by the dominating society within which they live, these individuals enter into the national dialogue when they are the subject matter of the conversations of the more empowered. They rarely are the ones speaking. What Parks succeeds in doing is showcasing the vocal marginalization of the disempowered within her play. She gives their silence a presence and a voice. Their silence encourages us, audience members and readers of her play text, to listen more attentively for the voice that never will

arise and then to give voice, through our collective imagination, to the body whose activities we witness.

Each of the playwrights featured within this chapter sought to break silences involving the black body. Parks takes two black bodies, places them onstage, and invites us to imagine their experiences. McCauley channels the memory of an ancestor alongside dreams about her encounters on the plantation grounds and performs them across her body. *Yellowman* stages epithets and descriptions of blackness that have been employed for centuries to fix an idea of the black body into a stereotype. Orlandersmith reveals how the internalization of these words has structured experiences of the body. What is striking about these plays is that they challenge the muting effect of historical erasure or historical misrepresentation by centering not the voice but the body. It is the body that speaks. In the next chapter, I continue to address the historical touch and the embodied voice by looking at the role that the black body has played within lynching campaigns in the twentieth century within the United States. I suggest that the events rarely were generative of remains of the performance, and that the body, either living or dead, became the chief artifact of those social enactments. I also offer an account of how a single lynching survivor has used his body and his memories of his near-death to create a memorial to racial violence within the United States.

CHAPTER FIVE

Housing the Memory of Racial Violence:
The Black Body as Souvenir, Museum,
and Living Remain

People are trapped in history and history is trapped in them.
—James Baldwin, *Stranger in the Village*

On 2 April 1899, approximately two thousand white men, women, and children participated, as both witnesses and active agents, in the murder of Sam Hose in Newman, Georgia. Sam Hose was burned alive. In the final moments of his life, the assembled crowd descended upon his body and collected various parts of it as souvenirs. The *Springfield* (Massachusetts) *Republican* recounted the scene of Hose's dismemberment in the following manner:

> Before the torch was applied to the pyre, the negro was deprived of his ears, fingers and genital parts of his body. He pleaded pitifully for his life while the mutilation was going on, but stood the ordeal of fire with surprising fortitude. Before the body was cool, it was cut to pieces, the bones were crushed into small bits, and even the tree upon which the wretch met his fate was torn up and disposed of as "'souvenirs.'" The negro's heart was cut into several pieces, as was also his liver. Those unable to obtain ghastly relics direct paid their more fortunate possessors extravagant sums for them. Small pieces of bones went for 25 cents, and a bit of liver crisply cooked sold for 10 cents.[1]

Seven months later in December 1899, the *New York World*, in an article entitled "Roasted Alive," reported on the similar fate of Richard Coleman in Maysville, Kentucky, before a crowd of "thousands of men and hundreds of

167

women and children." The article noted that "long after most of the mob went away little children from six to ten years of age carried dried grass and kindling wood and kept the fire burning all during the afternoon."[2] It also revealed that "relic-hunters visited the scene and carried away pieces of flesh and the negro's teeth. Others got pieces of fingers and toes and proudly exhibit the ghastly souvenirs to-night."[3] In a 27 February 1901 *Chicago Record* article on the hanging and burning of George Ward before a crowd of four thousand people in Terre Haute, Indiana, the newspaper gave the following account of the scene of Ward's murder:

> When the crowd neared the fire tired of renewing it after two hours, it was seen that the victim's feet were not burned. Someone called an offer of a dollar for one of the toes and a boy quickly took out his knife and cut off a toe. The offer was followed by others, and the horrible traffic was continued, youths holding up toes and asking for bids.[4]

Sam Hose, Richard Coleman, and George Ward are three of the more than three thousand black men, women, and children who were lynched across the United States between 1880 and 1930. My investment in the lynching tragedy does not center itself on the horrifying numbers of black men, women, and children who were forcibly taken from their homes (or from jail cells), paraded throughout town, and executed before a mass mob.[5] Nor does my interest rest in the allegations and charges used to justify these assaults—from stories of sexual assaults on white women to violations of minor laws and ordinances (such as vagrancy or trespassing). Nor am I interested in reading lynching in terms of a prescripted performance or ritualistic practice. These areas have been addressed, in books and articles, to the point of near-exhaustion in the areas of African American studies, English, history, sociology, and performance studies. What captures my attention is something that appears within the majority of these disciplines but has received scant attention in each: the dismemberment of the black body for souvenirs following the lynching event. I am interested in this feature, in large part, because I am haunted by the image of white hands, variably male or female, adult or child, holding aloft a slice of Sam Hose's crisped liver, Richard Coleman's burned flesh, or George Ward's toe. As a means of working through my own complicated relationship with this image while simultaneously spotlighting an often-neglected area of lynching scholarship, I here focus upon

the black body as a target of racial violence and read its experiences as encapsulated within lynching souvenirs and as represented within museum displays. In the first part of this chapter, I look at the black body in the aftermath of the lynching event and variously read it in terms of the souvenir, the fetish, and the performance remain. I contend that the lynching keepsake can not only be defined by, but also can exceed, each of these three terms. Containing within itself the various features of the souvenir, the fetish, and the remain, the body part recalls and remembers the performance of which it is a part. It not only gestures toward the beliefs that motivated its theft but also renders visible the body from which it was taken. In the second part, I chronicle the efforts of a lynching survivor, James Cameron, to create a lasting memorial to the history (and horrors) of racial violence that has targeted the black body within the United States. I discuss not only how the museum accreditation process can lead to the silencing of this history and the erasing of these horrors from governmentally sponsored displays but also how the experience of a single body can disrupt the racialized disciplining process of black stillness via the commemoration of spectacular violence.

Part I: The Body as Souvenir

The lynching souvenir is a spectacular performance remain or, more accurately, a remain of a performance spectacle. Although not typical of all lynchings, nearly a third of them were orchestrated affairs in which allegations of criminal wrongdoing by the accused were circulated in such a totalizing manner that the community rendered the accused guilty in advance of and without a trial. With the populace "so powerfully insistent on guilt, so uninterested in any other scenario," advertisements were placed in local newspapers in which the date, time, location, and even the schedule of activities (the program) were announced.[6] On the scheduled day and at the appointed hour, scores of spectators would assemble to witness the public staging of vengeance acted upon the accused by the victim or the victim's family, the prolonged torture of the accused by the lynching organizers, the lynching (by burning, hanging, or shooting) of the accused, and the dismemberment of the accused's body into souvenirs. As public performances, lynchings far surpassed all other forms of entertainment in terms of their ability to attract an audience and the complexity of their narratives. A lynching was an event—something not to be missed. In this section, I seek to understand the purpose

and the function of the souvenirs collected by participant-observers at the scene of the lynching event.

The word *souvenir* has its origins in the Latin word *subvenire*, which means "to come into the mind" (*OED*). Both a noun and a verb, *souvenir* can refer to the actions taken to ensure that something or someone is remembered, or can serve as a trigger toward that remembrance. Its memorial function, whether as a transitive verb or an actionable noun, anchors itself in its ability to bring the sensation of the other—an other person or an other place—into one's own body or conception of self. The souvenir, according to Susan Stewart, author of the only book-length study of the concept, "is by definition incomplete. And this incompleteness is always metonymic to the scene of its original appropriation in the sense that it is a sample."[7] It exists after the fact—after the passage of the event or the experience of which it was once a part, as part of the whole—in order to gesture back to the event or the experience that was. Stewart observes:

> But whether the souvenir is a material sample or not, it will exist as a sample of the now-distanced experience, an experience which the object can only evoke and resonate to, and can never entirely recoup. In fact, if it *could* recoup the experience, it would erase its own partiality, that partiality which is the very source of its power.[8]

The souvenir refers back to a larger experience, of which it is a fragment. If the souvenir could be the entire experience rather than just a part, then it would cease to be a souvenir. Jean Baudrillard makes a similar claim, observing that the collectible is "divested of its [originary] function and made relative to a subject."[9] Incomplete in itself, the souvenir requires an accompanying narrative furnished by its possessor in order to fill in that which is missing and to allow the fragment to reflect the event or experience of which it is a part. For example, a seashell, removed from a beach, can represent a beach vacation. Although the shell may not carry any real meaning in and of itself, it assumes a symbolic value when a narrative is attached to it.

An aura or a sense of mystique shrouds the souvenir because, in addition to being incomplete, it is also illicit. It "always displays the romance of the contraband, for its scandal is its removal from its 'natural' location."[10] Certainly, the appeal of a souvenir, to the person who takes the object and the audience to whom it is displayed, anchors itself in the souvenir's stolen quality.

Taken away from its environment, which is unlike the one in which it is displayed, the souvenir's presence reveals its own theft. In the case of the shell, its presence in the apartment of a landlocked city-dweller underscores the fact of its removal from its natural environment. Despite its incomplete and stolen nature, the souvenir threatens the stability of the present through its portrayal of the past as fixed and controllable. According to Stewart, it functions to "authenticate a past or otherwise remote experience and, at the same time, to discredit the present."[11] Jane Desmond, in *Staging Tourism*, situates this aspect of the souvenir within a "salvage paradigm":

> This belief assumes that that which is natural is vanishing and is in need of saving. . . . Ultimately, this is a liberal attitude with potentially conservative outcomes. While seeming to celebrate cultural difference or the natural world, this paradigm dehistoricizes certain people, practices, geographic regions, and their animal inhabitants, setting them up as avatars of unchanging innocence and authenticity, as origin and ideal.[12]

The souvenir saves the past and represents it in the present. It records the *that which was* in a material object that can be referenced and revisited over time. In contrast, the present, the *that which is now*, existing just beyond ourselves, resists both objectification and commodification because its ongoing status disallows the creation of an entrapping retrospective narrative. This retrospective narrative, when attached to the souvenir, fixes the past and thus renders it unchanging. It also creates the possibility of historical revision in that the narrative itself determines the meaning of the keepsake. For example, in the case of the shell, my accompanying narrative supplements its incompleteness and enables it to represent my beach vacation while simultaneously displacing the historical origins of the shell itself.

The lynching keepsake satisfies each of these descriptors of the souvenir. First and foremost, it is incomplete and finds a sense of wholeness through an embrace of an accompanying narrative. In the cases of the crisped liver of Sam Hose or the burned flesh of Richard Coleman, it seems unlikely that anyone encountering either without the aid of a story to flesh out the details of the lynching event would know what she was seeing.[13] George Ward's toe, even if recognized as being a toe, would still remain incomplete without the aid of a narrative to identify the original possessor of the body part and to relay the process of its collection. It is only when the details of the burning of

each individual are revealed that the objects become meaningful as souvenirs.

Unfortunately, the narratives attached to these body parts are difficult to locate. As performance scholar Kirk Fuoss realized, "One of the most significant aspects regarding the subjects of lynching is precisely the way in which the true and complete story evades the truth-telling capacity of even the ablest investigator employing the most insightful and uncompromising methods."[14] What makes the stories so evasive is not necessarily the lies and falsehoods told to the investigators, but the general unwillingness of members of localized communities to share their tales with strangers or outsiders. Arthur Raper, the sociologist who first offered a comprehensive study of lynching in 1933, referred to this tendency toward silence when he observed, "A lynching makes a lot of otherwise good people go blind or lose their memories."[15] An example appears in the court transcripts of a 1930 case involving the lynching of two teenagers in Marion, Indiana. In the following exchange, Earl Stroup, an "outside" prosecutor, questions Bert White, the town's longtime local sheriff.

Q. You have no doubt talked to a number of people who were spectators there and saw a lot of this.
A. Yes sir.
Q. Who?
A. I couldn't say.
Q. Acquaintances of yours were there?
A. Well, people—business people that were there in the crowds that night and was there on the street: I expect the whole town was down there.
Q. Can you name any particular person?
A. No sir I couldn't name any particular person.[16]

White's stonewalling of Stroup reveals the difficulty of obtaining the narratives of the people who participated, even as witnesses, in the various lynching campaigns. His selective amnesia explains how, as Raper noted, "Of the tens of thousands of lynchers and onlookers, the latter not guiltless, only forty-nine were indicted and only four have been sentenced."[17]

When the first-person stories of lynching events were revealed to outsiders of the community in which the lynchings had occurred, they either were broadcast by overzealous children or were spoken conspiratorially in

hushed tones to avoid detection. Walter White in *Rope and Faggot,* his 1929 study of lynchings in the southern regions of the United States, gives an example of the first type of leak by opening his book with the following personal anecdote:

> In Florida some years ago, several lynchings and the burning of the Negro
> section of the town followed the attempt of a Negro pharmacist to vote in a
> national election. One morning shortly afterwards I walked along the road
> which led from the beautiful little town to the spot where five Negroes had
> been burned. Three shining-eyed, healthy, cleanly children, headed for
> school, approached me. As I neared them, the eldest, a ruddy-cheeked girl of
> nine or ten, asked if I was going to the place where "the niggers" had been
> killed. I told her I might stop and see the spot. Animatedly, almost as joyously
> as though the memory were of Christmas morning or the circus, she told me,
> her slightly younger companions interjecting a word here and there or nod-
> ding vigorous assent, of "the fun we had burning the niggers."[18]

The children, in their sheer enthusiasm, share their narratives with White. Interestingly, the author elects to spare his reader the details given him and offers merely a summary of what was said. White's anecdote intrigues me because it underscores the vividness of the memory of the children who attended the lynching event. Compared to the memories of "Christmas morning or the circus," the children's reflections likely arrived in a torrent filled with so many details that the listener must have been taken aback by them. This memory of the children and their (later) willingness to show White the site of the burning—that is, if they had the time to do so—underscores the fact that these narratives did not immediately disappear.

Sociologist Orlando Patterson, in *Rituals of Blood,* writes, "It takes little imagination to understand now, how the powerful—and for the children who were forced to watch, no doubt traumatic—experience of watching the torture, mutilation, and the burning alive of the African-American victim would have become encoded forever, through the overwhelming odor of his roasting body, on the memories of all who participated."[19] Evidence in support of Patterson's claim appears in the 1997 documentary *Third Man Alive,* in which several senior citizens recall witnessing the performance of two lynchings in 1930.[20] Despite the passage of years and the onslaught of age, their memories remain so fresh and complete that at least one of them, like

White's informants, becomes animated in the retelling. If we consider White's sources, along with those depicted in the video documentary, to be representative of the participant-observers at the scene of the lynching spectacle, then it follows that lynching memories and the narratives through which they were expressed remained alive within localized communities but rarely may have been shared with outsiders. Whereas the youth and carelessness of children explain one way in which these narratives escaped the protective silence of the communities, it would be a mistake to assume that the only leaks were children. James Allen, the collector of a series of postcards that later became the much-discussed *Without Sanctuary* exhibit, gained his first lynching images by attending antique fairs and flea markets and, within those spaces, by being approached by individuals who, in a whisper, would offer to show and sell him various images of lynched figures.[21] Allen remembers that "a trader pulled me aside and in conspiratorial tones offered to sell me a real photo postcard."[22]

While it is remarkable that Allen was able to obtain the various images that fill his collection, what fascinates me, within the context of the accessibility of lynching narratives, are not the pictures on the postcards but the few lines of text that appear on the back of them. Although these words were written in a relatively public forum (postcard), they signal the types of conversations and exchanges people would have held within a private space. On one card, a son, referring to the image of the burned body of William Stanley, who was murdered in August 1915, writes to his mother, "This is the Barbecue we had last night, My picture is to the left with a cross over it, Your son."[23] On another, an unidentified author, on a postcard depicting the March 1910 murder of Allen Brooks, notes:

> Well John—This is a token of a great day we had in Dallas, March 3, a negro was hung for an assault on a three year old girl. I saw this on my noon hour. I was very much in the bunch. You can see the negro on a telephone pole.[24]

What these few lines reveal is that the lynching campaigns—and, more importantly, the crowd's participation as witnesses, in the execution of those campaigns—were significant events in the participants' lives. They motivated discussion and prompted audiences to share their experiences with one another. According to Jane Desmond, such narratives tended to "authenticate the acts of travel and of witnessing and then in turn position the recipient as

witness to the sender's experience. In this way, a public act (seeing a sight) is transformed into a private history (what I saw) with social meaning (look at what I saw)."[25] Beyond merely projecting a sense of wholeness upon an incomplete souvenir, these accompanying narratives appealed to a community of listeners. This displaying and sharing—a form of showing and telling—rendered the object and the event from which it was taken meaningful within a given community.

As powerful as the accompanying narratives are, they do not replace the need for the souvenir itself. The magic of the souvenir anchors itself in its status as contraband, an object improperly removed from a given place or an event. This is why the body part as a keepsake trumps postcards or pictures of the same lynched body. The former contains, in a Benjaminian sense, an aura lacking in the latter. The desire for the actual body parts was so pronounced that spectators literally stripped the scene of the lynching campaign for souvenirs that bore even the slightest relation to the event that had transpired there. Dennis Downey and Raymond Hyser, in their book *No Crooked Death*, underscore the frenzy for authentic items in their account of the behavior of the crowd following the murder by burning of Zachariah Walker in Coatesville, Pennsylvania, on 12 August 1911:

> Approximately one hundred and fifty individuals maintained an all-night vigil near the fire, waiting to collect souvenirs. Some of the more aggressive among them used fence railings to dredge Walker's bones from the glowing embers. The manacles and footboard were also pulled from the pyre and then doused in water and broken up as souvenirs. The next day, several enterprising boys even sold some of Walker's remains to anxious customers in Coatesville. A curious reporter who visited the lynching site several months later found many changes, including the absence of grass where the burning took place and the almost complete demolition of the split-rail fence. "Visitors have carried away anything that looked like a souvenir," he wrote.[26]

The absence of remains at the site of the lynching campaign reveals the actions of collectors who, in the aftermath of the event, took everything having to do with the lynching site—even the blades of grass that the ashes of the body had touched. To possess a souvenir of Zachariah Walker's body or of the scene of his murder was to have material evidence of one's presence at and proximity to the event. Recalling that the site was stripped bare, the souvenir

likely reminded its viewer of the looting that occurred in the aftermath of Walker's murder. Its presence as a souvenir underscored its absence from the scene of the lynching campaign.[27]

In addition to referencing their status as contraband, lynching souvenirs embody the past in the present. They not only fix the black body within a historical moment, but also transform it into a captive object to be owned, displayed, and, quite possibly, traded. What makes them so interesting is that they, much like the contemporary mass-produced, stereotypical commercial images of the black body, sought to commodify the body at a time when it was gaining new liberties in the present. The majority of scholars who have published studies on the lynchings of black men, women, and children agree that the motivating factor for such campaigns was a postemancipation backlash in which white, working-class residents of primarily agricultural communities sought to stay the perceived threats of increased social rights and property ownership by African Americans. Robyn Wiegman, in *American Anatomies*, views lynching campaigns as an organized effort by the dominating elements within society to prevent the "transformation from chattel to citizenry" of black folk.[28] Lynching objectified the bodies and rendered them permanently still. Lynching souvenirs commodified black bodies. Walter White asserted that "lynching is much more an expression of Southern fear of Negro progress than Negro crime."[29] Michael J. Pfeiffer, in *Rough Justice*, observed that lynchers "sought to 'preserve order,' that is to uphold the hierarchical prerogatives of the dominant residents of the locality."[30] W. Fitzhugh Brundage, in *Lynching in the New South*, writes that lynch mobs "enacted a ritual that affirmed their racial beliefs but also embodied their commitment to such values as white male dominance, personal honor, and the etiquette of chivalry."[31]

The lynched body, as a keepsake, conforms with the various attributes of the souvenir as outlined by Stewart, Baudrillard, and Desmond. It is therefore surprising that Stewart considers such "souvenirs of death" to be "the most potent antisouvenirs."

> They mark the horrible transformation of meaning into materiality more than they mark, as other souvenirs do, the transformation of materiality into meaning. If the function of the souvenir proper is to create a continuous and personal narrative of the past, the function of such souvenirs of death is to disrupt that continuity. Souvenirs of the mortal body are not so much a

nostalgic celebration of the past as they are an erasure of the significance of history.[32]

In the case of the body, Stewart contends that it is always already more than material; the effort to transform the meaning that it has into material (i.e., to turn the body into a screen upon which another meaning can be projected) exists as a form of historical erasure. Her argument suggests, in the case of lynching souvenirs, that George Ward's toe would represent the lynching campaign and, perhaps, the desire of the lynch mob to fix the body in the past—but not the lynched person George Ward. To view Ward's toe as a souvenir would be to erase George Ward from history.

Despite our own misgivings, we have to realize that the body, within lynching scenarios, did serve as a souvenir or keepsake for those who attended the lynchings; we must accept the fact that the souvenir, by definition, includes the body.[33] The body part gains its status as souvenir at (spatially) and in (temporally) the moment of its removal. Its theft signals a break in which the keepsake assumes a projected meaning that may or may not correspond with its prior, pre-removed status. Although it is unfortunate that we could lose sight of the person in our analyses, the reality is that the souvenir exists at the moment of its removal. It is at this point that the body part literally disassociates itself from the body. I suggest, therefore, that we reject any assertion that the body part cannot be a souvenir. In the preceding pages, I demonstrated that it satisfies the most significant attributes of the souvenir: it is incomplete and requires an accompanying narrative; its allure is its status as contraband, continually gesturing toward its own theft; it brings the past into the present by giving it a tangible, material form. Although the body part as keepsake threatens to erase the deceased body from history, I contend that the possibility of such historical revision is itself an aspect of the souvenir. In the pages that follow, I continue my investigation of these lynching souvenirs within the frame of fetishism and performance remains. I maintain that the referent (George Ward) of the souvenir (toe) never entirely disappears.

The Body as Fetish

Whereas the body part, when viewed as a souvenir, underscores its own materiality and consequently absents its originary wholeness, when read as a

fetish it regains its prior prefragmented status. Additionally, it projects—or, perhaps more accurately, has projected upon itself—powers that exceed its tangible properties. Beyond being the stolen catalyst that aids in the creation of a retrospective narrative concerning a witnessed event, George Ward's toe, for example, as a fetish object could be viewed as possessing magical abilities capable of bringing luck or restoring health. In this section, I examine the body parts as fetish objects with the aim of understanding why spectators collected them and how the meaning they bore directly referenced the lynching victims themselves.

In *Crowds and Power,* Elias Canetti contends that the desires within a group to kill and to collect pieces of the recently killed as souvenirs increase in proportion to the size of the swelling crowd. Detailing the scene of a public execution, he writes, "The real executioner is the crowd. . . . It approves the spectacle and, with passionate excitement, gathers from far and near to watch it from beginning to end. It wants it to happen and hates being cheated of its victim."[34] According to Canetti, the act of witnessing the death of another transforms and ultimately leads to the disbanding of the group, because in these moments the assembled spectators "recognize the [executed] as one of themselves . . . for they all see themselves in him." Haunted by the reflection of their own mortality, they disperse "in a kind of flight from him."[35] Why do the actions of Canetti's racially unmarked audience at a public execution differ from those of the white spectators who attended the lynching of a black individual? Unlike Canetti's "baiting crowd," whose newfound self-awareness compels them to flee the murder scene, the lynching audience lingered. In the murders of both Ward and Coleman, spectators remained at the site for hours after both men had been killed. Furthermore, they dismembered each body and collected its pieces as souvenirs of the lynching event that they had witnessed. If the spectators had recognized themselves in the figures of either man, it seems unlikely that they would have behaved in the manner in which they did. Instead, the crowd acted more like game hunters in the moments following a successful hunt. They sought souvenirs that could not only represent the experience of the hunt, but also testify to their presence at and, presumably, their participation in the death of their game. Canetti contends that such behavior is typical of the "hunting pack," "the most primitive dynamic unit known among men." He asserts that in the aftermath of the kill, "each man now wants something for

himself, and wants as much as possible."[36] George Ward's toe and Richard Coleman's tooth became analogous to a bear's claw and a shark's tooth. They were trophies. Unlike the animal pieces, however, the parts belonging to the human body were deemed special. They had value, meaning, and, by some accounts, unique powers. These body parts as trophies were not just souvenirs. They were fetish objects.

Meaning "charm" or "sorcery" and deriving from the Portuguese word *feitico,* the word *fetish* was employed by sixteenth- and seventeenth-century Portuguese merchants to describe the sculptures, figurines, trinkets, and other religious possessions of their West African trading partners. Offering a useful definition of the term in his two-part investigative study, William Pietz asserts that the fetish object has four traits: it is materially based; it synthesizes multiple elements in a single body; it has social value; it has the power to affect the physical body. "The first characteristic to be identified as essential to the notion of the fetish," Pietz writes, "is that of the fetish object's irreducible materiality." He continues, "The truth of the fetish resides in its status as a material embodiment; its truth is not that of the idol, for the idol's truth lies in its relation of iconic resemblance to some immaterial model or entity."[37] Whereas the idol does not have any power in itself, the fetish's magic emerges from its ability to resemble or reference something else.[38] For example, a crucifix does not have any real power other than its ability to reference the suffering of Jesus Christ. To pray to the cross is not to pray to the material object of the cross, but to Christ; the underlying premise is that the crucifix connects the praying body to Him. In contrast, the fetish, as Joseph Roach observes in *Cities of the Dead,* possesses "original motive powers."[39] Its power is both contained within and emerges from its materiality.

Furthermore, the fetish object "has an ordering power derived from its status as the fixation or inscription of a unique originating event that has brought together previously heterogeneous elements into a novel identity."[40] The lynching souvenir as fetish object satisfies this requirement in its ability to condense multiple meanings into a single body. George Ward's toe can represent George Ward, the lynching campaign, Ward's dismemberment, white chivalry, and dozens of other meanings that rally together at the site of the body (part). The toe, as fetish, structures and orders these meanings but exists as the sum total of them all. The third attribute of the fetish object is that it has social value. The fetish object carries meaning to those individuals

who desire to possess or who already own it. It is important to note that this value does not have to be widely accepted or universally understood; the Portuguese merchants did not hold the same religious beliefs as their trading partners. Finally, the fetish object must cause an effect in the physical body of the possessor or, as Pietz noted, it requires "the subjection of the human body (as the material locus of action and desire) to the influence of certain significant material objects that, although cut off from the body, function as its controlling organs at certain moments."[41] In the most dramatic reading of this attribute, the fetish exerts a real, tangible effect upon the physical body; its embrace or presence heals a sick person or helps an infertile person conceive a child. If we think of the somewhat caricatured image of the voodoo priestess manipulating a doll and the resulting effect on the human body, then we have gained a glimpse of the fetish object in its most extreme form.

Of the few published accounts that mention lynching souvenirs, Andrew Buckser's 1992 article, "Lynching as Ritual in the American South," most closely reads these collected body parts in terms of fetishism. Despite not employing the word, he repeatedly states that the mass mobs who participated in the lynching campaigns and subsequently dismembered the body believed that the remains were magical, or at least had the capacity to bring about physical changes in the body of the possessor. He observes that the collectors of body parts "attributed to these souvenirs the power to bring luck or to promote health."[42] Buckser makes repeated references to such keepsakes as "good luck charms"; George Ward's toe might have been the equivalent of a rabbit's foot. If we take the author's account at face value, then the lynching souvenirs were fetish objects. They were thought by those who collected them to be material objects that were meaningful, valuable, and capable of exciting a physical effect upon the body. Unfortunately, Buckser's claims are unsubstantiated; he does not cite a single source in support of his statements that people viewed souvenirs as being either magical or lucky.

Despite the fact that she does not view the body part as being particularly lucky, Trudier Harris, in *Exorcising Blackness*, her 1984 study of white-on-black lynchings as reflected in both history and literature, suggests that it did bestow symbolic power on its possessor. The author maintains that the majority of lynchings were used to check the threat of black male sexuality. Through the murder and castration of the black male body, the men within the crowd sought to reaffirm their privilege and status in society. According to Harris, sociopolitical power and sexual potency are indistinguishable:

For white males involved in the lynchings and burnings of black males, there is a symbolic transfer of power at the point of executions. The black man is stripped of his prowess, but the very act of stripping brings symbolic power to the white man. His actions suggest, that, subconsciously he craves the very thing he is forced to destroy. Yet he destroys it as an indication of the politi-cal (sexual) power he has and takes it unto himself in the form of souvenirs as an indication of the kind of power he would like.[43]

Harris reads the actions of the white lynchers as forms of phallus and penis envy. The crowd checks its perceptions of the excesses of the black male's sexuality through a dismemberment of his body. The body parts themselves as souvenirs and fetish objects signal the removal of the sexual threat and the crowd's desire for the power contained within such threats. Harris's critique reads the black body through a lens of psychoanalytic fetishism, conse-quently fixating the various stereotypes of the black body, potentially over-looking the social factors that contributed to these lynchings and ignoring the presence of women within such performance spaces. Still, her underlying thesis foregrounds the power contained within the various trophies of the lynching spectacle.

Unlike Harris and, to an extent, Buckser, Orlando Patterson does not view the lynching souvenir as being socially significant as a collectible before the enactment of the lynching performance. It is the lynching event itself that transforms the souvenir into a fetish object, giving it value, meaning, and motive powers. According to Patterson, a sociologist, the lynching spectacle can be read as a religious rite whose allure appears in its seeming ability to transform the everyday object into something rife with spiritual meaning. The body part, like the eucharistic wafer, changes within the framework of the performance event. Often incited by the rhetoric of priests or ministers, frequently occurring on Sundays, and usually conducted in public communal areas, lynchings, Patterson contends, bore striking similarities to religious services. Likening the spectacle to a sacrificial rite, he asserts:

Because the sacrifices did not take place in already consecrated places such as churches, the use of fire as a consecrating agent became necessary, in this way serving the multiple functions of consecration, torture, and the divine devour-ing of the soul. The stakes to which the victims were tied were obviously con-secrated in the process also, since they became relics to be treasured.[44]

The lynching event was a racial holocaust. It transformed the lynching victims into martyrs, not only sanctifying their bones but also the various properties of the murder scene. Much as people seek splinters from the True Cross on which Christ was nailed, and similar to Catholic churches blessed by their possession of the bones of deceased saints, the witnesses *cum* collectors sought a religious experience in their pursuit of lynching souvenirs. The souvenir-as-relic became a way for participant-observers to enhance their spirituality. Furthermore, the relic as a fetish object, with its perceived original motive powers, could be thought to bestow certain effects upon the physical body of its possessor. If the chalice that Christ's lips touched could bring eternal youth and the bones of St. Peter could consecrate the grounds of a basilica, then what, if any, power rested in George Ward's toe?

George Ward's toe, in reality, could not bring luck, resolve sexual anxieties, or engender a religious experience. While I do concede the possibility that some individuals may have held such beliefs, my discomfort with such an overarching reading of the meaning contained within the body parts rests in the fact that each reading absents the body of George Ward. The lynching souvenir becomes a number of possibilities, but none of them is as a representation of the lynching victim himself. Is it possible to hold Ward's toe without thinking of Ward himself or, at least, being aware of the body that was once Ward? I do not think so. In fact, I would assert that the value, the meaning, and even the desire for the lynching souvenir rested in the popular awareness that the possessed keepsake not only lived but also existed as a subject. This thing here was alive. It was him. The souvenir as a fetish object had the power to remember the dead.

The crowd's desire for the living remain, the fetishized lynching souvenir, and its meaning and value are all irrevocably tied to the lynching victim. Elias Canetti, at various points in *Crowds and Power*, remarks that the act of witnessing death, which entails being in its presence, leads not only to the recognition that the witness too could have died but also, and perhaps more importantly, that the witness has survived. She is lucky—because she continues to live. The lynching souvenir becomes, for her, a treasured keepsake remembering her encounter with death as well as a charm that protects her from death. The witness is lucky because she was not George Ward. Similarly, the souvenir's symbolic power emerges at the moment the spectator realizes that the lynching victim has died. Canetti writes, "Simply because he is still there, the survivor feels that he is *better* than [the dead]."[45] In his read-

ing of lynchings as a sacrificial rite, Orlando Patterson makes an important observation that bears on this discussion of the crowd's awareness of the life contained within the souvenir: "An essential part of the sacrificial rite is that some profound change occurs in the sacrificed object, and there is awe in actually witnessing the transition from a state of life to a state of death."[46] Indeed, according to Patterson, the silence-inducing transformation proves so striking, with its religious overtones, that the crowd feels compelled to strip the scene for mementos. Despite my doubts that the audience viewed the lynching body part as a consecrated object, I believe that the particular allure of the body part rested in its status as both a part and a remain of the transformation process. The possession, once viable, no longer lives.

In their reconstitution and remembrance of the lynching victim, the crowd had neither the opportunity nor the occasion to know the actual person being lynched. Considering the racial politics of the period and the fact that lynchings were intended to stem the social advancement of African Americans, it seems likely that the body part as souvenir prompted thoughts of an imagined and perhaps mythical construct of the black body. It was not George Ward's toe. It was a black toe. Some nigger's toe. This disavowal, through the creation of a generalized substitute, of the particular (the referent), absented the actual body from the lynching scene without jeopardizing its symbolic value as both souvenir and fetish. Perhaps the best way of understanding how Ward could disappear within the recollected spectacle that dismembered him is to consider two very different scenarios involving his remains. In the first, the crowd descends upon his body and collects pieces as souvenirs of the event they have witnessed. In the second, Ward's family, after the crowd has departed, searches the lynching site for pieces of the lynching victim to bury. Within each scenario, the body part triggers a different conception of Ward. Surely, the crowd and the family members did not think of the same person, in the same manner, in their respective interactions with his bodily remains.[47] Although I suspect that those who collected body parts were not seeking to commune with the recently departed (but still present), I believe it is important to consider the possibility of such an action occurring. Is there a way in which a person can know George Ward through the possession of his parts? Is it possible to see him when we look at his souvenired and fetishized toe? I believe it is.

To touch the body, even as a collected part, is to gain access to its embodied experience, memory, and history. It is to encounter the skin and

bloodstream memories about which contemporary artist-scholars Brenda Dixon-Gottschild and August Wilson have written.[48] These past experiences survive in the present, across new and present bodies, because the body itself remembers the violence that was directed against it. This violence lands upon and marks the body. It shapes its movements and governs its actions. It is this experience of violence, a body-marked violence, that gets passed from generation to generation through the socialization of children. For example, a child's "whuppin" echoes prior acts of corporeal punishment, such as the whippings of captives on plantations. From this perspective, future bodies carry the markings, the scars, of a passed/past violence. Violence passes. To touch the body part, as a souvenir of a lynching event, is to reopen or reawaken the embodied experience of prior bodies. Admittedly, this "inheritance of injury," as Hershini Bhana Young calls it, requires recognition and imagination. We must first acknowledge the similarities between our bodies and another body. Once we can see the body (part) as whole, living, breathing, and performing, then we can imagine the activities and experiences that led to the body's fragmentation, death, silence, and stillness.

In the previous chapter, I developed this contention through a close analysis of Suzan-Lori Parks's play *Venus* and Robbie McCauley's performance piece *Sally's Rape*. I asserted that Parks and McCauley could access the embodied experiences of Saartjie Baartman, Sally Hemings, and McCauley's great-great-grandmother, among others, because their embodied experiences reside within the black body. This occurs because African Americans share a common history and, more importantly, the legacy of that history structures similar experiences of the body. Whereas the differences in bodies and lifestyles among other "obvious axes of division," as Paul Gilroy terms them, affects the imagined experience and threatens to encourage the creation of a construct as substitute for the original body, the possibility exists that the imagined reconstruction could resemble the actual experience of that same body.[49] Is it feasible to say that a person can know entirely the experiences of another through the touch? No. To make such a claim would be to fall into the trap of racial essentialism. What I am asserting is that the presence and proximity of another person, even as a collection of parts, requires you to take that person into account. You must deal with her. You must engage with her. You must interact with her. The compulsory nature of this engagement promotes an awareness of a person who is literally other to one's self. Admittedly, this interaction does not have to espouse understanding,

compassion, or empathy, but it does mandate recognition. It forces us to see
George Ward, not just a toe.

The Body as Remain

In the preceding two sections, I have discussed the lynched body as a sou-
venir and as a fetish object. I have argued that the lynching keepsake satisfies
the core requirements of the souvenir and have challenged the contention
that such death remains are antisouvenirs. Concerning the collected body
part as a fetish object, I have introduced an anthropological understanding of
the concept and explained how the body part, in the aftermath of the lynch-
ing campaign, could be perceived as possessing unique powers. In this sec-
tion, I look at the body in terms of the remain. I contend that its presence al-
lows us to re-member the performance event.

In recent years, there has been a noticeable move within the discipline of
performance studies to redefine the concept of performance from the
ephemeral to the remaining. Whereas scholars from Herbert Blau to Peggy
Phelan have helped to build the popular understanding of performance as
that which is "always at the vanishing point" or that which "cannot be saved,
recorded, or documented," more contemporary voices, like those belonging
to Philip Auslander, Rebecca Schneider, and Matthew Reason, have offered
compelling cases to the contrary.[50] Auslander, who insists that recordable and
savable performance already exists in the form of theatrical productions that
utilize media technologies, critiques the traditional understanding of perfor-
mance: "All too often, such analyses take on the air of melodrama in which vir-
tuous live performance is threatened, encroached upon, dominated, and con-
taminated by the insidious Other, with which it is locked in a life-and-death
struggle."[51] Phelan, in a 2004 article, responds to such a critique and updates
her original argument by acknowledging that "the technology capable of
broadcasting live art has grown enormously" in the twelve years since she first
wrote about the role that disappearance plays in performance. Although she
concedes that media can "record and circulate live events," she refuses to give
them "live performance" status. She notes that "these technologies can give us
something that closely resembles the live event, but they remain something
other than live performance." According to the author, the value of live per-
formance, in which the bodies of actors encounter those of the spectators, is
the "possibility of [each group] being transformed during the event's unfold-

ing."[52] Although the spectator might be affected by the screened image, the presence of the spectator cannot effect a transformation in the prerecorded image. Schneider, in a more nuanced approach, similarly critiques this thrall toward disappearance by suggesting that performance can both disappear and remain. In her aptly titled article "Performance Remains," the "performing theorist" observes, "For upon any second look, disappearance is not antithetical to remains. Indeed, it is one of the primary insights of poststructuralism that disappearance is that which marks all documents, records, material remains. Indeed, remains become themselves through disappearance as well."[53] Although Auslander and Schneider agree that performance is savable, the latter's approach proves more diplomatic in that it seeks to create a space for the performance remain within the extant theories of others. Schneider encourages her reader "to think performance as a medium in which disappearance negotiates, perhaps becomes, materiality."[54]

The lynching spectacle exists as an example par excellence of the type of performance for which Schneider advocates. It stages the transformation of the living body into a set of lifeless parts to be collected; the spectacle becomes materiality. In the case of George Ward, his lynching enacts his disappearance. The person and, indeed, the body (as a whole) recognized as Ward vanishes in the moments surrounding his death. However, these same moments also mark the rebirth of a dismembered Ward as performance remains. His death creates souvenirs of his life. Their presence, as a consequence of his absence, bestows meaning, value, and the perception of power upon them. More interestingly, these material remains testify to the lynching victim's former living status. They continually evoke the victim's body through a repeated underscoring of its absence. Ironically, Ward's newfound visibility anchors itself in the fact of his invisibility. This is the magic of the performance remain. It remembers its own disappearance and, as a result, renders the performance event whole again.

The word *remain* acts both a noun and a verb. As a noun, it refers to "that which remains or is left (unused, undestroyed, etc.) of some thing or quantity of things." As a verb, it means "[to] continue to exist; to have permanence; to be still existing or extant" (*OED*). Coupled together, the two meanings suggest a temporally ambiguous object that existed in the past (and was saved), exists in the present, and will continue to exist in the future. The remain remains; it not only lingers, but also, in some instances, lives. Within the context of theater and performance studies, the remain can be thought to

be the opposite of the stage property (or prop). Unlike the prop, which, as Andrew Sofer has observed in *The Stage Life of Props*, is "visibly manipulated by an actor in the course of performance," the performance remain gains its social value and meaning through an accompanying narrative provided by its possessor, a person who bore witness to the original performance event.[55] Despite these differences, the remain does share one significant attribute with the prop; both evoke a sensation of "pleasure in seeing the relic revived, the dead metaphor made to speak again."[56]

This sense of pleasure in the revival of the body part as remain appears in Samuel Pepys's recollection of his encounter with Queen Katherine of Valois on 23 February 1669.[57] According to the famed diarist, the skeletal remains of the monarch, who died in 1437, were on display at Westminster Abbey on the day that Pepys encountered them. Remembering both the queen and the day, he recalls that he held "her upper part of her body in my hands. And I did kiss her mouth, reflecting upon it that I did kiss a Queen, and that this was my birthday, 36 years old, that I did first kiss a Queen."[58] Despite the fact that Pepys interacts with an assortment of two-hundred-year-old bones, he believes that he has had an encounter with the queen through his interaction with her remains. Prodded by his imagination, he revives the body in the present in order to enable the touch of flesh on flesh to occur. It is important to observe that Pepys writes that he did not kiss bones, or even the remains of the queen, but rather that he did kiss a queen. She lives through his remembrance. The diarist's account and actions reveal that it is possible to create a personal, physically intimate, and temporally present experience with human remains. Collectively, his experience suggests that we can re-member the body of another through an embrace of his or her remains.

In the cases of Sam Hose, Richard Coleman, and George Ward, each individual had to be dismembered in order to be remembered. The remains of their bodies remind the viewer of their ordeal. When we are confronted with a dismembered finger, we are compelled to imagine the hand and, by extension, the body from which it was taken. We similarly are invited to restage (in our minds) the process of its removal. The same applies when we are confronted with the various other corporeal souvenirs of lynching campaigns—teeth, toes, slices of liver, and clumps of hair, among other body parts. The souvenir as fetish object as performance remain exists both as a metonym, referencing the lynching campaign, and as a synecdoche, reminding the viewer of the formerly whole body of which it is a part. Indeed, the power of

the black body as souvenir emerges from its seeming ability to exceed each of the previous terms. It is and is not a souvenir. It is and is not a fetish. It is and is not a performance remain.

Reflecting upon the frequency with which participant-observers descended upon the body of the lynching victim with the aim of collecting souvenirs, and recalling that the lynching event was one of the most spectacular performance events of past two centuries, it is difficult to understand how or even why theater and performance studies scholars would deny the existence of such performance remains. While I acknowledge that the assertion that performance disappears or vanishes both creates a sense of urgency to the documentation of the live event and bestows a greater cultural value (because of its seeming rarity) upon the art form, I am convinced that such an approach prevents contemporary scholars from fully exploring all of the dimensions of the performance event, including the important role that the performance remain plays within remembered performance. It has been my contention that the remain as fetish object and souvenir not only encapsulates but also provides access to the entirety of the performance event. It brings the past into the present and, in so doing, allows its possessor to touch history. Through its accompanying narratives, it appeals to a community of listeners and gains social meaning in the process. It also creates the possibility of an imagined, personal interaction with the original body, even as a construct, that exists within the present as a series of parts. In short, the value of the performance remain is in its seeming ability to reactivate the expired performance event.

For the white participant-observers who attended the lynching event and collected souvenirs, the lynching souvenir certainly held meanings different from what it holds for me, a critic and black scholar who is more than three generations removed from the lynchings discussed in this chapter. Whereas the spectator might have used the souvenir to remember her experience at the scene of the event or to represent her determination to prevent the social ascendancy of African Americans, I employ it to gain access not only to a particular historical moment, but also to the embodied experience of a specific person within that moment. In the case of George Ward, the performance remain grants me, along with other contemporary audiences, the opportunity to remember the body of Ward. It renders the body whole again and, in so doing, offers a perspective on the lynching event that ended his life

and created the remain. Although no one knows exactly what Ward was thinking in his final living moments, the remain has the potential to activate the various embodied experiences that lie dormant within the body and, in so doing, offers the possibility of approximating Ward's experience. Whether the possessor of Ward's part proves successful in the endeavor to know Ward, his history, or the scene of his murder, her possession of his remains allows her to remember the nature of his disappearance. His toe may be a souvenir, but it also is the lynching spectacle.

Part II: Living History

Haunted by memories of his near-death at the hands of a lynch mob who murdered two of his friends in Marion, Indiana, on 7 August 1930, Dr. James Cameron founded America's Black Holocaust Museum in Milwaukee in 1988 with the aim of creating a public memorial to the estimated 3,000 black men, women, and children who were lynched between 1880 and 1960. As originally conceived by Dr. Cameron, America's Black Holocaust Museum was a museum of horror, or perhaps, to use a word often employed by the founder himself, a museum of "terror." Entering the museum space, visitors were confronted by two life-size wax black figures that had been "lynched." With heads crooked to the side to give the impression of broken necks and death, they hung from a fabricated tree. Moving beyond the slightly swaying black bodies, visitors entered the main gallery, which was filled with pictures and newspaper clippings documenting past lynchings. On one wall, the narrative of the lynching tragedy was delivered through a sequence of photographs.[59] In the first image, a local sheriff delivers a black teenaged male into the hands of a white mob. In the next, the teenager, now dead, hangs from a tree and before members of the same crowd. In the final photograph, the same body, now unrecognizable, burns before the assembled audience as spectators mug for the camera. Elsewhere within the museum, visitors encountered a mannequin dressed in the actual robes of a Ku Klux Klan member. Further on, they reached the real-life Cameron, or in some instances his grandson, who would unroll an enlarged, poster-sized reproduction of the famed photograph of the lynchings of Thomas Shipp and Abram Smith, Cameron's less fortunate friends, and relay the story of how Cameron nearly became a part of the picture. Adding authority and, perhaps, authenticity to

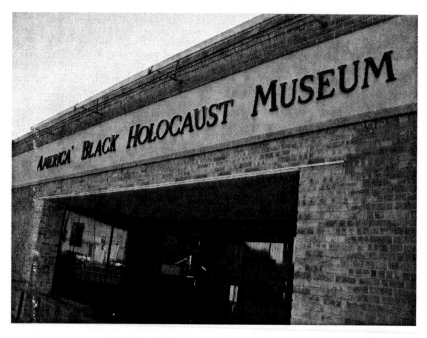

America's Black Holocaust Museum. Photograph by author.

the narrative, the museum founder would show his guests a dried, somewhat shriveled, and surprisingly small piece of rope that he would say was used to hang either Shipp or Smith.

Considering the content of the museum's early displays, it follows that guests of, and visitors to, the museum could find themselves emotionally unsettled by their experience. Newspaper columnists, critics, and reporters variously have described America's Black Holocaust Museum, including its "chamber of horrors," as "disheartening" and "heart-rending," among related adjectives.[60] Museum visitors had similar reactions. In a 1995 *New York Times* article entitled "Man's Museum of Terror Relives Terror for Blacks," Dr. Cameron, referring to the behavior of patrons at his museum, noted, "A lot of grown folks have to sit down after they see this."[61] Creating such an affect (and effect) appears to have been Cameron's goal from the beginning. In a 2004 interview, he not only reflected upon the emotions that he felt during his visit to the Yad Vashem Museum in Jerusalem but also revealed how

those emotions encouraged him to strive to evoke a similar response within the visitor of the museum that he would found. Cameron recalled:

> When you walk in that museum . . . the tears just start flowing out of your eyes. You can't help it. And you see the oven, the gas chambers and the pits dug out with bodies in them and others standing on the edge, ready to be mowed down by machine guns. And other artifacts in there just disturb you emotionally. So, when I came out of there and composed myself I told my wife, I said honey, we need a museum like this in America to show what has happened to Black people and freedom loving White people in this country who have been trying to help us ever since we've been here.[62]

Cameron's goal, in the creation of America's Black Holocaust Museum, was to reveal the horrible history of lynching to his museum visitors by emotionally disturbing them. He sought to invoke tears. He strove to create an environment in which the normally staid and historically distant museum patrons would lose their composure when confronted in the present with detailed depictions of past violence. The museum was meant to overwhelm, to horrify, to offend, and to enlighten.

In fall 2004, I visited America's Black Holocaust Museum with the aim of encountering a lynching souvenir. Although I did not know the particulars of the museum's collection, I knew that it housed a fragment of the rope that was used in the Marion lynching. I wanted to see this souvenir. After driving for approximately an hour from Chicago, I reached the city limits of Milwaukee. Signs along the highway directed me to the museum, which is located in a primarily African American, seemingly underclass, and arguably deteriorating neighborhood in the Bronzeville section of the city. The museum itself proved small and somewhat boxlike, rectangular in shape and consisting of one level. Entering the museum, I paid the five-dollar admission fee and walked into the main exhibition gallery, which was filled with six-foot cardboard displays depicting various generic moments in black history. Two rooms branched off of this main exhibition space. To the north, there was an all-purpose room that on this occasion was being used for a child's birthday party. The other, a video theater, offered seating for approximately one hundred spectators and featured a large screen upon which the 2001 documentary *Third Man Alive,* about Cameron's experience in Marion, was projected. The video theater marks the end of the museum. Once you have

reached it, nothing, with the exception of a closet-size bookstore and gift shop, remains to be seen. Somewhat depressed by my experience at the museum—I had driven all the way to Milwaukee to see a rope and there was *no rope*—I decided to stay and watch the documentary. My traveling companion and I were the only ones in the museum, other than those in attendance at the birthday party and the sole person at the reception stand. I turned on the video player, sat in the first row, and watched the documentary.

Within the video, Cameron tells his story and displays the rope fragment. In one segment, the founder stands within the space of his museum, and, in the background, the original displays, including the two wax figures, can be seen.[63] Making full use of being the only person in the theater, I rewound the video and reviewed the museum's depiction within the documentary. Although only onscreen for a few seconds, there, clearly depicted, were two hanging bodies. Did I miss this? How could I overlook something like that within a one-room gallery? Immediately, I returned to the main gallery and looked for what I had just seen on the video. The wax figures were not there. In fact, there were not any references to lynchings at all within this museum space. Not only was there *no rope,* there were *no lynched figures* and *no lynching pictures.* Searching for answers, I approached the woman who sold me the tickets to the exhibition. I asked, "What happened to the displays depicted in the documentary? The wax figures?" She replied, "Oh, we took them down awhile ago." She elaborated: "People would leave here in tears, crying. It was too much for them. People didn't want to bring their kids. We received a lot of complaints, so we took it down. It's a shame 'cause people should see it."

The decision to remove parts of the permanent collection and, in so doing, to unravel Cameron's vision for the museum, prompts a series of questions: how do you remember or memorialize a history that is too difficult and, perhaps, too traumatizing to revisit? How do exhibits that remember atrocities committed within the borders of this country violate the seemingly unwritten rules of proper or ethical museum display? I here interrogate these questions by exploring whether a museum can house the memory of America's lynching history, by discussing the role that "ethics" plays in the contemporary museum display, and examining the aspects of Cameron's original exhibits that succeeded in offering a glimpse of the experience of the black body in the midst of the lynching spectacle.

Can a Museum Remember This History?

The lynching event does not lend itself easily to *museumization,* the process through which tangible materials from past/passed events or people are collected, stored, and later displayed, for the following three reasons: lynching spectacles were flash events; they were not site specific; and they targeted the individual and not the community. Although not entirely spontaneous performances, lynchings were *flash occurrences* in which little advance notice of the event was given. Often incited within hours or perhaps days of the public broadcast of an alleged crime, the lynching spectacle was staged before its victim formally had been given a trial. The lynchings of Thomas Shipp and Abram Smith, along with the near-lynching of James Cameron, occurred hours after they had been accused of robbery, rape, and murder. It only took a few hours, after similar allegations of criminal misconduct spread throughout Duluth, Minnesota, for tens of thousands of people to gather together to participate in the lynchings of Elias Clayton, Elmer Jackson, and Isaac McGhie on the evening of 15 June 1920. The relative immediacy of the lynching spectacle suggests that lynchings, unlike other publicly staged human atrocities (African captivity, the Holocaust, or the Trail of Tears, among others) was not a systematic act that was planned in advance, enacted in a uniform manner, and, most importantly to this study, generative of significant remains that could be collected for museological purposes.[64]

As flash events, lynching spectacles were conducted within locales that were selected for their preexisting features, such as the presence of a tree or streetlight, or the ability of the site to accommodate a large crowd. They did not require the creation of camps, scaffolds, or other structures that could exist afterward as architectural remains of the performance event. In fact, lynchings occurred with such rapidity that the site, even when not dismantled for souvenirs, bore few, if any, visible signs or markings of the events that had occurred there. While the space of the lynching likely triggered memories in those who attended the event or knew its victims, the site proved incapable of memorializing the lynching tragedy. A contemporary example of the inability of the lynching site to remember the event that it hosted appeared in choreographer-dancer Ralph Lemon's 2004–5 performance project *Come Home Charley Patton* in which Lemon, within an accompanying documentary video, visits the site of the Duluth lynching. Within the video,

Lemon sits on a street corner and looks up at a streetlight. The light stands in the same place where another "lightpole" once stood from which Clayton, Jackson, and McGhie were hanged.[65] Although the symbolism of Lemon's revisitation proves immediately apparent—a black man sits and looks (reverently?) up at the site where three young black men were lynched—his actions do not conjure images of the lynching event. The lynched bodies neither haunt the documentary nor, as can be discerned within the video, the space of Duluth. The site cannot remember the tragedy. Similarly, the jail from which Cameron and his friends were extracted in Marion, despite being on the National Register of Historic Places, has been converted into an apartment building, ironically (perhaps purposefully?) for low-income, largely black residents.[66] The memory of the jail's prior role was preserved primarily by Cameron, who, by his estimation, returned to the site over forty times with the aim of reminding/informing people of the events that occurred there.[67]

Complicating efforts to memorialize lynchings, within the museum context, is the fact that lynchings, despite their relative frequency on a national scale, occurred rarely in localized communities and almost always targeted a specific individual or individuals. The specificity of the lynching event, enacted in a particular town as a response to a particular allegation, makes it difficult to create a generalized memorial or monument to the entire body of spectacularized murders. Having reviewed many of the published accounts of lynching spectacles, including Cameron's, I am taken by their emphasis on the individual. Separately and collectively, they literally underscore the tragic nature of the lynching event, which as a tragedy involves the destruction of its protagonist(s). While there are similarities in the manner in which these performances were enacted and in the behavior of the crowd who attended such performances, their repeated emphasis on the individual makes it difficult to think of the recounted lynching as being connected with a larger, more systematized structure of events. Despite the fact that numerous scholars, including Orlando Patterson, Robyn Wiegman, and Trudier Harris, repeatedly have used the word *ritual* to describe the manner in which the lynching performance was enacted, it is important that we remember that the lynchings themselves, even with their similarities, were local affairs that were independent of one another. While it is not difficult to identify shared qualities that seem to link such public spectacles of death, it would be erroneous to assume that the lynchings themselves

were conducted as part of a single, grand narrative. As Kirk Fuoss noted, "Any notion of a typical 'lynching' is best regarded as a convenient fiction."[68]

Considering the flash aspect of lynching spectacles, the generic nature of the sites in which they were performed, and the specific features of individuated lynching events, Dr. James Cameron's goal to create a museum to remember the history of race-based lynching appears unattainable. Contrary to other historical museums, even museums remembering other genocides, which use carefully arranged and extensive collections to build toward a seemingly complete account of a past event or people, America's Black Holocaust Museum sought to memorialize the history of lynching with the aid of three types of displays: the material remains of the rope, on-site photographs depicting actual lynchings, and, perhaps most importantly, Dr. Cameron himself, whom at least one reporter has described as the museum's "star exhibit."[69] The presence of the rope fragment, the only actual material remain of any lynching on display at America's Black Holocaust Museum, underscored the material absence of the museum. Unlike exhibitions in other museums that remember the murders of large numbers of individuals through displays of significant quantities of mundane objects (such as shoes), the single piece underscores the difficulty of remembering the entire lynching tragedy. It prompts the realization that out of an estimated 3,000 lynchings, the only remains that can be displayed within the only museum dedicated to the remembrance of such lynchings is this one, small bit of rope.

Although photographs taken during the lynching spectacle offer irrefutable evidence of the event's occurrence and, as a result, are historically valuable, their public presentation threatens to repeat and restage their past violence in the present. Eric Lott, responding to James Allen's controversial collection of lynching images, including his *Without Sanctuary* exhibition, observes:

> The pictures reanimate in the present the racial civil war they document. One irony of such pictures is that while they are taken by and for (and sometimes of) white people, their terroristic value depends on their being seen by black people. The terror they inspire relies on black viewers being placed in the minds of white lynching participants, seeing themselves with violent white eyes . . . black spectators are subjected to the violence committed both *in* and *by* these photographs.[70]

Lott, like Grace Elizabeth Hale in her exhibition review of *Without Sanctuary*, notes that the purpose of such photographs was to disseminate the terror of the lynching event. Whereas blacks rarely were present at lynchings, images documented the events and enabled blacks to witness them through their photographic remains. Certainly, one can think of the public nature of lynching postcards—which were designed to be seen by people other than the addressee—to begin to understand this feature. Hale writes, "Souvenirs extended the work of lynchings far beyond the time and place of the actual murder."[71] In the case of exhibits like *Without Sanctuary*, the violence not only gets extended to the present but also spreads geographically to the various places where the collection has been displayed. The same issues appear in Cameron's museum. Although his collection is significantly smaller than Allen's, it also re-presents lynchings from the perspective of the participant-observer and similarly repeats the terror that the original images were intended to evoke. Indeed, efforts to distinguish Cameron, the black survivor, from Allen, the controversial white collector who has profited from displaying the black body in various states of agony, become difficult when we acknowledge that America's Black Holocaust Museum hosted *Without Sanctuary* for an open-ended run in 2002. Rather than inserting a critical space between the two displays, Cameron, and his curatorial staff, embraced the traveling collection. Cameron's son, in a *Milwaukee Journal Sentinel* article, referred to the visiting exhibition as "the icing on the cake." He further stated, "We don't know how long it will be here. If [Allen] wants to keep it here, it would be fine with us."[72]

With the rope being too small to capture the entirety of the event and the photographs having the capacity to re-create the potentially traumatizing experience of witnessing the lynching spectacle (whether mediated or not), Cameron's narrative assumed greater meaning. Unfortunately, this too proved problematic. As Giorgio Agamben's reading of the complicated subject positions of survivors of atrocities who are called upon to testify about the event(s) that they survived reminds us, the notion that spectacular deaths can produce accurate "witnessed" testimonies proves fallacious on two accounts: first, the witnesses called to testify are those who did not experience the death, and, second, those who did experience the death cannot testify. Agamben's observation applies to Cameron, the lynching survivor, who missed the event, the murders of Thomas Shipp and Abram Smith that he seeks to recall. Although he can remember the sounds of the lynch mob, out-

side the jail, calling for the murder of his friends and can recall being dragged through the streets of Marion with a rope around his neck, Cameron fails to shed any light upon the most dramatic and, indeed, the final act of the lynching tragedy.[73] His narrative or testimony fails in the moment that it matters most.

America's Black Holocaust Museum, as originally conceived by Cameron, appears incapable of representing the entirety of the lynching narrative. The lack of material remains, the problems within witnessed accounts combined with the lynching event's flash nature, and emphasis on the individual suggests that a comprehensive memorialization of the lynching spectacle cannot be accomplished within a museum space: certainly, not within the displays of Cameron's museum. These limits offer a compelling reason for the museum to abandon its attempts to memorialize the lynchings of African Americans within the United States. However, the museum staff did not change the exhibit because they became aware of the difficulty and, perhaps, impossibility of memorializing the history of lynching with their original collection but because their existing display proved too disturbing for those in attendance. This shift toward a more conservative exhibition, within which all mention of lynchings and other abuses was eliminated, was designed to cater to its audience and, perhaps, to conform to the "ethical" standards of its peer museological institutions rather than to acknowledge the presently unattainable nature of Cameron's original goal.

Creating a Proper Museum Display

The decision of America's Black Holocaust Museum's curatorial staff to shelve the wax figures, rope, and lynching photographs (among other previously displayed items) is not surprising. The earliest indication of this shift appeared in a 1998 *Milwaukee Journal Sentinel* article celebrating the museum's tenth anniversary. In the article, Marissa Weaver, the executive director of the museum, expressed her desire that America's Black Holocaust Museum "become a member of the American Association of Museums, which recognizes excellence in the museum community."[74] In support of this goal toward accreditation and eventual membership, the article noted that the museum "recently completed the first step of the association's Museum Assessment Program (MAP), which included a visit by a museum professional and a report of the expert's recommendations." Although the article does not

reveal the findings of the MAP expert, it quotes an optimistic Weaver as say-ing, "That was a giant step for us in terms of moving the museum forward on a national level." She further estimated that the accreditation process could take five years.

The museum accreditation process is not tremendously difficult. The American Association of Museums's (AAM) definition of a museum, em-bracing those used by the International Council of Museums (ICOM) and the federal government's Museum and Library Services Act, proves sufficiently broad that most nonprofit entities that collect and display items, for essentially any purpose, qualify as a museum.[75] For example, the current list of AAM-accredited museums includes the American Museum of Fly Fishing, dedicated to "preserving our fly-fishing heritage for future genera-tions."[76] Among the AAM's more stringent requirements are the following: organizations must have been in operation for at least two years, own 80 per-cent of their permanent collection, operate within a physical facility, and have a mission statement. At the time of its application, America's Black Holocaust Museum could have satisfied each of these requirements. Two of the remaining criteria, however, may have caused problems for the museum and necessitated five years to remedy. First, AAM mandates that its mem-bers "have the financial resources to operate effectively." Although the finan-cial affairs of America's Black Holocaust Museum are not publicly available, its ten-year existence suggests that it could generate the financial resources to maintain itself into the future. Indeed, the museum not only has existed for an additional ten years since the accreditation review but also has been cited, by numerous local politicians, as a potential centerpiece of an urban renewal initiative for the Bronzeville section of Milwaukee.[77] The second, potentially thorny requirement, is that an AAM member museum must con-form with the organization's *Code of Ethics for Museums*. The *Code*, in its in-troduction, reads:

> [Museums] are organized as public trusts, holding their collections and in-formation as a benefit for those they were established to serve. . . . As non-profit institutions, museums comply with applicable local, state, and federal laws and international conventions, as well as with the specific legal standards governing trust responsibilities. This *Code of Ethics for Museums* takes that compliance as given. But legal standards are a minimum. Museums and those responsible for them must do more than avoid legal liability, they must take

affirmative steps to maintain their integrity so as to warrant public confidence. They must act not only legally but also ethically. This *Code of Ethics for Museums,* therefore, outlines ethical standards that frequently exceed legal minimums.[78]

The *Code,* seeking to maintain public confidence and trust in AAM museums, requires that museums behave in a manner that exceeds their legal liability. Among its extralegal mandates, two, appearing under the "programming" heading, may have ruined America's Black Holocaust Museum's chances for accreditation and membership. Programs must be "accessible and encourage participation of the widest possible audience consistent with [the museum's] mission and resources" and "respect pluralistic values, traditions, and concerns."

The museum, as curated by Dr. Cameron, violated both of these conditions. Filled with tear-inducing and potentially traumatizing exhibits, it was not designed to reach out to the "widest possible audience." Although one could say that the nature of the displays was consistent with the museum's mission to educate its patrons about the history of lynchings and racialized violence in the United States, an obvious response would be that such a history can be portrayed in a manner that would neither offend nor horrify.[79] Beyond the displays, others might have been offended by the museum's invocation of the word *Holocaust.* Wisconsin State Senator Glenn Grothman, writing of America's Black Holocaust Museum in a *Milwaukee Journal Sentinel* article, noted, "First of all, there was no black holocaust was there?" and added, "Calling that museum the Black Holocaust Museum is an insult to Jews."[80] Although the article points out that Grothman, who is not Jewish, had never visited the museum, the possibility exists that others shared Grothman's objections.[81]

Although the mandates of the AAM appear well intentioned, they prevent the establishment or, at least, the accreditation of museums, like America's Black Holocaust Museum, that seek to expose the less palatable aspects of U.S. history. In this instance, they render historical responsibility incompatible with museum ethics. Vivian Patraka reaches a similar conclusion in her discussion of the absence of the various local, intranational atrocities that have occurred throughout American history in the United States Holocaust Museum's depiction of genocides around the world. Patraka makes a much needed critique of national museum culture when she notes that the United

States has succeeded in remembering the abuses committed abroad but has yet, within any federally funded or federally assisted museum project, remembered those that have occurred closer to home. Patraka writes:

> Is showing genocide within our borders "going too far" . . . ? There are African American and Native American museums slated for the Smithsonian Mall but, as Philip Gourevitch has noted, no "Museum of Slavery" or "Trail of Tears" museum. Perhaps recognizing the contributions of specific ethnicities, emphasizing what their continuing presence and vitality offers us as a nation, constitutes a celebratory means of covering over what was done to them and who and what has been permanently lost. Our democratic discourse must repress highly visible borders. Thus, in order to sustain its fictions of nationhood and its imagined community, it must produce yet another set of highly visible representation of what it marks as a genocide occurring "elsewhere."[82]

Patraka makes a compelling point. The eagerness with which national, public museums or private museums located on federal land point to the abuses of human rights abroad without looking inward at similar atrocities that have occurred is troubling. The lack of a major museum or even a major exhibit within a major museum documenting these events suggests that the divisive history of the past has been deliberately bypassed in favor of an integrationist, forward-looking narrative. Certainly, such an approach would appeal to the "widest possible audience" while respecting their "pluralistic values, traditions and concerns." Within the currently maintained fiction of the nation-state, the lynching spectacle neither merits prolonged mention nor space within the context of the "ethical" museum. To pause and reflect upon any of the thousands of black individuals who were killed at the hands of lynch mobs could threaten to unravel the fabric of the nation. In order for the museum to maintain the confidence and trust of the public, not only in the museum itself but also in the nation, it must not reveal the spectacles of violence that have occurred.

When Proper Ain't Enough

Within America's Black Holocaust Museum, the violence directed against the black body was put on display. The rope fragment was used in the murder of either Thomas Shipp or Abram Smith. The photographs paused the

moment of the lynching spectacle, eternally inviting spectators to witness it, and, as Eric Lott memorably wrote, "[made] our looking violent." Cameron himself, as the sole survivor of the Marion lynching, not only was beaten severely but also was imprisoned for crimes that he did not commit. In sum, every object on display within the museum depicted the black body as the target of violence and abuse. Even the wax black figures had been lynched. Collectively, the original museum displays prompt the question: does the representation of such violence distract the spectator or patron from understanding the history being remembered within the space itself?

According to Elizabeth Alexander in her 1995 article, "Can You Be BLACK and Look at This?" "Black bodies in pain for public consumption have been an American national spectacle for centuries."[83] They serve as the scenes of violence in which the spectacle of assault and suffering is continually played and replayed. Although Alexander, at the time, was referring to the infamous "beating" of Rodney King by members of the Los Angeles Police Department, her comments describe accurately the spectacular abuse of the black body in both the past and the present: from the display of corporal punishment on plantations, to the spectacle of lynching, to the televised assaults enacted against civil rights demonstrators, to the recent images of black suffering in New Orleans. While this pairing of blackness and suffering problematically enables the continuance of potentially racist associations of blackness with poverty and criminality, the reality is that the publicly presented and mediated black body often appears in a moment of crisis. America's Black Holocaust Museum, within its collection and various exhibits, remembered many of these moments.

Several scholars and historians have written about, to use Alexander's phrase, the black body in pain. Less documented is how the embrace of those images, within the black community, has been used not only to structure behavior but also to memorialize the body subjected to violence. Claudine K. Brown, in "Mug Shot: Suspicious Person," contends that images of violence targeted against the black community have created a greater awareness of how the black body needs to present itself within the present. More than a Du Boisian notion of knowing how one is perceived from without, the idea that emerges from looking at such images is that one better behave and appear in a certain manner as a means of reducing the likelihood of becoming a victim of violence. The image makes the body responsive to the violence that potentially awaits it.

The best and earliest example of how the display of the abused body can structure behavior and preserve the memory of a past violence for the future is the presentation of Emmett Till's remains at his 1955 funeral service and, equally importantly, his re-presentation within the pages of several "black" newspapers and magazines. Shaila Dewan, writing for the *New York Times* on the fiftieth anniversary of Till's murder, described the appearance of the young boy with the following words: "Mutilated is the word most often used to describe the face of Emmett Till after his body was hauled out of the Tallahatchie River in Mississippi. Inhuman is more like it: melted, bloated, missing an eye, swollen so large that its patch of wiry hair looks like that of a balding old man, not a handsome, brazen 14-year-old boy."[84] In her article, Dewan proceeds to remind/inform her reader that the controversial decision to have an open coffin belonged to Till's mother; that "an image of young Emmett in a straw hat was taped to the coffin for comparison"; that photographs of the boy's abused body were first published in *American Defender* followed by *Jet* and *Chicago Defender,* all black publications; and that "no mainstream publications, even those that editorialized against the acquittal, printed the photographs." According to Chris Mettress, the editor of *The Lynching of Emmett Till,* and one of Dewan's interviewees, the publication of Till's image in newspapers effected different reactions among the white readership of the mainstream press and the black readership of the black newspapers. Quoted in Dewan's article, he observed: "You get testimony from white people coming of age at the time about how the case affected them, but you don't get them testifying, like countless blacks, that the *Jet* photo had this transformative effect on them, altering the way they felt about themselves and their vulnerabilities and the dangers they would be facing in the civil rights movement. Because white people didn't read *Jet.*"[85] The display encouraged black audiences to recognize the possibilities of themselves being the body within the picture at some future time. Elizabeth Alexander makes a similar contention when she discusses the impact of Till's display on the black community by noting that it "indoctrinated . . . young people into understanding the vulnerability of their own black bodies coming of age, and the way in which their fate was interchangeable with Till's."[86] Although it is not clear what type of response the same image would have received if printed within the mainstream press, the response within the black community, as interpreted by Mettress and Alexander, suggests that the published image not only gave a face, that of a fourteen-year-old boy, to the race-based

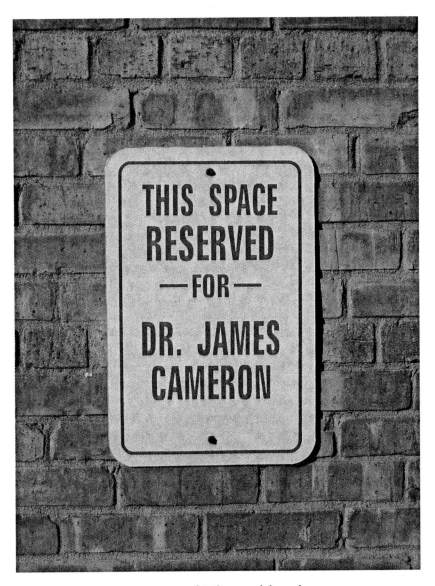

"Space Reserved." Photograph by author.

violence that had existed for decades but also established the spectators/
readers as witnesses to a past violent act. Despite being geographically and,
perhaps, temporally separated from the space of the Chicago South Side fu-
neral service and of the Money, Mississippi, murder, they were given the op-
portunity to bear witness to the enactment of history and, as witnesses, in-
vited to testify about their experience standing in the face of Till and the
violence that was directed toward him.

James Cameron, within the space of his museum, offers his visitor a sim-
ilar opportunity to witness the past. Although he could not resurrect the
physical bodies of his friends who were murdered in Marion, he did the next
best thing within his display. He placed wax figures in their stead with the
aim of approximating the experience of actually standing before the real bod-
ies that had been lynched. While we initially might think that their presence
would shatter the founder's attempt to offer real—and, therefore, horrific—
depictions of American lynching spectacles, Richard Voase contends that
"meaning is created in the mind of the visitor, rather than by the objects en-
countered . . . whatever meanings visitors create in their minds are shaped by
their own memories, interests and concerns as much as by their encounter
with the attraction."[87] In short, the visitor projects her own thoughts and
memories across the material museum and, in so doing, makes meaning and,
perhaps, renders "real" the inauthentic object on display. Voase, using
Madame Tussaud's wax museum as an example, notes that "research has
shown that visitor satisfactions emanated from an exploration of the memo-
ries, feelings and emotions associated with the person represented by a wax
figure, rather than in the artistry of the figure."[88] Through a similar appeal to
the imagination, Cameron's wax figures may have invited the museum spec-
tator into the event being restaged in a way that could not have occurred with
actual, flesh-and-blood bodies.[89] At the very least, the hanging wax bodies,
life-size replicas of Shipp and Smith, gave a sense of size and scale to the
"real" lynchings depicted in photographs on the museum's walls. They also
prompted a lingering question for the historian looking back at their display:
could a wax face trigger the need to testify in a manner similar to that of Till's
actual face?

In addition to the possible effect caused by the spectator's encounter
with the wax figures, we need to consider the role that photographs of past
lynchings played within America's Black Holocaust Museum. Could they op-
erate in the same manner as those in Till's case? Despite the obvious differ-

ences that the image of Till was created with the consent of his mother and was presented within the predominately black community by the black press, while the lynching images were photographed without the consent of the lynching victims or their families and were circulated as souvenirs for white spectators at the spectacle, we need to ask whether or not these photographs can be rehabilitated and reappropriated by their display within Cameron's museum. Among the images originally on display, many of them loaned, copied, or purchased from the Tuskegee Insitute's lynching archive, there are two types that merit special consideration. The first is the series of images depicting the handing-over of the black teenaged male by the sheriff to the murderous crowd, followed by his subsequent hanging and burning. Unlike the majority of surviving photographs, in which only one image of the event appears, this sequence demonstrates what Orlando Patterson has described as the "transition from a state of life to a state of death."[90] Within and across these images, the photographic spectator bears witness not only to the loss of life but also, and perhaps more importantly, to the transformation of a living, sentient subject into an object to be destroyed. As harrowing and horrific as the photo sequence is, it exists as one of the few images in which the black body appears alive before death. In a way, the photographer, in his sequential arrangement, does what Mamie Till did for her son. The brutality of the lynching scenario appears within and, perhaps, between the juxtaposition of the living with the dead.

The second is the infamous photograph of the Marion lynching. Unlike the former series that adorned the walls of the museum, this latter image originally was not displayed and only appeared as part of Cameron's, or his grandson's, lectures to museum visitors. By keeping the image hidden from the spectator, the museum founder was able to introduce the various players in the lynching tragedy. Through his narrative, Cameron gave his guests an opportunity to know Shipp and Smith before unveiling, or more accurately, unrolling the image of their dangling dead bodies, as the spectators of Till's face, whether in Chicago or through the pages of the black press, encountered the unblemished face of the teenager and then confronted the horror of his final appearance and, in the process, were able to bear witness to the violence that was projected across his body. This presentational strategy not only makes the actions of the white crowd, who mug before the camera, even more appalling but also shields Cameron's museum from the type of criticism that has been targeted against James Allen's *Without Sanctuary* exhibi-

tion, a collection of images presented largely without context. Whereas Cameron's more informative approach humanizes the objectified black body at the heart of the lynching spectacle, the former, as Michael Eric Dyson has observed, "[does] the ultimate disservice to black people."[91] It, according to Grace Elizabeth Hale, "[leaves] viewers with an exhibit that is too close to the spectacle created by the lynchers themselves."[92]

Cameron's important and redemptive contribution to the Marion lynching photograph underscores his centrality in the effort to memorialize the lynching tragedy. In addition to being the founder of America's Black Holocaust Museum and the sole survivor of the Marion lynching, Cameron, who died in June 2006 at the age of ninety-two, was widely recognized as the living remains of the lynching spectacle. James Allen referred to him as "the memory of America on lynchings."[93] Similarly, countless reporters, from across the globe and with varying interests, treated the museum founder as the embodied history of American lynching. In the final two decades of his life, he appeared on *The Oprah Winfrey Show* (twice), the *700 Club*, *The Jerry Springer Show,* and scores of others.[94] In 2005, when the United States Senate offered an apology for turning a blind eye to the thousands of lynchings that terrorized the black community from the late nineteenth to the twentieth centuries, it apologized to him. Although Cameron is the most visible person associated with the history of American lynching and, in most cases, has been viewed as its embodiment, the question remains: can a museum largely founded upon the memory of a single individual memorialize the history of American lynching?

After an extensive reimagination in 2005, the Yad Vashem Museum in Jerusalem reopened with a new multi-million-dollar facility filled with even more artifacts, giving it the largest Holocaust collection of any museum in the world. The museum's previous permanent exhibition—the one Cameron saw in 1976—was shelved. Gone were the images of human atrocities that emotionally unsettled Cameron and inspired him to found his own museum of horror. In their place were different photographs, family portraits and personal pictures of people who would soon be uprooted from their homes, confined in camps, and, in many cases, murdered. Explaining the motivation for the change in Holocaust-era photographs, Johnny Dymond, writing for the BBC, noted, "Put simply, too many of them were taken by Nazis, and too many of them make the Jews look like faceless victims rather than once-liv-

ing and breathing individuals." In the new exhibit, according to Avner Shalev, chairman of the Yad Vashem Directorate:

> We put the individual at the centre. We're telling the story through the eyes, the mouths, the feelings of the individual. Eye to eye, person to person. . . . We believe that if you get some human pieces of experiences, you can build your own empathy, you can think "what is my responsibility? Where am I in this story? What does it mean to me?"[95]

The new exhibition sought to portray the Holocaust survivors as individuals and not victims, with the assumption being that the gravity of the Holocaust experience along with its history could be relayed best from one person to another.

Although Cameron patterned the design of his museum after the original Yad Vashem collection, the manner in which he introduced the history of lynching to his audience was more akin to the contemporary museum. He revealed the history of the lynching spectacle by sharing his story and his experiences with museum guests: person to person. While his narrative constrains itself to the incidents in Marion, the vividness of his story, filled with details and remembered emotions, proves so vibrant that the remembered event can be rewitnessed by newer and (temporally) more present audiences. It invites them into his experience and memories, allowing them to become a part of the lynching spectacle and to empathize with the bodies centered in the picture. Does this experience of vicarious witnessing make Marion representative of all lynchings? No. It does not. However, it does engender an experience of a lynching that then can be used to gain access to and to approximate the experience of other similar lynchings. Historically, the Marion tragedy has served this function. In 1937, Abel Meeropol, after seeing the photograph of Shipp and Smith, was inspired to write a poem, "Strange Fruit," and, shortly thereafter, adapted it into a song, with an arrangement by Sonny White, for Billie Holiday, who popularized it. Together, the photograph, the poem, and the song have helped to make the Marion lynching the most famous or infamous of the estimated 3,000 white-on-black lynchings in the United States. Furthermore, the existence and relative accessibility of material (rope) and living (Cameron) remains of this particular event within America's Black Holocaust Museum make it a likely

starting point in any effort to memorialize the history of lynching within the United States.

Despite the fact that it is difficult, if not impossible, to memorialize the history of American lynching within a museum space, Dr. James Cameron, with his original displays, succeeded in presenting parts of that history. In building the museum around himself and his experiences, most notably his memories of the lynching in Marion, he not only managed to create a monument to the best-remembered lynching, from a popular culture standpoint, in U.S. history but also offered his patrons an opportunity to imaginatively witness a lynching through the presentation of photographs, the rope fragment, and his engaging narrative. The founder's ability to trigger the imagination of his guests through a combination of actual, fabricated, and living remains is impressive considering the many obstacles that stood in his way: from the event's flash nature to the scarcity of available material remains. While these obstacles create gaps and holes within the historical display, the museum's original collection did offer a vivid, disturbing, and emotionally unsettling picture of the abuses targeted against the black body over time. Considering the museum's ability to achieve the goals of its founder, it is surprising that its curators would dismantle its permanent collection in favor of a more generic and, perhaps, censored reading of black history. The revised collection, with the exception of the video documentary, did not offer a single image or reference to lynching. Gone were the wax figures, the photographs, the rope, and the real-life Cameron. No longer a place of "terror," the museum became an annual destination for regional school field trips and, on occasion, a place to celebrate special events such as a child's birthday party. In July 2008, the twentieth anniversary of the opening of America's Black Holocaust Museum, the museum's Board of Directors "temporarily" closed the museum and placed its permanent collection in storage. America's Black Holocaust Museum has yet to reopen.

Epilogue

In January 2009, psychologists at York University (Canada), the University of British Columbia, and Yale University published the results of a study that "examine[d] why acts of blatant racism against blacks still occur with alarming regularity."[1] After staging a "racist incident" in which a white actor calls a black actor, who bumps into him, a "clumsy nigger" before unsuspecting nonblack subjects, the authors observed that the majority of their 120 subjects "respond[ed] with indifference."[2] Their conclusion: apathy enables racist acts. In February, the *New York Post*, a newspaper known for printing controversial headlines, published a political cartoon depicting a chimpanzee murdered (by the police) that appeared to represent President Barack Obama.[3] In April, a poll conducted among teachers in the United Kingdom revealed that 64 percent of respondents "agreed or strongly agreed that racism [against 'black and ethnic minority' students] was an issue in schools generally."[4] In May, Omar Edwards, an off-duty black police officer who was engaged in "police action," was mistaken as a criminal suspect and gunned down by a fellow New York policeman.[5] In June, an eighty-eight-year-old "neo-Nazi" opened fire in the U.S. Holocaust Museum—killing a black security guard—in protest of the presidency of Obama. In July, black literary scholar Henry Louis Gates, Jr., was mistakenly identified as a burglar attempting to enter his own home and was arrested by the police for what cultural critic Michael Eric Dyson termed "housing while black." In October, a Louisiana judge refused to issue a marriage license to an interracial couple "out of concern for any children that the couple might have."

Spectacular events, charged, racializing scenarios that not only envelop black folk but also structure their embodied experiences, occur every day. They happen in schools, in the workplace (even as you are applying for a job),

in restaurants, and on the street. At times, they are subtle: the closed-door or behind-the-back conversations black folk suspect are occurring but to which they do not have access. It is these suspicions that cultural anthropologist John L. Jackson labels racial paranoia. At times, spectacular events are too flagrant to be ignored: racial profiling or the burning of a cross. This book places a spotlight on several of these scenarios and chronicles the ways in which black folk have responded to the violent intrusion of race/racism in their lives and reveals the similarities between the embodied black experiences of the past and the present. The performance of Renty before J. T. Zealy's daguerreotype machine resonates with the stillness of hundreds of thousands of black bodies in police precincts and detention centers. The stand of Ali, against governmental efforts to control and marshal his body, gestures back toward earlier efforts to control the bodies of Tom Molineaux and Saartjie Baartman and, perhaps, foreshadows the contemporary experience of Muslims within the United States, whose movements are tracked as part of an ongoing "War on Terror." The nightmares of Robbie McCauley remind us that the experiences of prior generations can be accessed and replayed by their descendants. James Cameron exemplifies and, indeed, embodies the process through which history and memory reside within the black body.

The frequency with which spectacular events occur exists as proof that we do not live within a "postrace" society. The everyday abuses of black folk continue with alarming regularity. In *The Many Costs of Racism*, Joe R. Feagin and Karyn D. McKinney assert that a person cannot be black within the United States and not experience some form of racism. They contend that ingrained racist attitudes and discriminatory actions have created "powerful domino effects on [black] families" in which black individuals "discover that racist actions have bankrupted them of all of their future possibilities."[6] A black job applicant may not get hired for the position for which she applied. Her unemployed status could affect the standard of living of her family, the possibility of her children attending college or university, her sense of self-esteem, and even her health. Devah Pager, a sociologist, tested this theory by recruiting black and white subjects to pose as applicants for the same job. She discovered that white applicants with a felony conviction were as likely to be contacted for interviews as a black applicant with a "clean" background. Pager concluded: "Being black in America today is just about the same as having a felony conviction in terms of one's chances of finding a job."[7]

Although it is tempting to place "the problem of the color line" squarely within the twentieth century and to look forward, with blinders, and assert

that past racisms no longer structure the experience of black folk, such an act not only would overlook the daily experiences of black people but also ignore the many ways in which twenty-first-century thinking resembles nineteenth- and twentieth-century racial logic. At the current moment, the study of genetics, specifically DNA tracing, has offered "new" evidence of the biological differences between blacks and whites. Pharmaceutical companies, seeking to exploit these differences, have begun to create and market race-specific medicines. In addition, for-profit companies are performing genetic tests for paying customers and offering them an opportunity to document their ancestral place of origin on the African continent and, for a few dollars more, to obtain a certificate of racial authenticity. It is difficult to encounter any of these companies or their advocates without thinking about Louis Agassiz's conviction that blacks are not of the "same blood" as whites. Furthermore, black folk, especially young males, continue to be stripped of their liberty and incarcerated at alarming rates. According to the United States Bureau of Justice Statistics, "newborn Black males [born in 2000] in this country have a greater than 1 in 4 chance of going to prison during their lifetimes."[8] The era of black captivity continues.

The goal of this project is not to ignore the myriad ways in which Western societies have evolved over the past two centuries. Instead, it is to appreciate the progress that has been made not only by black folk who employed performance(s) to respond to the intrusion of spectacular violence into their lives but also by those who took the time to learn from the experiences of earlier generations. Mr. and Mrs. Boyd, through collaboration with Richard Roberts, were able to control their presentation and, indeed, re-presentation in a manner that was not possible for Jack, Drana, or the other men and women who sat before Zealy's camera. Muhammad Ali was able to assert mastery over his own body in a way that Tom Molineaux could not. Suzan-Lori Parks restages the experience of Saartjie Baartman and imagines the life of a homeless black mother on public assistance with the aim of enticing empathy, which was denied to both the real Baartman and every woman who has been labeled as a "black welfare mother." It is possible that recognizable blackness will no longer be a determining factor in a person's embodied experience by the end of the current century. However, the path toward that future moment, as Barack Obama noted in a 2008 "Speech on Race," requires that we "embrac[e] burdens of the past without becoming victims of our past."[9]

LIVERPOOL JOHN MOORES UNIVERSITY
LEARNING SERVICES

Notes

Chapter One

1. Frantz Fanon, *Black Skin, White Masks,* trans. Charles Lam Markmann (London: Grove Press, 1967), 10.

2. Ibid., 111–12.

3. For Fanon, the word *Nigger* is interchangeable with *Negro* when employed as an interpellation. "Look at the Nigger!" (ibid., 113).

4. Ibid., 112.

5. Fanon does not record when or in which country the encounter occurred. Seeing that he lived in Lyon in the early 1950s and that he makes specific and repeated references to Lyon in the text of *Black Skin, White Masks,* it logically follows that the encounter may have occurred there in the 1950s. It is important to note that when and where the encounter occurred is, to this analysis, not as important as the fact that it happened. David Macey in his biography of Fanon frequently refers to Fanon's race problems in France. See David Macey, *Frantz Fanon* (New York: Picador, 2002).

6. Resisting arrest is a common charge levied against black and poor people. It provides an excuse for an arrest and an after-the-fact justification for a wrongful stop.

7. Henry Louis Gates, Jr., "Preface," in *Black Male: Representations in Contemporary American Art,* ed. Thelma Golden (New York: Whitney Museum of American Art, 1994), 13.

8. Radhika Monhanram, *Black Body: Women, Colonialism, and Space* (Minneapolis: University of Minnesota Press, 1999), xiv.

9. E. Patrick Johnson, *Appropriating Blackness: Performance and the Politics of Authenticity* (Durham, N.C.: Duke University Press, 2003), 9.

10. Monhanram, *Black Body,* 52.

11. Hortense Spillers, "Peter's Pans: Eating in the Diaspora," in *Black, White, and in Color: Essays on American Literature and Culture,* ed. Hortense Spillers (Chicago: University of Chicago Press, 2003), 21.

12. Ibid.

13. See Paul Gilroy, *Against Race: Imagining Political Culture beyond the Color Line* (Cambridge: Belknap Press of Harvard University Press, 2000), 25.

14. Ibid., 2.

15. American Civil Liberties Union, "ACLU Moves to Have Maryland Police Held in Contempt." Press Release (14 November 1996).

16. Quoted in Michael Kiefer, "State High Court Says Racial Profiling Can Get Cases Tossed," *Arizona Republic* (May 2005), http://www.azcentral.com/arizona republic/local/articles/0505racialprofiling.html.

17. Missouri Attorney Genetral's Office, "Executive Summary on 2008 Missouri Vehicle Stops" (2009), http://ago.mo.gov/racialprofiling/2008/racialprofiling2008 .htm.

18. See "Racism Reality on Force's Report," *Toronto Star* (31 March 2005).

19. See ""Police Stop More Blacks, Ont. Study Finds," *CBC News* (2005), cbc.ca/story/canada/national/2005/05/26/race050526.html.

20. W. E. B. Du Bois, *The Souls of Black Folk* (New York: Dover, 1994), 2.

21. See Brent Staples, *Parallel Time: Growing Up in Black and White* (New York: Harper, 1995).

22. Cited in David Cole, *No Equal Justice: Race and Class in the American Criminal Justice System* (New York: New Press, 1999), 41.

23. Although Jackson does not racially name his "suspect," the fact that his offices are located in the majority black South Side suggests that he envisioned a black assailant. It is also possible that any nonwhite assailant, in Jackson's theorizing, could be considered to occupy the ideological and political category of "black."

24. Paul Gilroy, *The Black Atlantic: Modernity and Double Consciousness* (Cambridge: Harvard University Press, 1999), 6.

25. See *Chris Rock—Bring the Pain* (Dreamworks, 2002).

26. See Allister Harry, "What's So Funny about Chris Rock?" *The Guardian* (4 December 1998), 6.

27. Barack Obama, *Dreams from My Father* (New York: Three Rivers Press, 2004), 80.

28. "The Road to the White House," *60 Minutes*, CBS News (28 December 2008).

29. Stuart Hall, "Cultural Identity and Diaspora," in *Colonial Discourse and Postcolonial Theory: A Reader,* ed. Patrick Williams and Laura Chrisman (New York: Harvester Wheatsheaf, 1993), 394.

30. Stuart Hall, "Introduction," in *Questions of Cultural Identity,* ed. Stuart Hall and Paul Gilroy (London: Sage, 1996), 4.

31. Stuart Hall, "Cultural Identity and Cinematic Representation," *Framework* 36 (1989): 68; also Hall, "Cultural Identity and Diaspora," 392.

32. Louis Chude-Sokei, *The Last Darky: Bert Williams, Black-on-Black Minstrelsy, and the African Diaspora* (Durham, N.C.: Duke University Press: 2005), 117.

33. Johnson, *Appropriating Blackness,* 44.

34. Ibid.

35. Houston A. Baker, "Black Modernity: Kitchen Memories, Likable Black Boys, and the American South," in *Critical Memory: Public Spheres, African-American Writing, and Black Fathers and Sons in America* (Athens: University of Georgia Press, 2001), 15.

36. Houston A. Baker, "Critical Memory and the Black Public Sphere," in *The Black Public Sphere*, ed. The Black Public Sphere Collective (Chicago: University of Chicago Press, 1995), 18.

37. Pierre Bourdieu, *Outline of a Theory of Practice*, trans. Richard Nice (Cambridge: Cambridge University Press, 1977), 22.

38. Pierre Bourdieu, *In Other Words: Essays toward a Reflexive Sociology*, trans. Matthew Adamson (Stanford: Stanford University Press, 1990), 12.

39. Ibid., 163.

40. Pierre Bourdieu, *Distinction: A Social Critique of the Judgement of Taste*, trans. Richard Nice (Cambridge: Harvard University Press, 2000), 175.

41. See Richard Rodriguez, *Hunger for Memory: The Education of Richard Rodriguez* (New York: Bantam, 1983).

Chapter Two

1. Mandy Reid, following the lead of art historian Brian Wallis, asserts that the fifteen surviving daguerreotypes "can be divided into two series": a "physiognomic" and a "phrenological" approach: Mandy Reid, "Selling Shadows and Subtance," *Early Popular Visual Culture* 4.3 (2006): 291. They base this conclusion on the presence of two types of poses: the captives either sit or stand before the camera. However, none of the captives are depicted doing both—standing and sitting. Although Reid's and Wallis's theory is plausible, the lack of information related to the behavior of the captives within the portrait studio prevents us from knowing what happened. It is equally plausible that the subjects, based upon their state of dress, sat first and then stood before Zealy. Regardless of whether the captives sat and then stood or were divided between those who would stand and those who would sit, my investment within this chapter rests on their performance of stillness, as they sat or stood, before Zealy and his daguerreotype machine. See also Brian Wallis, "Black Bodies, White Science: Louis Agassiz's Slave Daguerreotype," *American Art* 9.2 (1995): 45–46.

2. I use the present tense here to indicate that the photograph pauses their condition as captives and maintains it into the future. The earliest examples of photographic pornography appear with the advent of the daguerreotype machine. They are defined by poses of leisure—reclining on sofas, etc.—and as a result are compositionally dissimilar to Zealy's images.

3. In 1837, Agassiz publicly theorized the possible existence of an Ice Age. Thirty years later, he delivered a presentation in Washington, D.C., "Traces of the Glaciers under the Tropics." In the published version of the talk, the natural scientist wrote about the effects of a "sudden intense winter that was to last for ages." I am thankful

to Professor Wolfgang H. Berger and Patty Anderson, his teaching assistant, whose online introduction to the Ice Ages appears as part of their University of California at San Diego Climate Change, Part Two course. See "Discovery of the Great Ice Age," http://www.earthguide.ucsd.edu/virtualmuseum/climatechange2/02_1.shtml. Also see Nicholas Eyles, "Frozen in Time: Concepts of 'Global Glaciation' from 1837 to 1998," *Geoscience Canada* (May 2004), 3.

4. Charles S. Darwin, *The Origin of Species* (Oxford: Oxford University Press, 1998), 273.

5. Louis Agassiz, *Essay on Classification*, ed. Edward Lurie (Cambridge: Harvard University Press, 1962), 151. See also A. Hunter Dupree, *Asa Gray: American Botanist, Friend of Darwin* (Baltimore: Johns Hopkins University Press, 1959), 151; and Sara Joan Miles, "Charles Darwin and Asa Gray Discuss Teleology and Design," *PSCF* (September 2001), 196.

6. The names of the plantation "masters" were included on a note enclosed with each daguerreotype.

7. Agassiz studied with Cuvier during the winter and spring of 1832. Edward Lurie, describing the unique relationship between the two scientists, writes, "A typical evening at Cuvier's found the sixty-three year-old master alone with the young disciple." Edward Lurie, *Louis Agassiz: A Life in Science* (Chicago: University of Chicago Press, 1960), 56.

8. Lane Cooper, *Louis Agassiz as Teacher* (1917), 64.

9. Laura Dassow Walls, "Textbooks and Texts from the Brooks: Inventing Scientific Authority in America," *American Quarterly* 49.1 (March 1997): 1.

10. Ibid., 2.

11. Ironically, Agassiz's extensive ethnographic and zoological collection would be used, following his death, to affirm the theories of Darwin. By the opening years of the twentieth century, the creationist beliefs of the comparative anatomist were largely dismissed by the scientific community in favor of evolutionism.

12. David B. Williams, "A Wrangle over Darwin: How Evolution Evolved in America," *Harvard Magazine* (September–October 1998), 3.

13. Ibid.

14. Ibid.

15. Quoted in Wallis, "Black Bodies, White Science," 43.

16. Fanon, *Black Skin, White Masks*, 111–12.

17. Brian Wallis notes the following about Agassiz's biases: "Despite his personal repugnance for the blacks he encountered, Agassiz later claimed that his beliefs on racial typologies were without political motivation, and he remained a staunch abolitionist, a position that seems contradictory given the later proslavery embrace of his views." Wallis, "Black Bodies, White Science," 44.

18. Edgar Allan Poe, "The Daguerreotype," in *Classic Essays on Photography*, ed. Alan Trachtenberg (New Haven: Leete's Island Books, 1980), 38.

19. Richard Schechner, *Between Theatre and Anthropology* (Philadelphia: University of Pennsylvania Press, 1985), 110.

20. See John L. Jackson, Jr., *Real Black: Adventures in Racial Sincerity* (Chicago: University of Chicago Press, 2005), 21; Elinor Reichlin, "Faces of Slavery," *American Heritage Magazine* (June 1977), http://www.americanheritage.com/articles/magazine/ah/1977/4/1977_4_4.shtml.

21. Reichlin, "Faces of Slavery."

22. Alan Trachtenberg, *Reading American Photographs: Images as History, Matthew Brady to Walker Evans* (New York: Hill and Wang, 1990), 59.

23. Cherise Smith, "Subverting the Documentary Paradigm: Lorna Simpson and Collage," *Black Arts Quarterly* 4.2 (Summer 1999): 6.

24. Michael Kimmelman, "When a Glint in the Eye Showed Crime in the Genes," *New York Times* (22 May 1998), Arts E31.

25. Mandy Reid asserts that Gibbes wrote the notes. She writes, "The slaves' subjectivity, ironically penned on the daguerreotype in Gibbes' hand, re-inscribes their lack of status, for alongside their American given slave names, Gibbes noted their owners' names and the African tribes from which they were taken and enslaved" ("Selling Shadows and Substance," 291). While it is logical that the person who arranged the portrait session also would be the person who identified the subjects, I have yet to encounter conclusive evidence that Gibbes was the author of the notes.

26. Joseph E. Holloway, "'What Africa Has Given America': African Continuities in the North American Diaspora," in *Africanisms in American Culture*, ed. Joseph E. Holloway (Bloomington: Indiana University Press, 2005), 44.

27. Deborah Willis, a former curator at the Smithsonian, is a tireless champion for black photography who deservingly won a MacArthur "genius" award for her efforts. In representing the Zealy daguerreotypes, alongside Carla Williams and Mandy Reid among others, she walks a fine line between continuing to exploit the imaged captives and raising awareness of the past exploitation of the body. Certainly my representation of the various images within this book is liable to the same charge. See *The Black Female Body: A Photographic History* (Philadelphia: Temple University Press, 2002).

28. Kobena Mercer, "Reading Racial Fetishism: The Photographs of Robert Mapplethorpe," in *Visual Culture: The Reader*, ed. Jessica Evans and Stuart Hall (London: Sage, 1999). See also Kobena Mercer, "Looking for Trouble," in *The Lesbian and Gay Studies Reader*, ed. Henry Abelove, Michele A. Barale, and David M. Halperin (London: Routledge, 1993), 350–59.

29. Jana Evans Braziel and Anita Mannur, *Theorizing Diaspora* (Hoboken, N.J.: Wiley-Blackwell, 2003), 7.

30. Kim D. Butler, "Defining Diaspora, Refining a Discourse," *Diaspora* 10.2 (Fall 2001): 189.

31. Ibid.

32. Ibid.

33. Awam Amkpa discussed this work in a paper, "Archetypes, Stereotypes, and Polytypes: Theatre of the Black Atlantic," presented at Black Performance Studies: A Symposium, Northwestern University, 21 October 2006.

34. Herbert Klein, *The Atlantic Slave Trade* (Cambridge: Cambridge University Press, 1999), 130.

35. Sandra L. Richards, "What Is to Be Remembered? Tourism to Ghana's Slave Castle-Dungeons," *Theatre Journal* 57.4 (2005): 617–37.

36. Louis Jacques Mande Daguerre, "Daguerreotype," in Trachtenberg, *Classic Essays on Photography*, 12.

37. Manthia Diawara writes about the circulation of American soul music, especially the music of James Brown, in his native Mali in *We Won't Budge: An African in Exile in the World* (New York: Basic Civitas, 2003). Joseph E. Holloway, in "'What Africa Has Given America,'" details the numerous crops that were brought from Africa to the "New World," including rice, okra, blackeyed peas, watermelon, and yams among others (45–49). Henry Louis Gates, Jr., discusses the sustained presence of African orature in African American culture in *The Signifying Monkey: A Theory of African-American Literary Criticism* (Oxford: Oxford University Press, 1989).

38. The popular perception of Muybridge is that by setting up multiple cameras, he captured movement—which was not detectable by the eye. I do not dispute this assessment. What I am contending is that whereas Muybridge succeeded in capturing a fragment of motion by freezing it for the eye to see, the daguerreotype contains motion, the captives' various enactments of stillness.

39. Melissa Banta, *A Curious and Ingenious Art: Reflections on Daguerreotypes at Harvard* (Iowa City: University of Iowa Press, 2000), 49.

40. Rosalind E. Krauss, *Passages in Modern Sculpture* (Cambridge: MIT Press, 1977), 5.

41. See Rebecca Schneider, "Still Living: Performance, Photography, and *Tableaux Vivants*," in *Photography and Performance*, ed. Michelle Theriebault (Montreal: Dazibao, 2005).

42. Wallis, "Black Bodies, White Science," 54.

43. The Museum of Comparative Zoology at Harvard University was founded in 1859, nine years after the captives stood or sat before Zealy's camera.

44. Quoted in Wallis, "Black Bodies, White Science," 105.

45. Although the Atlantic slave trade was made illegal in 1808, slavers continued to capture Africans and smuggle them into the United States. On 30 April 1860, the slave ship *Wildfire* was caught off the coast of Key West, Florida, with 510 African captives onboard. In its 2 June 1860 issue *Harper's Weekly* printed an illustration of the captives huddled together.

46. Cited in Banta, *Curious and Ingenious Art*, 47.

47. Trachtenberg, *Reading American Photographs*, 59.

48. Christian Metz, "Photography and Fetish," *October* 34 (Autumn 1985): 87.

49. Banta, *Curious and Ingenious Art*, 48.

50. The Zealy daguerreotypes are easy to see but are difficult to access. As with most daguerreotypes, they are displayed in a relatively low-light environment and are encased in glass. The distance that the glass creates between the spectator and the daguerreotype, combined with the low light, prevents the reflection of the viewer from appearing alongside the daguerreotype image. However, the image of the viewer does appear as a reflection on the glass case, and the viewer must look through this reflection at the daguerreotype image. You must look into yourself to see the body of another on display.

51. National Portrait Gallery, "History of the National Portrait Gallery," http://www.npg.org.uk/live/history.asp.

52. This information was contained both on the circulating flyers for the exhibition and in press releases. See Ellen Woodoff, "Columbia Museum of Art's African-American History Month Programming and Events," *Columbia Art Museum News Releases* (January 2004), http://www.colmusart.org/html/news2004.shtml.

53. Thomas L. Johnson and Philip C. Dunn, *A True Likeness: The Black South of Richard Samuel Roberts, 1920–1936* (Chapel Hill, N.C.: Algonquin, 1989), 48.

54. bell hooks, "In Our Glory: Photography and Black Life," in *Picturing Us: African American Identity in Photography,* ed. Deborah Willis (New York: New Press, 2000), 38.

55. Susan Sontag, *On Photography* (New York: Picador, 2001), 15.

56. This reading would accord with the African American tradition of celebrating a death and mourning a birth.

57. Maurice Merleau-Ponty, *The Visible and the Invisible* (Evanston, Ill.: Northwestern University Press, 1969), 11.

58. Henry Louis Gates, Jr., "Introduction," in *Black Male,* ed. Thelma Golden (New York: Whitney Museum of American Art, 1994), 11.

59. Quoted in Richard Purday, ed., *Document Sets for the South in U. S. History* (Lexington, Mass.: D. C. Heath, 1991), 147.

60. By "legal lynching," I refer to a lynching in which the case was not prosecuted. Despite the presence of numerous witnesses at the actual event of the lynching, scores of cases were never investigated and the perpetrators were never brought to justice. This system changed in South Carolina on 21 February 1947 when Sheriff R. H. Bearden of Greenville charged thirty-one men with the murder of a black man ("31 Charged with Murder," *New York Times,* 22 February 1947, 28).

61. Quoted in Karin Becker Ohrn, *Dorothea Lange and the Documentary Tradition* (Baton Rouge: Louisiana State University Press, 1980), 52.

62. Maria Morris Hambourg, "A Portrait of the Artist," in *Walker Evans,* ed. Jeff L. Rosenheim, Maria Morris Hambourg, Douglas Eklund, and Mia Fineman (New York: Museum of Metropolitan Art, 2000), 11.

63. Ibid., 50.

64. Michael Brix and Birgit Mayer, eds., *Walker Evans: America* (New York: Rizzoli, 1991), 13.

65. Walker Evans, *Walker Evans at Work* (New York: Harper and Row, 1982), 125.

66. Brix and Mayer, *Walker Evans*, 9.

67. Quoted in Evans, *Walker Evans at Work*, 151.

68. Quoted in William Stott, *Documentary Expression and Thirties America* (Chicago: University of Chicago Press, 1986), 67.

69. Jeff L. Rosenheim, "The Cruel Radiance of What Is: Walker Evans and the South," in Rosenheim et al., *Walker Evans*, 82–83.

70. Jacques Lacan, *The Four Fundamental Concepts of Psycho-Analysis*, ed. Jacques-Alain Miller, trans. Alan Sheridan (New York: Norton, 1978), 95.

71. Ibid., 96.

72. Walt Whitman, "Visit to Plumbe's Gallery," in *The Gathering of the Forces*, ed. Cleveland Rodgers and John Black, vol. 2 (New York: G. P. Putnam's Sons, 1920), 117.

73. Trachtenberg, *Reading American Photographs*, 17–18.

74. Herbert Blau, "The Human Nature of the Bot: A Response to Philip Auslander," *PAJ* 70 (2002): 22–24.

Chapter Three

1. A presidential letter, an event in any household, proved even more noteworthy in the Ali household thanks to the fact that the heavyweight champion was an outspoken critic of the war in Vietnam and had announced his intention not to serve if drafted. Because of his antiwar stance, Ali was the only American heavyweight champion other than Jack Johnson not to be invited to the White House during his championship reign. In recognition of his athletic achievements and political activism (including his 1963 stand), Ali received the Presidential Citizens Medal in 2001 from President William Clinton and the Presidential Medal of Freedom in 2005 from President George Walker Bush. Both ceremonies occurred in the White House. He was an invited guest at the presidential inauguration of Barack Obama in 2009.

2. Muhammad Ali with Richard Durham, *The Greatest: My Own Story* (New York: Random House, 1975), 167.

3. Ibid.

4. Ibid.

5. Ibid., 174.

6. Bob Mee, *Bare Fists: The History of Bare Knuckle Prize Fighting* (New York: Overlook Press, 2001), 3.

7. Nat Fleischer, *Black Dynamite*, vol. 1 (New York: C. J. O'Brien, 1938), 1–5.

8. Chris Mead, *Champion: Joe Louis, Black Hero in White America* (New York: Charles Scribner and Sons, 1985), 16.

9. Nat Fleischer, in his ambitious multivolume study of the black body in boxing, *Black Dynamite*, contends that Tom Molineaux was trained by an English boxer (Davis) and that he was punished by his "master" for not training hard enough. He

writes, "Davis complained that young Tom was too docile and didn't take his training too seriously. When the master became aware of that, he thrashed Tom" (35).

10. William Faulkner, introducing the nature of his protagonist's (Thomas Sutpen's) fighting through the eyes of his wife, Ellen, writes:

> Yes, Ellen and those two children alone in that house twelve miles from town, and down there a hollow square of faces in the lantern light, the white faces on three sides, the black ones on the fourth, and in the center two of his wild negroes fighting, naked, fighting not like white men fight, with rules and weapons, but like negroes fight to hurt each other quick and bad. Ellen knew that, or thought she did, that was not it. She accepted that—not reconciled: accepted it almost with gratitude since you can say for yourself, *Thank God this is all; at least I know all of it*—thinking that, clinging still to that when she ran to the stable that night while the very men who had stolen into it from the rear fell away from her with at least some grain of decency, and Ellen seeing not the two black beasts she had expected to see but instead a white one and a black one, both naked to the waist and gouging at one another's eyes as if their skins should not only have been the same color but should have been covered with fur too. Yes. It seems that on certain occasions, perhaps at the end of the evening, the spectacle, as a grand finale or perhaps as a matter of sheer deadly forethought toward the retention of supremacy, domination, he would enter the ring with one of the negroes himself. Yes. That is what Ellen saw: her husband and the father of her children standing there naked and panting and bloody to the waist and the negro just fallen evidently, lying at his feet and bloody too save that on the negro it merely looked like grease or sweat.

Sutpen, like the plantation owner who teaches his captive how to box, makes a conscious statement with his presence in the "ring." By repeatedly fighting black bodies, he continually reestablishes his (white body's) "supremacy" and "domination" over them. William Faulkner, *Absalom, Absalom!* (New York: Vintage, 1991), 20–21.

11. Finis Farr, *Black Champion: The Life and Times of Jack Johnson* (New York: Charles Scribner and Sons, 1964), 3; Randy Roberts, *Papa Jack and the Era of White Hopes* (New York: Free Press, 1983), 2; Mead, *Champion*, 16.

12. Farr, *Black Champion*, 3.

13. In *Black Ajax*, a novel inspired by the life of Tom Molineaux, George Macdonald Fraser contends that the former captive won his freedom after a fight in New Orleans. I have not encountered any evidence to support or discount this contention. See George M. Fraser, *Black Ajax* (New York: Carroll and Graf, 1997).

14. "Enshrinees: Tom Molineaux," International Boxing Hall of Fame (2007), http://www.ibhof.com/pages/about/inductees/pioneer/molineaux.html.

15. The Molineaux-Cribb bout was not the first interracial fight in England. Bill Richmond, a black American sailor, fought Cribb on 8 October 1805. Cribb won.

16. Elliot J. Gorn notes, "While tens of thousands of Englishmen could recite

Molineaux's exploits, relatively few Americans even knew his name. No doubt word of his deeds circulated orally, but the sparseness of documentary evidence forces us to the conclusion that American interest was neither broad nor deep. Indeed, the most astonishing thing about Tom Molineaux is that we know so little about him." Elliot J. Gorn, *The Manly Art: Bare Knuckle Prize Fighting in America* (Ithaca, N.Y.: Cornell University Press, 1986), 34.

17. Alex Brummer, "Run for Your Rights," *The Guardian* (4 February 1989), 5.

18 John Sutherland, "The Blacker They Are The Harder They Fall," *The Independent* (London) (12 July 1997), 4.

19. Quoted in Steve Bounce, "Boxing," *Sunday Telegraph* (London) (29 October 1992), 35.

20. Johnson notes in his autobiography that his father worked as a custodian. No reference to his father's early life is made. John Arthur Johnson, *In the Ring and Out* (Chicago: National Sports Publishing, 1927), 33.

21. Geoffrey C. Ward, *Unforgiveable Blackness: The Rise and Fall of Jack Johnson* (New York: Knopf, 2004), 9.

22. Johnson, *In the Ring*, 32–33.

23. Roberts, *Papa Jack*, 6.

24. Ralph Ellison, *Invisible Man* (New York: Vintage, 1980), 22.

25. Ward, *Unforgiveable Blackness*, 25.

26. Gerald L. Early, *The Culture of Bruising* (New York: Ecco Press, 1995), 25.

27. Roberts, *Papa Jack*, 7.

28. To be "futured" is to have experienced something in the past—in a particular moment in the past—that will have a direct causal effect on the future. For example, a preproduction script is a futured remain of the performance that the script will eventually become. The remain precedes the act.

29. Randy Roberts notes, "Sometimes [Johnson and Choyinski] were allowed to spar for the amusement of jail authorities and the inmates" (*Papa Jack*, 15). Finis Farr writes, "In jail, the warden allowed Johnson and Choyinski to box in the courtyard everyday" (*Black Champion*, 21).

30. In his autobiography, Johnson notes that his first boxing match was against John Lee at the age of fifteen (*In the Ring*, 37).

31. The phrase *white hope* applies to every white fighter Johnson faced as heavyweight champion. In total, there were seven "white hopes," with Jess Willard being the last.

32. "Pink Furies Blaze Away," *Los Angeles Daily Times* (17 May 1901), 2.1.

33. Johnson's action of wearing pink pajamas reminds me of Marjorie Garber's work on transvestitism. In "Black and White TV: Cross-Dressing the Color Line," Garber contends that the manner in which black bodies dress, a performance played across the body, can be empowering:

The overdetermined presence of cross-dressing in so many Western figurations

of black culture suggests some useful ways to interrogate notions of "stereotype" and "cliché." For the immensely evocative concept of the "invisible man" coined by Ralph Ellison fits the description of the transvestite as that which is looked *through,* rather than *at,* in contemporary criticism and culture. The recurrent thematic of transvestitism is and as an aspect of black American culture—and, equally, as a device deployed to subvert or disempower that culture—is seldom noticed. Yet as we will see, it is one of the master's tools that does, in fact, help to dismantle the master's house.

For Garber, the act of costuming the black body is a potentially empowering act. It not only renders visibility to a heretofore "invisible" body but also grants the body control over its own image, its seen (scene) status. Furthermore, the level of visibility and the acceptance of one's own image varies within the black community as it is received by other members of that same community. For example, dress can connote varying levels of "realness." While the experiences of Jack Johnson and all of the other bodies introduced in this project suggest a rejection of the contention that the black body is invisible or transparent, there remains an important link with the work of Garber. Through Johnson's strategic transvestitism, the boxer creates a seen body that is entirely coded by him. What the white audiences in attendance at the fight in Los Angeles see—those "caterwauling, belligerent pink" pajamas—are what Johnson wants them to see. He controls their look. At the same time, it can be argued that members of the black community who may have witnessed the fight would realize the *unreal* attire and would revel in the prizefighter's parody. We can think of Mary Ann Doane's articulation of excess and spectatorship in "Film and the Masquerade" to better understand this contention. Marjorie Garber, *Vested Interests: Cross-Dressing and Cultural Anxiety* (New York: Routledge, 1997), 268; Mary Ann Doane, *Femmes Fatales* (New York: Routledge, 1991), 17–32.

34. On the day of the fight, the *Los Angeles Daily Times* announced the event with the following headline: "White Men Fight Black Men Tonight" ([16 May 1902], 2.2). In light of the fact that names are not mentioned within the header, it appears that the appeal of the fight to audiences was the witnessing of "white" against "black."

35. Sullivan declared, "In this challenge I include all fighters—first come, first served—who are white. I will not fight a Negro. I never have and I never shall" (quoted in Fleischer, *Black Dynamite,* 103).

36. Geoffrey Ward writes that Jim Jeffries challenged Jack Johnson to a match in the cellar of a California bar but Johnson refused to participate (*Unforgiveable Blackness,* 69).

37. Ellison, *Invisible Man,* 240–41.

38. Booker T. Washington would disagree with this assertion. He attributed Jack Johnson's celebrity to (white) media coverage and not black communities-at-large. Responding to a United Press Association request for a comment on Johnson's 1912 trial for violating the Mann Act, Washington wrote, "It was the white man not the

black man who has given Jack Johnson the kind of prominence he has enjoyed up to now" (23 October); see David K. Wiggins and Patrick B. Miller, *The Unlevel Playing Field* (Urbana: University of Illinois Press, 2005), 71.

39. "National News," *Boston Globe* (3 July 1910), 2.

40. "Yet Boxing is Taboo," *Boston Globe* (2 July 1910), 5.

41. An example of this appears in the *New York Daily Tribune* on the eve of the fight: "To-morrow afternoon James J. Jeffries and John A. Johnson will meet in their long talked of fight for the undisputed heavyweight championship of the world. Gloved fists will thud against flesh, and blood will rush through leaping muscles in the open area built near Reno. And the son of a slave mammy of the old South, Heavyweight champion Johnson, or the son of a preacher, the undefeated Jeffries, will be declared the most perfect fighting machine in the history of the prize ring." "Ring Supremacy at Stake in Reno Fight," *New York Daily Tribune* (5 July 1910), 4.

42. Roberts, *Papa Jack*, 74.

43. James J. Corbett, "Tradition Factor in the Big Fight," *Chicago Daily Tribune* (1 July 1910), 13.

44. "Pink Furies Blaze Away," 1.

45. W. W. Naughton, "Johnson Knocks Jeff to Pieces in 15 Rounds," *Washington Post* (5 July 1910), 1.

46. John L. Sullivan, "Johnson Wins in 15 Rounds; Jeffries Weak," *New York Times* (5 July 1910), 1.

47. "Jeffries Falls before Johnson," *New York Daily Tribune* (4 July 1910), 1.

48. "Jeff Trying to Forget," *New York Daily Tribune* (6 July 1910), 8.

49. Rex Beach, "Shell Only of the Former Jeff," *Boston Globe* (5 July 1910), 6.

50. Quoted in "Lacked the Snap of Youth, Says Jeffries," *Washington Post* (5 July 1910), 10.

51. Quoted in "I Outclassed Him, Johnson Declares," *New York Times* (5 July 1910), 3.

52. Quoted in "Both Fighters Assert Fitness and Confidence on Eve of Big Battle," *Washington Post* (4 July 1910), 2.

53. Quoted in "Ring Supremacy at Stake in Reno Fight," *New York Daily Tribune* (4 July 1910), 4.

54. The earliest reference that I could find of "trick" connoting a sexual reference within popular discourse is 1915. Although it is possible that Johnson intended the word to refer to his successful mission, I suspect that the prizefighter's frequent attendance at nightclubs, the types of subcultural establishments that create popular culture parlance, likely introduced him to this usage of the term long before it became a part of the mainstream lexicon. If so, then it's easy to imagine Johnson chuckling at the fact that a major newspaper would print these words.

55. Quoted in "Lacked Snap," 10.

56. It is important to note that black people were not passive during the "Jack Johnson riots." They did fight back. "Almost Lynch Negro," *New York Times* (5 July 1910), 4.

57. Roberts, *Papa Jack*, 217; Farr, *Black Champion*, 226.

58. Johnson never formally announced that he would not give a black boxer a chance to compete for the title. Instead, he insisted that black fighters had to compete against a series of other opponents before Johnson would consider granting them a title match. Shortly after defending his title against Jeffries, Johnson told his brother that he would not give leading black contender Sam Langford a chance to win the championship "until Sam has beaten the men that Jack has." When Johnson did meet black boxers in the ring, it always was an exhibition. "Langford Must Fight Three," *Chicago Defender* (30 July 1910), 3.

59. Roberts, *Papa Jack*, 220–21.

60. Johnson ended his professional fighting career in 1928 at the age of fifty. He continued to perform in "sparring contests" and "exhibitions" until 1945.

61. Farr, *Black Champion*, 256.

62. Johnson, returning from an engagement with a Texas circus, was killed in a car accident on 10 June 1946.

63. Joe Louis, *My Life Story* (New York: Duell, Sloane and Pearce, 1947), 17.

64. Mead, *Champion*, 52.

65. "Louis Knocks Out Birkie in Tenth," *New York Times* (12 January 1935), 26.

66. "Louis, Heavyweight Title Threat, Predicts He Will Stop Carnera within Five Rounds," *New York Times* (26 March 1935), 20.

67. "Troubles Are Over, Says New Champion," *New York Times* (23 June 1937), 30.

68. Lewis A. Erenberg, *The Greatest Fight of Our Generation: Louis vs. Schmeling* (Oxford: Oxford University Press, 2006), 108.

69. David Remnick, writing about Louis, notes, "His talent was so undeniable and his behavior so deferential that in time he won over even the Southern press, which deigned to call him "a good nigger" and an "ex-pickaninny." David Remnick, *King of the World* (New York: Vintage, 1998), 226.

70. "Lynch and Anti-Lynch," *Time* (26 April 1937), http://205.188.238.109/time/magazine/article/0,9171,757674-1,00.html.

71. Certainly, the *Pittsburgh Courier's* "Double V" campaign (1942–43), which called for "Victory over our enemies at home and victory over our enemies on the battlefield abroad," suggests an awareness of the everyday racisms experienced by black folk in the United States in the 1940s at the same time that the United States critiqued fascism abroad. It is possible that Owen's success in the 1936 Olympics followed by Louis's 1937 victory could have inspired this later movement. See Beth Bailey and David Farber, "The 'Double-V' Campaign in World War II Hawaii: African

Americans, Racial Ideology, and Federal Power," *Journal of Social History* (Summer 1993): 817–27; Cheryl Black, "'New Negro' Performance in Art and Life: Fredi Washington and the Theatrical Columns of the People's Voice, 1943–1947," *Theatre History Studies* 24 (2004): 57–72.

72. "Nazis Boycott Schmeling-Louis Fight Trip; Sport Heads Oppose Bout with Negro," *New York Times* (8 April 1936), 18.

73. Quoted in Erenberg, *Greatest Fight,* 105.

74. Arthur Daley, "The End of a Glorious Reign," *New York Times* (2 March 1949), 35.

75. Ali, *The Greatest,* 322.

76. Jones appeared on the *Late Show with David Letterman* (with actor Kelsey Grammar as a stand-in host). The interview was originally broadcast on 19 June 2003.

77. Ali, in his autobiography, writes the following about Sugar Ray Robinson: "I respect Sugar Ray in the ring as one of the greatest of all times. But he stayed out of what I call the real fighting ring, the one where freedom for black people in America takes place, and maybe if he had become my manager he might have influenced me to go a different way. I'm glad he had no time" (*The Greatest,* 54).

78. Ibid., 64.

79. Quoted in Gerald L. Early, ed., *Muhammad Ali Reader* (Hopewell, N.J.: Ecco Press, 1998), 135.

80. "Clay Refuses Army Oath," *New York Times* (29 April 1967), 1.

81. Quoted in Early, *Muhammad Ali Reader,* 221.

82. Dave Anderson, "Clay Prefers Jail to Army," *New York Times* (17 March 1967), 50.

83. "Clay Gives Flat Advice on How to Face the Music," *New York Times* (23 March 1967), 203.

84. "Clay Puts His Affairs in Order as Day of Decision Approaches," *New York Times* (28 April 1967), 59.

85. Robert Lipsyte, "Clay Refuses Army Oath; Stripped of Boxing Crown," *New York Times* (29 April 1967), 1.

86. Lipsyte, "Clay Puts Affairs," 59.

87. Lipsyte, "Clay Refuses Army Oath," 1.

88. Thomas Hauser, *Muhammad Ali: His Life and Times* (New York: Simon and Schuster, 1991), 14.

89. Daley, "End of Glorious Reign," 35.

90. It is rumored that Tom Molineaux, once in England, behaved in a manner not unlike Jack Johnson. He drank heavily, attended many parties, and was involved with many women. Fleischer, referring to Molineaux, writes, "He engaged in street fights, drank beyond his capacity, failed to take proper care of himself." In George Macdonald Fraser's novel *Black Ajax,* Molineaux leads a lifestyle, in England, similar to that led by Johnson a century later. Fleischer, *Black Dynamite,* appendix; Fraser, *Black Ajax.*

Chapter Four

1. Suzan-Lori Parks, *Venus* (New York: TCG, 2005).

2. "She'd Make a Splendid Freak" is the title of the first scene of Venus.

3. Chris McGreal, "Coming Home," *The Guardian* (21 February 2002), Features 6.

4. Richard Altick, *The Shows of London* (Cambridge: Belknap Press of Harvard University Press, 1978), 270.

5. See T. Denean Sharpley-Whiting, *Black Venus: Sexualized Savages, Primal Fears, and Primitive Narratives* (Durham, N.C.: Duke University Press, 1999).

6. Parks was awarded the Pulitzer Prize for *Topdog/Underdog.*

7. The Khoi-Khoi is marked by an ample, protruding buttocks and a large vulva. These are the things audiences were paying to see. I deliberately insert this information here rather than putting it within the main text at this moment to prevent the misreading of Baartman as nothing more than a bodily object.

8. Jean Young, "The Re-objectification and Re-commodification of Saartjie Baartman in Suzan-Lori Parks's Venus," *African American Review* 31 (1997): 699.

9. Ibid., 704.

10. Michele Wallace, "The Hottentot Venus," *Village Voice* (21 May 1996), 31.

11. Ibid.

12. W. B. Worthen, "Citing History: Textuality and Performativity in the Plays of Suzan-Lori Parks," *Essays in Theatre* 18.1 (1999): 18.

13. Alvin Klein, "About Women, about Pedestals," *New York Times* (31 March 1996), CN21.

14. Murray Berdick, "A Production Unraveled," *New York Times* (12 May 1996), H54.

15. Although I believe that playwrights often have a "message" and directors a "vision," the phrases *playwright's message* and *director's vision* are commonly employed to give the impression that a particular play/production *only* carries the voice of a single creator and, as a result, overlooks the influence and impact of other theatrical collaborators.

16. Mel Gussow, "Identity Loss in 'Imperceptible Mutabilities,'" *New York Times* (12 May 1996), C24.

17. Patti Hartigan, "Theater's Vibrant New Voice," *Boston Globe* (14 February 1992), Living 37.

18. Alvin Klein, "Yale Rep Offers 'America' Premiere," *New York Times* (30 January 1994), CN17.

19. David Richards, "Seeking Bits of Identity in History's Vast Abyss," *New York Times* (11 March 1994), SM8.

20. Klein, "About Women," CN21.

21. Shawn-Marie Garrett, "The Possession of Suzan-Lori Parks," *American Theatre* 17.8 (2000): 23.

22 Harry Elam and Alice Rayner, "Unfinished Business: Reconfiguring History in Suzan-Lori Parks's *The Death of the Last Black Man in the Whole Entire Universe*," *Theatre Journal* 46 (1994): 446.

23. Worthen, "Citing History," 16.

24. Joseph Roach, "The Great Hole of History: Liturgical Silence in Beckett, Osofisan," *South Atlantic Quarterly* 100.1 (2001): 307.

25. Elizabeth Dryud Lyman, "The Page Refigured," *Performance Research* 7.1 (2002): 92.

26. Vanessa E. Jones, "Drama Queen Suzan-Lori Parks Has Won a Tony Nomination, a Pulitzer, and a 'Genius Grant'—What's Next?" *Boston Globe* (28 May 2002), E2.

27. Hartigan, "Theater's Vibrant New Voice," 37.

28. Suzan-Lori Parks, "Elements of Style," in *The America Play and Other Works* (New York: TCG, 1995), 11–12.

29. This is where I part company with Elizabeth Lyman. Lyman contends that the physical layout of Parks's page reveals her effort to make language visual. An example of this appears within the "architectural look" of the spells. She's building something on the page and that thing being built is visual. While I agree with the spell example, I find that Lyman encounters a problem that she herself realizes. The acting edition from Dramatist Play Service compresses the dialogue and omits many of these spatial constructions. Perhaps the reader who buys the TCG edition may see them, but certainly not the actor. In addition the page layout itself does not create a multidimensional presence. It does not lead toward embodiment. See Suzan-Lori Parks, *Venus* (New York: Dramatist Play Service, 1998).

30. Michael Phillips, "On History; Her Language," *Los Angeles Times* (8 July 2002), Calendar 8.

31. Parks, "Elements of Style," 16.

32. Ibid., 16–17.

33. It is important to note that the language of history differs from the language of Parks. They should not be equated. In the former, the word exists as the remains of an event that has transpired. It is all that is left. There is the implication that an event happened and someone sat down and wrote about it lest we, future generations, would doubt the likelihood of its happening. In the latter, the word actively seeks out the forgotten and attempts to give its past, but not passed, experience a present voice. The event is the resurrection. It is the digging. Whereas the word in history fills in the void left by the body, the word in Parks's attempts to create a space for the body.

34. David Pannick, a columnist for *The Times* (London) summarizing the case, writes: "The court ordered that officials should be given 'free access' to Baartman 'for the purpose of conversing with her.' This satisfied the judges that the 'the woman came over here, and was exhibited, by her own consent, upon a contract to receive a certain proportion of the profits arising from the exhibition.' Case dismissed. The law report does not record what precisely were the financial advantages to Baartman of

making an exhibition of herself." David Pannick, "A Fine Line between Art and Making an Exhibit of Yourself," *The Times* (9 April 2002), 1.

35. The centrality and centeredness of the body of the character Baartman requires attention. It is the most significant aspect of the play. It is the unspoken subject matter of every "spell." It is the organizing theme of *Venus:* the exhibition of the Venus Hottentot in South Africa, England, France, and elsewhere as a series of remains on display. It even consumes the young male protagonist in the play-within. This requirement likely explains the poor reviews of the Foreman production. What Foreman did was to incorporate a series of distracting devices, none of which facilitated the telling of the story, which ultimately shifted attention away from the centered and central body. The presence of the criss-crossing ropes and, more importantly, the blinking red light threatened to take the attention away from the Hottentot body. Like a marching band parading through a chess tournament, these directorial interventions shattered the concentration of those participating as witnesses in the performance occurring before them. How can the look be maintained when it is being summoned elsewhere? Although the playwright crafted a character whose silence demanded greater attention to the body, the director managed to undercut the playwright's efforts. The spotlit black body found itself cast in the shadow of Foreman's red light.

36. Despite Yale's history, it is worth noting that Parks was a faculty member there in the mid-1990s. I would also be remiss if I did not mention that I was an undergraduate student at Yale during both Parks's tenure and the staging of *Venus.* The methodological approach used within this project has been greatly influenced by Yale's distinctive approach to American studies.

37. Similar photographs can be seen in James C. Allen, ed., *Without Sanctuary: Lynching Photography in America* (Santa Fe: Twin Palms, 2000).

38. Worthen, "Citing History," 16.

39. Garrett, "Possession," 24.

40. Hershini Bhana Young, *Haunting Capital: Memory, Text, and the Black Diaspora Body* (Hanover, N.H.: University Press of New England, 2006), 6.

41. Robbie McCauley, "Sally's Rape," in *Moon Marked & Touched by the Sun,* ed. Sydne Mahone (New York: TCG, 1994), 223.

42. Ibid., 231.

43. Ibid.

44. It is important that we neither overlook nor overstate the significance of the "master" in *Sally's Rape.* Never referred to by name and rarely mentioned in the play—even within the dream sequence remembered, there are not any references to the "master"—the "master's" centrality to the narrative appears through his haunting presence.

45. McCauley, "Sally's Rape," 215.

46. Examples include Fawn McKay Brodie's groundbreaking biography, *Thomas Jefferson: An Intimate History;* the story of the relationship told from the perspective

of Heming's children in *A President in the Family* by Byron R. Woodson, Sr.; and the motion picture treatment of the relationship, *Jefferson in Paris* (USA, 1995). The first recorded reference to the Jefferson-Hemings affair appears in an article by James T. Callendar in the *Richmond Recorder* published on 1 September 1802. It reads: "It is well known that [Thomas Jefferson] keeps, and for many years past has kept, as his concubine, one of his own slaves. Her name is SALLY. The name of her eldest son is TOM. His features are said to bear a striking although sable resemblance to those of the president himself." See Fawn McKay Brodie, *Thomas Jefferson: An Intimate History* (New York: Norton, 1974).

47. "Jefferson's Blood." *Frontline* (21 July 2003), http:www.pbs.org/wgbh/pages/frontline/shows/Jefferson.

48. James Hugo Johnson, *Race Relations in Virginia and Miscegnation in the South, 1776–1860* (Amherst: University of Massachusetts Press, 1970), 166.

49. Ibid., 167.

50. For a more detailed exploration of policies used to determine race in the United States, see F. James Davis, *Who Is Black? One Nation's Definition* (State College, Pa.: Pennsylvania State Press, 1991).

51. Ann Nymann, referring to this moment, writes, "In the performance I saw, it happened so fast. I don't remember seeing Robbie take her dress off. I was still dealing with the web of personas and identities being rehearsed, tried on, sorted through. Suddenly, I realized she was naked. It seemed to come out of nowhere. There was no melodramatic build-up, no sentimental anticipation and dread, no fear and delight, no narrative seduction, no strip-tease." Ann Nymann, "Sally's Rape: Robbie McCauley's Survival Art," *African American Review* 33 (1999): 135.

52. Hershini Bhana Young, *Haunting Capital: Memory, Text, and the Black Diasporic Body* (Hanover, N.H.: University Press of New England, 2006), 118.

53. There is one moment in which the actress who plays Alma also plays Eugene's mother.

54. See Stuart Miller, "The Education of Dael Orlandersmith," *American Theatre/"CG* (2002), http://tcg.org/publications/at/2002/dael.cfm.

55. Kathryn Osenlund, "Review of *Yellowman* at the McCarter and Wilma Theaters," *Curtain Up* (2001), http:www.curtainup.com/yellowman.html.

56. Claire Hamilton, "Yellowman @ Everyman," BBC (22 April 2004), http://www.bbc.co.uk/liverpool/stage/2004/04/yellowman/review.shtml.

57. Peter Marks, "'Yellowman,' Illuminating Bigotry's Subtle Gradations," *Washington Post* (15 March 2004), Style C1.

58. Faedra Chatard Carpenter, "Embodying Anxieties: Race, Culture, and Identity in Contemporary American Performance," Ph.D. diss., Stanford University, 2005.

59. Nicole Fleetwood, "Yellowman," *Theatre Journal* 55.3 (2003): 332.

60. Dael Orlandersmith, *Yellowman and My Red Hand, My Black Hand* (New York: Vintage, 1999).

61. Deborah Gray White, *Ar'n't I a Woman?: Female Slaves in the Plantation South* (New York: Norton, 1985), 107.

62. See E. Franklin Frazier, *The Negro Family in the United States* (Notre Dame, Ind.: University of Notre Dame Press, 2001), 46; and Angela Davis, *Women, Race, and Class* (New York: Vintage, 1983), 18.

63. Olaudah Equiano, *The Interesting Narrative and Other Writings* (Whitefish, Mont.: Kessinger, 2004), 61.

64. W. L. Bost, "WPA Narrative of W. L. Bost," National Humanities Center (1937), http://nationalhumanitiescenter.org/pds/maai/enslavement/text1/wlbost.pdf.

65. Orlandersmith, *Yellowman*, 29.

66. Ibid., 31.

67. Ibid., 55.

68. Ibid., 62.

69. Dael Orlandersmith, interview,"Black Women Playwrights: Interview: Dael Orlandersmith," Kentucky Educational Television (KET), http://www.ket.org/americanshorts/poof/orlandersmith.htm.

70. Quoted in Miller, "Education of Dael Orlandersmith."

71. Orlandersmith, "Black Women Playwrights."

72. Ibid..

73. David Patrick Stearns, "The Pain of Racism within a Race Drives *Yellowman*," *Philadelphia Inquirer* (22 February 2002), Weekend.

74. Peter Marks, "Her Crime? Daring to Be Different," *New York Times* (18 December 1996), C19.

75. Peter Marks, "A Rhapsodic Embrace of Language in a Cruel World," *New York Times* (5 May 1999), E1, E4.

76. Suzan-Lori Parks, *In the Blood* (New York: Theatre Communications Group, 2000), 6–7.

77. Ibid., 44–45.

78. Ibid., 60.

79. Ibid., 64.

80. Ibid., 78.

81. Ibid., 79.

82. Ibid., 98.

83. Shoshana Felman, "The Return of the Voice," in *Testimony: Crisis of Witnessing in Literature, Psychoanalysis, and History,* ed. Shoshana Felman and Dori Laub (New York: Routledge, 1991), 204.

84. Giorgio Agamben, *Remnants of Auschwitz: The Witness and the Archive,* trans. Daniel Heller-Roazen (New York: Zone Books, 2002), 34.

85. Layne Hubbard, "Parks Speaks," *Eastern Echo* (16 January 2004), http://www.easternecho.com/cgi-bin/story.cgi?4182.

Chapter Five

1. Quoted in Ralph Ginzburg, *100 Years of Lynching* (Baltimore: Black Classics Press, 1988), 12.

2. Ibid., 24.

3. Ibid.

4. Ibid., 37.

5. Walter Brundage, using Georgia and Virginia as case studies, estimates that approximately one-third of all lynchings involved mass mobs (crowds of sixty or more). If his estimate is correct, then more than 1,100 black individuals died before mass mobs. This number is relevant because Brundage observes: "Mass mobs, more than any other type of mob, were likely to torture or burn victims. The size and fervor of mass mobs and the anonymity offered by the vast crowds incited lynchers to acts of almost unlimited sadism. In Georgia, news accounts suggest that mass mobs tortured and mutilated nearly a quarter of their victims in grisly ceremonies." Walter Brundage, *Lynching in the New South* (Urbana: University of Illinois Press, 1993), 42.

6. Toni Morrison, in her essay on the 1995 O. J. Simpson trial, uses these words to describe the seeming attitude of the contemporary media read relative to the media environment during the peak of white-on-black lynchings. See Toni Morrison, "The Official Story: Dead Man Golfing," in *Birth of a Nationhood,* ed. Toni Morrison and Claudia Brodsy Lacour (New York: Pantheon, 1997), xiii.

7 Susan Stewart, *On Longing: Narratives of the Miniature, the Gigantic, and the Souvenir, the Collection* (Baltimore: Johns Hopkins University Press, 1984), 136.

8. Ibid.

9. Jean Baudrillard, "The System of Collecting," in *The Cultures of Collecting,* ed. John Elsner and Roger Cardinal (Carlton: University of Melbourne Press, 1994), 7.

10. Stewart, *On Longing,* 135.

11. Ibid., 139.

12. Jane Desmond, *Staging Tourism: Bodies on Display from Waikiki to Sea World* (Chicago: University of Chicago Press, 1999), 254.

13. A common, everyday example of this is "show and tell," the classroom activity popular in elementary and middle schools. To simply stand before an assembled audience and show something is not sufficient. A narrative is required. In fact, the act of showing piques interest and creates a desire for the telling.

14. Kirk Fuoss, "Lynching Performances, Theatres of Violence," *Text and Performance Quarterly* 19.1 (1999): 4.

15. Arthur Raper, *The Tragedy of Lynching* (New York: Arno Press, 1969), 40.

16. Quoted in Arthur Madison, *A Lynching in the Heartland* (New York: Palgrave, 2001), 83.

17. Raper, *The Tragedy of Lynching*, 2.

18. Walter White, *Rope and Faggot: A Biography of Judge Lynch* (Notre Dame: University of Notre Dame Press, 2002), 3.

19. Orlando Patterson, *Rituals of Blood* (Washington, D.C.: Civitas/Counterpoint, 1998), 201.

20. See *Third Man Alive*, videocassette, directed by Michael McKiver (Milwaukee: America's Black Holocaust Museum, 2001).

21. It is important to make an observation about the privilege possessed by White and Allen that enabled them to gain access to these stories. Both are men who appear identifiably white. I mention this because we can presume that White and Allen were approached in their respective cases because of their visible whiteness. The children volunteered their stories to White. The trader offered to sell his postcards to Allen. Their cases are not unique. Over the years, I have heard similar stories from friends of mine who appear white. In their touristic travels throughout the historical (and memorial) sites of the American South, often southern plantations, their (white) tour guides, in a whisper, have repeatedly asked them if they would be interested in seeing where the slaves lived, an area not part of the official paid tour. In these and the cases of White and Allen, the visibility of whiteness grants access to a history of white privilege upon which the subjugation of black bodies was founded. I mention this because as a recognizably black cultural historian, I am aware that my appearance lessens the likelihood of such occurrences happening to me and I realize that my access to such narratives is filtered through the skin privilege of others.

22. James Allen, "Afterword," in Als, *Without Sanctuary*, 204.

23. Quoted in Als, *Without Sanctuary*, 174.

24. Ibid., 169.

25. Desmond, *Staging Tourism*, 43.

26. Dennis B. Downey and Raymond M. Hyser, *No Crooked Death: Coatesville, Pennsylvania and the Lynching of Zachariah Walker* (Urbana: University of Illinois Press, 1991), 38–39.

27. Laura Wexler writes that lynching organizers, in an effort to delay the process of the dismemberment of the lynching victim, would tack notes on the black body imploring participants to leave it intact for awhile. Referring to the 1911 lynching of Tom Allen in Walton County, Georgia, Wexler notes that members of the mob "discouraged such souvenir-collecting by pinning notes to his body that instructed people to leave it hanging as long as possible. The mob members reasoned that the longer Tom Allen's body hung, the longer it could serve as a warning to black men. . . . Those who wanted souvenirs made do with photographs of Tom Allen's body." Laura Wexler, *Fire in Canebrake* (New York: Scribner, 2003), 73.

28. Robyn Wiegman, *American Anatomies: Theorizing Race and Gender* (Durham, N.C.: Duke University Press, 1995), 82.

29. White, *Rope & Faggot*, 11.

30. Michael J. Pfeifer, *Rough Justice: Lynching and American Society, 1874–1947* (Chicago: University of Illinois Press, 2004), 4.

31. Brundage, *Lynching,* 17.

32. Stewart, *On Longing,* 140.

33. I understand and respect Stewart's objection. It is discomforting to think of a program from a theatrical production and a body part in the same manner—as being souvenirs of a witnessed performance event. To read the body part as a souvenir is to sacrifice its status as a subject, reified with a distinct personality, and to transform it into an object. At the same time, I believe that we cannot impose a personal, moral limit to the souvenir.

34. Elias Canetti, *Crowds and Power,* trans. Carol Stewart (New York: Noonday Press, 1998), 51.

35. Ibid., 52.

36. Ibid., 97.

37. William Pietz, "The Problem of the Fetish," *Res* 9 (1985): 7.

38. The fact that the word *fetish* was used to describe the religious objects of the West Africans rather than *idol* points to the ethnocentrism and, perhaps, racism of the Portuguese traders who refused to acknowledge the legitimacy of African spirituality. Their bias/prejudice prompted the creation of a new, separate word. I find it interesting that the black body was always already a fetish—the word was created with blackness in mind.

39. Joseph Roach, *Cities of the Dead* (New York: Columbia University Press, 1996), 124.

40. Pietz, "Problem of the Fetish," 7.

41. Ibid., 10.

42. Andrew Buckser, "Lynching as Ritual in the New American South," *Berkeley Journal of Sociology* (1992): 18.

43. Trudier Harris, *Exorcising Blackness* (Bloomington: Indiana University Press, 1984), 22.

44. Patterson, *Rituals of Blood,* 196.

45. Canetti, *Crowds and Power,* 228.

46. Patterson, *Rituals of Blood,* 194.

47. This section is about the lynching participants who collected body parts as souvenirs. An equally compelling project would be to study how the members of the black community reacted/responded to the body in the aftermath of the lynching event. What, if any meaning, did the body part have to them? It is my belief that they saw themselves in the lynching victim or, more accurately, realized that they too could have been the person lynched. The body part was a person and a life, not just a souvenir. Evidence in support of this contention appears in Shaila Dewan's July 2005 *New York Times* article in which she reported on a recent reenactment of a 1946 lynching in Monroe, Georgia. The players were all amateur actors from the black community who assumed the roles of the four lynching victims and the lynchers

(whom they played by wearing white masks). The performance raised awareness of the fact that no one had ever been found guilty of committing the murders and "brought memories back for many who turned up to watch." Quoting seventy-nine-year-old Flosse Hill, who recalls the lynching of a seven-month-pregnant woman, Mae Murray Dorsey, Dewan writes, "'Mae was about my age. She was a pretty lady, she was pregnant then. They say her baby's still living somewhere', she said, referring to the persistent rumor that the baby was cut from Ms. Dorsey's stomach." I am intrigued by the quote because it suggests that the body part as souvenir (the baby) still lives. See Shaila Dewan, "Group Lynching Is Re-created in a 'Call for Justice,' *New York Times* (26 July 2005), A12.

48. See Brenda Dixon-Gottschild, *Digging the Africanist Presence in American Performance: Dance and Other Contexts* (New York: Praeger, 1998); and August Wilson, "The Ground on Which I Stand," *Callaloo* 20.3 (1997): 493–503.

49. Gilroy, *Against Race*, 24.

50. See Herbert Blau, *Take Up the Bodies: Theater at the Vanishing Point* (Urbana: University of Illinois Press, 1982). Also see Peggy Phelan, *Unmarked: The Politics of Performance* (New York: Routledge, 1993).

51. Philip Auslander, *Liveness: Performance in a Mediatized Culture* (New York: Routledge, 1999), 40–41.

52. Peggy Phelan, "Marina Abramovic: Witnessing Shadows," *Theatre Journal* 56 (2004): 575.

53. Rebecca Schneider, "Archives: Performance Remains," *Performance Research* 6.2 (2000): 104.

54. Ibid., 106.

55. Andrew Sofer, *The Stage Life of Props* (Ann Arbor: University of Michigan Press, 2003), 11.

56. Ibid., 3.

57. I first encountered this passage from Pepys in Joseph Roach's short essay "History, Memory, and Necrophilia." Roach uses Pepys's encounter to develop his earlier contentions, as outlined in *Cities of the Dead,* of surrogated performances by drawing special attention to the effigy and the desire of both performers and audiences to "re-flesh" the dead. According to Roach, the effigy "fills by means of surrogation a vacancy created by the absence of an original." This definition only partly applies to the lynching souvenir. The souvenir, as representative of the performance (lynching) event, also creates the absence that it itself seeks to fill. See Joseph Roach, "History, Memory, Necrophilia," in *The Ends of Performance,* ed. Peggy Phelan and Jill Lane (New York: New York University Press, 1998), 23–30.

58. Duncan Grey, "Samuel Pepys Diary," July 2002, http://www.pepys.info/1669/1669feb.html (15 November 2004).

59. Scott Sherman, "Preserving Black History," *Progressive* 55.12 (1991): 15.

60. Cameron himself named the room housing the KKK robes and lynching pictures a "chamber of horrors." See Bill Heavey, "Beer Hogs and a Giant Duck," *Wash-*

ington Post (29 August 1991), E01; Ruth D. Manuel and Valerie Vaz, "Cultural Caravans: African-American Pilgrimages We Can Make to Celebrate Black History Month All Year Along," *Essence* (February 1991).

61. Don Terry, "Man's Museum of Terror Relives Terror for Blacks," *New York Times*, 10 July 1995, A10.

62. James Cameron, interview by Robert A. Franklin, "Interview with Dr. James Cameron, Founder of America's Black Holocaust Museum" (2005), http://www.clt .astate.edu/rfranklin/james-camerontext.htm.

63. McKiver, *Third Man Alive.*

64. Obviously, lynchings involving mass mobs required planning. The October 1934 lynching of Claude Neal, in which the schedule of events was printed in advance in local newspapers (and reprinted nationally), is the most extreme example. Nevertheless, the lynchings themselves were local affairs and not aspects of a larger, national agenda.

65. The Minnesota Historical Society maintains an extensive online resource guide on the Duluth lynchings. It notes, "After a hasty mock trial, Clayton, Jackson, and McGhie were declared guilty and taken one block to a light pole on the corner of First Street and Second Avenue East. A few tried to dissuade the mob, but their pleas were in vain. The three men were beaten and then lynched, first Isaac McGhie, then Elmer Jackson, and lastly Elias Clayton." See "Duluth Lynchings," Minnesota Historical Society (23 August 2005), http://collections.mnhs.org/duluthlynchings/html/ lynchings.htm.

66. Associated Press, "Jail Were [*sic*] Teens Were Lynched Now Apartment Building," *Indianapolis Star* (7 August 2005), http://www.indystar.com/articles/2/239594-6772-127.htm (accessed 6 June 2009).

67. Cameron, interview.

68. Fuoss, "Lynching Performances," 9.

69. Leonard Sykes, Jr., "Lynching Exhibit Coming to Milwaukee," *Milwaukee Journal Sentinel* (7 April 2002), News 1B.

70. Eric Lott, "A Strange and Bitter Spectacle," *First of the Month* (13 June 2005), http://www.firstofthemonth.org/culture/culture_lott_sanctuary.html.

71. Grace Elizabeth Hale, "Exhibition Review (Without Sanctuary)," *Journal of American History* 89.3 (2002): 992.

72. Sykes, "Lynching Exhibit," 1B.

73. McKiver, *Third Man Alive.*

74. Felicia Thomas-Lynn, "Hip, Happening Entertainment District Outlines for North Ave., Near King Drive," *Milwaukee Journal Sentinel* (25 February 2001), 1A.

75. American Association of Museums, "What Is a Museum?" (10 September 2005), http://www.aam.us.org/aboutmuseums/whatis.cfm.

76. "Welcome," American Museum of Fly Fishing (10 September 2005), http:// www.amff.com/home.htm.

77. In a 2000 *Milwaukee Journal Sentinel* article, Felicia Thomas-Lynn wrote,

"Known as 21st century Bronzeville, the cultural district would run from N. 4th to N. 7th streets, using America's Black Holocaust Museum as a main attraction" (1A).

78. American Association of Museums, "Code of Ethics for Museums" (10 September 2005), http://www.aam-us.org/museumresources/ethics/coe.cfm.

79. The U.S. Holocaust Museum seeks to educate without horrifying its visitors. In his study of its creation, Edward T. Linenthal writes that "there was a general fear that the museum might be too horrible, and that no one would come. This fear was reinforced by the reaction of the focus groups, many of whom had a 'deeply ingrained cultural image of the Holocaust' as simply 'piles of bodies.' People would need to be convinced that the museum would be more than a horror story before they could be persuaded to visit." See Edward T. Linenthal, *Preserving Memory: The Struggle to Create America's Holocaust Museum* (New York: Columbia University Press, 2001).

80. Quoted in Tom Kertscher, "Training Trip for Prison Workers Criticized," *Milwaukee Journal Sentinel* (17 January 2000), 2B.

81. Recent history suggests that it was the manner of displays and not the name of the museum that was the source of the offense. In its 2000 publication on the state of black/Jewish relations, the Foundation for Ethnic Understanding recognized the museum for a special exhibit entitled "Giving Voice to Jews of the African Heritage." See Foundations for Ethnic Understanding, 5th Annual Report on Black/Jewish Relations in the United States (2000), 14.

82. Vivian Patraka, "Spectacular Suffering : Performing Presence, Absence, and Witness at U.S. Holocaust Museums," in *Memory and Representation: Constructed Truths and Competing Realities,* ed. Dena E. Eber and Arthur G. Neal (Bowling Green, Ohio: State University Popular Press, 2001), 151.

83. Elizabeth Alexander, "Can You Be BLACK and Look at This?" in Black Public Sphere Collective, *The Black Public Sphere,* 82.

84. Shaila K. Dewan, "How Photos Became Icon of Civil Rights Movement," *New York Times* (25 August 2005), National.

85. Ibid.

86. Alexander, ""Can You Be BLACK," 94.

87. Richard Voase, "Rediscovering the Imagination: Investigating Active and Passive Visitor Experience in the 21st Century," *International Journal of Tourism Research* 4.5 (2002): 391.

88. Ibid., 393.

89. Tracy Davis observed that wax figures whether depicted in nineteenth-century anatomical museums or the current National Civil Rights Museum can assist the spectator, along a range of degrees, into engaging in an imagined experience (whether it is sex or sit-ins). See Tracy C. Davis, "Performing the Real Thing in the Postmodern Museum." *TDR* 39.3 (1995): 15–40.

90. Patterson, *Rituals of Blood,* 194.

91. Quoted in Dora Apel, "On Looking: Lynching Photographs and Legacies of Lynchings after 9/11," *American Quarterly* 55.3 (2003): 464.

92. Hale, "Exhibition Review," 993.

93. Quoted in Sykes, "Lynching Exhibit."

94. Reflecting upon the "halo effect" of his media celebrity on his museum, in his 2002 interview with Robert Franklin, Cameron proudly declared that America's Black Holocaust Museum "is making Milwaukee famous again." In an unintentionally humorous exchange, the founder asked his interviewer, "You know what made Milwaukee famous the first time?" The interviewer replied, "I believe the old expression was beer" and Cameron responded, "Schlitz beer, yes, Schlitz beer, that's right. But now people are coming here from all over the world to see my museum." His fame, in his perception, had reinvigorated his hometown and transformed it, from the beer capital of America into the place where the living memory of American lynching dwells.

95. Quoted in Jonny Dymond, "Holocaust Museum's 'Journey to Light,'" *BBC News* (15 March 2005), http://news.bbc.co.uk/2/hi/middle_east/4350505.stm.

Epilogue

1. Kerry Kawakami, Elizabeth Dunn, Francine Karmali, and John F. Dovidio, "Mispredicting Affective and Behavioral Responses to Racism," *Science* 323.5911 (January 2009): 276–78.

2. Ibid.

3. The political cartoon was published in the *New York Post* on 18 February 2009.

4. "Teachers Report Racist-Bullying," *BBC News* (23 April 2009), http://news .bbc.co.uk/2/hi/uk_news/education/8014880.stm.

5. Simone Weichselbaum, Joe Kemp and Alison Gendar, "Outrage over Omar Edwards Shooting Means Earful for Ray Kelly," *New York Daily News* (2 June 2009), http://www.nydailynews.com/news/ny_crime/2009/06/02/2009-06-02_outrage_over_ omar_edwards_shooting_means_earful_for_ray_kelly.html.

6. Joe R. Feagin and Karyn D. McKinney, *The Many Costs of Racism* (New York: Rowman and Littlefield, 2003), 114.

7. Devah Pager, "Black Man and White Felon—Same Chances for Hire," *CNN: AC 360* (9 August 2008), http://ac360.blogs.cnn.com/category/devah-pager/.

8. Bureau of Justice Statistics, "Lifetime Likelihood of Going to State or Federal Prison," http://www.ojp.gov/bjs/abstract/llgsfp.htm.

9. Barack Obama, "Speech on Race," *New York Times* (18 March 2008), http:// www.nytimes.com/2008/03/18/us/politics/18text-obama.html.

Bibliography

Agamben, Giorgio. *Remnants of Auschwitz: The Witness and the Archive.* Translated by Daniel Heller-Roazen. New York: Zone Books, 2002.

Agassiz, Elizabeth Cary. *Louis Agassiz: His Life and Correspondences.* 1885.

Agassiz, Louis. "Natural Provinces of the Animal World and Their Relation to the Different Types of Mankind." In *Types of Mankind: Or, Ethnological Researches,* edited by J. C. Nott and Geo R. Glliden, lviii–lxxvi. Philadelphia: Lippincott, Grambo, 1854.

Alexander, Elizabeth. "Can You Be BLACK and Look at This?" In *The Black Public Sphere,* edited by The Black Public Sphere Collective, 81–88. Chicago: University of Chicago Press, 1995.

Ali, Muhammad, with Richard Durham. *The Greatest: My Own Story.* New York: Random House, 1975.

Allen, James C., ed. *Without Sanctuary: Lynching Photography in America.* Santa Fe: Twin Palm Publishers, 2000.

"Almost Lynch Negro." *New York Times* (5 July 1910).

Altick, Richard. *The Shows of London.* Cambridge: Belknap Press of Harvard University Press, 1978.

American Association of Museums. "Code of Ethics for Museums." 10 September 2005. aam.us.org/museumresources/ethics/coe.cfm.

American Association of Museums. "What Is a Museum?" 10 September 2005. aam.us.org/aboutmuseums/whatis.cfm.

Amkpa, Awam. "Archetypes, Stereotypes, and Polytypes: Theatre of the Black Atlantic." Paper presented at Black Performance Studies: A Symposium, Northwestern University, 21 October 2006.

Amnesty International. *Racism and the Administration of Justice.* New York: Amnesty International, 2000.

Anderson, Dave. "Clay Prefers Jail to Army." *New York Times* (17 March 1967), 50.

Apel, Dora. "On Looking: Lynching Photographs and Legacies of Lynchings after 9/11." *American Quarterly* 55.3 (2003): 457–78.

Associated Press. "Jail Were [sic] Teens Were Lynched Now Apartment Building." *Indianapolis Star* (7 August 2005). http://www.indystar.com/articles/2/239594-6772-127.htm.

Auslander, Philip. *Liveness: Performance in a Mediatized Culture.* New York: Routledge, 1999.

Baker, Houston. "Critical Memory and the Black Public Sphere " In *The Black Public Sphere,* edited by The Black Public Sphere Collective, 5–38. Chicago: University of Chicago Press, 1995.

Baker, Houston. *Critical Memory: Public Spheres, African-American Writing, and Black Fathers and Sons in America.* Athens, Ga.: University of Georgia Press, 2001.

Bailey, Beth, and David Farber. "The 'Double-V' Camapaign in World War II Hawaii: African Americans, Racial Ideology and Federal Power." *Journal of Social History* (Summer 1993): 817–43.

Banta, Melissa, ed. *A Curious and Ingenious Art: Reflections on Daguerreotypes at Harvard.* Iowa City: University of Iowa Press, 2000.

Barnes, Clive. "'White Hope,' Tale of Modern Othello at Capital." *New York Times* (2 December 1967), 57.

Barthes, Roland. *Image-Music-Text.* New York: Hill and Wang, 1977.

Baudrillard, Jean. "The System of Collecting." In *The Cultures of Collecting,* edited by John Elsner and Roger Cardinal, 7–24. Carlton: University of Melbourne Press, 1994.

Beach, Rex. "Shell Only of the Former Jeff." *Boston Globe* (5 July 1910), 6.

Bearden, Romare. "Robert S. Duncanson." In *A History of African-American Artists: From 1792 to the Present,* edited by Romare Bearden and Harry Henderson, 19–39. New York Pantheon Books, 1993.

Berdick, Murray. "A Production Unraveled." *New York Times* (12 May 1996), H54.

Berger, John. *Ways of Seeing.* London: BBC/Penguin Books, 1972.

Berger, Wolfgang H., and Patty Anderson. "Discovery of the Great Ice Age." 2002. www.earthguide.ucsd.edu/virtualmuseum/climatechange2/02_1.shtml.

Bhabha, Homi K. *The Location of Culture.* London: Routledge, 1994.

Bilchik, Shay. "Minorities in the Juvenile Justice System." *Juvenile Justice Bulletin* (December 1999), 1–16.

Blau, Herbert. "The Human Nature of the Bot: A Response to Philip Auslander." *PAJ* 70 (2002): 22–24.

Blau, Herbert. *Take up the Bodies: Theater at the Vanishing Point.* Urbana: University of Illinois Press, 1982.

Black, Cheryl. "'New Negro' Performance in Art and Life: Fredi Washington and the Theatrical Columns of the People's Voice, 1943–1947." *Theatre History Studies* 24 (June 2004): 57–72.

Bodner, Allen. *When Boxing Was a Jewish Sport.* Westport, Conn.: Praeger, 1997.

"Both Fighters Assert Fitness and Confidence on Eve of Big Battle." *Washington Post* (4 July 1910), 2.

Bounce, Steve. "Boxing." *Sunday Telegraph* (London) (29 October 1992), 35.

Bourdieu, Pierre. *Distinction: A Social Critique of the Judgement of Taste*. Translated by Richard Nice. Cambridge: Harvard University Press, 2000.

Bourdieu, Pierre. *In Other Words: Essays toward a Reflexive Sociology*. Translated by Matthew Adamson. Stanford: Stanford University Press, 1990.

Bourdieu, Pierre. *Outline of a Theory of Practice*. Translated by Richard Nice. Cambridge: Cambridge University Press, 1977.

Braziel, Jana Evans, and Anita Mannur, eds. *Theorizing Diaspora: A Reader*. Hoboken, N.J.: Wiley-Blackwell, 2003.

Brix, Michael, and Birgit Mayer, eds. *Walker Evans: America*. New York: Rizzoli, 1991.

Brodie, Fawn McKay. *Thomas Jefferson: An Intimate History*. New York: Norton, 1974.

Brummer, Alex. "Run for Your Rights." *The Guardian* (4 February 1989), 5.

Brundage, Walter. *Lynching in the New South*. Urbana: University of Illinois Press, 1993.

Buckser, Andrew. "Lynching as Ritual in the New American South." *Berkeley Journal of Sociology* (1992).

Bureau of Justice Statistics. "Federal Bureau of Prisons: Quick Facts." U.S. Department of Justice, 2001.

Butler, Judith. *Bodies That Matter*. New York: Routledge, 1993.

Butler, Kim D. "Defining Diaspora, Refining a Discourse." *Diaspora* 10.2 (Fall 2001).

Canetti, Elias. *Crowds and Power*. Translated by Carol Stewart. New York: Noonday Press, 1998.

Carpenter, Faedra Chatard. "Embodying Anxieties: Race, Culture, and Identity in Contemporary American Performance." Ph.D. diss., Stanford University, 2005.

Chaudhuri, Una. *Staging Place: The Geography of Modern Drama*. Ann Arbor: University of Michigan Press, 1995.

Chinn, Sarah E. *Technology and the Logic of American Racism: A Cultural History of the Body as Evidence*. London: Continuum, 2000.

Chris Rock—Bigger and Blacker. DVD. Directed by Keith Truesdell. 1999. HBO Home Video, 2000.

Chris Rock—Bring the Pain. DVD. Directed by Keith Truesdell. 1996. Dreamworks, 2002.

Chow, Rey. *Primitive Passions: Visuality, Sexuality, Ethnography, and Contemporary Chinese Cinema*. New York: Columbia University Press, 1995.

Chude-Sokei, Louis. *The Last Darky: Bert Williams, Black-on-Black Minstrelsy, and the African Diaspora*. Durham, N.C.: Duke University Press, 2005.

Cole, David. *No Equal Justice: Race and Class in the American Criminal Justice System.* New York: New Press, 1999.

Collins, Patricia Hill. *Black Sexual Politics.* New York: Routledge, 2005.

Cooper, Lane. *Louis Agassiz as Teacher.* 1917.

Corbett, James J. "Tradition Factor in the Big Fight," *Chicago Daily Tribune* (1 July 1910), 13.

Curtin, Mary Ellen. *Black Prisoners and Their World, Alabama, 1865–1900.* Charlottesville, Va.: University Press of Virginia 2000.

Daguerre, Louis Jacques Mande. "Daguerreotype." In *Classic Essays on Photography,* edited by Alan Trachtenberg, 11–14. New Haven: Leete's Island Books, 1980.

Daley, Arthur. "The End of a Glorious Reign." *New York Times* (2 March 1949), 35.

Darwin, Charles S. *The Origin of Species.* Oxford: Oxford University Press, 1998.

Davis, Angela. *Women, Race, and Class.* New York: Vintage, 1983.

Davis, F. James. *Who Is Black? One Nation's Definition.* State College, Pa.: Pennsylvania State Press, 1991.

Davis, Tracy C. "Performing the Real Thing in the Postmodern Museum." *TDR* 39.3 (1995): 15–40.

Desmond, Jane. *Staging Tourism: Bodies on Display from Waikiki to Sea World.* Chicago: University of Chicago Press, 1999.

Dewan, Shaila. "Group Lynching Is Re-Created in a 'Call for Justice.'" *New York Times* (26 July 2005), A12.

Dewan, Shaila K. "How Photos Became Icon of Civil Rights Movement." *New York Times* (25 August 2005), National.

Diawara, Manthia. *In Search of Africa.* Cambridge: Harvard University Press, 1998.

Diawara, Manthia. *We Won't Budge: An African in Exile in the World.* New York: Basic Civitas, 2003.

Diedrich, Maria, Henry Louis Gates, Jr., and Carl Pedersen, eds. *Black Imagination and the Middle Passage.* New York: Oxford University Press, 1999.

Dixon-Gottschild, Brenda. *Digging the Africanist Presence in American Performance: Dance and Other Contexts.* New York: Praeger, 1998.

Doane, Mary Ann. *Femmes Fatales.* New York: Routledge, 1991.

Downey, Dennis B., and Raymond M. Hyser. *No Crooked Death: Coatesville, Pennsylvania and the Lynching of Zachariah Walker.* Urbana: University of Illinois Press, 1991.

Du Bois, W. E. B. *The Souls of Black Folk.* New York: Dover, 1994.

Dupree, A. Hunter. *Asa Gray: American Botanist, Friend of Darwin.* Baltimore: Johns Hopkins University Press, 1959.

Dymond, Jonny. "Holocaust Museum's 'Journey to Light.'" *BBC News* (15 March 2005). http://212.58.226.17/1/hi/world/middle_east/4350505.stm.

Dyson, Michael Eric. *Reflecting Black: African-American Cultural Criticism.* Minneapolis: University of Minnesota Press, 1993.

Early, Gerald. *The Culture of Bruising*. New York: Ecco Press, 1995.

Early, Gerald, ed. *Muhammad Ali Reader*. Hopewell, N.J.: Ecco Press, 1998.

Ellison, Ralph. *The Invisible Man*. New York: Vintage, 1980.

Equiano, Olaudah. *The Interesting Narrative and Other Writings*. Whitefish, Mont.: Kessinger, 2004.

Erenberg, Lewis A. *The Greatest Fight of Our Generation: Louis vs. Schmeling*. Oxford: Oxford University Press, 2006.

Evans, Jessica, and Stuart Hall. *Visual Culture: The Reader*. London: Sage, 1999.

Evans, Walker. *Walker Evans at Work*. New York: Harper and Row, 1982.

Eyles, Nicholas. "Frozen in Time: Concepts of 'Global Glaciation' from 1837 to 1998." *Geoscience Canada* (May 2004), 157–66.

Fanon, Frantz. *Black Skin, White Masks*. Translated by Charles Lam Marxmann. London: Grove Press, 1967.

Farr, Finis. *Black Champion: The Life and Times of Jack Johnson*. New York: Charles Scribner and Sons, 1964.

Faulkner, William. *Absalom, Absalom*. New York: Vintage, 1991.

Favor, J. Martin. *Authentic Blackness: The Folk in the New Negro Renaissance*. Durham, N.C.: Duke University Press, 1999.

Feagin, Joe R., and Karyn D. McKinney. *The Many Costs of Racism*. New York: Rowman and Littlefield, 2003.

Felman, Shoshana, and Dori Laub, eds. *Testimony: Crisis of Witnessing in Literature, Psychoanalysis, and History*. New York: Routledge, 1992.

Fields, Gary. "Blacks Now a Majority in Prisons." *USA Today* (4 December 1995), 1A.

Fine, Elsa Honig. *The Afro-American Artist: A Search for Identity*. New York: Holt, Rinehart and Winston, 1971.

Fleetwood, Nicole. "Yellowman." *Theatre Journal* 55.3 (2003): 331–32.

Fleischer, Nat. *Black Dynamite: The Story of the Negro in the Prize Ring from 1782 to 1938*. Vol. 1. New York: C. J. O'Brien, 1938.

Foresta, Merry A., and John Wood, eds. *Secrets of the Dark Chamber: The Art of the American Daguerreotype*. London: Viking, 1995.

Fossett, Judith Jackson, and Jeffrey A. Tucker, eds. *Race Consciousness*. New York: New York University Press, 1997.

Foster, Hal. *Return of the Real*. Cambridge: MIT Press, 1999.

Franklin, Robert A. "Interview with Dr. James Cameron, Founder of America's Black Holocaust Museum." 2005. cl.astate.edu/rfranklin/james-camerontext.htm.

Franko, Mark, and Annette Richards, eds. *Acting on the Past: Historical Performance across Disciplines*. Hanover, N.H.: Wesleyan University Press, 2000.

Fraser, George M. *Black Ajax*. New York: Carroll and Graf, 1997.

Fuoss, Kirk. "Lynching Performances, Theatres of Violence." *Text and Performance Quarterly* 19.1 (1999): 1–37.

Futrell, Alison. *Blood in the Arena: The Spectacle of Roman Power*. Austin: University of Texas Press, 1997.

Garber, Marjorie. *Vested Interests: Cross-Dressing and Cultural Anxiety.* New York: Routledge, 1992.

Garrett, Shawn-Marie. "The Possession of Suzan-Lori Parks." *American Theatre* 17.8 (2000): 22–26, 132–34.

Gates, Henry Louis, Jr. Preface to *Black Male: Representations of Black Masculinity in Contemporary American Art,* edited by Thelma Golden. New York: Whitney Museum of American Art, 1994.

Gates, Henry Louis, Jr. *The Signifying Monkey.* Oxford: Oxford University Press, 1989.

Gates, Henry Louis, Jr., ed. *"Race," Writing and Difference.* Chicago: University of Chicago Press, 1986.

Gilmore, Al-Tony. *Bad Nigger! The National Impact of Jack Johnson.* Port Washington, N.Y.: Kennikat Press, 1975.

Gilroy, Paul. *Against Race: Imagining Political Culture beyond the Color Line.* Cambridge: Belknap Press of Harvard University Press, 2000.

Gilroy, Paul. "'To Be Real': The Dissident Forms of Black Expressive Culture." In *Let's Get It On: The Politics of Black Performance,* edited by Catherine Uguwu, 12–33. Seattle: Bay Press, 1995.

Gilroy, Paul. *The Black Atlantic.* Cambridge: Harvard University Press, 1993.

Ginzburg, Ralph, ed. *100 Years of Lynching.* Baltimore: Black Classics Press, 1988.

Golden, Thelma. *Black Male: Representions of Masculinity in Contemporary American Art.* New York: Whitney Museum of American Art, 1994.

Golding, Louis. *The Bare Knuckle Breed.* London: Hutchinson, 1952.

Gooding-Williams, Robert. *Look, a Negro! Philosophical Essays on Race, Culture, and Politics.* New York: Routledge, 2006.

Gordon, Lewis R. *Fanon and the Crisis of European Man.* London: Routledge, 1995.

Gordon, Robert J. *Picturing Bushmen: The Denver African Expedition of 1925.* Athens: Ohio University Press, 1997.

Gorn, Elliott J. *The Manly Art: Bare-Knuckle Prize Fighting in America.* Ithaca: Cornell University Press, 1986.

Grosz, Elizabeth. *Space, Time, Perversion: Essays on the Politics of Bodies.* New York: Routledge, 1995.

Grosz, Elizabeth. *Volatile Bodies: Toward a Corporal Feminism.* Bloomington: Indiana University Press, 1994.

Gunning, Sandra, Tera W. Hunter, and Michele Mitchell, eds. *Dialogues of Dispersal: Gender, Sexuality, and African Diasporas.* Malden, Mass.: Blackwell, 2004.

Gunther, Lenworth, ed. *Black Image: European Eyewitness Accounts of Afro-American Life.* Port Washington, N.Y.: Kennikat Press, 1978.

Gussow, Mel. "Identity Loss in 'Imperceptible Mutabilities.'" *New York Times* (12 May 1996), C24.

Hale, Grace Elizabeth. "Exhibition Review (without Sanctuary)." *Journal of American History* 89.3 (2002): 985–94.

Hall, Stuart. "Cultural Identity and Diaspora." In *Colonial Discourse and Postcolonial Theory: A Reader,* edited by Patrick Williams and Laura Chrisman, 392–403. New York: Harvester Wheatsheaf, 1993.

Hall, Stuart. "Culture Identity and Cinematic Representation." *Framework* 36 (1989): 68–81.

Hall, Stuart, and Paul Gilroy, eds. *Questions of Cultural Identity.* London: Sage, 1996.

Hambourg, Maria Morris. "A Portrait of the Artist." In *Walker Evans,* edited by Maria Morris Hambourg and Jeff L. Rosenheim, 2–28. Princeton: Princeton University Press, 2000.

Hamilton, Claire. "Yellowman @ Everyman." BBC (22 April 2004). http://bbc.co.uk/liverpool/stage/2004/04/yellowman/review.shtml.

Harris, Trudier. *Exorcising Blackness.* Bloomington: Indiana University Press, 1984.

Harrison, Jim. "Focusing on the Face." *Harvard Magazine* (November–December 2000). http://harvardmagazine.com/2000/11/focusing_on_the_face.html.

Harrison, Paige M., and Allen J. Beck. "Prison and Jail Inmates at Midyear 2004." *Bureau of Justice Statistics* NCJ 208801 (April 2005).

Hartigan, Patti. "Theater's Vibrant New Voice." *Boston Globe* (14 February 1992), Living 37.

Harry, Alister. "What's So Funny about Chris Rock?" *The Guardian* (4 December 1998), 6.

Hauser, Thomas. *Muhammad Ali: His Life and Times.* New York: Simon and Schuster, 1991.

Heavey, Bill. "Beer Hogs and a Giant Duck." *Washington Post* (29 August 1991), E1.

Hietala, Thomas R. *The Fight of the Century.* London: M. E. Sharpe, 2002.

Holloway, Joseph E. "'What Africa Has Given America': African Continuities in the North American Diaspora." In *Africanisms in American Culture,* edited by Joseph E. Holloway, 39–64. Bloomington: Indiana University Press, 2005.

Home Office. *Statistics on Race and the Criminal Justice System.* London: Research, Development and Statistics Directorate, 2000.

Home Office. *Statistics on Race and the Criminal Justice System—2005.* London: Research, Development and Statistics Directorate, 2006.

hooks, bell. *Black Looks: Race and Representation.* Boston: South End Press, 1992.

hooks, bell. "In Our Glory: Photography and Black Life." In *Picturing Us: African American Identity in Photography,* edited by Deborah Willis, 43–54. New York: New Press, 2000.

hooks, bell. "Performance Practice as a Site of Opposition." In *Let's Get It On: The Politics of Black Performance,* edited by Catherine Uguwu, 210–21. Seattle: Bay Press, 1995.

Hubbard, Layne. "Parks Speaks." *Eastern Echo* (16 January 2004).

"I Outclassed Him, Johnson Declares." *New York Times* (5 July 1910), 3.

International Boxing Hall of Fame. "Enshrinees: Tom Molineaux." IBHOF, 2007. www.ibhof.com/molineau.htm.

Jackson, Bruce. *Wake up, Dead Man: Hard Labor, Southern Blues*. Athens: University of Georgia Press, 1999.

Jackson, John L., Jr. *Racial Paranoia: The Unintended Consequences of Political Correctness*. New York: Basic Books, 2008.

Jackson, John L., Jr. *Real Black: Adventures in Racial Sincerity*. Chicago: University of Chicago Press, 2005.

James, Joy, ed. *States of Confinement: Policing, Detentions, and Prisons*. New York: St. Martin's Press, 2000.

Jansen, Anthony F. *Worthington Whittredge*. Cambridge: Cambridge University Press, 1990.

"Jeff Trying to Forget." *New York Daily Tribune* (6 July 1910), 8.

Jefferson's Blood. Frontline (21 July 2003). http:www.pbs.org/wgbh/pages/frontline/shows/Jefferson.

"Jeffries Falls before Johnson." *New York Daily Tribune* (4 July 1910), 1.

"Johnson and Age Defeat Jeffries." *Chicago Tribune* (5 July 1910).

Johnson, Jack. *Jack Johnson Is a Dandy*. New York: Chelsea House, 1969.

Johnson, Jack. *Jack Johnson: In the Ring and Out*. Chicago: National Sports, 1927.

Johnson, E. Patrick. *Appropriating Blackness: Performance and the Politics of Authenticity*. Durham, N.C.: Duke University Press, 2003.

Johnson, Thomas L., and Philip C. Dunn. *A True Likeness: The Black South of Richard Samuel Roberts, 1920–1936*. Chapel Hill, N.C.: Algonquin, 1986.

"Johnson Reaches Ogden." *New York Daily Tribune* (5 July 1910).

Johnston, James Hugo. *Race Relations in Virginia and Miscegenation in the South, 1776–1860*. Amherst: University of Massachusetts Press, 1970.

Jones, Vanessa E. "Drama Queen Suzan-Lori Parks Has Won a Tony Nomination, a Pulitzer, and a 'Genius Grant.' What's Next?" *Boston Globe* (28 May 2002), E2.

Kawash, Samira. *Dislocating the Color Line: Identity, Hybridity, and Singularity in African-American Narrative*. Stanford: Stanford University Press, 1997.

Kentucky Educational Television. "Black Women Playwrights: Interviews: Dael Orlandersmith." 2004. KET. ket.org/americanshorts/poof/orlandersmith.htm.

Kertscher, Tom. "Training Trip for Prison Workers Criticized." *Milwaukee Journal Sentinel* (17 January 2000), 2B.

Ketner, Joseph. *Robert S. Duncanson: The Emergence of the African-American Artist*. St. Louis: University of Missouri Press, 1993.

Kiefer, Michael. "State High Court Says Racial Profiling Can Get Cases Tossed." *Arizona Republic* (May 2005). http://www.azcentral.com/arizonarepublic/local/articles/0505racialprofiling.html.

Kimmelman, Michael. "When a Glint in the Eye Showed Crime in the Genes." *New York Times* (22 May 1998).

Klein, Alvin. "About Women, About Pedestals." *New York Times* (31 March 1996), CN21.

Klein, Alvin. "Yale Rep Offers 'America' Premiere." *New York Times* (30 January 1994), CN17.

Klein, Herbert S. *The Atlantic Slave Trade.* Cambridge: Cambridge University Press, 1999.

Krasner, David. *A Beautiful Pageant: African American Theatre, Drama, and Performance in the Harlem Renaissance, 1910–1927.* London: Palgrave, 2004.

Krauss, Rosalind. *Passages in Modern Sculpture.* Cambridge: MIT Press, 1977.

Lacan, Jacques. *The Four Fundamental Concepts of Psychoanalysis.* Translated by Alan Schneider. New York: W. W. Norton, 1978.

"Lacked Snap of Youth, Says Jeffries." *Washington Post* (5 July 1910), 10.

"Langford Must Fight Three." *Chicago Defender* (30 July 1910), 3.

Lemelle, Sidney, and Robin D. G. Kelley, eds. *Imagining Home: Class, Culture, and Nationalism in the African Diaspora.* London: Verso, 1994.

Linenthal, Edward T. *Preserving Memory: The Struggle to Create America's Holocaust Museum.* New York: Columbia University Press, 2001.

Lipsitz, George. *Time Passages: Collective Memory and American Popular Culture.* Minneapolis: University of Minnesota Press, 1990.

Lipsyte, Robert. "Clay Puts His Affairs in Order as Day of Decision Approaches." *New York Times* (28 April 1967), 59.

Lipsyte, Robert. "Clay Refuses Army Oath; Stripped of Boxing Crown." *New York Times* (29 April 1967), 1.

Locke, Alain Leroi. *Race Contacts and Interracial Relations: Lectures on the Theory and Practice of Race.* Washington, D.C.: Howard University Press, 1994.

Longhurst, Robin. *Bodies: Exploring Fluid Boundaries.* London: Routledge, 2001.

Lott, Eric. "A Strange and Bitter Spectacle." *first of the month* (2005). http://www.firstofthemonth.org/culture/culture_lott_sanctuary.html.

"Louis Heavyweight Title Threat, Predicts He Will Stop Carnera within Five Rounds." *New York Times* (26 March 1935), 20.

Louis, Joe. *My Life Story.* New York: Duell, Sloane and Pearce, 1947.

"Louis Knocks out Birkie in Tenth." *New York Times* (12 January 1935), 26.

Lovejoy, Paul E. *Identity in the Shadow of Slavery.* London: Continuum, 2000.

Lurie, Edward. *Louis Agassiz: A Life in Science.* Chicago: University of Chicago Press, 1960.

Lyman, Elizabeth Dryud. "The Page Refigured." *Performance Research* 7.1 (2002): 90–100.

"Lynch and Anti-Lynch." *Time* (26 April 1937). http://205.188.238.109/time/magazine/article/0,9171,757674-1,00.html.

Macey, David. *Frantz Fanon.* New York: Picador, 2002.

Madison, Arthur. *A Lynching in the Heartland.* New York: Palgrave, 2001.

Malkin, Jeannette R. *Memory-Theater and Postmodern Drama.* Ann Arbor: University of Michigan Press, 1999.

Mann, Coramee Richey. *Unequal Justice.* Bloomington: Indiana University Press, 1993.

Manuel, Ruth D., and Valerie Vaz. "Cultural Caravans: African-American Pilgrimages We Can Make to Celebrate Black History Month All Year Long." *Essence* (February 1991), 100.

Margolick, David. *Beyond Glory: Joe Louis vs. Max Schmeling and a World on the Brink.* New York: Knopf, 2005.

Marks, Peter. "Her Crime? Daring to Be Different." *New York Times* (18 December 1996).

Marks, Peter. "A Rhapsodic Embrace of Language in a Cruel World." *New York Times* (5 May 1999).

Marks, Peter. "'Yellowman,' Illuminating Bigotry's Subtle Gradations." *Washington Post* (15 March 2004), Style C1.

McCauley, Robbie. "Sally's Rape." In *Moon Marked and Touched by the Sun,* edited by Sydne Mahone, 211–38. New York: Theatre Communications Group, 1994.

McCreal, Chris. "Coming Home." *The Guardian* (21 February 2002), Features 6.

Mead, Chris. *Champion: Joe Louis, Black Hero in White America.* New York: Charles Scribner's Sons, 1985.

Mee, Bob. *Bare Fists: The History of Bare-Knuckle Prize-Fighting.* Woodstock, N.Y.: Overlook Press, 2001.

Mercer, Kobena. "Looking for Trouble." In *The Lesbian and Gay Studies Reader,* edited by Henry Barale, Michele A. Abelove, and David M. Halperin, 350–59. London: Routledge, 1993.

Mercer, Kobena. "Reading Racial Fetishism: The Photographs of Robert Mapplethorpe." In *Visual Culture: The Reader,* edited by Jessica Evans and Stuart Hall, 435–47. London: Sage, 1999.

Merleau-Ponty, Maurice. *The Invisible and the Visible.* Evanston, IL: Northwestern University Press, 1968.

Metz, Christian. "Photography and the Fetish." *October* 34 (Autumn 1985): 81–90.

Miles, Sara Joan. "Charles Darwin and Asa Gray Discuss Teleology and Design." *PSCF* (September 2001): 196–201.

Mirzoeff, Nicholas, ed. *Diaspora and Visual Culture.* London: Routledge, 2000.

Monhanram, Radhika. *Black Body: Women, Colonialism, and Space.* Minneapolis: University of Minnesota Press, 1999.

Morrison, Toni. "The Official Story: Dead Man Golfing." In *Birth of a Nationhood,* edited by Toni Morrison and Claudia Brodsy Lacour, vii–xxiii. New York: Pantheon, 1997.

Moutoussamy-Ashe, Jeanne. *Viewfinders: Black Women Photographs.* New York: Dodd, Mead, 1986.

Nakao, Annie. "Play Explores Corrosive Prejudice within Black Community." *San Francisco Chronicle* (28 January 2004).

"National News." *Boston Globe* (3 July 1910), 2.

National Portrait Gallery. "History of the National Portrait Gallery." 2007. www.npg.org.uk/live/history.asp.

Naughton, W. W. "Johnson Rends Jeff to Pieces in 15 Rounds." *Washington Post* (5 July 1910).

"Nazis Boycott Schmeling-Louis Fight Trip." *New York Times* (8 April 1936), 18.

Nichols, Joseph C. "Marciano Knocks out Louis in 8th." *New York Times* (27 October 1951), 25.

Nott, J. C., and Geo R. Glliden. *Types of Mankind: Or, Ethnological Researches.* Philadelphia: Lippincott, Grambo, 1854.

Nymann, Ann. "Sally's Rape: Robbie Mccauley's Survival Art." *African American Review* 33 (Autumn 1999): 577–87.

Obama, Barack. *Dreams from My Father.* New York: Three Rivers Press, 2004.

Ohrn, Karin Becker. *Dorothea Lange and the Documentary Tradition.* Baton Rouge: Louisiana State University Press, 1980.

Olsen, Jack. *Black Is Best: The Riddle of Cassius Clay.* New York: G. P. Putnam's Sons, 1967.

Omi, Michael, and Howard Winant. *Racial Formation in the United States.* New York: Routledge, 1994.

Orlandersmith, Dael. *Yellowman and My Red Hand, My Black Hand.* New York: Vintage, 1999.

Osenlund, Kathryn. "Review of Yellowman at the McCarter and Wilma Theaters." *Curtain Up* (2001). http://www.curtainup.com/yellowman.htm.

Oshinsky, David. *Worse than Slavery.* New York: Simon and Schuster, 1996.

Pannick, David. "A Fine Line between Art and Making an Exhibit of Yourself." *The Times* (London) (9 April 2002), Features 1.

Parenti, Christian. *Lockdown America: Police and Prisons in the Age of Crisis.* London: Verso, 1999.

Parks, Suzan-Lori. "Elements of Style." In *The America Play and Other Works,* edited by Suzan-Lori Parks, 6–18. New York: Theatre Communications Group, 1995.

Parks, Suzan-Lori. *In the Blood.* New York: Theatre Communications Group, 2000.

Parks, Suzan-Lori. *Venus.* New York: Dramatist Play Service, 1998.

Patraka, Vivian. "Spectacular Suffering: Performing Presence, Absence, and Witness at U.S. Holocaust Museums." In *Memory and Representation: Constructed Truths and Competing Realities,* edited by Dena E. Eber and Arthur G. Neal, 139–66. Bowling Green: Bowling Green University Press, 2001.

Patterson, Orlando. *Rituals of Blood.* Washington, D.C.: Civitas/Counterpoint, 1998.

Pattilo-McCoy, Mary. *Black Picket Fences: Privilege and Peril among the Black Middle Class.* Chicago: University of Chicago Press, 1997.

Pfeifer, Michael J. *Rough Justice: Lynching and American Society, 1874–1947.* Chicago: University of Illinois Press, 2004.

Phelan, Peggy. "Marina Abramovic: Witnessing Shadows." *Theatre Journal* 56 (2004): 569–77.

Phelan, Peggy. *Unmarked: The Politics of Performance.* New York: Routledge, 1993.

Phillips, Michael. "On History; Her Language." *Los Angeles Times* (8 July 2002), Calendar 8.

Pietz, William. "The Problem of the Fetish." *Res* 9 (1985): 5–17.

"Pink Furies Blaze Away." *Los Angeles Daily Times* (17 May 1902), sec. 2, 1.

Poe, Edgar Allan. "The Daguerreotype." In *Classic Essays on Photography,* edited by Alan Trachtenberg, 37–38. New Haven: Leete's Island Books, 1980.

"Police Stop More Blacks, Ont. Study Finds." *CBC News* (2005).cbc.ca/story/canada/national/2005/05/26/race/050526.html.

Purday, Richard, ed. *Document Sets for the South in U.S. History.* Lexington, Mass.: D. C. Heath, 1991.

"Racism Reality on Force's Report." *Toronto Star* (31 March 2005).

Raper, Arthur. *The Tragedy of Lynching.* New York: Arno Press, 1969.

Rayner, Alice, and Harry J. Elam, Jr. "Unfinished Business: Reconfiguring History in Suzan-Lori Parks's *The Death of the Last Black Man in the Whole Entire Universe.*" *Theatre Journal* 46 (1994): 447–61.

Reason, Matthew. *Documentation, Disappearance, and the Representation of Live Performance.* London: Palgrave Macmillan, 2006.

Reichlin, Elinor. "Faces of Slavery." *American Heritage Magazine* (June 1977): 4–10.

Reid, Mandy. "Selling Shadows and Substance." *Early Visual Popular Culture* 4.3 (2006): 285–305.

Remnick, David. *King of the World: Muhammad Ali and the Rise of the American Hero.* New York: Random House, 1998.

Richards, David. "Seeking Bits of Identity in History's Vast Abyss." *New York Times* (11 March 1994), SM8.

Richards, Sandra L. "What Is to Be Remembered?:Tourism to Ghana's Slave Castle-Dungeons." *Theatre Journal* 57.4 (2005): 617–37.

Richter, Stefan. *The Art of the Daguerreotype.* London: Viking, 1989.

"Ring Supremacy at Stake in Reno Fight." *New York Daily Tribune* (4 July 1910).

Roach, Joseph. *Cities of the Dead.* New York: Columbia University Press, 1996.

Roach, Joseph. "The Great Hole of History: Liturgical Silence in Beckett, Osofisan." *South Atlantic Quarterly* 100.1 (2001): 307–11.

Roach, Joseph. "History, Memory, Necrophilia." In *The Ends of Performance,* edited by Peggy Phelan and Jill Lane, 23–30. New York: New York University Press, 1998.

Roach, Joseph. *It.* Ann Arbor: University of Michigan Press, 2007.

"The Road to the White House." Video. *60 Minutes,* CBS News (28 December 2008).

Roberts, Randy. *Papa Jack: Jack Johnson and the Era of White Hopes.* New York: Free Press, 1983.

Rodriguez, Richard. *Hunger for Memory: The Education of Richard Rodriguez.* New York: Bantam, 1983.

Rosenheim, Jeff L. "The Cruel Radiance of What Is: Walker Evans and the South." In *Walker Evans,* edited by Jeff L. Hambourg, Maria Morris Rosenheim, Douglas Eklund, and Mia Fineman, 54–105. New York: Museum of Metropolitan Art, 2000.

Runstedtler, Teresa E. *In Sports the Best Man Wins: How Joe Louis Whipped Jim Crow.* New York: Palgrave, 2005.

Sartre, Jean Paul. *Being and Nothingness.* Translated by Hazel E. Barnes. New York: Philosophical Library, 1956.

Sayre, Henry M. *The Object of Performance: The American Avant-Garde since 1970.* Chicago: University of Chicago Press, 1989.

Schechner, Richard. *Between Theater and Anthropology.* Philadelphia: University of Pennsylvania Press, 1985.

Schneider, Rebecca. "Archives: Performance Remains." *Performance Research* 6.2 (2001): 100–108.

Schneider, Rebecca. "Still Living: Performance, Photography and Tableaux Vivant." In *Point and Shoot: Performance and Photography,* edited by Michelle Theriebault, 61–72. Montreal: Daziboa, 2005.

Shadrake, Susanna. *The World of the Gladiator.* Strood (U.K.): Tempus, 2005.

Shaft. DVD. Directed by Gordon Parks. 1971. Warner Home Video, 2006.

Sharpley-Whiting, T. Denean. *Black Venus: Sexualized Savages, Primal Fears, and Primitive Narratives.* Durham, N.C.: Duke University Press, 1999.

Sherman, Scott. "Preserving Black History." *Progressive* 55.12 (1991): 15.

Smith, Cherise. "Subverting the Documentary Paradigm: Lorna Simpson and Collage." *Black Arts Quarterly* 4.2 (1999): 5–7.

Smith, Felipe. *American Body Politics: Race, Gender, and the Black Literary Renaissance.* Athens: University of Georgia Press, 1998.

"Social Justice Report 2002." Human Rights and Equal Opportunity Commission. 2002. www.hreoc.gov.au/social_justice/sj_reports.html#02_14.

Sofer, Andrew. *The Stage Life of Props.* Ann Arbor: University of Michigan Press, 2003.

Sontag, Susan. *On Photography.* New York: Picador, 2001.

Spillers, Hortense. *Black, White, and in Color: Essays on American Literature and Culture.* Chicago: University of Chicago Press, 2003.

Spivak, Gayatri. "Subaltern Studies: Deconstructing Historiography." In *The Spivak Reader,* edited by Donna Landry and Gerald MacLean, 203–36. New York: Routledge, 1999.

Staples, Brent. *Parallel Time: Growing up in Black and White.* New York: Harper, 1995.

Stearns, David Patrick. "The Pain of Racism within a Race Drives Yellowman." *Philadelphia Inquirer* (22 February 2002), Weekend.

Stewart, Susan. *On Longing: Narratives of the Miniature, the Gigantic, the Souvenir, and the Collection.* Baltimore: Johns Hopkins University Press, 1984.

Stott, William. *Notes on Documentary Expression and Thirties America.* Chicago: University of Chicago Press, 1986.

Sullivan, John L. "Johnson Wins in 15 Rounds; Jeffries Weak." *New York Times* (5 July 1910), 1.

Sutherland, John. "The Blacker They Are, the Harder They Fall." *The Independent* (London) (12 July 1997), 4.

Sykes, Leonard, Jr. "Lynching Exhibit Coming to Milwaukee." *Milwaukee Journal Sentinel* (7 April 2002), News 1B.

Third Man Alive. Videocassette. Directed by Michael McKiver. Milwaukee: America's Black Holocaust Museum, 2001.

Thomas-Lynn, Felicia. "Hip, Happening Entertainment District Outlines for North Ave., Near King Drive." *Milwaukee Journal Sentinel* (25 February 2000), 1A.

Thompson, Deborah. "Blackface, Rape, and Beyond: Rehearsing Interracial Dialogue in *Sally's Rape*." *Theatre Journal* 48 (1996): 123–39.

Trachtenberg, Alan. "The Emergence of a Keyword." In *Photography in 19th Century America,* edited by Martha A. Sandweiss, 17–47. New York: Harry N. Abrams, 1991.

Trachtenberg, Alan. *Reading American Photographs.* New York: Hill and Wang, 1989.

"Troubles Are Over, Says New Champion." *New York Times* (23 June 1937), 30.

Uguwu, Catherine, ed. *Let's Get It On: The Politics of Black Performance.* Seattle: Bay Press, 1995.

Voase, Richard. "Rediscovering the Imagination: Investigating Active and Passive Visitor Experience in the 21st Century." *International Journal of Tourism of Research* 4.5 (2002): 391–99.

Wacquant, Loic. *Body and Soul: Notebooks of an Apprentice Boxer.* Oxford: Oxford University Press, 2004.

Wallace, Michele. "The Hottentot Venus." *Village Voice* (21 May 1996), 31.

Wallis, Brian. "Black Bodies, White Science." *American Art* 9.2 (1995): 38–61.

Walls, Laura Dassow. "Textbooks and Texts from the Brooks: Inventing Scientific Authority in America." *American Quarterly* 49.1 (1997): 1–25.

Ward, Geoffrey C. *Unforgiveable Blackness: The Rise and Fall of Jack Johnson.* New York: Knopf, 2004.

Wexler, Laura. *Fire in Canebrake.* New York: Scribner, 2003.

White, Deborah Gray. *Ar'n't I a Woman? Female Slaves in the Plantation South.* New York: Norton, 1985.

"White Men Fight Black Men Tonight." *Los Angeles Daily Times* (16 May 1902), sec. 2, 1.

White, Walter. *Rope and Faggot: A Biography of Judge Lynch.* Notre Dame: University of Notre Dame Press, 2002.

Whitman, Walt. "Visit to Plumbe's Gallery." In *The Gathering of Forces,* edited by Cleveland Rodgers and John Black, vol. 2. New York: G. P. Putnam's Sons, 1920, 113–17.

Wiegman, Robyn. *American Anatomies: Theorizing Race and Gender.* Durham, N.C.: Duke University Press, 1995.

Wiggins, David K., and Patrick B. Miller. *The Unlevel Playing Field.* Urbana: University of Illinois Press: 2003.

Williams, David B. "A Wrangle over Darwin: How Evolution Evolved in America." *Harvard Magazine* (September/October 1998). http://www.harvardmagazine.com/1999/09/darwin.html.

Willis, Deborah. *The Black Female Body: A Photographic History.* Philadelphia: Temple University Press, 2002.

Willis, Deborah. *Picturing Us.* New York: New Press, 1994.

Willis, Deborah. *Reflections in Black.* New York: W. W. Norton, 2000.

Willis, Deborah. *Vanderzee.* New York: Harry Abrams, 1993.

Wilson, August. "The Ground on Which I Stand." *Callaloo* 20.3 (1997): 493–503.

Woodoff, Ellen. "Columbia Museum of Art's African-American History Month Programming and Events." *Columbia Art Museum News Releases.* 2004.

Worthen, W. B. "Citing History: Textuality and Performativity in the Plays of Suzan-Lori Parks." *Essays in Theatre* 18.1 (1999): 3–22.

Wright, Richard. *12 Million Black Voices: A Folk History of the Negro in the United States.* New York: Arno Press, 1969.

Wynn, Wilhelmina Roberts. "Pieces of Days." *Callaloo* 27 (1986): 391–403.

"Yet Boxing Is Taboo." *Boston Globe* (2 July 1910), 5.

Young, Hershini Bhana. *Haunting Capital: Memory, Text, and the Black Diasporic Body.* Hanover: University Press of New England, 2006.

Young, Jean. "The Re-Objectification and Re-Commodification of Saartjie Baartman in Suzan-Lori Parks's Venus." *African American Review* 31.4 (Winter 1997): 699–709.

Index